THE MIRROR
OF VENUS
WOMEN IN ROMAN ART

DR IAIN FERRIS is a professional archaeologist of over forty years' standing, and has taught at the universities of Birmingham and Manchester. He is a Fellow of the Society of Antiquaries of London and has published widely. His other books include *Vinovia* and *Roman Britain Through Its Objects*, both published by Amberley. He lives in Pembrey, Carmarthenshire, Wales.

THE MIRROR
OF VENUS
WOMEN IN ROMAN ART

IAIN FERRIS

AMBERLEY

*To my late parents, William Adam Ferris
and Rosemary (Dryden) Ferris.*

First published 2015
This edition published 2017.

Amberley Publishing
The Hill, Stroud
Gloucestershire, GL5 4EP

www.amberley-books.com

Copyright © Iain Ferris, 2015, 2017

The right of Iain Ferris to be identified as
the Author of this work has been asserted in
accordance with the Copyright, Designs and
Patents Act 1988.

ISBN 978-1-4456-6028-8 (paperback)
ISBN 978-1-4456-3384-8 (ebook)

British Library Cataloguing in Publication Data.
A catalogue record for this book is available
from the British Library.

Typesetting and Origination by Amberley
Publishing
Printed in the UK.

CONTENTS

ACKNOWLEDGEMENTS

In putting this book together I have received help from a number of individuals and organisations and I would like to take the opportunity to thank them all here.

For help in obtaining photographs for reproduction in the book I would like to thank Hugues Savay-Guerraz of the Musée Gallo-Romain in Lyon (and Peter Leather for putting me in touch with him); Chokri Bourissa of the Agence National de Patrimoine, Tunisia (and Abderrazak Khechine for putting me in touch with APT); Lorène Linarès-Henry of the Musée Départemental Arles Antique; Suzanne Plouin and Frédéric Hamet of the Musée d'Unterlinden, Colmar; Françoise Clémang and Laurianne Kieffer of the Musée de la Cour d'Or, Metz Métropole, Metz; Thomas Zühmer of the Rheinisches Landesmuseum, Trier; Dr Paula Zsidi and Dr Orsolya Láng of Aquincum Museum (and Professor Maureen Carroll for facilitating this contact); Elena Braidotti of the Museo Archeologico Nazionale di Aquileia and Dott. Luigi Fozzati and Stefano Scuz of the Soprintendenza per i Beni Archeologici del Friuli Venezia Giulia; Professor Bert Smith of Oxford University and Dr Julia Lenaghan of the Ashmolean Museum, Oxford; Alex Croom of Arbeia Roman Fort and Museum; Dr Carl Rasmussen of www.HolyLandPhotos. org; Linda Davis; Soprintendenza per i Beni Archeologici delle Marche; and Roberto Piperno.

Acknowledgements

I am also indebted to Julian Parker for sourcing a number of images for me and turning them into digital prints suitable for reproduction here and John Boden for his expert technical help with digital photographs.

The British Museum is to be thanked for the creation of its wonderful web-based image research resource and for its incredibly generous facility for researchers and academics to make use of these images without charge. Other museums, both large and small, could benefit from following this example and fruitfully opening up their collections to further scholarly inquiry in this way.

There are a small number of artworks that I would have liked to picture in this book housed in museums that I was unable to visit in person. Unfortunately, though, despite making an effort to contact those museums both by email and letters in the appropriate language, the museums housing them in some cases failed to acknowledge my inquiries and reply at all.

I am particularly grateful to Gianfranco Mastrangeli of the Vatican Museums' Segreteria dei Dipartimenti e Reparti who kindly arranged for me to visit the Museo Gregoriano Profano in summer 2014 when it was otherwise closed to the public.

Professor Maureen Carroll of Sheffield University kindly provided me with a proof version of her paper on families on the Danube frontier ahead of its formal publication.

The staff of the Institute of Classical Studies library, London; the Institute of Archaeology (UCL) library, London University; the British Library, London; and Swansea University library were unfailingly helpful in obtaining books and journals for my reference while researching this book.

As always, my colleague and wife Dr Lynne Bevan read and commented on a draft of the book, much to the benefit of the finished work. At Amberley Publishing I would like to thank Nicola Gale for commissioning this book in the first place and Christian Duck for her editorial work and advice in seeing the book into print.

PREFACE

It is true to say that this is the first well-illustrated general book in English to present a coherent, broad analysis of the numerous images of women in Roman art and to attempt to interpret their meaning and significance, set against the broader geographical, chronological, political, religious and cultural context of the world of the Roman Republic and empire and of Late Antiquity. However, this does not mean that there have not been numerous academic studies of images of Roman women published before – far from it. Groundbreaking and inspiring work has been done in particular by a group of female American academics, such as Natalie Boymel Kampen, Diana Kleiner, Eve D'Ambra, Elaine Gazda, Susan Matheson and Susan Pomeroy, to whom all subsequent researchers such as myself owe a very great debt indeed.

Although images of women were ubiquitous in Rome itself and in the broader Roman world, these images were seldom intended to be taken simply at face value. Their analysis today needs to be undertaken in cognisance of the fact that Roman society was on most levels male-dominated and that women's roles were sometimes subordinate to political and cultural needs and imperatives, so much so that some ancient historians have questioned whether Roman women 'had an empire' at all. Images of mortal women – empresses and other female members of the imperial family; elite women from

Rome and around the empire; working women from Rome, Ostia, Pompeii and elsewhere; provincial women; and barbarian women – will be analysed in this book alongside images of goddesses, personifications and complex mythological figures such as Amazons. This study encompasses the examination of images in the form of portrait sculptures, portraits on coins, historical friezes, decorated tombstones, mosaics, wall paintings, decorated metalwork, other luxury goods such as engraved gemstones and, to a lesser extent, many decorated everyday items.

This book consists of eight chapters, primarily focussing on issues of identity and status in relation to female gender in the Roman world. An introductory chapter sets out the scope and scale of the study, followed by a chapter on images of the imperial women, with particular reference to the powerful and influential empresses Livia, Julia Domna and Helena. The importance of marriage, dynastic alliances, motherhood, family and political stability through continuity of purpose was often conveyed to the Roman people and the peoples of the empire through the creation and deployment of carefully constructed images of the women of the ruling house.

There then follows a chapter presenting an analysis of representations of elite women in public and private contexts in Rome and around the provinces, and what the presentation of such images can tell us about power, wealth and status and, in the case of provincial elite women, about the significance of ethnic identities. Discussion in Chapter 4 then turns to funerary monuments bearing images of women of all classes in the Roman world. Questions of status and identity are further explored in a chapter on the portrayal of working women in Ostia, Rome and the provinces. The widespread use of images of goddesses, personifications such as Victory and mythological women such as Amazons in various contexts, including their appearances on major civic monuments in Rome, is discussed in Chapter 6. Instances of mythological representations of women being used metaphorically to present moral and political lessons to the women of Rome are

also discussed. More thematically, an examination is then made in Chapter 7 of the concept of the Roman male gaze and the link between power and eroticism in imperial Rome, and how this may have impacted on the reception of many of the images discussed in the preceding chapters. A final chapter presents a discussion of images of women in the Roman world in a broader cultural and historical context, including that of ancient sexual politics. I have tried to avoid too much discussion on the semantics of the very real distinction between female gender and female sexuality as constructed and negotiated in ancient Roman society through the deployment of visual imagery, but almost inevitably this looms large in the account that follows below.

By necessity, a study such as this has to be well illustrated and I have tried to source photographs of both canonical Roman artworks that one would expect to see reproduced here and perhaps many lesser known ones. Over half of the photographs I have taken myself during museum visits spread over the last thirty years. Inevitably, therefore, there is a bias among the images used towards works in museum collections in Rome and more broadly in Italy, France and Britain, for which I apologise.

It has been impossible to write about women without occasionally having to also write about men, particularly in the patriarchal society of ancient Rome. The issue of gender difference and its study is crucial to the underpinning of this book's thesis. Men and women at this period were not 'two sides of the same coin' but rather refracted images in mirrors. In order to try and understand and interpret some of the images discussed in the book it has been necessary to step outside the chronological framework of the Roman world, and indeed outside of its borders, to look for cultural instances of relevant gendered behaviour.

This is not a history of women's lives in the Roman world illustrated by appropriate ancient artworks, nor is it an account of the quotidian routine of individual women in Rome or the provinces, in the city or in the countryside. Many such books

already exist. Rather, it is an attempt to make sense of the image of the Roman woman in all its various forms through the presentation of a thematic survey of such images in different and quite distinct contexts.

I first became interested in this topic in the late 1980s and the 1990s when researching images of barbarian women in Roman art for my first book and on my many linked study visits to museums in Britain, France and Italy, and it is a topic that I have found myself returning to again and again over the subsequent years, so much so that I eventually became convinced that in the absence of anyone else doing so I should definitely produce a full-length study on the subject. I hope it is not too egotistical to say that, like many authors, I am inexorably drawn towards writing books that I would like to read myself.

This book is intended as a general work for undergraduate students of Roman art and archaeology and an informed lay audience interested in the Roman world in general. It aims to demonstrate how close readings of Roman and Romanised artworks depicting women, and an examination of the social structures of Roman society itself, can enable certain aspects of the past history of Rome, from Republican times to Late Antiquity, to be reconstructed and for some sense to be made of the gendered nature of this rapidly changing city and society and of its empire and peoples.

I. M. Ferris, Pembrey, October 2013–January 2015

I

IMAGE AND REALITY

An Empire of Women

In writing about almost any aspect of life in the ancient Roman world there is always the danger of anatomising the chosen area of study to such a degree that its relevance to the bigger picture is sometimes lost or at best becomes blurred. It is therefore useful to start this book by asking why I have selected images of women in Roman art to analyse and discuss here. Surely Roman society would in fact be better understood by concentrating instead on a study of images of men? Was it not Roman men after all who exclusively controlled the political and military institutions which made Rome the power that it became and who created and ruled its empire? In any case, there is no disputing the fact that it was probably a cadre of exclusively male Roman artists who over the centuries created the artworks and built the monuments on which these images of women discussed here appeared.

It is not being suggested here that the history of Roman women should be divorced from the history either of Roman men or of Roman life and its social, political, economic and religious institutions in general. Social networks underpinned all Roman political and economic structures. Such social networks, of course, included women, and those networks found one outlet for the

expression of their existence and power in the use of signs, symbols and images that included images of both men and women, whether in the form of mortals, gods and goddesses, personifications in male and female form or of mythological men and women. Claiming status and constructing a public role for women was achieved in this way. In many respects the Roman *domus* or house, the domain of women, was both a private and public space by function and design and this meant that the great civic spaces like the Forum Romanum, where the activities, concerns and lives of men were pre-eminent, were not necessarily privileged in terms of allowing Roman social networks to operate. Overt and covert operations of these networks coexisted. Indeed, gender and gender imagery were used in Roman society in a rhetoric of difference that both led to and justified hierarchies and boundaries.

It can be argued that by concentrating on the position of women in Roman society as a whole as reflected in the artistic images of women created, consumed and viewed in the Roman world a mirror is being turned on that society and its workings. While the resulting mirror image we see might be refracted by metaphorical cracks in the glass or partially obscured by spotting it is nevertheless illuminating in many ways, though it is not a direct reflection of social practices. It does not tell us directly about women's lives and experiences, even if it might hint at certain aspects of those lives, nor about their agency in society. Some artworks simultaneously conjured up a performance of life and real life together; they became a vacant point around which ideas and ideals clashed. As always in art historical and archaeological studies it is context that is key to understanding. Thus it has been crucial during the writing of this book to constantly consider not only critical information about the date of artworks and objects discussed, but also to ask questions about who commissioned the work, how and where it was meant to be seen or used and who the intended viewers were. Were images of women in Roman art being produced for Roman women themselves, to allow them to say something about their individual

identities or their status and position in society? Or were such images being produced for Roman men, to allow them to situate female being, sexuality and behaviour in predominantly male narratives of power and control; in other words to define women's history in terms of men's history? The answer to both of these questions is the same: 'yes' in both cases, with context deciding which situation applied to which particular artwork. Another key to understanding the significance of images of women in Roman art is actually the medium itself and the reproductive function of this art as part of a mass culture.

Some years ago the feminist ancient historian Phyllis Culham quite rightly asked, 'Did Roman women have an empire?', so frustrated was she at the absence of women from so many contemporary mainstream academic studies of the Roman period.[1] Another ancient historian, Sarah Pomeroy, wondered whether the fascination of many male historians with women in classical antiquity in the stereotypical roles of goddesses, whores, wives and slaves truly reflected any kind of historical truth about women's lives, roles and status at this time.[2] When Boris Johnson, the mayor of London at the time of the London Olympic Games in 2012 and a trained classicist, was gleefully quoted by the press as referring to female beach volleyball players as 'Semi-naked women ... glistening like wet otters,' he was not that far removed in his salacious opinions on sporting women from some male ancient historians commenting on the frolicking 'bikini girls' on the famous Roman mosaic pavement from the Villa Romana del Casale on Sicily, better known as Piazza Armerina. While that situation may have been remedied to some extent in the interim period there is still a tendency for some academics studying the ancient world to pay only lip service to equality, for instance by introducing discussion of Roman imperial women's hairstyles or other such minor, diverting topics rather than of their power. However, it is in the field of ancient history and art history that the most significant contributions to understanding Roman women have probably been

made; it is inevitable in a literary and visual culture such as that of ancient Rome that aspects of women's lives will be best revealed through documents and images. I am writing here as a Roman archaeologist who has a particular interest in material culture in all its forms, including art. I therefore tend not to see a divide between studying artefacts and artworks; they both form a part of society's material culture.

Because of the evident primacy of context over chronology I decided to structure this book accordingly, eschewing a periodisation of the images and choosing instead a thematic analysis of artworks, hoping that a looser structure such as this would allow cross-chronological themes to emerge of their own accord and locate trends in artistic practice in their socio-political context. Such a structure should also allow for changing practices to be analysed in terms of ideological change rather than simply aesthetic fashions, though these too are of great significance and importance.

In any case it would not appear that images of women in general were more numerous or more important at certain periods than at others, though *certain types* of images of women undoubtedly were, and the Augustan era could be singled out most obviously in this respect. The reasons behind the greater visibility of women at certain periods will most definitely need to be considered below. However, in this study I have chosen to make use of examples from Rome's Republican period as well as its imperial era, indeed extending my field of inquiry into the period of Late Antiquity, though avoiding discussion of Christian art. This is not to say that chronological trends or even temporal watersheds cannot be identified among the evidence, rather that it would seem that such trends and watersheds can best be explored through thematic and contextual analysis.

While many of the images of women discussed and illustrated in this book are symbolic in some way of broader concepts, many others are images of real, historical women, even if sometimes these women are somehow disguised, idealised and, in most cases, anonymous in the absence of an accompanying inscription naming

them. In that case, they are very often subjects in their own right, with the autonomy that accompanies this state. I always fear that like a character in a popular quest novel, I will find myself forever consigned to the relentless pursuit of meaning in signs and symbols and lose track of the bigger human picture. So I hope this has not happened here.

Of course, the use of the term 'Roman' in the title of this book may also be problematic, in that I am not limiting discussion to artworks produced in Rome for exclusively Roman audiences. Even in Rome the types of commissioners of artworks and the viewers of those artworks varied tremendously across the social scale, from freedmen to emperors. In fact, examples have been drawn here from quite widely across the Roman Empire, from the cities of the North African littoral to the forts and frontiers of northern Britain. In dealing with provincial art, or rather art from the provinces, one needs to be even more aware of the context of that art and sometimes its meaning in ethnic as well as cultural terms. In order to reflect this, in the case of Roman Britain, for instance, I have distinguished between Roman or Romanised art, which is art firmly or at least broadly in the classical tradition, and Romano-British art, which is a truly provincial variant on Roman art, much of it constituting a folk-art tradition. The same applies to Gaul and other provinces. Today provincial art can generally be subsumed into the grand narrative of Roman art and indeed helps us to chart its march from pure classical art to the more complex art of Late Antiquity. To further complicate the matter, there are some cross-provincial strains of art dependant on both context and chronology, rather than necessarily geographical or cultural factors. Such cross-provincial artistic phenomena could include military art, both Roman/Romanised and provincialised, and in the later empire an elite art which reflected the wealth, interests, tastes and concerns of a relatively small but hugely powerful empire-wide elite of high-ranking administrators, provincial governors, senior military officials, commercial brokers and landowners.

Many studies of Roman women's daily lives have been published over the last twenty or thirty years, based both on literary and historical sources and on archaeological evidence and material culture and art, and indeed many of these have considered the evidence for individual provinces, most notably Gaul and Britain.[3] These accounts of ancient women's daily routines were often by necessity biased towards discussions of women's appearance, grooming, dress and health. Much groundwork has been done by ancient historians on the social and legal positions of Roman women, much of this work being pursued by the study of the Roman family and of Roman law.

Recently attention has been paid to analysing the corpus of private epigraphic dedications to deities and tombstone dedications from Roman Italy in gendered terms in order to try and identify any differences in the record between dedications made by men and those made by women.[4] It would appear from a detailed examination of the evidence that the corpus suggests a shared customary approach to the expression of belief and the use of the cultural apparatus through which this expression could be given voice. There would seem to have been little difference in levels of participation between men and women; indeed, certain areas of epigraphic expression previously thought of as being male preserves now look as if they were not so clearly gendered after all. In some contexts a unique female perspective can be discerned from some inscriptions. If it can thus be demonstrated in this way that Roman women had some active role in commissioning inscriptions and making dedications, then their agency in commissioning and consuming artworks might also have been equally significant.

The most inspiring work in the field of the analysis of female images in Roman art has been undertaken by Natalie Boymel Kampen, and her studies of Roman working women at Ostia in 1981, women on Roman imperial monuments in 1991 and 1995, sexuality in the broader ancient world in 1996 and the imperial family unit as fiction in 2009 remain highly important and

influential to this day.[5] Another benchmark academic event in the history of studying images of women in the past was the staging of the exhibition 'I Claudia' at the Yale University Art Gallery in New Haven in 1996 and the publication of an accompanying catalogue by Diana Kleiner and Susan Matheson in the same year.[6] In their writings, these academics changed the discourse about women and Roman art history, and to some extent the academic floodgates subsequently opened in response.

Underpinning all these important studies of women in Roman art has been the examination of identity formation and its maintenance. The personal identities we construct for ourselves are to some extent quite makeshift and often tend to come apart when the stability and coherence of a society can no longer be taken for granted by all levels of that society. Personal identity may sometimes be different from social identity, the two may alternate or one may be submerged in the other, again depending on context of course. While female and male sex is biologically determined in the womb, female and male gender is culturally determined by society and the individual, often not acting in harmony, and is therefore intimately linked to the issues of identity and self-definition.

Many of the images illustrated and discussed in this book might at first sight seem simple to interpret. Images of a man and a woman appear together on a sarcophagus; an accompanying inscription tells us their names and that they were husband and wife (see image 1). A woman may be depicted with both her husband and children or alone with her children (see image 2). In many of these situations the woman is being depicted not simply as an individual, a member of Roman society in her own right; rather, she is being depicted as someone's wife or someone's mother and it is her depiction in this role that is often the point of the portrayal in the first place. This might be especially understandable in the context of portrayals of the imperial family at any one particular period, in that the image of stability represented by the imperial family with its promise of dynastic continuity and a smooth, seamless transfer of power from

generation to generation was intended to reassure the viewer of a stable future. Here the idea of family was used in the service of political ideology and propaganda. However, the family was equally a symbol of political and social power in Roman society. Yet, given this constant bombardment of the viewer with images of the ideal mother or the ideal Roman family, there was little in the way of representations of nursing scenes or suckling mothers in Roman art. Why might this have been?

Wherever possible in this book I have tried to distinguish between women as (passive) subjects of representation and women as (active) agents of some kind in the creation of images. To do otherwise and to accept that most female images in the Roman world were produced at the behest of men principally for other men would ignore the nuanced nature of women's experiences within the accepted constrictions of public and private lives. These nuances become even more significant when analysing and discussing women of different classes and status in Rome and, of course, women outside Rome and Italy, in the provinces of the Roman Empire. Women's lived experiences might have been used here to blur the boundaries of image and reality. How else can we explain the more public role of some powerful elite women in the cities of the eastern empire at certain periods?

Perhaps issues of identity as reflected in images in Roman art are best explored during watershed moments in private lives rather than through public monuments and social and religious rituals when definitions of active and passive roles perhaps became blurred. Tombstone dedications and images employed on artwork on tombs, tombstones, funerary altars, sarcophagi and cremation caskets are of particular interest in that these might be expected to have reflected a heightened and more dramatic rhetoric referencing the meeting here of life and death, a moment of crisis of identity and of personal and social tension.

The age at which a girl was thought to become an adult woman in Roman society was in the early teens, around fourteen years of age.[7]

That many young girls were married off at this age meant that while there might have been a physical transition from girl to woman with the beginning of periods around this age, and from virgin to initiate following marriage if all went well, these transitory rites were not necessarily accompanied by a break with the past entirely. A girl might simply have moved from a household dominated by her father to a household dominated by her husband. Her position as a girl or woman was remarkably similar in this respect. Again, with multiple sequential marriages being very common among the Roman elite, and later with some of the imperial families, feelings of change linked to the acquisition of another husband and another house might not have felt so momentous.

In many respects, there could not be a better representative image of this mysterious state of change mediated by stasis than a haunting image from a Pompeian wall painting from the House of Meleager, of a veiled woman standing just inside the opened door of a house looking out (see image 3). The woman stands perfectly still. She holds a small casket in her hands. She is of the house. It is her realm. It both encloses and protects her and it partly imprisons her. She stands by the open door, perhaps not wanting or daring to cross the threshold from her private space to the public space of the streets. She is caught here perhaps in a moment of reflection, of reverie, of contentment or of regret, her identity forever linked to the house *inside* whose walls she is secure in identity and *on* whose wall her image has been caught forever.

Three Women

The complexity of the task in hand, of analysing and interpreting images of women in Roman art, can best be illustrated by the presentation of three brief case studies of images of women on Roman period funerary monuments, which are from distinctly different contexts: one on a funerary relief from the city of Rome; one on the so-called Circus Relief from Ostia, the bustling port of Rome, also from a funerary monument; and one on a tombstone

from northern England. Each representation says something different about the protagonists portrayed and each was intended to provoke a particular response from the viewer. Each example chosen has its own in-built limitations to full interpretation.

The first work of art chosen to illuminate an aspect of the thesis behind this book is a particularly interesting example provided by a unique first-century BC freedman/freedwoman funerary sculpture of a mother and daughter which is in the collection of the Musei Capitolini in Rome (in its outpost museum at the Centrale Montemartini) and which is thought to have been erected on one side of a house-tomb facade and which probably formed a pendant decoration to a sculpture of a father and son on the other side (see image 4).[8] The figures are free-standing. Both mother and daughter wear different types of garment, in the mother's case a tunic and *palla*, with the fold of the mother's garment looped over her head as a veil. Her face is undoubtedly a portrait, but an idealised one typical of the period. Her head is slightly turned to look to her right, presumably towards the posited pendant statue figure of her husband. The mother's left hand is held up at her neck, caught in the process of forming the so-called *pudicitia* gesture of marital modesty and piety, while her right arm is positioned across her body with the wrist extended down to her waist. She wears no jewellery and her hair is dressed in a plain, practical style. Her daughter stands by her side, a tiny figure of perhaps only five or six years old. She too is dressed and posed in a very formal manner, a kind of miniature adult no less. She faces directly out at the viewer, with one arm held down by her side and the other across her chest, supported in the folds of her garment. She is wearing a toga over a tunic. Her face is individual enough to be a portrait and her hair is arranged in quite intricate plaiting, suggesting a degree of fashionability which might not have suited the position of her mother as a dignified matron but which is altogether appropriate for a younger girl not yet subject to societal expectations of this kind.

If the role of the image of the woman in this funerary setting was

to act as the foil to the image of the husband, that is, to show that he was a respectful and respectable married man; the child acted as a foil to both the man and the woman by enhancing the married man's status by also making him a father and the woman's role by making her a loving mother as well as a dutiful wife. The suggested glancing look of the woman to the man, and presumably his return glance to her, would have almost linked them physically; they were to some extent touching from a distance.

The fact that the daughter is dressed in the way she is seems highly significant in this particular case. The mother, being a former slave but now a freedwoman, would not have been expected to present herself in the same manner as a freeborn contemporary adult. The freedwoman here to some extent has adopted the appearance, fashions, pose and gestures of a freeborn Roman matron, something that would suggest to the viewer that she was making herself publicly available to be judged by the same moral and social criteria. The child though could be presented in another way; her present and her mother's present were very different indeed in terms of their social status and of nuances of status. The future of the child was much brighter than it had been for her mother at a similar age.

While our understanding and interpretation of the image on the tombstone of Regina discussed below is greatly enhanced by a reading of an accompanying inscription and by consideration of its context, in the case of the Musei Capitolini mother and daughter we are denied access to this further layer of exposition by the absence of an inscription. Both mother and daughter must for the moment, and probably forever, remain unnamed and anonymous, unless other parts of their family tomb are uncovered by archaeological excavation in the future.

The Ostia Circus Relief, our second case study example, dates to the early second century AD and is either Trajanic or early Hadrianic and is now in the collection of the Musei Vaticani in Rome (see images 5 and 6).[9] It is a thrillingly vibrant carved panel depicting

a chariot race around a circuit, probably the Circus Maximus in Rome, and was likely set up in a funerary context, perhaps for a male chariot-race official. There is no accompanying inscription. Its style of carving is both original and retrogressive at the same time, employing multiple perspectives and differential scaling of figures. Leaving aside both the issue of style and the depicted chariot race itself, one of the most interesting aspects of the relief is the depiction of the deceased man and his wife which appears to one side of the panel. The man is depicted at a much larger scale than the woman and indeed is much larger pro rata than all the other figures engaged in the race. He faces out frontally to the viewer, one arm held partly across his body to grasp the folds of his toga, with his other hand clasping the hand of his wife by his side in the *dextrarum iunctio* gesture, symbolising their union in marriage. His face is so distinctive and gnarled with age that we can suppose that this is a portrait of the deceased. In contrast, his wife stands sideways on to her husband, dwarfed by his size. She is much younger facially, which suggests that she might have died some years before her husband or that she was much younger than him at the time of their marriage, something that would not have been at all unusual in Roman society at the time.

If not immediately apparent to the viewer, closer inspection of the image of the woman in the relief reveals that she is not in fact a human figure at all but rather a statue standing on a raised pedimental base, something which again indicates that she had in fact pre-deceased her husband. That this woman is represented by an image of a statue, an image of an image in other words, is quite unprecedented. She is in fact not only dead but made of stone or bronze. The playing of past against present here is quite extraordinary. Intertextuality of one kind or another is not uncommon in Roman art, but it is difficult to think of anything quite as original as the Ostia marriage of the dead male and the statue of his dead wife. Her representation as a portrait statue perversely gives her additional status and by association her husband also would have garnered an additional cultural fillip or social cachet.

Finally, the mid-to-late second-century AD Romano-British tombstone of Regina from Bath Street, South Shields in northern England, to the south-west of the Roman fort there, represents an object lesson in how much more informative visual culture can be when an image, in this case a carving on a tombstone, is accompanied by an inscription (see image 7).[10] Again, being able to put a name to the individual or individuals portrayed in an image also represents a pleasing form of closure for those who study such remains of the past. Acquiring the epigraphic habit as well as a knowledge of visual signs and symbols and of modes of status representation would have placed Regina and her family firmly in the mainstream of provincial society in Britain at that time. Or would it?

On her tombstone, now in Arbeia Roman Fort Museum, Regina is depicted in a gabled niche flanked by two pilasters. She sits in a high-backed wicker chair facing directly out at the viewer. She wears a long-sleeved, floor-length tunic and an over-robe or coat, a cable necklace and cable bracelets on both wrists. Unfortunately, the area of her head has been badly damaged and so we are unable to say anything about her facial features, hairstyle or any hair ornament or covering, though one authority has suggested that she could have been wearing a bonnet of some kind with long locks or strands of hair protruding from under the bonnet and hanging down onto her neck. On her lap in her left hand she holds a distaff and spindle, while on the ground to her left sits a basket of wool and another possible distaff. On the floor to her right is a casket, probably a jewellery box, though it could be a strongbox or a container of toilet articles, which she holds open with her right hand.

From the image itself we can probably assume that Regina was a respectable woman, a provincial equivalent of the staid Roman matron, pictured in the home whose smooth operation she oversaw. She took evident pride in spinning and wool-working and an acceptable feminine interest in her appearance, as reflected in her wearing of jewellery and the depiction of her private jewel casket. As we will see in subsequent chapters, wool-working was considered

an appropriate and seemly craft for elite Roman women – even for an imperial woman such as Livia – and was a symbolic signifier of feminine virtues and moral probity. Sometimes it had a further particular cultural resonance in certain provincial societies in the empire, as in Pannonia where it was a marker of female ethnic identity as well as status. Textile working and weaving therefore need not necessarily be seen as a means by which Roman or Romanised society could control women and establish order. However, we are very far away from being able to talk about Roman or Romanised women subverting the presentation of their craftwork in some way in order to express their feelings rather than simply their status, tempting though it is to think about a Roman equivalent to the idea of the 'subversive stitch', to use Rozsika Parker's useful and alluring phrase.[11]

It has been noted that Regina's dress is much more elaborate than most of the costumes worn by other Romano-British women depicted in funerary images, though as there are so few of these in total, as will be discussed in Chapter 3, this might not necessarily be particularly significant.

The inscription on Regina's tombstone reads, '*D(is) M(anibus) Regina liberta et coniuge Barates Palmyrenus natione Catuallauna an(norum) XXX*', translated as, 'To the spirits of the departed (and to) Regina, his freedwoman and wife, a Catuvellaunian by tribe, aged 30, Barates of Palmyra (set this up).'[12] Underneath this formal Latin inscription is a less formal line of abbreviations in Palmyrene Aramaic which reads in translation in full as, 'Regina, the freedwoman of Barate, alas.' Thus from the inscription we learn her name, her tribal or ethnic origin in the south-east of England, her social status as a slave and then as a freedwoman, her marital status, her husband's name and ethnic origins and her age at death, making our interpretation of the tombstone even more complex and nuanced. Regina is far from being a Romano-British equivalent of a Roman matron; leaving aside her having been a British slave so many generations after Britannia had become a Roman province,

we now see that she was probably a well-travelled woman whose manumission and subsequent marriage represented an extraordinary series of social transformations perhaps not necessarily quite so common in the Roman Empire as we might think.

Possibly even more can be added to this already complex picture by the fact that remarkably we also have part of a tombstone from Corbridge, again in northern England but some distance away from South Shields, of a Palmyrene who some academics have suggested might just be the same Syrian man Barates. This is, however, somewhat speculative, as the inscription on the tombstone is incomplete. It reads, '*[D(is)] M(anibus) []rathes Palmorenus uexil(l)a(rius) uixit an(n)os LXVIII*'; in translation, 'To the spirits of the departed: []rathes, of Palmyra, a flag-bearer [or some say 'a flag seller'], lived 68 years.'[13]

The final point to be made about Regina's tombstone is an obvious one which nevertheless needs raising. There is no way of knowing whether Regina had any hand in approving the design of her tombstone or the wording of the epigraphic inscription on it. She may have died suddenly before any such arrangements had been set in train and what we are seeing is Barates' version of Regina's reality, an image and view of a dead woman filtered through the grief of her evidently loving husband and ex-master. In Romano-British society, portrait sculpture was an art not widely embraced, as will be discussed in a later chapter, and it is unlikely that an image of her could have been created in any circumstances other than death, given her status and the society in which she lived and from which she came. The total number of decorated tombstones from Roman Britain is quite small and of those the majority are for men, principally members of the Roman army, so for us to know so much about Regina is almost as extraordinary as her personal story.

Thus analysis of this tombstone demonstrates that gender can shift significantly according to its interrelationship with culture, class, ethnicity and, of course, with age. It also shows how diverse audiences of viewers throughout the Roman Empire could, with the correct understanding of the dominant ideology and its symbolism,

interpret or view a particular work of art according to a collective view of the world forged under other skies.

Thus, in these three chosen examples we have seen three quite distinct types of representation of a woman's life in the Roman world and three performances of different realities. In the first, a freedwoman has adopted the role and status of a Roman matron, wife and mother and displayed for all to see the contrast between her origins – the past – and those of her freeborn daughter – the future. In the second case study we have seen how linear time has been perverted and altered to suit the circumstances of commemoration of a Roman wife who has pre-deceased her husband. She does not appear as an image of a real woman but rather as a statue image of a real woman, a kind of metafictional character. In the final example, a Romano-British freed slave, another freedwoman, was celebrated at death by her Palmyrene husband and presented as an image of a good wife, adept at female crafts and proud to display her material possessions.

A Truthful Fiction

There is, of course, a vast range of different types of representations of women to be found in Roman art, from nudes and semi-clothed women to fully clothed ones. Each of these states of dress or undress had its own meaning according to context. Some were more truthful to realities than others. It would certainly be a big mistake to think that all naked or semi-naked portrayals of women were meant to be erotic or sexual images. When faced with the less common male naked or semi-naked statue or image, art historians have often fallen back on the term 'heroic nudity' to describe the mentality and reasoning behind the adoption of such a strategy of representation in these cases. These men have not been viewed by ancient historians as provocative beefcakes. But, of course, something as glorious as 'heroic nudity' cannot necessarily account for something as incongruous and downright unpleasant as semi-naked Julio-Claudian emperors battering personified women on reliefs from Aphrodisias, as we will see in a later chapter. In the same way, not all clothed representations

would have had the same value or meaning, and differences in dress, hairstyles, body adornment, jewellery and personal possessions, not to forget pose and gesture, would have been intended to generate specific responses from viewers. Dress and nudity were both strong indicators of sexual status in Roman society.[14]

At the basest level, a study of images of Roman women can tell us a great deal about Roman male attitudes to women and male takes on truth and reality, as many of these images were created for male clients and some were intended principally for male viewing, to be interpreted through the male gaze. However, significant numbers of these images undoubtedly were produced for women patrons, particularly as a result of the opportunities afforded them perhaps unintentionally by the Augustan programme of social and political legislation to assert their status and rank by assuming public responsibilities and by the continuation of such initiatives in whole or in part by later emperors.

In simple terms, it could be said that by creating an image of a woman one was somehow controlling her, indeed framing her femininity. There may well often have been a balance between the generic or idealised and the particular in the creation of some images, and between a portrait and a facsimile of the individual in others. Nevertheless, in making the selection of the form of the female image, male control could be exerted in this way. The negative connotations of this element of control might have been further emphasised by the public display of the image. For instance, the eroticisation of the female form within an urban interior had a particularly personal meaning and meant something altogether different from the heady mixture of power and eroticism that often surfaced in Roman imperial art.

If at times we can detect a virulent strain of hyper-masculinity running through certain Roman works of art, so indeed can a counter-strain of hyper-femininity also sometimes be found. We do have to consider, though, whether overt displays of images of hyper-masculinity were also intended by their very nature to be anti-feminine. It would therefore be useful for a moment to consider

here the concept of the display of hyper-masculinity in Roman artistic images and ask if this very hyper-sexualised display had its roots in male sexuality and male-gendered power structures alone.[15] Did the common portrayal of many of the third-century emperors in the likeness of hard and uncompromising figures have the same intended impact on female viewers as on male viewers? Did the tactic of the Tetrarchy to present images of its ruling members as interchangeable men reflect any kind of contemporary gender reality? In the third century there was scarcely time for narratives of family, dynasty and continuity to be created. Many of the emperors of the period rose without trace and disappeared from the scene almost as quietly, as did their empresses and families.

Images of women were ubiquitous in Roman and Romanised society but almost as tokens, existing both everywhere and nowhere. In terms of their symbolic presence in Roman art of all periods, it is true to say that Roman women most certainly did 'have an empire', as well as a Republic, and an examination of the creation and deployment of images of Roman women in Rome itself, Italy and more broadly throughout the empire suggests that there was a dynamic tension at all periods between the identities being promoted for women by men and those identities being presented for public consumption by women themselves. It is this tension that runs through this present study and drives the narrative. Roman women through their representation in art migrated from reality to the Roman collective imagination, where they were transformed into a kind of truthful fiction.

In this chapter I have considered the basis of the study of images of women in the Roman world in general terms, and in passing have noted the importance of the images of female members of the imperial family. In the next chapter, these imperial women will be considered in more detail in terms of how the presentation and wide circulation of their images impacted on wider Roman society and how these imaginary bodies of famous women sometimes functioned as signifiers of both stability and change, and stasis and transition.

2

POWER AND THE IMPERIAL WOMEN

Images of Livia

Images of Roman imperial women totalled together undoubtedly represent the largest single group of portrayals of mortal women in Roman art by a long stretch.[1] They also, of course, appeared in a number of media, most commonly as statue portraits and as portrait heads on coins, and less commonly on imperial and civic monuments and on carved gemstones and cameos. In the period of Late Antiquity, images of imperial personages also appeared on a broader range of media, including silver vessels, ivory diptychs and mosaics.

Rather than present here a chronological survey of appearances of imperial women in Roman art from the first century BC to the fifth century AD, discussion will instead concentrate principally on images of the empresses Livia, Julia Domna, Faustina the Younger and Helena, though other empresses will also be alluded to in passing. The methodologies for the presentation of images of these four women to the Roman people and the people of the Roman Empire would appear to encompass most, if not all, of the propaganda strategies that linked particular types of images of imperial women to particular aspects of Roman imperial rhetoric and ideology.

The first and most detailed case study to be presented here involves discussion of images of Livia Drusilla, the second wife of Octavian, later to become the emperor Augustus, and mother of Tiberius to her first husband Tiberius Claudius Nero (see images 8–10). On their marriage in 38 BC, Livia could not have known that the then Octavian would go on to seize sole personal power in Rome and become its first emperor. With Augustus's adoption of her son as his heir, Livia's importance was then represented by both her being wife to an emperor and mother to a future ruler. Livia represents perhaps the most interesting of the case studies of imperial women being presented here because of the fact that her public position, that of the first empress of Rome, was unprecedented and because of her great longevity in public and political affairs in Rome, reflected in the very large number of surviving portraits of her. Her sixty-plus years of public life are represented by over 100 surviving statues, and many more are attested by inscriptions, certainly the largest corpus of works for any individual Roman woman. Her image also appeared on coins, though interestingly only on issues struck in the provinces, and on gemstones. Just as the images adopted by Augustus as his public persona resonated down the ages and influenced the presentation of the imperial ruler down to the age of Constantine and beyond into the Byzantine world, so would images of Livia have an equally influential impact on the depiction of the imperial women. Such imperial images would also influence private, elite individuals, as will be seen in later chapters.

Examining Livia's portraits may also allow us to consider how the Augustan interest in the appropriate and moral behaviour of the women of Rome, a topic discussed below in Chapter 6, might have impacted on the presentation of the images of his wife to the Roman viewer. Much of Augustan art was tied in to the ideology of dynastic order, social cohesion and peace, ironically brought about through war.

When we call the imperial statue representations of emperors, imperial women and other family members 'portraits', it should

be noted that these portraits were all to some extent idealised. Imperial iconography was not a respecter of the strain of veristic representation that grew up in the period of the Republic, though certain of the bull-necked, fearsome soldier-emperors of the third century AD might fit this bill. So though certain physiognomic traits might be regularly identifiable in the corpus of portraits of some imperial figures, and indeed this is the case with Livia, these traits might simply have been part of the constructed image rather than representations of real features. Identifying and describing Livia's real or created physiognomic appearance is not a topic that is strictly relevant to the main theme of the book, though, and in any case as I suffer from a mild and occasional form of prosopagnosia, which is an inability to recognise both familiar and unfamiliar faces by virtue of their constituent parts and the interrelationship of those parts as a visual whole, this would be difficult to attempt.

Four principal portrait types for Livia have been identified by Elizabeth Bartman, whose study of images of Livia is, and will probably remain, the definitive study of her representation.[2] It is quite astonishing to note that though these types obviously differ in their presentation of Livia's image to the Roman people and peoples of the empire at different stages of her long life, nevertheless they all still portray her as youthful, even though she was to live into her eighties. However, several portraits on gems do show her ageing face, indicating a conscious split between the public and private image. [3] The four main portrait types are known as the Marbury Hall type, the Faiyum type, the Kiel/Salus type and the Diva Augusta type. The exact dates and longevity of each type is uncertain: the first two types appeared during Augustus's life; the third after his death, when Livia's status changed to imperial mother and priestess of her late husband's cult; and the fourth type appeared after her death and deification. As well as the four clearly defined types, there are many variant examples that display single or sometimes multiple traits from the main types.[4] Each of the main types will now briefly be discussed in turn. Consideration will then be given

to Livia's appearance on major Roman imperial monuments and on certain items of court luxury art.

The Marbury Hall portrait type has an elongated face and narrow eyes but is at first most noticeable for the elaborate but not showy hairstyle that includes a wide and flat *nodus*, a kind of gathered roll of hair, high up on the brow of the forehead, connected to a braid that runs over the top of the scalp and down the back of the head where it is wound around a tight bun of hair. The hair at the sides of the head is styled in waves.[5] The adoption here of the *nodus*, a hairstyle element whose origins would appear to be strictly Roman and which was a marker of female restraint in Republican times, signals a kind of public female seriousness and modesty that might not have necessarily been expected in the portrait of such a powerful woman.[6] Generally, no jewellery is worn, nor other items of adornment such as hair-combs. She usually appears heavily draped and sometimes veiled.

The Faiyum portrait type is of a more relaxed, less stretched face with a larger nose and larger eyes.[7] Livia retains the *nodus* at the front, which here is more pronounced, and a tight bun at the back, though the rest of the styling is softer, and individual strands of hair are artfully arranged coming down onto the face. This portrait represents almost a simplification of the Marbury Hall image. Again, as before, jewellery is generally absent.

It seems likely that the Marbury Hall type represents the earliest standardised portrait type for Livia and that it therefore dates to the early Augustan period, something that is perhaps also hinted at by the relatively small number of examples known to us, there being nine recorded up to 1999 when Elizabeth Bartman published her catalogue. We have no idea of the likely appearance of the public honorific statue of Livia recorded by Cassius Dio as being dedicated by the Senate in 35 BC along with a statue of her sister-in-law Octavia, or even if the two women were portrayed singly or together. Quite possibly the face, features and hairstyle of the Marbury Hall Livia replicated in whole or in part those of the statue of 35 BC.

Indeed, the backwards-looking, conservative, what I have called heritage, elements of the Marbury Hall type can perhaps be better explained in the context of an approved senatorial design in a time of severe political crisis for Rome. If Augustus was to cleverly but falsely style himself as being *primus inter pares* – first among equals – then here Livia was being presented as equal to, but different from, her female, elite, Republican peers. The fact that the Faiyum type is represented by about twice as many extant examples as the Marbury Hall type perhaps suggests that it represented the first imperial portrait of Livia, possibly circulated quite shortly after Augustus's accession of 31 BC and remained the predominant public type for much of his reign, despite Livia's increasing age over that period.[8] If indeed it was the first widely circulated image of Livia then it would be expected to have been reproduced hundreds of times, something that its relatively simplified and idealised classicising character would have made easy. Elizabeth Bartman sees the Faiyum portrait type as being of 'an ageless and elegant beauty, calm and dignified in her demeanour', locating the empress in a newly created space between a Republican matron and a classical goddess.[9]

These first two portrait types, with their referencing of the Roman past and its cultural traditions as represented by the sporting of the *nodus*, to some extent can be seen not only as being 'of Livia' but also most definitely as 'not of Cleopatra', consort of Octavian's sworn enemy Mark Antony. In other words, western traditions were being invoked against the lure of her eastern otherness. Livia's sedate matronly bearing, and her lack of ostentatious jewellery and hair accessories, was being held up as a cultural norm against the overtly sensuous and luxurious presentation of the Egyptian queen. Indeed, it has been suggested that the 35 BC statues of Livia and Octavia were set up next to one of Cleopatra in the Temple of Venus Genetrix in Rome.[10]

Visually, Livia's image in both early portrait types was quite self-explanatory, certainly reassuring to the viewer, and at the same time she would have come across as decorous but moderate and,

most importantly, as conciliatory. She conveyed the idea of change and renewal in a non-threatening manner and in a timeless fashion. The real woman was transfigured to create an exemplary model for the women of Rome and, for that matter, for the men of Rome too. In offering up an image of his wife in this way to be viewed by the Roman public, Augustus was being somewhat voyeuristic. It was something newer and older at the same time; it was at once of the Roman cultural tradition and yet above it.

The Kiel/Salus portrait type of Livia is facially perhaps more relaxed, with large eyes, but it marks a break with the first two portrait types in that the *nodus* is abandoned as the defining hair style.[11] Instead, the hair is parted in the middle and used to frame the front of the face. At the back, a bun secured with braids is still the fashion. Her look is still surprisingly youthful in certain aspects, even though she was probably in her seventies at the time the new portrait type was inaugurated. This awkwardly named type is an amalgam of a portrait head of Livia in the Kunsthalle, Kiel, and her portrait on what are known as the *Salus Augusta* coin issues and probably came into being in the early AD 20s to reflect Livia's changed circumstances.

The Diva Augusta portrait type appears much more idealised, with a more regular, somewhat vacant face with large eyes and a rounded chin.[12] The centre-parted hair radiates out across the head in wavy strands. There is still a bun holding the hair at the back, but this is simpler and looser than in the three other types. The face is astonishingly young, rejuvenated by death and deification in a way that not even the most prohibitively expensive wrinkle cream could achieve today.

Augustus's rule from 31 BC to AD 14 was marked by the transformation of both Rome itself and of the wider Roman world. Consequently, new literary and artistic languages needed to be found to record, celebrate and commemorate the Augustan age. The formulation of this new visual language and its exercise in the service of Augustan power has received a great deal of attention

from ancient historians, art historians and archaeologists in the last twenty years. The portraits produced of Livia equally contributed towards the promulgation of the Augustan message and programme in all its studied complexity. The first two portrait types of Livia might be considered somehow to have included a 'heritage' element in their creation, which means that they were looking back to earlier Roman precedents in styling and appearance, while the latter two types were less rooted in controlled nostalgia and somehow more forward looking. This cautious combination of tradition and innovation and the blending and blurring of past, present and future is typically Augustan in purpose, intent, execution and ambition. It is difficult to know what the contemporary viewer would have made of Augustan art's seamless blend of clarity and confusion, of openness and obfuscation.

In addition to the setting up of Livia's sculptural portrait images in public places in Rome, Italy and around the Roman Empire, some associated with the imperial cult, Livia's appearance on the monumental Ara Pacis Augustae, or Augustan Altar of Peace, in Rome and on a number of lesser monuments, and on the Grand Camée de France, perhaps the most significant imperial cameo gemstone to have survived from antiquity, placed her in the viewer's eye firmly at the centre of the Augustan court and of the succeeding Julio-Claudian dynasty. Her portrait also, of course, appeared on coins, though relatively few coin issues featuring images of Livia were produced during Augustus's reign. The extent of her individual power and significance can be discerned from the ubiquity of the appearances of her image around the Roman world and the contexts in which it appeared.

The Ara Pacis Augustae is one of the most significant surviving monuments from ancient Rome. Restored and reconstructed today, it sits within a glistening white, custom-built, modernist museum compound near the banks of the River Tiber and close to Augustus's mausoleum, a short distance away from its original location facing the Via Flaminia. Completed and dedicated in 9 BC the

monument comprises a rectangular, white Luna-marble enclosure wall surrounding an altar inside, with doors or openings at both ends. The high enclosure walls are profusely decorated with relief sculpture.

The upper parts of the outer faces of the long sides of the enclosure walls are carved with processional scenes involving the imperial family and participating religious officials. A procession of Vestal Virgins also appears in relief on the inner altar itself. Due to damage in places and perhaps over-zealous restoration of some portrait faces, not all the members of the imperial entourage can be identified with certainty, and even then there is not always accord among academics as to the acceptance of certain of these identifications. It is generally accepted that Augustus, Marcus Agrippa, Livia, her sons Tiberius and Drusus, Drusus's wife Antonia the Younger, their son Germanicus, Antonia the Elder, her husband Lucius Domitius Ahenobarbus and their children Gnaius and Domitia Lepida all appear in the frieze on the south side of the precinct wall of the Ara Pacis (see images 11 and 13).[13] On the north side can be seen another family group whose members might have included Augustus's daughter Julia and his sister Octavia. The number of women portrayed here is unusual, as is the presence of children in the processional scenes.

This is not really the place to discuss the meaning and ramifications of these particular scenes. By singling out Livia's presence on the monument there is a danger of misinterpreting her appearance here as being more significant than it probably would have been at the time. She is here as one of a number of subsidiary and supporting actors in a drama whose lead character and principal subject is without any doubt Augustus himself. Her role is crucial and integral to the plot of the drama but no more and no less than that. She is not the only woman on the monument. The artistic programme of the monument aimed to demonstrate to the Roman viewers the legitimacy of Augustus within the continuum of Roman history and historic myth through the transformation of reality into symbolic political capital.

Importantly, at this time Livia was not only wife to the first emperor but also mother of a child from her first marriage and therefore not a child of the emperor's. While messages about motherhood and dynasty were part of the propaganda programme of the monument, this was conveyed through another female image on the precinct wall, that of Roma or Tellus, and by the more abstract vegetal decoration on the friezes that alluded to concepts of growth and fertility.

The south-east panel, in the upper register to one side of the entrance, is dominated by images of female fecundity and plenty. At its centre sits a nursing mother figure, a personification, usually identified as being either Tellus Italia (Tellus meaning 'the Earth'), or Roma. Less convincingly, she has been argued to be Venus, Pax or Rhea Silvia, the mother of Romulus and Remus.[14] In many ways it is not actually important which of these figures she is because of the overall message conveyed by her being first and foremost female and a mother. She holds two naked babies. To either side of her are semi-naked females with their mantles blowing out and billowing in such a manner as to suggest that these are personifications of the winds. Behind and below the three women are luxuriant plants and flowers, while below them in the foreground are a seated cow, a sheep and a large bird caught in flight. This is a scene of peace and harmony, of growth and abundance, of fertile crops, fertile mothers and contented children. This is the Augustan peace in an image. It is a seemingly non-political image that is actually intensely political.

All Livia's past and present roles as wife, mother, empress and widow were to be brought together pictorially in the way that she was depicted on the court gemstone of around AD 26–9 now known as the Grand Camée de France and in the Cabinet des Médailles, Bibliothèque Nationale in Paris. I will limit my brief discussion here to the middle and upper registers of the design. Once more, though, it must be borne in mind that the key figures on the gem are Tiberius, then emperor, and the late, deified Augustus; Livia is an important subsidiary presence here but is subsidiary nonetheless.

The propaganda message of the gemstone is securely tied to the promulgation of the glory of the ruling Julio-Claudian dynasty.

At the very centre of the gem, in its middle register of design, sits the emperor Tiberius, bare-chested in the guise of the god Jupiter. Livia sits beside him, also on a throne and with her feet resting on a stool, her expression calm and grave. In her right hand she holds poppies and wheat sheaves, identifying her with the goddess Ceres and with ideas of fertility and abundance, an altogether appropriate sub-theme in the overall meaning of the gemstone's decorative programme. Other male and female figures stand both in front of and behind Tiberius and Livia. While probably all members of the broader dynastic family, their identities are not certain and in any case are not strictly relevant here.

In the upper register, in the heavens directly above Tiberius, can be seen the veiled figure of the deified Augustus being transported through the skies by male attendants, one of whom might be the late Drusus, Tiberius's son. A cupid or *putto* moves towards Augustus holding a horse's reigns in his hands; mounted on the horse is another male figure who may be the late Germanicus.

Livia, or her image makers, often sought to manipulate her mortal status and earthly power and prestige and to identify her with certain deities who had particular associations with the lives of Roman women, particularly Ceres, as on the Grand Camée, but also Juno, Venus, Vesta and others. Such divine role playing by a woman was unprecedented. The Vestal Virgins became particularly favoured and honoured during Augustus's reign, hence their prominent appearance on the Ara Pacis. On a large sardonyx cameo in the Kunsthistorisches Museum, Vienna, Livia appears holding and staring at a bust of the deified Augustus. Her mural crown evokes Cybele, as do the poppies in her hand and the lion shield; the wheat sheaves in her hand evoke Ceres; and the chiton falling off her shoulder evokes Venus Genetrix. On some of her statues floral wreaths or *cornucopiae* again reference Ceres and ideas of abundance and fecundity, particularly during Tiberius's

reign when Livia's role as mother, rather than wife, was stressed in imperial propaganda, as on the Grand Camée.

Images of Livia also appeared on other artworks from public monuments: an altar from Vicus Sandaliarius, Rome; one of the relief panels at the Sebasteion at Aphrodisias in modern Turkey; a relief in Ravenna; and as Diva on a fragmentary relief from Aquileia. The Vicus Sandaliarius altar, now in the Uffizi Gallery in Florence, is what is known as a *lares* altar set up at a street intersection in Rome. On its front are three figures, generally thought to be Augustus in the centre, Gaius Caesar on the left and Livia on the right. All are veiled to take part in some religious rite. Augustus holds a *lituus* as Gaius looks on. A chicken grubs in the earth by Augustus's feet. Livia holds a *patera* and a jar of incense.[15] On the Aphrodisias Sebasteion panel, Livia is pictured standing waiting to be crowned with a laurel wreath by a personification of Roma, in a scene more normally reserved for emperors. From the same building come reliefs of Agrippina joining hands in marriage with the emperor Claudius and Agrippina crowning Nero. The Ravenna relief, now in the Museo Nazionale di Ravenna, carries an image of Livia as a young Diva Augusta and in the guise of Venus, Eros on her shoulder, standing next to a semi-naked Divus Augustus in the guise of Mars. Germanicus, Drusus the elder, Claudius's father, and Antonia, his mother, also appear here. The Ravenna relief and the Aquileia fragment in the Museo Archeologico Nazionale di Aquileia both probably date to the reign of Claudius and probably represent his attempt in his propaganda to somehow link himself directly with Augustus.

The question as to whether Livia herself had a role in the creation and presentation of her image, and its periodic change over time, or whether her image was created for her as part of the broader creation and maintenance of the Augustan image must remain unanswered here. We simply do not know, and there is no evidence to prove the point either way. What we do know is that the creation, manipulation and presentation of her image set a precedent for the

representation of imperial women for hundreds of years afterwards and indeed influenced female elite portraiture in the private sphere for just as long. Paul Zanker's broad concept of *zeitgesicht*, the defining of the look of the age, can be applied to the trend for the physiognomic borrowing of Livia's features to be reassembled in certain private portraits as other women.[16]

Competing for Attention

If Livia was the first of the imperial women to forge a public image for herself, or to have it created for her, then images of Octavia, sister of Augustus and wife of Mark Antony, and Julia, the daughter of Augustus and wife of Marcus Agrippa and Tiberius, may also be of interest here, as for part of Livia's life these two were her contemporaries. Indeed, there has sometimes been a certain amount of confusion among art historians and archaeologists in distinguishing between portraits of these three individual women because of the great similarities in the presentation of their images and in their hairstyles in particular.[17]

It is perhaps significant that it would appear that Livia was often portrayed in paired portraits with the other important imperial women of her time, first with Octavia and then with Julia or another female relation, such as Agrippina or Livilla. Not only did this help to reinforce in the viewer's mind the idea of there being an imperial dynasty, which would by its very existence guarantee a prolonged respite from civil conflict and a peaceful future for Rome, but it might also have been a way to deflect any criticism away from Livia as an individual woman holding too much personal power. In the words of Elizabeth Bartman, 'When combined with another woman, Livia was seen less as a powerful individual in her own right and more as an element of a group categorized as "female".'[18] In her various representations the viewer might have been expected to interpret Livia's role in a number of different ways, to see her as the wife of the emperor or as a mother, although it must be remembered that it was not until 4 BC that Augustus adopted Livia's son Tiberius, thus to all

intents and purposes making him his heir to the imperial throne. It might have been thought that following Augustus's death in AD 14 Livia's public life would have come to an end. However, her role now simply changed, from that of wife and mother, to widow and mother. This new phase of her life was as much about keeping Augustus's memory alive and his political project on course as it was about mourning his passing. To this end Livia was tasked with overseeing various aspects of the honouring of the new Divus Augustus. Again, she gained further prestige by being formally adopted into the Julian family as set down in Augustus's will.

If the style and content of some of the earlier images of Livia were indeed conceived in direct reaction to Roman responses to circulated images of Cleopatra in the Roman world, then perhaps it would be worth backtracking here to briefly discuss the image of the Egyptian queen before looking at images of later Roman empresses. In particular, attention will need to be paid to coin portraits of Cleopatra that appeared on issues minted for Antony, following his public spurning of his wife Octavia in favour of Cleopatra. On such coins Cleopatra was clearly not presented as a steadfast matron, good wife and mother, a stabilising influence in whom the Roman people could trust; rather, she was presented as a powerful individual in her own right, someone who in a political alliance would be advantageous to Rome, leaving aside the value of the sexual alliance with her in which Antony was embroiled. Of course, Antony's fourth marriage to Octavia, Augustus's (Octavian's) sister, after the treaty between the two men at Brundisium, could equally be viewed as a highly pragmatic political alliance rather than a natural love match. In an unprecedented move a coin was struck in 39 BC which bore a portrait bust of Antony on the obverse and one of Octavia on the reverse, and Octavia was to appear on subsequent issues as well. Octavia was not here disguised in any way as a goddess or personification. Rather, she was portrayed as a serene young woman, whose *nodus* and bun hairstyle marked her out as quintessentially Roman.

Between 38 and 32 BC, the relationships between Antony and Octavia and Antony and Cleopatra became hideously complicated both in sexual and political terms. Both bore Antony's children, but only Cleopatra provided him with the male heir he had so obviously desired. In 32 BC, Antony and Octavia were formally divorced, marking the final severing of the shaky alliance between Antony and Augustus. It was also in the same year that Antony had a coin struck that paired him with Cleopatra on the obverse, in the same way that he had advertised his marriage alliance with Octavia in 39 BC. Although this particular coin issue was only circulated around the eastern Mediterranean, it is likely that some copies would have reached Rome and provoked the antagonistic response they were so self-evidently inviting. The image of Cleopatra on this silver denarius was, like the 39 BC image of Octavia, probably closer to a portrait than it was a strictly idealised image. Yet there are some startling physiognominal similarities between Antony and Cleopatra in these coin portraits, with Antony's portrait indeed boasting the kind of protruding Ptolemaic chin exhibited to a lesser degree by Cleopatra.

As has been noted by one authority, not only was Antony here on his official coinage replacing one woman with another, something that his multiple marriages up to this point show as being par for the course for a man such as him, but he was replacing a Roman woman with a non-Roman woman, yet giving her some kind of Roman political legitimacy in the process. Once more, this was an unprecedented use of coinage for a certain type of personal and political propaganda.

However, this bold and blatant act by Antony had to some extent been pre-empted by Cleopatra herself, who, perhaps as early as 37 BC, had issued a coin, struck possibly by the mint at Antioch and other mints, that once more paired her head on the obverse with Antony's on the reverse. Here, she at first appears almost like a Roman woman, though with an elaborate hairstyle with braids and curls and wears elaborate jewellery. Her portrait here and that of Antony with his Ptolemaic chin quite obviously provide the blueprint for the denarii coin portraits of 32 BC.

To Follow Her Example

It must be remembered that at certain times and in certain circumstances imperial women were also celebrated as part of the imperial cult, especially in the Greek east of the empire. The cult came into being at quite an early stage in the birth and growth of the Roman imperial system, indeed shortly after Octavian/Augustus's naval victory at Actium in 31 BC, and became a way in which individuals, groups and cities could honour an emperor and his family and gain social and political cachet in return, and from which they could perhaps even yield some economic benefit. Many of the statuary images of imperial women that have come down to us were probably produced under the aegis of the operation and celebration of the cult. Most significant in this present context have to be the dynastic group images from the cult Sebasteion at Aphrodisias, Turkey, a temple to the Julio-Claudian emperors and their families.[19] The focus on women in the imperial cult can only have been increased by the deification of Livia after her death, with a subsequent increase in the circulation of her image in one form or another doubtless occurring. Certainly, the nature of the cult changed significantly as time passed and more and more imperial figures died and joined the ranks of the deified.

Following Livia and the Julio-Claudian empresses, it is true to say that all subsequent imperial women mined a common repertoire of artistic forms and approaches to present their images to the Roman public or to have them presented on their behalves. However, it is the way in which they engaged with, contributed to and manipulated this common pool that is of inherent interest here. This process cumulatively created a larger field of competition in the process through sometimes self-referential presentation and constant artistic intertextuality. It is the choice of the motivations that inspired change through innovations and departures that fascinates.

Imperial women then, following the lead of Livia, appeared on occasions as individuals alone; most often with the emperor as wives, mothers, daughters or sisters; or sometimes, quite commonly,

in family or dynastic groups. Interestingly, when such groups were presented, often it is as important to try and identify which members of the family or dynasty are absent as it is to correctly identify those who are actually portrayed, as will be seen in a few instances below. Who was in or out of favour, who might have been in disgrace and whose presence would not have contributed towards or enhanced the message behind the image would all have been factors in the formation and manipulation of the image of the imperial group. Context here, as ever in archaeological or art historical studies, was of prime importance.

The reign of the emperor Hadrian, who ruled AD 117–38, was a time of relative stability in Rome and across the empire. Seen both by his contemporaries and by succeeding generations as one of the so-called 'good emperors', Hadrian very much relied on the support of his wife Sabina, who was equally admired and revered and who was deified by the emperor after her death in AD 136 or 137 (see image 12). On one of two surviving reliefs from the Hadrianic monument known today as the Arco di Portogallo appears a scene representing the apotheosis of Sabina, the first time an empress had been depicted in this way, although there were certainly male imperial apotheosis scenes to set a precedent, such as that on the Arch of Titus. Sabina is depicted sitting on the back of a winged, female figure bearing a large torch who has been identified as Aeternitas. She carries Sabina up to the heavens while down below a seated Hadrian and a personification of the Campus Martius, the scene of her ceremonial cremation on a pyre, watch her ascent. Contemporary coin issues also depicted the apotheosis of Sabina, with her being carried to the heavens on the back of an eagle.

Discussion will now be turned to the images of the Faustinas. Empress Annia Galeria Faustina, known more commonly to us today as Faustina the Elder, was the wife of emperor Antoninus Pius and mother of two sons and two daughters, one of whom was Annia Galeria Faustina Minor, Faustina the Younger, who was to marry her cousin, the later emperor Marcus Aurelius. Jumping from

discussion of Livia and the Julio-Claudian imperial women to the Faustinas, with only a brief interlude to make mention of Sabina who appears to have been an exception of sorts, is not meant to imply that in terms of their images the imperial women of the intervening period are not of interest in themselves. As far as we can tell they were not invisible from the public gaze: their portrait heads appeared on coins, dedications and statues to them are attested, some of them received the honorary title of Augusta and some were honoured after death. But these things were not necessarily at that time exceptional and indeed by now were part and parcel of the operation of the structures of imperial and dynastic authority, part of the essential theatre of imperial dynamics. The honouring of the women in these ways 'rebounded to the glory of the emperors', and there is no other evidence to suggest that these particular imperial women of the mid- to later first century and early second century exercised any real individual power or autonomy.[20]

It may be that in the era of the so-called adoptive emperors, from Trajan through to Marcus Aurelius, when the dynastic principle no longer applied, the biological role of the imperial women in the transfer of power through the production of sons may have then become to some extent obsolete.[21] However, new ways were found to symbolise the indivisibility of Roman imperial power through the image of the empress, sometimes in company with the emperor, sometimes on her own.

Faustina the Elder married around AD 110 and died in 141. During that time three main portrait types of her were created, all of them depicting her as a modest woman (see image 14).[22] However, the most famous image of her occurs on one of the faces of the pedestal base of the Column of Antoninus Pius that stood in the Campus Martius in Rome and which was commissioned by Pius's heirs Marcus Aurelius and Lucius Verus some time after his death in AD 161, in other words almost twenty years after the death of Faustina. Here was depicted the apotheosis of Antoninus Pius and Faustina, in the tradition of the earlier, Hadrianic scene

of the apotheosis of Sabina on the Arco di Portogallo. In the apotheosis scene, the couple, who died twenty years apart and are here reunited, bearing attributes of Jupiter and Juno, rise together to the heavens transported on the wings of Aion. Roma and the personification of the Campus Martius watch their ascent. The imperial couple are shown not as full-length figures, but rather as truncated busts, a remarkable innovation in imperial art and one that may trace its origins back to the busts of freedmen on funerary monuments. The scene is a fitting testament to the attested strength of their bond of marriage.

The Antonine dynasty was one in which the strength of the idea of family lineage was important, best illustrated by the way in which the elder Faustina was further celebrated after her death by the continued practice of representing and naming her on Pius's coinage more commonly than was the case with any other imperial family member after their death.

Faustina the Younger married in AD 145 and died in 175 while on campaign with her husband Marcus Aurelius in the east. During that period, nine portrait types of her were created, each of them depicting her in a form that more or less reflected her true age at the time.[23] Both the number of portrait types and the total of surviving statues of her suggest that her image, like that of Marcus, was popular and thus more widely circulated throughout the Roman world than some of her more recent predecessors. Interestingly, because of her apparently staunch support of her husband's almost constant campaigning towards both the northern and eastern borders of the empire, Faustina was given the title of Mater Castrorum – Mother of the Camp – in recognition of the especial affection of Marcus's army towards her.[24] The title appeared alongside her name on a number of coin issues, though it is not attested in inscriptions. However, it has been suggested that Faustina may be represented as Mater Castrorum in the *adventus* scene on one of the panel reliefs of Marcus Aurelius from a major monument in Rome. In this context, there is also some debate among academics as to whether

the figure of Victory on what might have been known in antiquity as the Column of (Divine) Marcus Aurelius and Faustina, rather than simply the Column of Marcus Aurelius as we call it today, represented Faustina in that role.

The striking image of Victory appears on the north-east face of the column where Marcus himself first appears and on which all the emperor's appearances are linked together vertically; thus, it may be that Victory/Faustina was intended to be part of this enchainment. It could have been the artist-designer's intention that the knowledgeable viewer would automatically identify Victory with the person of Faustina here. There are a number of other, less equivocal instances in which imperial women appeared in contexts where they were portrayed as Victory, and indeed there are Antonine links with the goddess, in that the temple dedicated to Antoninus Pius and Faustina the Elder after their deaths bore victories set as corner *akroteria*. It has even been suggested that Faustina the Elder is the female figure portrayed on the Hutcheson Hill legionary distance slab from the Antonine Wall in Scotland awarding a wreath to the victorious Roman troops, possibly in the guise of Victory but more probably as Divus Faustina – Divine Faustina.[25] Later, Julia Domna, wife of the emperor Septimius Severus, was portrayed in the early third century as a winged Victory on a cameo from Kassel and as a wingless Victory crowning Caracalla with a laurel wreath on a decorated relief now in a Polish collection, indicating that this practice of conflating Victory and empress extended well beyond the immediate Antonine period.

The Antonine dynasty's strong adherence to the concept of family lineage was undeniable, and for Commodus to have celebrated his mother Faustina along with his father Marcus on the column would have been in keeping with this revived dynastic tradition and with her military links and honorary title of Mater Castrorum.

It is of great interest here to note that a popular Antonine statuary theme was to depict mortal married couples as Mars and Venus, with the figure of Venus/wife sometimes modelled on the Aphrodite of Capua statue type in order 'to praise the wife's

beauty, desirability, and love for her husband'.[26] It may have followed, therefore, that the erotic Victory/Venus on the Aurelian Column could have been equated with Faustina in just such a manner, while the soldier-emperor guise for Marcus attributed to him on the column frieze could have equated him in the viewer's eyes with Mars. This would, however, raise some issues about the mindset of a son who would sanction his parents' depiction in this way, particularly the eroticisation of his mother through the promulgation of such a seductive public image.

A cursory examination of portraits of Julia Domna, the wife of the emperor Septimius Severus, between AD 193 and 211 suggests that in some instances she bears more than a passing resemblance to the earlier empress Faustina the Younger, who we have just discussed, particularly with regard to her hairstyle. However, when this resemblance is considered in the broader context of the imperial portraiture of the Severan house, this can be seen to be a deliberate borrowing from the past very much in keeping with the overall Severan strategy of claiming direct lineage from the Antonine dynasty when no such link actually existed. Indeed, Severus came to power towards the end of the second century after a debilitating civil war. Not only, therefore, did statues and coin portraits of Julia Domna often resemble those of Faustina, but often those of Severus closely resembled images of Marcus Aurelius, and Severus's sons likewise were often presented in the form of close likenesses of Marcus's sons.

This super-competitiveness with a dead woman also probably accounted for the fact that Julia Domna actively sought the title of Mater Castrorum that Faustina had also held and was portrayed in a number of instances as Victory, as has already been noted. Despite her evident competitiveness with her earlier rival, as she saw it, there is no doubt that Julia Domna was in fact the most influential and powerful individual imperial woman since Livia. Like Livia, her influence continued after her husband's death in AD 211 into the reign of her surviving son Caracalla. Indeed, she was to outlive him as well and

died in AD 217, being subsequently deified under Alexander Severus. Like Livia, she too moved through the stages of being revered as the wife of an emperor and then as the mother of emperors-in-waiting, being hailed as Mater Augusti et Caesaris in AD 198. Over the twenty-four-year period of her time in positions of power her portrait image was regularly redesigned and revamped and six official types of portrait have been recognised by art historians. Named after the location of the best example of each type, these are known today as the Gabii, Vienna, Leptis, Berlin, Munich and Vatican types. Their differences are not strictly relevant here, though the broader points of the evolution of her portrayal are of direct interest. Little in the way of ageing is noticeable between the types, and though she seems always to have favoured the wearing of a wig, in the later types the wigs have become less naturalistic and almost helmet-like.

A well-known, early third-century, full-length statue of Julia Domna in the guise of Ceres from Ostia (see image 15) and a coin portrait of her in the possible guise of Abundantia immediately bring to mind the much earlier identification of Livia with Ceres and perhaps suggest a deliberate echoing of her distant forebear in the choice of such a disguise. The fertility of Julia Domna and her provision of two male heirs to Severus was probably being invoked here in both cases.

The Severan period is also of interest in the context of this present work in that at this time dynastic group portraiture once again became significant, perhaps more so than at any other time since the Julio-Claudian era. The idea of continuity, security and prosperity were promulgated through statuary images and portraits on coins of the Severan imperial family in various combinations. Perhaps the most famous of these family groups appeared in an unusual medium, on a painted wooden round panel or *tondo* from Egypt, which is now in the Staatliche Museen in Berlin. Dating probably from around AD 200 when Severus visited Africa, the panel carries depictions of Septimius Severus, Julia Domna and their young sons Caracalla and Geta, though the face of the latter tellingly has been

erased, possibly as the result of his much later *damnatio memoriae*. The work has a more intimate feel than statue or coin representations of the family, perhaps due to the front-facing pose adopted for the portraits. Severus and Julia Domna stand at the back of the group, with their sons in front of them. Severus has a full head of grey, curly hair and a beard and wears a diadem or crown and a toga with gold stripes. Julia has long, wavy, dark hair in her trademark helmet style, undoubtedly a wig, and wears a jewelled tiara and showy pearl earrings and necklace. Her head is not veiled and she appears as anything other than the demure Roman matron.

Images of Julia Domna also appeared on two major public monuments, one in Rome and the other at Leptis Magna in Libya. Perhaps understandably, she was absent from the principally martial scenes on the Arch of Septimius Severus and from the political scenes on the Palazzo Sacchetti Relief. She does appear, though, on the Arch of the Argentarii, or Porta Argentariorum, which was built in the Forum Boarium in AD 204, and indeed she is named along with her husband and son Caracalla as one of the honorands of the arch in its lengthy dedicatory inscription. Though set up by the guild of silversmiths, and therefore not an imperial monument as such, it is likely that some form of official approval was sought and granted for the form and content of the artworks that depicted the imperial family, aspects of their secular and religious duties and those that alluded to military matters through the depiction of Roman soldiers with Parthian prisoners, victories and military standards and a trophy. The large, decorated relief panel on the inside of the east pier carries a depiction of Emperor Severus in his role as *pontifex maximus* engaged in making a formal sacrifice to the household gods or *penates*. With the folds of his garment covering his head in the appropriate fashion for such a religious rite, he is caught in the process of emptying a *patera* over a portable tripod altar. He faces the viewer frontally, as does Julia Domna, who stands to his side and just behind him. She too is veiled but can still be seen to be wearing a jewellery headpiece of some sort

and her familiar helmet-like wig. She was originally holding a *caduceus* in her role as Mater Castrorum, but the position of her arm has been subsequently altered by recarving. The blank space next to her marks the former position of their son Geta, his image now completely erased. Likewise, on the panel on the opposite pier, Caracalla sacrifices alone, with images of his wife Plautilla and her father Plautianus also scrubbed out entirely.

On the Arch of Septimius Severus at Leptis Magna in Libya, built in Severus's birthplace after his return visit there in AD 203, Julia Domna appears in a scene of military triumph – a highly unusual depiction of a woman in what is usually an exclusively male ritual – as well as in another scene of sacrifice and another of what has been called a Concordia Augustorum – an imperial accord between father and sons (see image 16).[27] She is also depicted along with Severus as Jupiter and Juno, not just two divine individuals but the most powerful divine family; identification of the imperial couple with these two particular deities was doubtless intended to be conveyed to the viewer.

At the triumph in which Severus and their two sons ride together in the triumphal chariot Julia Domna is accompanied by a male in the guise of Hercules and looks on as mounted soldiers ride by and female Parthian captives are carried past her on litters or biers. This contrasting of the powerful empress with the abject and powerless female prisoners was surely a deliberate ploy to show the viewer two sides of feminine being, with the empress through her own authority and links with the army as their Mater Castrorum almost becoming some kind of honorary man. Similarly, in the sacrifice scene Julia Domna is the only mortal woman present, as a crowd of male dignitaries looks on. While it has been argued that there are two precedents for such a scene involving women on Augustus's Ara Pacis and on Lucius Verus's Parthian monument of AD 169–76 at Ephesus in Asia Minor, these examples would not appear to me to be strictly comparable. On the Ara Pacis, a number of women and children are depicted as taking part in the dedicatory procession for the monument but not in the actual scene of sacrifice. Again, on the

Ephesus monument it is not clear who the unidentified women at a sacrifice and a scene of dynastic adoption are and in what way they are directly involved in the events being depicted there. Julia Domna, of course, is present in a scene of sacrifice on the Arch of the Argentarii in Rome, as has just been discussed above.

The reasons behind Julia Domna's presence in the scene of imperial accord again probably relate to her triple responsibilities as imperial wife, dynastic mother and military Mater Castrorum. The use of the *dextrarum iunctio* to signify imperial accord between father and sons and heirs has its origins in Antonine imperial ceremony. The clasping of hands in this way was a gesture originally associated with a man and a woman and was then exclusively symbolic of a marriage or of marital stability and harmony. Thus, this imperial political 'marriage' is sanctioned by the presence in the same scene of the actual wife of the main protagonist. Here, the personal has quite literally become political and female acquiescence and active participation in the rite gives it a curious legitimacy, which serves to illustrate the nature of the considerable power exercised by Julia Domna within the Severan court and in public.

Thus, on the Leptis arch ideas of family, harmony, public and private accord and stability are conveyed alongside the standard tropes of Roman imperial power – a triumphal parade, abject prisoners on display, Roman soldiers, victories and so on – by the careful deployment of images of both the emperor and empress. Whether this testifies to the power then deemed inherent in dynastic solidarity or whether it reflected the actuality of a great deal of power having been personally assumed by Julia Domna or ceded to her by Severus, we can never know. However, it would appear that the use of images of Julia Domna here was vital to the promulgation of the overall message of the arch, and her unusual presence at otherwise more-or-less exclusively male rituals and rites was somehow essential to the composition and coherence of those very messages. There are a number of possible motives for this. Firstly, there is the fact that, like Augustus, Septimius Severus

came to power during a time of political instability and indeed open civil war and offered himself up to the Roman senate and people as someone who could bring peace and harmony out of this escalating state of war, discord and instability. This promise is reflected in the wording of the lengthy inscription on the Arch of Septimius Severus, symbolically erected in the Roman Forum. And, like Augustus, Severus knew that marital harmony in the private sphere and political harmony in the public world could be successfully juxtaposed in symbolic terms to advertise the imperial programme. No matter that Severus came from Leptis Magna and Julia Domna from Syria, together they could be said to reflect the strength of diversity within the empire and indeed embody the very transition of the Roman world and the very idea of what it meant to be Roman that had been ushered in by Augustus's programme.

Far from Julia Domna's multiple appearances on the Leptis arch being simply a reflection of the deep conservatism of the time and of Roman imperial art and propaganda in general, it would instead seem to me to be a reinvention of the very idea of the basis of that power and authority. Trajan had presented himself as the father of the country and had designed his *alimenta* programme to feed the children of Rome and Italy so that many of these strong male children would ultimately become the Roman soldiers on which the future of the empire depended. Similarly, Septimius Severus introduced legislation to allow soldiers of the Roman army to marry for the first time and to put what had previously been illicit relationships between serving soldiers and local women on a legal footing. Once more, this seemingly liberal move was in fact anything but, in that it would allow for the legitimate male offspring of these now state-sanctioned marriages to serve the empire as soldiers as their fathers had done before them. What better way to advertise the importance of motherhood than by emphasising the presence and power of Julia Domna through her depiction in diverse roles on the Leptis arch: as an actual imperial mother; as the titular Mater Castrorum; and in the guise of Juno, the mother of the gods? This was not simply

a case of a Roman emperor once more hijacking the idea of female sexuality and reproductive capacity in the service of the state.

An important point to be made here is that the images of female members of the imperial household meant as much to their creators and viewers as those of male emperors and imperial family members. There is no better demonstration of this than the fact that the act of *damnatio memoriae* was applied equally to male and female imperial persons deemed somehow to have transgressed, from the Augustan period until at least the Constantinian era. Indeed, it would appear that at least twenty-four imperial women were condemned in this way, either as collateral damage due to their association with a particular condemned emperor or in their own right for some specific transgression, most commonly, for indulging in some form of political or sexual intrigue.[28] The *damnatio* included the removal of images of the imperial transgressor or transgressors from public display and their placement in storage or, in some cases, the mutilation or destruction of those images, particularly ones on imperial monuments where the image could not as easily be removed as a free-standing statue. In some cases, statue portraits were recarved or altered to erase the memory of the original subject and his or her moral or political crimes.

Distant Echoes

As the Roman Empire entered the third century AD, dealing with political and military instability, economic crises, population movements and changing cultural imperatives, the very nature of Roman imperial authority and its representation in art and ceremony also began to change, at first almost imperceptibly and incrementally and later quite drastically and swiftly. While distant echoes of the images of Augustus and Livia could still occasionally be found in certain third-, fourth- and fifth-century imperial images, new modes of propaganda were replacing the old. By the fourth century, the culturally accepted use of *spolia* – curated old artworks and architectural fragments reused and reset in contemporary

monuments, the recarving of old portrait statues and reliefs and the recutting of old cameos and gemstones – added another complex layer of meaning to the creation and manipulation of imperial identity in such uncertain times. In simplistic terms, we move from an era in which a succession of images of imperial military hardmen predominated, through the time of the Tetrarchy – the rule of four – when individuality was often subsumed into images of group solidarity and anonymity, to a period when transcendent images of the emperor and his court reflected the distancing techniques of Late Antique propaganda and ceremony.

Many of the third-century emperors reigned for only relatively brief periods, and though images of their empresses appeared as part of their imperial propaganda programmes, few of these were associated with major works of art or public monuments and their images are mainly known to us through coin portraits. One exception, it might be argued, was the wife of Balbinus, emperor for only three months before his death in AD 238. Despite this, his wife's name is not recorded. Portrait images of the couple in the round appear together on the Balbinus Sarcophagus, now housed in the Catacomb of Praetextatus in Rome.

The couple recline together on a couch, perhaps a funerary bed, on the sarcophagus lid, suggesting that the sarcophagus was intended for both their burials. The portrayal of reclining figures like this harked back to the first and second centuries AD when such *kline* portraits were popular among Roman freedmen and even back to pre-Roman Etruscan forms. Some statement about Roman heritage and identity was quite clearly being made here.

The decoration on the front panel of the sarcophagus consists of a marriage scene on the right and a scene of sacrifice on the left, both husband and wife appearing in each scene, though the heads of two of the figures have been damaged. In the wedding scene, which occupies about a third of the coffin front, the empress is veiled, a typically modest Roman bride. The empress appears in the guise of Venus in the larger sacrifice scene, along with Mars

and personifications of Virtus and Fortuna, implying perhaps that she predeceased her husband. The emperor is shown dressed in military uniform making the sacrifice on a portable altar while at the same time being crowned by Victory. On the left short side of the sarcophagus appear the Three Graces, probably celebrating the qualities of beauty, grace and happiness associated with the empress, and on the right short side appear dancing figures whose significance is unclear.

In the general moratorium on the raising of imperial monuments in Rome during much of the third century, something that probably had more to do with fashions in the media of imperial ideological expression than with economic or political factors, the Balbinus Sarcophagus represents an interesting hybrid work of art of its time. It is both a private commission, touchingly so in many respects, particularly with regard to the celebration of the empress as a woman, but also a public work of some kind in which Balbinus was keen to stress the value of Roman heritage, the solidity that a strong marriage can bring to the service of the state and his imperial virtues expressed through service and sacrifice. Yet both emperor and empress were given equality of status and appearance on the sarcophagus in a way that had not been seen since the days of the Antonine dynasty. In many ways, this pre-empted the trend for the later Tetrarchs to stress familial and dynastic solidarity from the time of the founding of the Tetrarchy in AD 293 to its collapse in the first quarter of the fourth century.

For most of the third century, there was scarcely time for narratives of family, dynasty and continuity to be created. Many of the emperors of the period rose without trace and disappeared from the scene almost as quietly, as did their empresses and families.

Did the common portrayal of many of the third-century emperors in the likeness of hard and uncompromising figures have the same intended impact on female viewers as on male viewers? Were they all reassured? Did the tactic of the Tetrarchy to sometimes present images of its ruling members as almost interchangeable men reflect

any kind of contemporary gender reality? As for many of the third-century empresses, their portraits are notable for the 'maturity and even homeliness of their subjects, who are represented in a matter-of-fact and even unflattering manner'.[29] The archetype for these portraits, at least for the manner in which their hair is styled, seemed to be Julia Domna.

It would appear that for many of the later imperial women, their individual personalities became subsumed within the identity of their emperor husbands, brothers, fathers or sons, or indeed within the overall ideology of Roman imperialism in general. Helena, the mother of the emperor Constantine, constitutes an unusual case study in this respect.

Both Constantine's beloved mother Helena and his daughter Constantina played some significant part in his promotion of church building in Rome, and both were buried in elaborate mausolea just outside the ancient city.[30] Helena's mausoleum at Tor Pignattara, a short distance outside the city, probably had originally been constructed for the eventual interment of Constantine himself, and indeed Helena may well have been laid to rest in what was intended to be Constantine's own sarcophagus. The now-ruinous, large-domed mausoleum adjoined a larger complex of buildings forming a funerary and basilica complex and would have originally been adorned with mosaics and other decorations.

The huge, decorated porphyry sarcophagus found in Helena's mausoleum and now in the Musei Vaticani in Rome is today generally thought to be a funerary item originally intended for a male imperial individual but then brought into service upon Helena's death in AD 329. However, this is not altogether a satisfactory explanation, and such a pragmatic solution seems somehow at odds with the status of Helena and the reverence accorded her in her later life. The decoration on the sarcophagus stressed the continuing link between imperial authority and Roman military power and between the defence of civilisation against barbarian peoples and barbarian cultures. It consisted of a number of scenes of battle on both the

long and short sides of the sarcophagus, creating the impression to a viewer who walks around the sarcophagus of an unending and continuous struggle on both a military and metaphorical level. Large, high-relief figures of Roman cavalrymen with lances ride down and trample male barbarians, some of whom are already bound and kneeling in thrall to the power of Rome. Other male barbarians are led away in chains. However, there are other elements of decoration on the sarcophagus body and on its lid. On the two long faces in the upper corners are both male and female busts, so heavily restored as to make their identification impossible. On top of the lid rests a lion and two female figures with a garland, and further garlands held by cupids drape the sides of the lid.

In a previous study of mine centred on the Arch of Constantine in Rome, I have discussed the way in which artworks dating to the reigns of the so-called good emperors, Hadrian, Trajan and Marcus Aurelius, were reused on the arch with the faces of the former emperors recarved as the portrait head of Constantine.[31] Constantine here had 'become' Hadrian, Trajan or Marcus in the eyes of the arch's viewers. A few instances of such recarving and replacement of heads of female members of the later imperial family can also be cited, most relevant here being the reclining figure of Helena in the Musei Capitolini, Rome, created by replacing the head on an earlier work with the portrait head of Helena.

The so-called Ada Cameo, now mounted on the cover of the Ada Gospels in the Stadtbibliothek, Trier, Germany, depicts a dynastic family group thought to be Constantine, Helena, Constantius II, Fausta and Constantine II. Dated to between AD 318 and 323, the family group appear as more-or-less head-and-shoulder portraits in the background of the cameo, with two large, imperial eagles with outstretched wings dominating the foreground. The claustrophobic nature of the scene, with the figures bunched together as if in an enclosed space, probably reflects the fact that they were most likely depicted in an imperial box at the circus in Rome. Most interestingly, it has been suggested that the Ada Cameo is not

an original Constantinian era piece, but rather that it represents the recutting of a Julio-Claudian cameo of Claudius, his fourth wife Agrippina the Younger, their son Nero, his daughter Claudia Octavia and his son Britannicus, reused and recontextualised in a manner not unlike the use of *spolia* on the Arch of Constantine.[32]

One of the most bizarre artistic strategies used to merge individuals into some new creation was the rare but nevertheless occasionally attested transposing of an emperor's face, or at least some of his facial characteristics, onto a female imperial portrait, thus creating 'a subtle and considered assimilation', something that occurred in both the early empire and Late Antiquity.[33]

Constantina's mausoleum and circus basilica on the Via Nomentana in the area of Rome today known as Santa Costanza also originally contained a massive porphyry sarcophagus which has today been replaced by a facsimile, the original also now being in the collections of the Musei Vaticani. The mausoleum was probably built around AD 351 or 352, and though the interior is heavily restored, it is nevertheless noteworthy for the quite exquisite, fourth-century ceiling mosaics, which include scenes of viticulture.

The sarcophagus of Constantina, while still obviously another exclusive imperial artefact by nature of both its size and of the porphyry from which it was made, could not be more different from Helena's sarcophagus in terms of its decoration, which consists of detailed and complex scenes of cupids harvesting grapes and garlands, again as on Helena's sarcophagus lid. On the two long sides, the winged cupids, enclosed in circular fields formed by acanthus scrolls, gather grapes and place them in overflowing baskets. Above the scrolls are further vegetal tendrils and doves, and below another cupid with grapes walks in a landscape inhabited by peacocks and rams. This abundant world of plenty almost seems to hark back to the idealised landscapes, symbols of female fertility, on the Augustan Ara Pacis. On the short sides of the sarcophagus, the cupids are depicted standing in a trough treading the grapes, the grape juice flowing copiously into barrels or vessels beneath

the press. Scrolls, tendrils and clusters of grapes frame the central main motif. On the lid are found garlands suspended from two male and two female heads or masks. The decoration on all four sides of the sarcophagus and on its lid can be seen to some extent to mirror the themes of some of the stunning ceiling mosaics inside the mausoleum, with the emphasis being on the natural world and its taming by agriculture as a metaphor for its control by Roman imperial authority. Of course, such lush imagery could also have had and would have had Christian connotations, though there is no overt Christian symbolism on the sarcophagus. The date of Constantina's death is uncertain and the sarcophagus could date to any time between AD 330 and 360.

Another, later imperial mausoleum, that of the empress Aelia Galla Placidia, more commonly known simply as Galla Placidia, who died in AD 450, is of interest here. Buried in Ravenna in Northern Italy, Galla Placidia was another imperial woman with a complex string of family relationships within the power structure of Late Antique Roman rule. As the daughter of the emperor Theodosius and half-sister of the emperors Arcadius and Honorius, she was first wed in a marriage alliance to the Gothic king Athaulf, something that fully reflected the political situation and reality of the day. After his death, her second marriage to the future emperor Constantius III was equally strategic, being within the elite group that controlled Roman politics at the time. She was also to be the mother of the future emperor Valentinian III. The best images of her we have are in the form of portrait heads on coins and medallions, though some commentators have sought to identify her as the older woman wearing a pearl necklace and earrings on a gold in glass roundel from Brescia in Northern Italy. Statue images of her are surprisingly rare given her status and powerful connections. Parts of an inscribed marble base for an honorific statue to her came from the Forum of Caesar in Rome, a prestigious spot for its location, though sadly no part of the statue itself has been found. The very fragmentary inscription with its mention of her 'raised to

the purple' probably dates the dedication of the statue to AD 421 when she assumed the title Augusta.

She oversaw the refurbishment of churches in Rome and Jerusalem initially dedicated by Theodosius and Honorius and the building of the church of San Giovanni Evangelista in Ravenna. Her mausoleum in Ravenna contained three sarcophagi, possibly for Galla Placidia, Constantius and Valentinian, acting as a family burial place, if the linking of her name to the building is indeed correct. The decorative wall and ceiling mosaics in the mausoleum, including images of the Apostles and Christ as the good shepherd, offer no links to imperial imagery and certainly none to gendered symbolism linked to Galla Placidia's person, very much as with the mausoleum of Constantina discussed earlier.

Given her position it has been asked by one authority whether Galla Placidia was some kind of 'conduit of culture', implying that she was a catalyst of some kind through her marriages and her architectural and artistic benefaction, reflecting the changed nature of imperial authority and gendered power at a time of the redefinition of what it meant to be Roman.[34] A similar question can be asked of Serena, the Roman wife of the half-Roman, half-Vandal Stilicho, the powerful general who in his role as *magister militum* was very much the power behind the throne of the emperor Honorius. Serena was the niece and adopted daughter of the emperor Theodosius and was married to Stilicho in AD 384, probably for political and strategic reasons. She was a cousin of Galla Placidia. Most famously, Stilicho and Serena are depicted together with their son Eucharius on the ivory leaves of a consular diptych that is now housed in the Cathedral Treasury at Monza, near Milan in Northern Italy.[35] Stilicho is portrayed here as an upright and formal figure dressed in military garb, powerful, and depicted holding a spear in his right hand and a shield in his left. He looks straight ahead towards the viewer, his bearded face expressionless in the kind of transcendent manner that was a typical signifier of absolute power in the often theatrical official ceremonies and imperial displays of Late

Antiquity. On the opposing leaf of the diptych, Serena appears with their young boy Eucharius at her side. Again, both figures gaze out at the viewer almost in a trance-like state, emphasising Serena's power both by reason of her imperial status and of her relationship to Stilicho. Her role as mother is also emphasised here in a way that recalls the reassurance given by dynastic group portrayals in the Augustan and Julio-Claudian eras. She holds up a flower with one hand and with the other holds the folds of her cloak. Eucharius holds what appears to be a book.

Considered together, with the leaf bearing Stilicho's image appearing on the right or the left of the diptych as originally created, these images represented an idealised portrait of Stilicho and his family, the emphasis on family being one of the most significant messages conveyed by the work. Such family groupings do not occur on any of the other surviving consular diptychs that have come down to us, and here such an image must have been used to stress the stability of this important marriage alliance and its future continuance through the line of Eucharius. This in turn both acted as a message of stability within the Roman state and stressed the prime role that certain outsider figures, such as Stilicho, would inevitably play in guaranteeing the future of the Roman administration.

Whether the use of floral and vegetal motifs on the sarcophagus of Constantina and mirrored in the mosaic wall and ceiling mosaics in her mausoleum, the vegetal or floral garlands on the lid of the sarcophagus of Helena and the flower held by Serena on the Monza diptych constitute any sort of coherent strategy to associate some of the imperial women of Late Antiquity with the images of abundance on artworks of the Augustan era, such as the Ara Pacis, must remain uncertain. The idea, though, is certainly appealing in a number of respects.

However, in some respects the Monza diptych represented a form of 'family fiction' of a kind that was common in imperial circles and which had its origins once more in the Augustan period.[36] Images of Roman families were becoming rarer in Late Antiquity for some

reason, so the diptych again was perhaps harking back to earlier iconographic precedents, though dynastic imagery, often without the empress, continued to be important in certain contexts. Stilicho and Serena also had two daughters, Maria and Thermantia, both of whom incidentally in turn married the emperor Honorius, which suggests that the subtext of the diptych imagery was concerned with presenting one kind of family, with a male heir, and not with representing the real family.

In Late Antiquity the range of media on which images of imperial personages thus appeared changed to some degree, with a decline in the number of imperial monuments, and account must now be taken of images on ivory consular diptychs and of wall and ceiling mosaics, which became more commonplace, particularly in churches in the sixth century. Overall, though, it is true to say that images of empresses and other imperial women became much rarer than in previous centuries. This phenomenon was probably tied to the emergence of a complex state ceremony that placed the emperor, the male ruler, in a position of transcendent detachment from the physical world. In the words of Natalie Boymel Kampen, 'The fourth-century fading of the empress' presence in public imagery may be part of a larger process of removing the court from its conceptual proximity to the everyday and from its biological imperatives.'[37]

As has been made clear in this chapter, the constantly evolving images of the imperial women of Rome, from the time of Livia through to the time of Helena and her successors up to the mid-fifth century AD, filtered out into wider Roman society and further afield in the Roman world. The impact of changing images had a particularly profound effect on the uppermost echelons of society, and in the next chapter I will consider how elite women in particular reacted to these influences in terms of presenting themselves, or how they were presented, visually in both the public and private domains.

3

PUBLIC AND PRIVATE
IDENTITIES

An Empty Plinth

As already discussed at length in the previous chapter, Livia was the first woman to construct an image for herself as an empress of Rome in portrait sculptures and on coins and gemstones, or to have that image constructed for her. The construction of her image had a profound effect on the presentation of images of imperial women for centuries after. Livia and the succeeding imperial women in turn influenced many private, non-imperial portrait and statue commissions of Roman and provincial women. In this chapter, consideration will be given to when and how other non-imperial but elite women appeared on public artworks and in private homes in the city of Rome, in Italy more broadly and in the provinces in certain specific contexts, while their absence from other contexts will also be discussed. Images of women on funerary monuments will be considered as a separate issue in Chapter 4.

It is probably true to say that it was under Augustus that the trend began at Rome for imperial or elite and influential women to be sometimes honoured through the erection of public honorific statues, sometimes by multiple dedications, taking their inspiration from the presentation of the image of Livia to the Roman people.

However, such a phenomenon is attested as having already occurred in some of the cities of the Roman east before that time, but perhaps Cato the Elder's fulmination against such provincial practices in 194 BC caught the general mood of public antipathy and hostility to such displays.[1]

The practice of setting up honorific statues to women in Rome seems to have begun as a coherent phenomenon in 35 BC, with the Senate agreeing to the setting up of statues of Livia and Octavia, as was discussed in the previous chapter. Thereafter, to some extent the floodgates opened. We do know from historical sources that the only potential precedent for this was the voting by the people of Rome, not the Senate, for the erection of a statue to Cornelia Africana, daughter of Scipio Africanus, wife of Tiberius Sempronius Gracchus and the mother of 'the Gracchi', after her death in 100 BC aged either ninety or ninety-one.[2] Only the base of the statue that stood in the Porticus Metelli has come down to us, if the inscribed base attributed to it and now in an out-of-the-way place in the Musei Capitolini, Rome, without a caption to alert the casual visitor to its significance, indeed comes from this same dedication (see image 17). Though it can be surmised that it was probably in the form of a lifesize bronze of Cornelia seated, it is in effect for us today an image without substance, without form. We can only imagine it.

The Gracchi, as they were known, were the brothers Tiberius and Gaius Gracchus, who were both revered and feared in Rome as champions of the plebeian class when each held the position of tribune in the later second century BC. Tiberius was killed by a hired mob, assassinated in other words, while around ten years later Gaius was forced to take his own life to avoid meeting a similar fate to his brother.

In this instance, Cornelia was, of course, being honoured because of her sons, but this did not necessarily make the image of her simply about them – that could have been more easily achieved by simply erecting a statue of the sons themselves. Certainly, her image was

being used here in service to political ideology in Rome at the time, particularly 'Cornelia's loyalty to the aims of her sons, champions of the *populares*'.[3] Her statue did not represent the conscious start of a trend; rather, it 'specifically responded to political tensions and propaganda of the period'.[4]

The inscription on the base is thought to have originally read as, '*Cornelia Gracchorum*', that is 'Cornelia, mother of the Gracchi'. However, it has subsequently been altered to read, '*Cornelia Africani f. Gracchorum*', meaning, 'Cornelia, daughter of Scipio Africanus and mother of the Gracchi,' a subtle alteration of meaning but quite significant nonetheless. An artist's attribution inscribed on the front of the base, '*opus Tisicratis*' – 'the work of Tisicratis' – is probably also a later addition. That the inscription on the base was altered perhaps in the Augustan era to include this reference to her father – the famous Publius Cornelius Scipio Africanus, the hero of the Second Punic War – suggests a move to depoliticise the image, something further suggested by the statue's moving to the Porticus Octaviae, built to honour Augustus's sister Octavia after 27 BC. The original power of the image because of its historical context and its original inscription seems to have been demonstrated beyond all doubt by its recontextualisation and neutering in this way. The possibility exists that the Porticus Octaviae became a deliberate focus for the display and exhibition of statues of famous, lauded Roman mothers, an idea that a number of scholars seem to accept as a distinct possibility, part of Augustus's programme of didactic tutoring of the women of Rome on moral behaviour and codes.[5] In this context, it is worth noting that among the almost exclusively male statues set up in the Forum of Augustus in 2 BC, there is known to have been at least one draped female figure, but who she was we do not know as the fragmentary statue found here is now sadly headless and otherwise without identifying attributes.[6]

Therefore, it is no surprise that Augustus's initiative to have the Senate vote for the erection of statues of Octavia and Livia in 35 BC was not necessarily so simple an act as honouring these two

women for themselves alone. At this time, honouring Octavia was very much more a statement about Antony's foul treatment of her and the severing of his political alliance with Octavian/Augustus sealed by marriage to Octavia. Honouring Livia as Augustus's wife and consort was nothing less than setting her up as a figure who was an exemplar of the moral Roman woman and not the decadent Cleopatra. Thus, both statues were intended to be thinly veiled criticisms of Antony rather than celebrations of individual Roman women of the imperial house.

There was an extraordinary contradiction inherent in the Augustan moralising programme aimed at women, created by the fact that the overall Augustan programme required the idea of dynastic harmony and assured succession to underpin its promotion of a world of peace won by war. While traditional Roman values defined the linking of male space with public life and female space with private, domestic life and the clear distinction between them, Augustus desired to move further beyond these distinctions and legislate on women's private and public behaviour. Modesty, simplicity and domesticity were to be the watchwords of this campaign. Yet his promotion of dynastic ambitions brought women into the spotlight like never before, and made images of the contemporary imperial women tools to influence other women in Rome and beyond.

According to information and descriptions given in Pliny the Elder's *Naturalis Historia*, there were four other statues of named women set up in Rome in the Republican period in addition to that of Cornelia discussed above, but nothing survives of these other four, not even their bases. The four lost works comprised statues of the widely revered and admired Vestal Virgins Quinta Claudia and Gaia Taracia, an equestrian statue of the semi-legendary heroine Cloelia at the top of the Via Sacra and a bronze statue of Gaia Caecilia, wife of Tarquinius Priscus, one of the early kings of Rome.[7]

That two of these celebrated women should have been Vestal Virgins is of little surprise, given the great significance attached to the crucial role of the College of the Vestals in maintaining ancient Roman

historic religious rites and traditions. Gaia Caecilia and Cloelia too were linked to Rome's semi-mythic deep past. The one-time existence of the equestrian statue of Cloelia, verified by other ancient sources as well, is of particular interest here, given that equestrian statues in the Roman world were almost exclusively associated with male subjects. As part of the peace treaty that ended the war between Rome and Clusium in 508 BC, male and female hostages were handed over to Lars Porsenna by the Romans. An escape of the Roman women hostages was led by Cloelia, who was said to have bravely crossed the seething River Tiber on horseback on her way back to the city. However, the Romans were forced to comply with the terms of the treaty and returned her to Porsenna. He allowed her to pick other hostages to be freed in recognition of her courage, and in keeping with her patriotism she chose young, male hostages who could eventually mature to fight for Rome in the future. She was eventually freed herself and came back to Rome where her exploits were honoured with the dedication of the equestrian statue.

The Herculaneum Women

Perhaps the most interesting aspect of the habit of elite women in certain parts of the empire celebrating, stating or enhancing their status by erecting statues and accompanying dedicatory inscriptions, or having it done in their honour in some cases, is the widespread distribution of one particular statue type, which was evidently deemed most suitable and acceptable in this role. Known as the Large Herculaneum Woman type, after the town in which an example of the type was first found and analysed, a recent academic study of this statue type has revealed some crucial and important information about its significance.[8] These large, marble statues of clothed adult women all looked the same from the neck down. Individual portrait heads would have been added when displayed. In the words of Jennifer Trimble, who conducted the study, 'They represented individual women but replicated the same body from the neck down, recreating the same stance, the same gesture, the

same elaborate drapery folds, over and over again.'[9] Most common in the second century AD, the production and consumption of these statues became a spent cultural force by the third century. These statues represent the most common standardised and mass-produced portrait statue body type in the Roman world.

Over 200 examples of such statues are known. Their distribution is of some considerable interest. Fifteen examples come from Rome itself and around the same number from elsewhere in Italy. Find-spots in the western provinces of the empire are few, with two examples coming from Roman Spain and two from Gaul. None is recorded in Britain or Germany for instance. Around twenty come from the cities of the North African coast. That means that the majority of examples of the statue type come from Greece, Asia Minor and the cities of the eastern empire in general. Nine alone come from the city of Perge in Antalya province in south-west Turkey. The statues were mostly erected in prime locations within their city, in civic spaces where their presence would have great visual and political impact: in fora, theatres, in temples, sanctuaries, nymphaea, cemeteries and on city gates.

The distribution clearly suggests that either economic, social or cultural factors have dictated this pattern, or a combination of such factors. The production of these marble statues and their shipping must have made their cost considerable. Their commissioning, purchase, dedication and display must have had some cultural cachet that was more embedded in the social and political practices of the elite in Rome, Italy and the eastern empire than in the west. Just such a cultural difference, not to say a cultural schism, also appears to have been reflected in the widespread acceptance of the political benefits of euergetism or architectural benevolence in the eastern empire and the marked indifference to this cultural practice among the elite of the west. This does, though, make the examples from the western provinces not simply outliers of little or no interest but rather exceptions that indicate cultural disruption in their geographical milieu.

This is not a situation that simply represented a lack of imagination on the part of the rich and powerful commissioners and buyers of such statues, each wanting the same statue type as others through a lack of visual education and knowledge. Rather, the tight chronological popularity of the statue type and the geographical specificity of its distribution suggest an isolated cultural episode, a genuine phenomenon in which replication served as a marker of individuality, high status and aspiration. Again, in Jennifer Trimble's words, 'Sameness helped to communicate a woman's social identity ... visual replication in the Roman Empire thus emerged as a means of constructing social power and articulating dynamic tensions between empire and individual localities.'[10]

Many of the 200-plus statues have accompanying inscriptions that allow further analyses to be made of the nature of the individuals and social groups commemorated in this way. Eumachia at Pompeii quite possibly represents the best example of an elite woman almost directly emulating a contemporary Roman empress, in this case Livia, in acting as a public patron of building works and being thanked in return by the dedication of a statue to her in her home town (see image 18). Eumachia would appear to have been responsible for funding the construction of a large building on the east side of the city's forum, possibly to act as the headquarters of the fullers' guild, with it being the grateful *fullones* commissioning her image in stone. The inscription on the statue base, along with the dedicatory inscriptions on the building and on her tomb in the cemetery outside the Porta Nuceria, tell us that Eumachia was the daughter of Lucius Eumachius (who, brick and tile stamps indicate, owned a tilery and pottery in the town); that she had married into the influential Pompeian family of the Numistrii Frontones and had a son, Marcus Numistrius Fronto (who was a co-dedicatee of the building); that she was a public priestess (*sacerd[oti] publ[icae]*); and that the building was dedicated to the Concordia Augusta and to Pietas.

It is generally thought that she was a priestess of both Pompeian

Venus and of the imperial cult, which would account for the presence of statues of both the contemporary emperor Tiberius and his mother Livia inside the fullers' building. It is possible that certain elements of the decoration of the building, such as acanthus leaves on the white marble doorway and images of Aeneas and Romulus either side of the entrance, were intended to mimic or echo resonant, then-common motifs in the canon of Augustan state art.

Civic Benefactors

Eumachia, though, does not represent an isolated or exceptional case of female civic benefaction in the Roman world. Substantial inheritances were sometimes left to women, an arrangement which would have allowed them to use their wealth in the same way as men to enhance their power and prestige through civic benefaction. That other women often did act as civic patrons in the Roman world is attested by epigraphic evidence and papyri in the east, although, of course, women could not serve as state officials or magistrates in the west.[11] Often, like Eumachia, they may therefore have exercised power through religious office of some kind. One other notable instance of the honouring of an elite woman such as this was in AD 71, when the city of Naples buried in a tomb built at public expense a woman called Tettia Casta, a priestess possibly of the cult of Demeter and a civic benefactor; the Senate voted a statue to her, adorned with a gold crown, to be erected and other honours to be bestowed. Sadly, this statue has not survived. Much of the evidence for the patronage of women comes from Roman Greece where the common occurrence of statues of female benefactors not just near temples but in civic spaces must have been openly accepted. However, these women could only act within the constraints of the social and political frameworks created by their male relatives.

Perhaps the most widely discussed of these female civic benefactresses outside of Italy is Plancia Magna of Perge in the province of Antalya in Asia Minor (south-west Turkey), known from a surprisingly large number of inscriptions.[12] Though her family, the

Plancii, were originally from Italy they had settled in Perge in the late Republican period. Her father, Marcus Plancius Verus, was a senator in Rome, subsequently a praetor and a provincial governor. There may have been as many as five statues of her set up in the city, some dedicated to her by the city's council and assembly and council of elders, attesting to the visual celebration of her life, position, achievements and largesse, and on the bases of some of these she is referred to as 'daughter of M. Plancius Varus' and 'daughter of the city' (see image 19). Again, the Large Herculaneum Woman type was among these. Her major public work of benefaction would appear to have been the renovation of the highly decorated southern gate, a magnificent triple arch, into the city between AD 119 and 124, inscriptions on two of the statue bases for images of her family referring to 'M. Plancius Varus ... father of Plancia Magna' and 'C. Plancius Varus ... brother of Plancia Magna.' The phrasing of these inscriptions is fascinating in that it defines both the father and brother in terms of their relationship to Plancia Magna and not the other way around, as might usually have been expected in relation to a Roman or Romanised woman. It has been estimated that Plancia Magna was around eighteen or nineteen years of age when she endowed the city with its impressive southern gate and that she was unmarried at the time.

The decorative programme of the arch is of considerable interest in that its make-up could provide some evidence of Plancia Magna's own hand in the choosing of the suite of images employed here and their potential significance from a gendered perspective. The arch bears statues of Olympian gods, civic deities, city founders, her family members and imperial figures. More female than male members of the imperial family are depicted. While this might simply have reflected the power of the women of the imperial household at the time, it is surely more likely to have reflected Plancia Magna's identification with these women, and Sabina, wife of Hadrian, in particular, as powerful individuals in their own right.

The question arises as to whether Plancia Magna was an exception

among the women of the Roman Empire, or whether women played more public roles in some parts of the empire than in others and that what was acceptable in a far city in Asia Minor would certainly not have been acceptable in the mother city of Rome. Perhaps surprisingly, epigraphic evidence tells us a considerable amount about Plancia Magna's official positions and standing in the city. She was evidently one of the annual city magistrates (*demiourgos*), as well as a priestess of Artemis and of the Mother of the Gods. She was also probably a priestess of the imperial cult. In other words, as well as her family and personal riches, which were in any case to be further greatly enhanced by her marriage some time after AD 122 to C. Iulius Cornutus Tertullus, she also held considerable political and ideological power locally.

Another female patron and benefactress of works at Perge, though of a generation or so after Plancia Magna, was Aurelia Paulina, of Syrian origin and again a priestess of both the cult of Artemis Pergaia and the imperial cult. The large monumental nymphaeum she had constructed outside the southern gate of the city was dedicated to Septimius Severus, Julia Domna and their sons Caracalla and Geta. Its decoration must have included numerous statues in niches, many of the imperial family, particularly its female members, but few have survived fully intact, though a life-size statue of Aurelia Paulina herself, dressed in Syrian costume to proudly display her ethnic origins and perhaps to link her in the viewer's mind to the Syrian Julia Domna, does survive (see image 20).

Other rich and powerful women from the Greek east of the Roman Empire are known, mainly from the evidence provided by dedicatory inscriptions and papyri. Among them were Flavia Publicia Nicomachis of Pleket in Asia Minor, who in the second century AD was praised by the council and people of the city as a benefactor and honorary founder of the city; Aurelia Leite of Paros in Greece, who in the late third century AD is recorded as having been 'gymnasiarch of the gymnasium which she repaired and renewed when it had been dilapidated for many years' and who had a statue dedicated

to her; and Appia Annia Regilla Atilia Caucidia Tertulla, known to us generally as Regilla, from Olympia in Greece, who built a monumental nymphaeum there in the AD 150s.[13] Regilla was born in Rome and was well connected, being related to the empresses Faustina through her father's side of the family. When settled with her husband Herodes, one-time tutor to Marcus Aurelius, and their family in Olympia, she became a priestess of Demeter in AD 153 and set about overseeing the building of the richly decorated nymphaeum there, whose twenty-two niches contained statues of deities, the emperor Antoninus Pius, his family and descendants and of Regilla, her husband, children and ancestral family. Her statue survives today, sadly now headless. Even more tragically and ironically, given the emphasis on images of family and lineage in the decorative scheme of her great Olympian monument, Regilla was murdered in AD 160, aged just thirty-five years old and pregnant at the time, the murderer probably acting on the orders of her husband.[14]

From Parts to the Whole

If images of powerful, significant and rich individual women, such as Eumachia of Pompeii, Tettia Casta of Naples, Plancia Magna and Aurelia Paulina of Perge and Regilla of Olympia, could be displayed in public spaces to acknowledge their contributions to civic life and thus elicit a positive response from viewers, so perhaps could the opposite effect occur, particularly if changing political allegiances in the Roman world were reflected in shifting perceptions of public displays of certain images.

The Cartoceto gilded bronzes represent one of the most impressive survivals of a bronze statuary group from classical antiquity (see image 21).[15] These gilded bronze figures were discovered largely in fragments 'piled on top of one another' in 1946 during groundworks on a farm at Santa Lucia di Calamello, near Cartoceto, in the Commune of Pergola, Pesaro, in the region of Marche in eastern Italy, close to the Via Flaminia. The circumstances leading to the burial of the statues at Cartoceto and the potential motives behind

their careful disposal inevitably have been the subject of much academic speculation. Questions of the meaning of certain gestures and of gender and power are also raised by the unique composition of the group.

The date of the statues has generally been accepted as being between the second half of the first century BC and the latter half of the first century AD, though life-size, gilded bronze sculptures such as this were not common until well into the Roman imperial period. The statues in the Cartoceto group consist of two men, two women and two horses, the men being represented as equestrian figures with outstretched right arms and the women portrayed with veiled heads and standing upright in the so-called *pudicitia* pose, which is a common female pose alluding to chastity, piety and humility, and most often associated in the modestly veiled form with older women. The statues are larger than life-size, something which is obviously of some significance in terms of defining the perceived power of the individuals and of the family portrayed. The number of individual statues in the group, their costly gilding, the use of the equestrian motif for the males, the manner of their attire and poses and their transportation from somewhere in Latium, if not actually from a workshop in Rome, though more recently it has been suggested that they could have been made in Rimini, all allude to the wealth, prestige and status of the statues' commissioning patron.

There was differential survival of the statues, which were recovered in many fragments in some cases, with only the two most complete figures of one of the women and one of the men being found with their portrait heads intact or reconstructable. It has been argued for the identification of the statuary group as being that of the family of Domitius Ahenobarbus.

The arrangement of the figures in a formal, posed group can be seen in the Museo Archeologico Nazionale delle Marche in Ancona, where the newly conserved statues are now on display, and in the form of a full-size set of copies displayed on the terrace of the museum. In both instances, the two mounted male figures are

arranged in the centre of a tableau, with the women standing one on either side of the men.

Most previous academic discussion of the Cartoceto group has focused on the possible identifications of the family represented by the four gilded bronzes, despite the fact that there was no inscription or dedicatory plaque found with the statues. The identifications have either been of members of the imperial family in the early Empire, a Roman aristocratic family of the late Republic or early Empire or of members of a local, provincial Italian aristocratic family, again of the late Republic or early Empire. The imperial identifications would now appear to be generally discounted, and John Pollini's suggestion that the family group was the powerful and influential Roman Domitii Ahenobarbi family, that is Gnaeus Domitianus Ahenobarbus himself, his wife Aemilia Lepida, his mother Porcia and his father Lucius, is accepted.[16]

The destruction of the statues as part of a process of *damnatio memoriae* has been discounted by John Pollini, who suggested that the statues, for whatever reason, were interrupted in transit and then destroyed, and that they were never actually set up in position anywhere, something that he surmised from an absence of lead tenons in the feet for erecting the figures.[17] In many ways the motives behind their destruction may be hidden from us by our inability to identify which individuals were represented here.

The equestrian male statue type in the course of the first century BC became most associated with the Roman senatorial class, eventually to become the sole preserve of the imperial family, beginning with a series of equestrian statues of Augustus, as depicted on coins. The gilding of the Cartoceto bronze statues would presumably have placed them in a category of higher opulence than other non-gilded bronze or indeed stone equestrian statues.

The Cartoceto statue group makes a very specific statement about the power and status of the family and the individuals portrayed. It also makes a statement about gender relations within the group and within the aristocratic families of provincial Italy, away from

Rome. The very existence of the female statues in the group showed that the women of such a family could be honoured with public statuary images in the late Republican period in provincial Italy. This is unusual given the relative dearth of female images in Rome itself at the time outside of funerary contexts.

A statue of a veiled woman similarly posed to the most complete of the Cartoceto female figures and represented in recut half-figure is in the collection of the Museo Gregoriano Profano in the Musei Vaticani. The Cartoceto and Vatican figures are represented in the so-called *pudicitia* pose.

Elite women playing some public role in civic life in the Roman Empire, principally through benefaction or religious observance, may have then done so following the obvious example of the imperial women who, as we have seen in Chapter 2, were especially prominent and sometimes autonomous in the Julio-Claudian, Antonine and Severan periods. Most interestingly, such women 'seemingly paradoxically ... had a much more conventional public image ... [often being depicted] as *Pudicitia* and other traditional female virtues associated with harmonious families ... [an ambivalence] justifying both political power and a retiring persona'.[18]

It would appear that there is unlikely ever to be a conclusive identification of the four individuals portrayed in the Cartoceto bronzes group. Equally, they could date from any time between the latter half of the first century BC and the second half of the first century AD and a more precise dating may remain elusive. There would, though, now appear to be a consensus that these statues do not represent members of the imperial family, but rather that they represent either a powerful Roman aristocratic family or a rich and politically engaged local elite family associated with one of the Roman cities in the region in which the statues were discovered.

The financial outlay invested in such an unusually large and opulently finished statuary group makes them an impressive visual statement about the power, status, competitiveness and aspirations of that provincial aristocratic Italian family. That the statue types

represented – equestrian males and females in *pudicitia* poses – were archetypes respectively for male aristocratic and later male imperial power, and female aristocratic and later female imperial virtues, makes their appearance together a juxtaposition that says much about gender relations between the men and women portrayed in the Cartoceto group.

It has been suggested that rather than assuming that the group represented the family of a powerful local male aristocrat, it could perhaps be viewed in a more nuanced manner, with the totality of the group, the unity of the family and the strength resulting from that unity being the intended messages. We have already seen in this chapter that there is a considerable body of mainly epigraphic evidence for elite women in some instances playing significant public roles in the Roman world, and not just in the Greek east, and such powerful women we know were on occasions honoured for their civic contributions by the commissioning, erection and dedication of statues to them. They may indeed have honoured themselves, their families and their ancestors by setting up statues themselves.

Private Portraits

In most of the examples of statues of elite women discussed in this chapter so far, the heads of those statues have been in the form of portraits of the individual women portrayed, even if only in some cases in a sketchy or idealised form. These have all been life-size or full-length public statues, intended to adorn buildings or monuments or to stand in prominent positions in public spaces in various towns and cities of the Roman Empire. To what extent elite women were represented in portrait form in the private sphere is more difficult to assess, as so many of the Roman portrait heads and busts that have come down to us are unprovenanced or shorn of their original context. Many of them were doubtless originally from funerary contexts and indeed it would appear that private portrait sculpture was most closely associated with the commemoration of the dead or of the ancestors rather than with the representation of the living.

If the origins of Roman portraiture lay in the tradition of the production of *imagines* – images of the ancestors in the form of wax masks – exclusively for aristocratic Roman families, then women were automatically excluded from being celebrated in this ancestral cult in the home or at funerals because of their exclusion from political life, as the ancestors so celebrated had to have held high political office. Once the honouring of the ancestors became a more generalised elite phenomenon trickling back down the social hierarchy, involving the commissioning and display of portrait heads and busts in the home, it is possible that women too were sometimes so honoured. At what stage and in what way women were allowed to become part of the Roman family's ancestral gallery is unknown.

It is not intended here to attempt to provide an extended, detailed history of Roman portraiture of women: that is way beyond the scope of this study. Rather, I have chosen to illustrate here just four examples of portrait sculpture, two from the Republican period and early imperial period and two from the second century AD, each of which exhibits some aspect relative to broader trends in image making at the time.

Dating to the time of the late Republic, around 91–4 BC, is a marble portrait of an elderly woman from Colle Fagiano, Palombara Sabina, now in the Museo Nazionale Romano Palazzo Massimo delle Terme in Rome (see image 22). She is frontally posed, directly facing the viewer. The viewer's eye is at first drawn immediately away from the woman's face towards her hair, and in particular to the then highly fashionable pronounced roll or *nodus* of hair over her forehead. When attention returns to the woman's face, it can be seen that the artist has not shirked from depicting the physical signs of ageing, but these seem significantly less pronounced when the statue itself is viewed rather than the stock black-and-white photographic image of the statue that appears in so many Roman art books. Nevertheless, her thin face, slightly sunken cheeks, the bags under her eyes and creases at the corners of her mouth can be taken to represent her experience and status as an elite matron.

This is perhaps the best known of a series of Republican veristic studies of elderly women, part of a broader phenomenon in the period of the late Republic of portraying the elderly, both men and women. Indeed it could be suggested that in some way the veristic portrait of this period personified Republican values. Unfortunately, none of the portraits of elderly women that have come down to us bear inscriptions which might have helped provide further information on the individuals portrayed and therefore on any such broader phenomenon. A proper archaeological context is also missing for many.

The same anonymity applies to another portrait of an elderly Roman matron dating to the late Trajanic period – the first decades of the second century AD – in the collections of the Musei Capitolini in Rome (see image 23). While her age is apparent from the modelling of her facial features, the blunt veracity of the later Republican portrait style is absent, or at least greatly toned down. Her hairstyle is quite elaborate and in contemporary fashion, quite obviously influenced by those sported in portraits of Trajan's wife Pompeia Plotina. The pose again reflects the dignity and virtue embodied in Plotina's portraits.

The age at which one was considered to be old in ancient Rome varied considerably, from 'anywhere between forty-six and sixty', with an individual's physical and mental health being significant factors in determining in individual cases when being viewed as old commenced. Being viewed as old meant that social expectations of you changed. For the old or elderly, 'their role and obligations as citizens reverted to those of a child'.[19] There was considerable potential, therefore, for the marginalisation of the old, particularly of elderly women, though Roman society undoubtedly recognised and celebrated the contributions made in the past by the elite elderly, principally through the veneration of civic duty in the case of men and motherhood in the case of women. The relative numbers of portraits of young, mature and elderly Roman women that have come down to us probably represent a fair reflection of those prejudices and concerns.

In contrast, the other two examples here are both of young women, one from Tivoli and the other from Cinecittà, Rome, both now in the Palazzo Massimo museum in Rome. The Tivoli young woman dates to around 40–30 BC and is clearly idealised to some extent and perhaps modelled on contemporary portraits of Livia, as discussed in Chapter 2 (see image 24). The Cinecittà young woman dates to the mid-second century AD and is portrayed in an understated manner, being presented as calm and demure, as was thought to befit a woman of her age, perhaps before her marriage (see image 25). There is little influence from contemporary imperial portraits discernible here.

Finally, mention should be made of one of the most famous portrait depictions of an individual woman from the Roman world, on a wall painting from Pompeii, comprising a double portrait of a man and his wife. The man has short hair and a well-clipped beard and moustache; he wears a white toga and holds up a rolled scroll, which nestles under his chin. The woman stands next to him, closely and intimately. Her hair is in a relatively simple style with centre parting and curled locks coming down over her brow. She wears a red tunic and holds a wooden-framed wax writing tablet in one hand and a metal stylus in the other, which she holds up to her lips in a pensive pose. Both are probably in their twenties or thirties. While at first viewing the picture might be thought to be of a learned couple, some authorities have warned that the scroll, writing tablet and stylus might be no more than the painter's props or props chosen by the depicted couple. There is no doubt that even though they may be people playing a role in the picture, the couple are represented by portraits, painted portraits such as this being surprisingly rare commissions in the Roman world.

Power and Prestige
As we have seen in Chapter 2, in Late Antiquity strategies of representation of imperial personages changed quite significantly and to some extent the same is true of elite private individuals, including women. To illustrate this change I have chosen a small

number of works of art of this period that each encompasses some novel element in terms of the creation of the female image as a manifestation of the contemporary cultural milieu. These examples include the use of images of women on silver vessels in the Esquiline Treasure from Rome, on a decorated ceiling from a private house in Trier, on the leaves of an ivory diptych from Rome and on two mosaic pavements from North Africa.

An example of an altogether different kind of gendered representation to any that has been discussed before in this chapter is provided by the iconography of the decoration on the silver Projecta Casket, one of sixty or more individual precious metal items forming the Esquiline Treasure from Rome, most of which is now in the collections of the British Museum in London (see images 26–8).[20] Discovered in the late eighteenth century inside a large private house behind the convent of San Francesco di Paola on the Esquiline Hill, there is little doubt that the treasure's owners were people of considerable wealth and status. Whether or not they were the Secundus and Projecta named in the inscription on the casket is open to question. In any case, the decoration on the Projecta Casket and on the accompanying Muse Casket in the same treasure suggests beyond any doubt that these were items owned by and used by the elite lady of the house, whoever she was.

Before describing the decoration on the casket, there are issues relating to the casket itself which need to be taken into consideration when assessing the significance of the object and its complex iconographic programme. Firstly, it is generally considered that all the items in the treasure are of broadly the same mid- to late fourth-century date and stylistically probably made in the same master silversmith's workshop. However, although the casket bears an inscription on the otherwise plain horizontal rim of the lid, '*Secunde et Proiecta vivatis in Christo*' – 'Secundus and Projecta, may you live in Christ' – there is no way of knowing if this inscription is indeed contemporaneous with the actual vessel and integral to its visual programme or if it was added later. In other words, while logic might dictate to us that the Secundus and Projecta of the

inscription are the male and female figures depicted on the vessel, this might not in fact be the case. Secondly, though not particularly impacting on the discussion here of the casket's decorative scheme, it is possible that the handles, feet and hinges of the casket are not original to it, though they might be Roman-era replacements or additions rather than much later ones.

The Projecta Casket takes the form of 'two truncated rectangular pyramids', each with five flat faces, hinged to form a casket, with drop handles at either end and standing on slightly raised feet. Nine of the ten flat faces are decorated; the tenth, undecorated face, forms the base of the casket. As the casket is obviously designed to sit on a table or other flat surface, the most impact on the user of the casket would be made by the viewing from above of the uppermost decorated surface of the lid, both on opening and on closing the casket. It might, therefore, be thought that the images placed here on top of the lid held some kind of primacy of place in a hierarchy of significance among the iconographic programme on the vessel. This is where there appears the image of a man and woman framed within a wreath held by two *erotes* or *putti*. The man, standing on the right, is bearded and wears a long-sleeved tunic under a *chlamys*, and the woman, on the left, wears a long-sleeved tunic and a high, jewelled collar of some kind and holds a parchment scroll. If the inscription is indeed contemporary to the vessel, then we must assume that this couple are Projecta and Secundus. The portrayal of the couple on the upper surface of the lid of the casket is not unlike other more or less contemporary portrait groups of couples in Late Antiquity in other media, most notably on sarcophagi, on gold-glass medallions and on late Roman jet cameos from Britain.

On the front long side of the lid appears Venus seated on a large shell and flanked on either side by a centauro-triton, upon each of whose backs stands a cupid or *putto*, one of whom offers her a gift of a casket and the other of whom proffers a basket of grapes or fruit. One of the centauro-tritons holds up a mirror to the goddess and she peers into it, as with her right hand she holds up a hairpin

that she may be about to put in place in her hair. The depiction here of the giving of gifts to a woman, one of which is a casket, ties in well with the notion of the Projecta Casket itself as being a gift. The goddess adjusting her appearance by checking herself in the mirror also echoes the decoration on the front of the base, on the long side directly below the scene depicting Venus and her companions.

On the lid's other long side the decoration consists of a busy scene in which two sets of three figures each move towards a building at the centre of the panel. It is unclear what is happening here, other than the fact that processions of some kind are taking place and that gifts or offerings are being brought by both parties. Indeed, the group of male processors carries what appear to be items from a collection of silver, including a candlestick, a large casket, a jug and a plate or platter. This intertextuality, with the appearance of images of silver vessels on an actual silver vessel and the portrayal of the giving of gifts on an item that may have been a gift itself, is typical of the art of Late Antiquity.

On each of the lid's short faces can be seen aquatic scenes, involving a *nereid* riding on the back of a sea monster or *ketos/cetus* in one case and on a hippocampus in the other. In both scenes the *nereid* is accompanied by a *putto* and dolphin.

Attention will now be turned to the base portion of the casket. On the front long side of the base is depicted a lady at her toilet, placed centrally in the scene, with two female figures, presumably her personal slaves, in attendance on either side of her. The fully clothed lady is seated on an elaborate chair and appears to be pinning her hair in a pose that mirrors that of Venus pinning her hair on the lid of the casket. She looks over towards one of her servants, who holds up a mirror for her use, as indeed did Venus's attendant on the lid above. The other female servant holds a closed casket, presumably a jewellery box. Columns and arches frame the individual figures and stress the privacy and intimacy of the setting. A sense of cloistered seclusion and hierarchical transcendence is suggested by the figure of the woman.

While for the purposes of description here the casket is being broken down into a sequence of separate sections, starting with the top of the lid, proceeding through the sides of the lid and then ending with the individual face and side panels of the base, the viewer or user of the casket would have experienced the artwork on the casket in simultaneous combinations depending on whether the casket was closed or open, or being viewed from the front, the side or the back. In other words, the images would have been processed at times as being other than constrained by their framing in separate panels. Crucially, in terms of the viewer's overall experience, a viewing of the front of the closed casket would allow the viewer's eyes to move down from the top of the lid to the base of the casket, uniting visually and conceptually the married couple on the top of the lid, Venus on the front panel of the lid, the inscription and the seated Roman woman on the basal front panel.

On the base's other long side, the decoration consists of another processional scene involving three female servants carrying various items to their mistress, including a circular casket with a long chain handle, ewers and *paterae*, all items for the toilet or bathing. On each of the base's short faces can be seen a female servant holding a very large casket, flanked on either side by a youth, possibly eunuchs, holding candlesticks, the figures framed by architectural columns and arches. Finally, as previously mentioned, the underside of the base is undecorated.

If the Projecta Casket represented a wedding gift, or at least an item created in celebration of a betrothal or wedding or on an anniversary of a wedding, as has been suggested by a number of authorities, then the iconography of part of its decorative scheme makes perfect sense in terms of celebrating the union and the love of the married couple, the strength of their personal bond and of the institution of marriage as an example of the stability of Roman society. However, much more is suggested about the position of the woman for whom the casket was made, whether she was Projecta or not.

This item is generally accepted as being an elite woman's jewellery

or cosmetics box for use in her private grooming routine in her own room, and I have not been able to find any serious contrary views to this interpretation. The Projecta Casket therefore can be thought of as being an object that was subject throughout most of its life to the female gaze of its elite owner or owners, whether including Projecta herself or not being open to debate. The interaction here between viewer and viewed is crucial to the creation and maintenance of the viewer's self-image.

The polished reflective surfaces of such a silver vessel, the very materiality of the silver from which it was made, may have made it like a mirror in terms of its turning back the owner's image upon herself. Both casket and mirror could be reflecting and reflexive.[21] The very fact that the mirror was a recognised attribute of Venus, the goddess most greatly revered by Roman women, meant that links between the unreal, as represented by celestial beings and reflections, and the real, as represented by the Roman or Romanised woman at her toilet and using her mirror, were made on an almost daily basis by the woman's use of the casket in her toilet routine.

It can therefore be seen that an examination of the Projecta Casket from the Esquiline Treasure has revealed all kinds of information about the creation and maintenance of an elite woman's image in the later Roman period. The not necessarily contradictory juxtaposition of an overtly Christian inscription on the casket's lid and the apparently largely pagan iconography of the complex decorative programme on both the lid and base of the casket would have been typical of its time, if the inscription was indeed contemporary. Roman silver vessels from the Republic through to Late Antiquity were often carriers of complex iconographical programmes such as this.

Because it is widely considered that the Muse Casket in the same treasure hoard was also a woman's private toilet item, this casket will be discussed here briefly as well in terms of the iconography and possible significance of its decoration. The Muse Casket was again a large silver vessel, with a flat base, scalloped body and domed lid, with three chains for suspension. Inside were settings to

hold five small silver bottles that would have contained perfumes or unguents. Both the body of the vessel and the lid were highly decorated. The panels around the body bear repoussée images of eight of the nine Muses, identified by their feather headdresses and attributes, framed by arches, alternating with panels bearing vine tendrils, wine *canthari* and birds, these latter naturalistic images also being repeated on the lid. On the very top of the lid is an image of a seated woman in a landscape setting, in association with a bird, a basket of fruit and a tree decked with garlands. The female owner of the casket is here being associated with the natural world, as we have seen being done in the case of Helena and Constantina in the previous chapter, and with the accomplishments of the Muses.

Another opportunity to examine a rare image of an elite Romanised woman in a private domestic context is afforded by the fifteen excavated and painstakingly restored painted *trompe l'oeil* ceiling coffers from a late antique house in Trier, Germany. Three of these fourth-century paintings are of richly adorned women, including a woman with a jewellery box and another woman with a mirror, depictions that perhaps allude to Venus or a Roman betrothal and marriage in a similar way to the images on the Projecta Casket. Other panels carry depictions of bearded, rather ascetic-looking men with the appearance of philosophers or educated elite men who cultivated such an image in public.

The two most significant panels in relation to the present theme of the construction of female images both depict nimbed women – women with a nimbus or halo of light around their heads – both veiled and wearing elaborate and costly jewellery. The woman on the west side of the ceiling, wearing a sleeveless garment, holds a mirror in her right hand and is caught in the process of drawing back her veil with her left hand in order to look into the mirror. She wears hair jewellery, earrings, a necklace and a gold bracelet on each wrist. The woman on the east side wears a contrasting long-sleeved garment, and is depicted pulling a string of pearls out of a square jewellery box with raised lid in front of her. She is wearing another

item of what appears to be pearl jewellery in her hair, a hair crown and necklace. The third woman, in the central part of the ceiling, holds a silver *cantharus* with one hand as she again draws back her veil in what is here used as a standard pose for the Trier elite women. The so-called *anakalypsis* pose of the women, caught drawing back veils to reveal their faces, might allude to the moment of revelation in a marriage ceremony as in classical Greek tradition or simply to the status of the women as demure Roman matrons.

Various suggestions have been made over the years since its discovery in 1945 as to the identifications of the men and women portrayed on the Trier ceiling. There is a possibility that rather than being from a private dwelling the excavated building beneath Trier Cathedral was in fact part of a palace complex built by the emperor Constantine and therefore that the individuals portrayed are actually members of the imperial family and court. There is, however, no evidence to support this claim other than circumstantial details. It has also been suggested that the human figures depicted are in fact sophisticated personifications: in the case of the woman with the mirror, Sapientia or Wisdom, and in the case of the woman with the jewellery box, Pulchritudo or Beauty. Such identifications seem unlikely.

Most recently, it has been suggested that the human images on the ceiling when viewed together constitute not a group of portraits of imperial or elite individuals or personifications of some kind, but an overall artistic expression of the house owner's elite status and power in general and of family and domestic harmony.[22] If this was indeed the case, it would be expected that the ceiling was located in the part of this late Roman house that served some kind of public function and where visitors or clients would have been able to view and understand the meaning of such a programme. The decoration would certainly have provided a backdrop for the kind of ceremonial display of power, prestige, generosity, understanding and munificence beloved by the late Roman, pan-provincial aristocracy.

A third example of the opportunity for an elite woman to represent herself or her ideas and aspirations, or have them presented for

her, appears in the form of two ivory leaves from what is known as the Nicomachi/Symmachi diptych, the two panels of which are now sadly in different museum collections, being respectively in the Musée de Cluny, Paris, and the Victoria and Albert Museum in London. This luxury item was probably produced to mark the almost-dynastic marriage that brought the two great pagan senatorial Roman families of the Nicomachi and Symmachi together in the late fourth or early fifth century, between AD 388 and 401. The classicising image on both leaves is similar, being the depiction of a young woman sacrificing at a rustic or rural shrine, the woman either being an officiating priestess or, less likely, a goddess. There must have been some significance in the use of female images on both the leaves of this diptych, but this can only really be guessed at. Such idyllic scenes dominated by women at first sight might appear unlikely signifiers of male political power, but that is what they are to all intents and purposes. It has been suggested that these works are exercises in nostalgia. While the classical style of the images is certainly backwards looking and perhaps deliberately anachronistic, rather than nostalgic, the medium of the diptych was nevertheless strictly contemporary. The pagan theme of the sacrifice and allusions in the imagery perhaps to the worship of Cybele and Jupiter reflected the realities of contemporary religious duality.

Two late Roman mosaic pavements in the Musée National du Bardo in Tunis depict scenes in which elite women feature significantly and which echo strategies of depiction of women common at this time. The first of these, known as the Dominus Julius Mosaic, probably depicts the family of Julius of Carthage and dates from the later fourth century or early fifth century AD (see image 29). Found on the Byrsa Hill, the mosaic is divided into three interrelated horizontal registers which depict the owner's large estate in operation over the seasons. At the very centre of the central register, to which the viewer's gaze is first invited, can be seen a depiction of the great estate house itself, with fortified towers, high walls and a large bath suite with vaulted roof. The

master on horseback is shown riding towards the house with a servant on foot in attendance. Striding away from the house is a group of hunters with dogs off to pursue hares, among whom is probably the Dominus again, one of the attendant men carrying a long pole in one hand and a catch-net over his shoulder. In the upper register appears the mistress of the estate seated on a couch or bench set under a grove of cypress trees. She fans herself and looks out into the distance. On the bench beside her sits a plate of what might be pastries, around her are servants and slaves, agricultural workers variously carry in ducks or geese for the table and fruit for the mistress, while others harvest olives, bring in lambs and shear sheep. Incidental details are quite delightful: a chained dog sits outside his or her kennel and little birds, perhaps quail, grub around on the ground for food outside their hutch.

The master and mistress of the estate appear together in the bottom register of the mosaic. Julius, the master, is seated in an orchard with his feet resting on a stool and receives a scroll with his name on from a messenger, who is also depicted carrying live waterfowl destined for the dining table. Behind him a grapevine can be seen trailing around the trunk of a tree. The mistress has just stood up from her chair and is depicted leaning on a column and holding out her hand to receive a necklace being handed to her by a female servant holding an open jewellery box against her chest. A boy kneels before her with a basket of freshly caught fish. On both the left and right outer parts of the register appear male servants bringing in more agricultural produce, flowers, it would appear, in the case of the man proffering a basket on the right and perhaps a basket of nuts in the case of the male who also holds a dead hare in his left hand.

The second Tunisian mosaic from the collections of the Musée National du Bardo to be briefly discussed here comes from the site of a private villa and bath complex at Sidi Ghrib and captures once more a scene of a richly adorned, seated woman with two servants or slaves dancing attention upon her, one holding up a mirror to

her mistress and the other standing waiting with an open basket of jewellery. The woman is presumably dressing after bathing. Other items belonging to this rich woman can be seen on the floor by her chair and beside each of the servants, including a pair of bath sandals, a basket of robes, water jugs and other vessels.

Both the women on the Dominus Julius and Sidi Ghrib mosaics represented members of the North African provincial elite whose power, wealth, interests and influence would have been equivalent to those of many other elite, non-imperial women in Late Antiquity, including the Trier women discussed above, the women of the Nicomachi/Symacchi alliance and Projecta.

The final mention in this chapter should be reserved for perhaps the most powerful of these late Roman women, Melania the Younger (*c.* AD 383–439), later Saint Melania, scion of one of the great senatorial families of Rome, who in the late fourth century AD is recorded as owning land in and around Rome, in Italy more broadly, in Sicily, North Africa, Spain, Gaul and Britain. It is recorded by Gerontius in his *Life of Melania the Younger* that she and her equally wealthy and well-connected husband, Valerius Pinianus, from an old consular family, after the birth of their two children sold their joint, vast land holdings to pursue a simple, ascetic Christian life and to fund the establishment of monasteries and monastic communities. Sadly, there are no contemporary images of Melania that have come down to us and it is not really until much later that she becomes regularly portrayed in Byzantine art, as in one of the miniatures in the Menologion of Emperor Basil II, which is thought to date from around AD 1000 and which is now in the Vatican libraries. Obviously, at such a remove in time, these images can in no way be considered to be portraits.

In this chapter, discussion has largely focused on the presence of elite women in the form of public representations and those in the home. In the next chapter, attention will be turned on the much more common images of women in funerary contexts, some strictly private and others more public.

4

A FINE AND PRIVATE PLACE

Images of non-imperial women could only be presented in a relatively limited number of public contexts in Rome and in the broader Roman world, as discussed in the previous chapter, while private portraiture displayed in the home was also a relatively minor strain of gendered representation at the time. An altogether different picture emerges in terms of the use and deployment of images of women in funerary contexts, and, for the archaeologist, images found in such contexts also often have the added value of being identifiable from an accompanying inscription. Such inscriptions can sometimes not only tell us the name of the deceased but also their age at death, their family links or status, perhaps their origins and occasionally much other useful, perhaps esoteric, information. In investigating here some representations of women on funerary monuments in Rome, elsewhere in Italy and in some of the provinces of the empire, it will be considered whether images of women when dead were accorded a different status perhaps to women when alive and active in society, insofar as they were allowed to be.

Images of women appeared on many different types of Roman funerary monuments from tombs to catacombs, and on cremation urns and sarcophagi. They were represented in the form of free-standing statues, on funerary reliefs, on tombstones or stele or

as funerary busts, either on their own as individuals, as part of a couple with their husband or partner or in larger family groups with husband and children. Obviously, each of these types of appearance had a specific gendered aspect to it. Many of the most interesting female images on Roman funerary monuments are of freedwomen rather than of elite women and this will be reflected in the bias towards the discussion of this category of representation in this chapter.

The Mask of Death

Insights into the funerary rituals involving Roman women are provided by a close analysis of one of the reliefs on the Tomb of the Haterii in Rome and by the wall paintings in the Tomb of the Varii in Ostia, the port of Rome.

Reliefs from the Tomb of the Haterii, which originally stood on the Via Labicana in Rome, beyond the Porta Maggiore, are now in the Museo Gregoriano Profano in the Musei Vaticani in Rome (see images 30–3).[1] Dating to the early second century AD the tomb was erected by the Haterii family, freedmen who apparently had made their fortune in the building industry in Rome. The tomb and the walled funerary garden in which it stood were profusely decorated with sculptures, and the tomb itself bore dedicatory inscriptions, highly decorated reliefs and portrait busts. The scenes on the reliefs were probably intended to be viewed and understood in sequence, with the viewer following a narrative that starts with the lying-in-state of a deceased family member, a scene that is going to be discussed at length shortly below. The action then moves on to what is known today as the Sacra Via relief, a depiction of a street in Rome lined on one side by five to seven large buildings and monuments, perhaps buildings constructed by the Haterii family firm, though equally these could have represented significant buildings along the route of the funerary procession. The final scene in this narrative is on the so-called 'tomb-crane relief' and is of the building of a huge temple tomb that probably represented the Tomb

of the Haterii itself, with a building crane depicted in action at the side of the building. An analysis of this busy third relief suggests that there is enough evidence here to confirm that the tomb in the relief was indeed the final resting place of the same woman depicted lying dead in the first relief.

Returning to the lying-in-state relief, it is true to say that this is an altogether unique depiction in Roman art, in that the deceased in this particular case was a woman, probably the unnamed wife of Quintus Haterius (both she and her husband are represented on portrait busts associated with the site), and in that no other depiction of this ritual subject involving an adult survives in Roman art. She is laid out on a funerary bed or couch, presumably in the atrium of the family home in Rome, and is attended by ex-slaves and mourners. The deceased woman is depicted at a much larger scale than the other figures on the relief, even taking into account any differences caused by perspective, and her importance is further stressed by the placing of her image at the very centre of the scene to draw in the viewer's eye. The room is decorated with funerary garlands and is lit by torches and free-standing candelabra. To add to this penumbral atmosphere, a female musician is pictured in one corner of the relief playing a set of pipes to accompany a singer or reciter. The three mourners standing directly behind the funeral couch are engaged in strikingly different activities: one, a male slave, is caught in the process of placing a garland around the deceased woman's neck, while the other two female figures, perhaps the woman's daughters or other close relatives, are depicted beating their breasts in a clearly highly distressed state. Coming around the head of the bed is a procession of mourners entering with gifts or offerings and in the foreground are five further women, four standing and one seated, probably freed slaves of the dead mistress of the house.

Two further small images appear in square panels on the upper right and upper left of the relief. The panel in the right-hand corner depicts a woman sitting writing at a desk, with a slave in

attendance. We are presumably looking on at the deceased woman as she was in life, perhaps caught here composing her will, just as most of our time as viewers has otherwise been taken up with viewing her in death. Finally, the panel in the left-hand corner bears a mythological scene, a contest between Pan and Eros as a herdsman looks on, a scene that could somehow allude to the Bacchic cult, as has been suggested by some authorities.

This same woman also appears no less than three times in the tomb-crane relief scene, firstly in portrait form, a veil covering her head, her portrait appearing on the pediment above the tomb's entrance. Her second appearance is in a scene of a funerary banquet where she is shown reclining on a couch while three small children play on the floor at the side of the couch. To one side of the banqueting scene there appears a small commemorative funerary arch above, where three portrait heads of children hover. Standing in the central archway is the naked figure of the Haterii matron in the guise of Venus. This should be understood in terms of an identified trend among Roman matrons from the first century AD onwards into the second century to be portrayed in the guise of a nude Venus, with their realistic, aged portrait heads being set on top of youthful naked bodies of the goddess.

These Venus statues were set up in tombs and may have been influenced in their inception by an imperial tradition of representing female members of the imperial family as Venus, though not perhaps as nudes. A study of these artworks depicting nude matrons has concluded that while 'to a modern audience these portraits appear incongruous, the often stern features and lined faces of matrons oddly juxtaposed with the highly charged eroticism of figures that display a youthful anatomy and firm flesh ... the mythological conceit implied that these women rivalled Venus in beauty, charm, and the ability to bear healthy children'. Venus's nudity, it has been suggested, was in these instances 'worn as a costume that replaces rather than reveals the body of the deceased' mature or elderly woman (see images 34–6).[2]

The gravity, modesty or self-restraint conveyed by the portrait heads of these mature women, probably all freedwomen, acted perhaps as a visual manifestation of their identification with those mature and elderly elite matrons who were praised by historians and eulogists for their dignified bearing and achievements in domestic and civic spheres. 'If the portrait head conveys the dignity and authority of the matron, then the replacement of the ageing body by the immortal physique of Venus suggests a belief in the resilience of the maternal body ... The rejuvenating nude portrait with its Venus imagery was appropriate for matrons whose bodies were renewed and whose social horizons were extended through several marriages.'[3] The commissioning of such portraits may also have been a visual counterblast to the cacophonous din of contemporary misogynistic satirists such as Martial, who publicly and popularly stereotyped older women for their 'foul smelling cavernous genitals, ugly breasts, and animalistic sexual voracity'.[4]

Thus, the Haterii matron appeared on the tomb and its associated artworks in the form of a portrait bust and five times on two of the reliefs, as a living person at work, as a laid-out corpse, as a sculptural head, at her own funerary banquet and in the form of a naked Venus.

Also depicted on a damaged relief from the tomb is the mythological story of the abduction and rape of Persephone/Proserpina, the daughter of Zeus/Jupiter and Demeter/Ceres, and her reunion with her parents after her return from Hades. The popularity of this particular myth on burial sarcophagi of women is discussed fully in Chapter 6, but here it may well allude to the earlier, premature death of a Haterii daughter.

As has already been mentioned, while no similar lying-in-state scene involving an adult is otherwise known in Roman art, there is a small group of decorated children's sarcophagi on which smaller-scale scenes of mourning around the couch of a deceased child are depicted. One such *conclamatio* scene appears on the front panel of a later second-century AD coffin from Rome, which is now in the

British Museum, London. Here we see the body of a young girl laid out in a slightly propped-up position on a couch, presumably in her home. Beneath the couch, the household dog, perhaps her pet, pines for the deceased girl. A pair of shoes rests on a footstool next to the dog. At the head of the bed sits a veiled, bearded man on a stool, presumably her father, and at the foot of the bed sits a veiled woman in a chair who is presumably her mother. Both hold up one hand to their heads in a gesture of mourning. Each is accompanied by a small group of mourners: the mother by a young man and two women, the father by two men. Three further female mourners in highly animated poses of grief stand behind the funerary couch.

While all the known examples of this type of sarcophagus are probably the products of the same workshop, so similar are they in composition and workmanship, nevertheless the heads and faces of the deceased children are quite individual and probably therefore constituted portraits of them.

The Tomb of the Varii in the Isola Sacra cemetery at Ostia is probably the best preserved of the house tombs built here by freedmen.[5] Identified by inscriptions as being the tomb of Varia Servanda, daughter of Publius, and of her two freed slaves Ampelus and Ennuchis who had the tomb built for her and for themselves. Taking the form of a tomb chamber within a walled enclosure, the interior of the chamber is lavishly decorated with wall paintings and probably originally portrait statues or busts as well.

On the back wall is located Servanda's epitaph set amid a representation of the story of Pyramus and Thisbe, the tragic lovers of myth. Their story was of a childhood love thwarted by their parents' mutual disapproval, despite the fact that they were quite literally the boy and girl next door to one another. Forbidden to meet, they communicated through a hole in the party wall between their parental homes, until the time came for them to meet at a nearby tomb and elope. Thisbe arrived at the meeting place first, her face hidden by a veil in case of discovery, but quickly fled from her hiding place when a lioness came on the scene to drink at an adjacent

spring after hunting. In her haste Thisbe dropped her veil, which was subsequently mauled at, picked up and chewed by the blood-covered beast. Seeing the lion's pawprint tracks and coming upon the discarded blood-stained veil, Pyramus jumped to the conclusion that Thisbe had been mauled to death and in his grief stabbed himself to death with his sword. Shortly afterwards Thisbe came back to the tomb, assuming the coast was now clear, only to come upon the dead body of her beloved. She too now took her own life, to join Pyramus in the realm of the dead. The bodies of the tragic lovers were eventually cremated together and placed in the same urn for burial, following the reconciliation of their two sets of parents.

Images depicting this particular myth do not necessarily seem altogether appropriate to the context in which they were used here, although it might raise the issue as to the nature of the relationships between Servanda, Ampelus and Ennuchis. Again, another painting inside the chamber depicts a scene from the Trojan Wars involving the forcible abduction and rape of Cassandra, the Trojan prophetess and daughter of Priam and Hecuba, by the Greek warrior Ajax. A similar scene of her being found by Ajax taking shelter in the Temple of Athena, her hands being prised away from the statue of the goddess onto which she is clinging, can be seen in a wall painting from the House of Menander in Pompeii. Although Ajax was later to be punished for this sacrilege and killed by the gods, Cassandra was not released and afterwards was given to Agamemnon as part of the spoils of war. She was to bear him two sons, but both Agamemnon and Cassandra were to be murdered by Agamemnon's wife Clytemnestra and her lover Aegisthus. Perhaps such scenes involving a woman who had suffered abduction and rape were metaphors once more for the actual death and carrying away of Varia Servanda or in some way she had empathised with some aspect of the biography of the fated Cassandra.

One of the most imposing, surviving, non-imperial Roman funerary monuments of Rome is the Tomb or Mausoleum of Caecilia Metella, located outside the city on the Via Appia near

its third milestone and probably dating to the last quarter of the first century BC (see image 37). The accompanying dedicatory inscription on the tower tomb reads, '*Caecilia Q(uinti) Cretici F(ilia) Metella Crassi*,' translated as, 'Caecilia Metella, daughter of Quintus Caecilius Metellus Creticus, wife of Crassus.' The sheer scale of this monument and its link with the influential Crassus family – her husband Marcus Licinius Crassus junior was the grandson of Marcus Licinius Crassus senior, one of the richest men in Rome at the time and who had served alongside Julius Caesar and Pompey in the First Triumvirate – would make it of great interest in any case; its dedication to an elite woman makes it doubly significant in the context of this present book. Some surviving elements of the decoration of the monument are of considerable interest, consisting of cattle skulls – *bucrania* – and garlands and military trophies, perhaps reflecting her links to such martial men as her father, a consul who enjoyed a triumph in 62 BC, her husband's famous father and her own husband, who himself sided with Octavian/Augustus and celebrated a triumph in 27 BC. However, although a sarcophagus has been found at the site, this is considerably later in date than the tomb and is unlikely therefore to be linked in any way to Caecilia Metalla. The same applies to the damaged female statues found nearby and now on display in the courtyard adjoining the tomb: these probably derived from other, lesser tombs nearby on the Via Appia. Thus, as in the cases of the powerful Cornelia and Melania discussed in Chapter 3, sadly we are left without a contemporary image of this influential woman to help us interpret and illustrate certain aspects of her life.

A Love That Dare Not Speak Its Name

Funerary group portraiture was popular and common in Rome and Northern Italy in the later first century BC into the early first century AD among freedmen, though it largely went out of fashion in subsequent periods. Group portraiture also became a phenomenon in parts of Gaul and in the Danube region. A number of such reliefs

from Rome and Italy are illustrated here. Many of these group images were reliefs in the form of a window or an *aedicula* – a small shrine – and the former are therefore often termed window reliefs today. They would have been set into the front of a funerary enclosure wall or into the wall of a tomb from where the deceased would then appear to be looking down onto a viewer from out of a window in the structure. When mature or older women were portrayed in freedmen funerary reliefs with husbands and children, the role of wife and mother was generally stressed for the benefit of the viewer (see images 38–43). In her study of group portraiture in funerary contexts in Rome of the late Republic and early empire, Diana Kleiner analysed a group of ninety-two freedmen/ freedwomen reliefs exhibiting anything from two to six figures, the most common types being a man and woman portrayed together (twenty-four examples); two men and a single woman (twenty-two examples); a man, woman and child (eight examples); and three men and a woman together (eight examples).⁶ Only fourteen of the reliefs depicted children in the company of adults.

Three of the ninety-two catalogued representations on reliefs from Rome were of two women portrayed together, these three being images of a mother and daughter and of *conliberti*, ex-slaves freed by the same patron. In each case, the women were depicted side by side, with there being no physical or eye contact between them. However, another funerary relief, probably also from Rome and now in the collection of the British Museum in London, bears an altogether different kind of image of two women together. The marble window funerary relief of Fonteia Eleusis and Fonteia Helena, both described in the accompanying inscription as being freedwomen of Gaia Fonteia, probably dates to the Augustan period, the late first century BC or the early first century AD (see image 44).⁷ The relief is very much in the style and form of freedmen reliefs in general. Yet it is the depiction of the two women together that marks this funerary monument out as unusual, in that they hold their right hands clasped together in the gesture of *dextrarum*

iunctio, which normally was used in Roman art to symbolise a married couple. The left hand of the woman on the right is held at chest height with the index finger and thumb extended as if pointing. The heads of both women are turned towards each other.

Had these two women been mother and daughter, as well as being *conliberti*, this would doubtless have been made explicit in the inscription. There could be a representation of some familial obligation here, but again this seems unlikely. Their names certainly suggest that they might have been associated through some religious affiliation, but this would not account for their explicit and overt physical linking through the grasping of hands.

According to one source, of the seventy-eight recorded examples of the *dextrarum iunctio* depicted in Roman funerary contexts, sixty-nine of these are depictions of a man and woman together, linked in marriage (see image 45). Seven examples are of same-sex couples or pairs.[8] There is the possibility that the gesture of *dextrarum iunctio* as used on the Fonteii relief could have been intended to represent a signifier of farewell between the deceased or conversely have been a sign of the reunion of two people who had been separated by death at different times. Danielle Baillargeon has suggested that the gesture here may have served 'a generalized iconographical function', yet all these explanations seem somehow unsatisfactory.[9] Was the reciprocity of the two women's affection a sign of friendship or desire, or indeed of both? Was the tactic of triangulating the viewer into the relationship a way of validating their gesture?

Later recutting of the relief, probably in Late Antiquity, has altered the image considerably. The head and face of the left-hand woman has been recarved to become that of a man, with the original veil or head covering cut away, but not enough to conceal its one-time presence. A veil may also have been cut away from the head of the other woman. The 'man' has now also been provided with a ring. The motive for recutting and in the process reconfiguring the relief and its meaning must remain unknown, but it does seem unlikely that this was done in a fit of outraged pique at the brazen

exhibitionism of the two women originally honoured in the carving, particularly as the inscription remained intact to identify both the original subjects as having been women. Other motives might have to be considered.

I am forcibly reminded here of the Roman poet Ovid's tale about Iphis and Ianthe as related in his *Metamorphoses*. Iphis came from Phaistos on Crete and was the daughter of Ligdus and his wife Telethusa. Unusually for such a story, all were of poor stock and were not well off. When Telethusa was pregnant with her daughter, she was threatened by Ligdus, who ominously told her that should the baby turn out to be a girl, and thus less useful to them economically, he would have no qualms about killing the child there and then. Telethusa's dilemma and fear were, however, somewhat assuaged when the goddess Isis came to her in her dreams and exhorted her to accept what would be, to embrace fate in other words. The child was duly delivered and before she was presented to her father Telethusa decided to hide from him the fact that the baby was indeed a girl. Ligdus cannot have been one of the great minds of the age as he was easily fooled by this lie. Emboldened by the success of this initial minor deceit, Telethusa carried on the subterfuge in more elaborate ways, naming the child Iphis, a common name at the time for both boys and girls, and bringing the child up as a boy, though technically still a girl. When Iphis reached her early teens, her father set up an arranged marriage to Ianthe, the most beautiful girl in Phaistos, still none the wiser as to his offspring's true sex. During their betrothal and chaperoned courtship, the two girls fell in love, Ianthe blissfully unaware that Iphis was also a girl and Iphis happy too but wracked with guilt at her deep passion for one of her own sex.

The years of successful deceit now seemed to be about to end and, having succeeded in temporarily postponing the marriage, Telethusa feared that the truth would now come out. In a blind panic, she once more sought the help of the goddess Isis, who answered her prayers by turning Iphis into a boy, thus allowing the marriage to take place

at last. Thus, this story of fate, deceit, gender-confusion, forbidden love and metamorphosis or transformation came to a close. If there are moral lessons to be learned from the tale it is perhaps that one cannot escape one's fate without divine intervention, that mortals cannot go against their nature, or conversely that you cannot choose who you love.

Thus it can be suggested that the Fonteia Eleusis and Fonteia Helena funerary relief could have been recut with transformative intent rather than malicious intent or for censure. Could a sympathetic person have overseen the recutting exercise in order to see one of the women metamorphosed into a man and thus a suitable partner in a legal Roman marriage, as the male Iphis had wed Ianthe?

We are unable to really distinguish whether an artwork like this was commemorating a homosocial relationship or a homoerotic or homosexual one. The workings of Roman society meant that women spent a great deal of time in the exclusive company of other women, but it was not a segregated society in most respects. Another Roman funerary monument from Gaul may also be of interest here. This tombstone or stele, from Horbourg-Wihr in Alsace and now in the Musée Unterlinden, Colmar, carries a depiction of two standing women (see image 46). One woman holds a spindle and ball of wool in one hand and grasps the hand of the second woman who stands beside her. While the clasped hands of the two women cannot necessarily be interpreted as a subversive form of the Roman marriage *dextrarum iunctio*, it is possible that again we are most likely seeing a lesbian couple being commemorated here. Three other double funerary representations of women from Lyon, Arles and Herculaneum are also illustrated here (see images 47–9). Whether these are individually examples of familial, homosocial or lesbian relationships remains uncertain.

An undated funerary relief from Capua in Southern Italy depicts three women, two of whom – the two outer figures – are linked in the *dextrarum iunctio* pose. All are posed frontally and look out towards the viewer. This relief was dedicated by a wife, Plania Philumina, to

her husband, Aulus Planius, and daughters Plania and Plania Prima, and the linked hands here quite evidently relate to familial love.

If it is accepted that one or both of the Fonteii and Horbourg-Wihr funerary images just discussed, and maybe some of the others also mentioned, did indeed represent the celebration and commemoration of a same-sex female relationship, then it is worth considering if other Roman visual or literary images could have less overtly alerted others to similar relationships. Certainly images of the female poet Sappho were relatively common, generally in the form of Roman copies of Greek or Hellenistic originals, including a particularly fine bust from Smyrna that is now in Istanbul Museum, but the ownership of such artworks scarcely counts as evidence of the owners' sexual orientation or preferences. The famous wall painting from Pompeii depicting a meditative young woman poised with pen in hand is sometimes today suggested to be a depiction of Sappho but there is no real basis for this identification. Other figures associated with Sappho, such as the Muses and Aphrodite/Venus, were also extremely common subjects in Roman art. But did the appearance of images such as these hint at some homoerotic subtext involving women gazing at images of women? Did these images reflect some kind of homosocial or homoerotic reality?

A Distant Shore
Discussion will now be turned to an examination of funerary images of women from Roman Britain, which should provide some kind of a snapshot of the broader picture in the provinces, though it is not suggested here that the situation in Britain was necessarily typical. In many respects, Roman Britain was indeed atypical. There is surprisingly little evidence recovered to date from Roman Britain to suggest that the commissioning of portrait sculpture and the setting up of dedicatory public inscriptions by named individuals was common, or rather as common as in many other provinces. The same applies to the commissioning and dedication of funerary monuments.

The primacy of group dedication of inscriptions celebrating

architectural projects in the province over individual dedication can be clearly demonstrated. Visual self-representation through commissioning of images and epigraphic dedication by an individual were undoubtedly linked phenomena. Though the origins of Roman portraiture can be traced back to the creation and use of wax *imagines* by the upper echelons of the Roman Republican elite to commemorate and venerate their ancestors, the conceptual link between the present and the past represented by the very medium of portrait art was probably lost by the time the consumption of portraits filtered down the social scale and interacted with other cultural traditions in the individual provinces of the empire. In those provinces there may have been other media, other items of material culture, through which connections with the ancestors could be made.

My own feeling is that the paucity or lack of portrait sculpture in Roman Britain has something to do with the fact that the concept of the portrait providing a link with ancestors and thus acting as an indicator of family status simply meant nothing to the elite of the province, the very people who would have had the financial resources to commission portraits had they so desired. Equally, the conceptual idea behind the portrait bust, that an image of part of the person can be taken to represent to the viewer an image of the whole person, appears to have been anathema to the Romano-British imagination.

In the volumes so far published in the *Roman Inscriptions of Britain* series and the *Corpus Signorum Imperii Romani* for Great Britain, only a relatively small number of funerary monuments of private individuals is represented, alongside a larger number of soldiers and military veterans and their family members. Nevertheless, these are important in helping to demonstrate the role that post-funerary display could have played in the formation of the post-mortem social self in Roman Britain.

Just over thirty of these Romano-British private funerary monuments bear representations of women (females over fourteen years of age). These are principally tombstones, but the group includes one sarcophagus; the majority come from either northern

England or London. The types of images break down as follows: a woman and man together, in all cases assumed to be husband and wife; a woman, husband and child/children together; a full length image of a woman on her own; a head or bust of a woman; a woman lying on a funerary couch; and a woman seated in a chair.

The three most striking individual tombstones of women from Roman Britain are those of Julia Velva from York (RIB 688), Curatia Dinysia from Chester (RIB 562) and Regina from South Shields (RIB 1065) in the northern military zone, the latter tombstone having already been discussed in detail in Chapter 1. The inscription on Julia Velva's third-century AD tombstone reads, '*D(is) M(anibus) Iulie Velue pientissi me uixit an(nos) L Aurel(ius) Mercurialis her(es) faci undum curauit uiuus sibi et suis fecit,*' translated as, 'To the spirits of the departed (and) of Julia Velva: she lived most dutifully 50 years. Aurelius Mercurialis, her heir, had this set up, and in his lifetime made this for himself and his family.' The carved scene on the tombstone depicts three individuals who must be assumed to be Julia Velva herself lying propped up on a banqueting couch with a drinking vessel in one hand, a bearded man holding a scroll who may be her husband and heir, a young girl seated in a wicker chair and holding a bird who may have been her daughter and a young male holding a jug and standing next to a table holding other vessels and who might be Julia Velva's servant.

The inscription on Curatia Dinysia's early third-century AD tombstone reads, '*D(is) M(anibus) Curatia Dinysia uix(it) an(nos) XXXX h(eres) f(aciendum) curauit,*' translated as, 'To the spirits of the departed, Curatia Dinysia lived 40 years: her heir had this erected.' On it she is depicted lounging on a high-backed banqueting couch, one hand holding a goblet or beaker while her other hand rests on a cushion. A small table stands on the floor in front of the couch. Above her are doves and garlands, and above those, in the spandrels above the niche containing the main image, are two tritons blowing conch shells.

The images of both Julia Velva and Curatia Dinysia, both mature

women at the time of their deaths, take a similar form and both women were represented as strong, self-reliant figures. In the case of Julia Velva it was obviously felt important to portray her as a mother, as well as an individual woman of high status and means. While the inscription on Regina's tombstone from South Shields discussed in Chapter 1 provided a more detailed and nuanced biography of her, in the case of Julia Velva and Curatia Dinysia it was the images on their tombstones that were intended to inform the viewer most about their individual identities.

Painted Faces

A complete contrast to the situation in Britain is provided by evidence from Roman Egypt where the continuation of the pre-Roman Pharaonic tradition of painting mummy portraits fused with the classical tradition led to the creation of a highly significant regional, provincial art form. Known collectively today as the Fayum Portraits, these are mainly images painted on wooden panels that were placed over the head area of a mummified, wrapped or shrouded body.[10] Such portraits have also been found painted directly onto linen shrouds, or were painted on plaster heads that were sometimes attached to coffin lids or other funereal items.

Men, women and children are all represented among the known corpus of Fayum portraits and there seems to have been no specific gender or age-related practices that require discussion here. Sometimes the context of a particular entombment allows us to suggest relationships of certain mummified individuals, either familial or through marriage. Where it has been possible to scientifically examine the mummified bodies in such burials, it has been found that the ages of the deceased usually correspond very closely in age to that of the individuals portrayed in the paintings. This suggests that the majority of these pictures were painted at or close to the time of death, and, as is suggested by contemporary written sources on papyrus, they were carried through the streets in procession with the dead body before its embalming and mummification.

The individuals buried with portraits according to this rite would have been members of the elite and upper echelons of Romano-Egyptian society, as is reflected in the fashionable and contemporary Romanised clothing, jewellery and hairstyles adopted by many of those depicted, such elements of the portraits helping to tie down their dating to some extent when other contextual evidence is absent (see image 50). One woman is accompanied by an inscription on her shroud which identifies her as '*Hermione grammatike*', a teacher of Greek grammar, a rare role for a woman to undertake.[11]

Motifs of Life and Death

It would appear that certain motifs that appeared on provincial Roman tombstones and stele had a specifically gendered meaning within this mortuary context and were linked not just to individual women but to the female gender as a whole. The potential iconographic significance of scenes of female grooming and the concomitant creation and maintenance of female identity has already been discussed in Chapter 3 in the context of the imagery on the Projecta Casket, and such imagery was also sometimes employed in the funerary domain. Examples include a funerary relief from Chester in Roman Britain on which is depicted a woman holding a comb and mirror, with a servant standing at her side holding a casket or box; reliefs from a mausoleum at Neumagen, Germany, which variously portray a man and woman clasping hands, with a child between them, a hunt scene, a man reading tablets, a funerary banquet and a woman in a chair being helped to dress and prepare by four female servants, one holding a mirror and another arranging her hair (see image 51); a relief from Bordeaux depicting a woman called Summinia holding a *mappa* in one hand and a powder puff in the other; the tombstone of Iulia Maximilla of Poitiers, Gaul, depicting the reflected image of a woman's face in a mirror; a funerary relief from Vanvey-sur-Ource, Lyon, Gaul, depicting a young girl holding a mirror and a coffer; and finally a tombstone from Mainz bearing motifs of a double mirror, comb and two perfume flagons.[12]

Again, another activity that was very specifically linked to women by employment of representative motifs in both domestic and funerary contexts, as well as on some public monuments, was spinning and wool working. In Chapter 1 reference was made to the tombstone of Regina from South Shields in Roman Britain. On it she was depicted holding a spindle and distaff with her left hand, with a basket of wool at her feet. With her other hand she opens a coffer on the floor to her right. Other British examples include a relief from Carlisle depicting a woman with a spindle and distaff in her left hand and a bird in her right and one from Chester depicting a soldier and his wife who holds a distaff and a weaver's comb. From Beaune in Gaul comes a stele with a portrait bust of a woman holding a spindle and the tombstone of Censorina who is depicted holding a spindle in her right hand and a distaff in her left. Further afield still, from Dorylaion in Phrygia comes a tombstone of a married couple, the man holding scrolls and tablets, the woman being pictured with a mirror, wool basket, spindle and distaff.[13] Numerous other examples occur across the Roman world.

However, the depiction of women holding or accompanied by spinning implements on funerary reliefs from Roman Pannonia represents a genuine sociocultural phenomenon, with fifteen examples having been recorded to date, all dating to the period from the second half of the first century AD into the second century.[14] It is worth noting that in adult female burials in the area, spindles, spindle whorls and short hand-distaffs were common grave goods.[15] A few examples from Pannonia will now be considered.

Perhaps the best known is the grave stele or tombstone of eighty-year-old Flavia Usaiu from Gorsium in modern Hungary, a memorial to a Romanised Eraviscan woman dating to around AD 130 and dedicated to her by her son Quintus Flavius Titucus (see image 52). Today it is on display at the Tác-Gorsium Archaeological Park. Not only does Flavia herself appear on the upper part of the gravestone, but below her is depicted a covered waggon pulled by oxen, perhaps symbolising her journey to the next world, with a formal inscription

beneath that identifies her ethnicity. Flavia is depicted full-face on to the viewer, only her head and upper body being shown. Her portrait suggests a strong, proud woman who appears here with her modestly covered hair under a headdress and scarf and bedecked with jewellery, including a thick necklace or torc. In one hand she holds a loaded distaff and in the other a spindle.

Also illustrated here is the tombstone of the freedwoman Valeria Severa from Aquincum, in present-day Hungary (see image 53). Dating from the early second century AD, this tall stele consists of three separate registers, two upper 'windows' with images of the deceased and her family or heirs and a lower window with a formal inscription. Although her head is damaged, Valeria Severa can clearly be seen holding wool-working tools. Although Flavia Usaiu and Valeria Severa have very different biographies, as can be gauged from the inscriptions on their monuments and the way in which it has been chosen to present their images, the motif of the distaff and spindle was a common element of gendered definition in both cases.

The gravestone depictions from Pannonia fall into two groups: the first group is represented by just three examples and consists of images of freedwomen with Latin names and wearing Roman attire, as with Valeria Severa.[16] One stone in this group, from Walbersdorf and now in the museum at Soprom, is a joint memorial to Petronius Rufus and Julia Urbana, master and freedwoman and now obviously a married couple, hands clasped in the *dextrarum iunctio* pose, are depicted as half-figures holding something in each of their free hands. He perhaps holds a scroll and she holds a distaff, suggesting in this context that she has become a respectable Romanised wife. The second group of twelve gravestones carries images of women in less-Romanised attire and inscriptions which locate them by their names as being of local Celtic stock, as indeed Flavia Usaiu was by being described as Eravisca. A study of the inscriptions and images on this second group of gravestones shows that these women were in formal relationships that equated to marriage and that indeed this state was emphasised by their holding of spindles and/or distaffs.

Thus both fully Romanised incomers and indigenous women used the same iconographic code to inform the viewer of their social status while also tapping into both a local tradition of associating women's craftwork with achieving their sexual majority, of becoming a woman, and the Italian/Roman tradition of using textile craft as a metaphor for female moral behaviour.

These links were further made by the fact that some of the so-called bone or ivory finger distaffs from Pannonian burial contexts were themselves decorated with small, carved, naked or partially naked female figures, either alone or with a child, some of whom may bear birthing scars, thus further linking women, spinning and fertility in terms of both the function of the object, its decoration, its potential symbolic value and its context in a burial.

While most imperial women would have had a portrait created to mark each of the various rites of passage in their lives, such as marriage, the birth of a child or of children, the award of the title Augusta and in some cases deification, as has been discussed in a previous chapter, most non-imperial Roman and Romanised women if they had a portrait made of themselves would generally only have had it made once, in association with their funerary commemoration. Some other elite women might, of course, have had honorific statues of themselves set up, as well as a funerary portrait. It should have become apparent from this chapter that there were numerous ways in which images of women were created for funerary contexts and many different contexts in which the images could be deployed. We finished the discussion of funerary images by considering how some very specific motifs linked both to the reality of some women's lives and to metaphors for other lives recurred across a wide geographical swathe of the Roman world. Among these were motifs linked to women's craft work, specifically wool working. However, in the next chapter we will be looking at representations of professional working women, and at how their appearance in Roman artworks throws further light on the complexity of the creation and use of the female image in ancient art.

5

THE DIGNITY OF LABOUR

While in the previous three chapters discussion has mainly focused first on images of imperial women, then elite women in Rome and the provinces and finally on images of women in funerary contexts, attention will now be turned to women lower down the social hierarchy – working women who appear to have used representations of their jobs to help define their public identity or whose images were used to present an altogether different view of non-elite Roman women's lives than those of their social superiors and contemporaries.

Before discussing this further category of representation of mortal women, it needs to be noted that the fact that I have discussed images of imperial, elite, provincial and freedwomen first does not necessarily privilege these images in importance in this study. Rather, it is important to consider how interrelated these four categories of status-based representations were and how common motives, common symbolic content and common tropes can often be found underpinning the presentation and meaning of each category.

Working Women of Ostia

There is an extraordinary group of images of Roman working women, most famously from the Roman port at Ostia, which

formed the subject of a groundbreaking and thought-provoking feminist art historical study by Natalie Kampen in the early 1980s.[1] To the Ostia examples can be added significant other such representations from the city of Rome itself, from Pompeii and from some of the provinces, most notably Gaul and Germany. However, it must be stressed here that even when added together the number of images of working women from the Roman world is minute compared to the number of images of working men.

Indeed, if one examines the surviving three-quarters of the busy, decorated frieze on the extraordinary and unique mid- to late first-century BC funerary monument known as the Tomb of Eurysaces the Baker, which stands on the Via Labicana just outside the later Porta Maggiore in Rome, not one woman is evident among the forty-five or so bakery workers and officials or overseers depicted there. Named in an inscription on the tomb as Marcus Vergilius Eurysaces, it is likely, though, that statues of Eurysaces and his wife, perhaps the Atistia named in a stray inscription found nearby, once adorned the facade of the tomb. Whether these are the statues found near the tomb in 1838 and now in the Museo Palazzo dei Conservatori in Rome is perhaps uncertain. Eurysaces then, it would appear, wished to be seen by viewers of his tomb as both a rich and successful professional man, with no qualms about splashing his cash on a bizarre and ostentatious funerary memorial, and a conservative, doting Roman husband. The question as to whether he was a freeborn Roman or a freedman does not alter this duality in the presentation of his legacy and memory.

At Ostia, Natalie Kampen identified six examples of the representation of working women, according to her definition, all dating to the second and third centuries AD. The creation of these images placed the representation of these women in the public domain, even though some of the funerary items on which some of the images appeared might be more technically thought of as private art. These Ostia representations consisted of nurses or childcarers, a midwife, a waitress or barkeeper, a poultry seller, a vegetable seller

and a cobbler or shoemaker. It must be noted here that there are, of course, many representations of working men at Ostia too, and indeed most of these apparently date to roughly the same period, when the port was both prosperous and expanding. Its teeming workforce evidently shared to some extent in this prosperity and in celebrating the status that their jobs gave them within the overall enterprise.

The nurses or childcarers appeared as part of the decoration on a now-damaged biographical sarcophagus from Via Ostiense, known as the Curriculum Vitae sarcophagus. The image, to the right of the central scene on the sarcophagus front, is partial, but it can clearly be seen that three women are engaged in caring for a number of infant children. One woman holds what appears to be a swaddled baby and looks on while the other two bathe a second child. A large bowl of water sits on the floor, and one woman is caught in the act of lifting a baby out of the bath and into the soft embrace of a towel being held ready by her companion who will now dry the child. This scene needs to be considered in the context of the overall decorative programme of the sarcophagus, as far as it can be surmised, comprising the care of an infant, the teaching of the child and then the parents either attending the coming-of-age oration of their child or mourning the deceased youth. Biographical scenes such as these on sarcophagi, including the nursing of children, are so well recorded as to suggest that they were standard tropes rather than specific manifestations of any kind of reality. These images of nurses and carers represented the cadre of such working women and not specific women as such. Although the person of the nurse was largely incidental on such sarcophagi, her presence was nevertheless a key component of the decorative programme's encrypted narrative.

The midwife appeared on one of two pendant terracotta reliefs set into the facade of tomb 100, the tomb of Scribonia Attice, on Isola Sacra, the cemetery or necropolis area just outside of Ostia. The birthing scene is simply composed and uncluttered with detail

but is nonetheless powerful. A naked woman with enlarged belly sits in a chair, supported from behind by another woman. A third female, the midwife, sits on a low stool in front of the mother in labour and reaches up between the open legs of the expectant mother as if caught at the moment of delivering the baby. On the pendant plaque, a doctor treats the leg of a patient. It can be assumed from the decoration on the tomb and the dedicatory inscription – stating that it was built by Scribonia Attice for herself, her husband M. Ulpius Amerimnus, her mother Scribonia Callityche, Diocles and her freedmen and their descendants (with the exception of Panaratus and Prosdocia) – that the couple were respectively a midwife and doctor-surgeon. It is interesting that their professional identities were not brought to the viewer's attention in the inscription but rather through the more active representation of their roles via the terracotta images.

The image of the waitress or barkeeper serving a drink appeared on the front of a sarcophagus, again from the Isola Sacra necropolis. To some extent, this was subsidiary to the main scene on the sarcophagus panel, which is taken up with the depiction of a ship and rowing boat coming into a harbour, presumably at the port of Ostia itself, with a landmark pharos or lighthouse guiding their way. Moving to the right across the panel, the decoration segues into a scene inside a tavern, again presumably at the port. Behind the tavern counter, decorated with a dolphin carving it seems, can be seen a well-stocked bar of jars, jugs and wine amphorae. A woman walks across the tavern to a table where two men are seated. She is carrying a glass or beaker of beer or wine and proffers it to one of the men who holds out his hand ready to take it. The second man has already been served his drink and is in the process of downing it. A small dog reaches up towards the table, flexing his front paws ready to scratch the woodwork.

While the scenes depicted here can be taken at face value as representing contemporary genre scenes quite specific to the geographical location, at the same time they include motifs and

symbols quite commonly linked to funerary contexts. These include journeys across water, travelling or voyaging in general, dolphins, dogs and funerary drinking scenes. It is as if a very local set of themes has been applied to a more universal concept. For whom the sarcophagus was made remains unknown.

The fourth instance of the portrayal of a working woman from Ostia to be discussed here is that of the female poultry seller who appeared on what is known as the Via della Foce relief, a vibrant and busy scene of shop or market trading found at the entrance to a building on that street in the ancient port town (see image 54). It was possibly a shop sign of some kind. A woman and a man stand behind a stall or counter, with the woman placed in the foreground and the man partially hidden behind her, thus emphasising the relative importance of the two traders. To one side of the counter is a rack or gibbet on which are hung some chickens or other poultry birds. In front of the woman are two large, shallow baskets containing either bread or fruit and vegetables, or indeed both. A tall, cylindrical wicker container with clearly delineated air holes cut through it would appear to contain live snails, as shown by the fact that the artist has depicted one snail making its escape from the basket, though this rather large snail may simply be a rebus or ideogram. At the far end of the stall sit two monkeys.

Trade at the stall or shop seems very brisk, with one male customer being caught in the act of being served by the female vendor, who holds a piece of fruit in her hand, while two other men stand to one side of him, deep in animated conversation, one of these men holding a chicken in one hand that he has already purchased. Finally, in the bottom left of the panel can be seen the heads and tell-tale raised ears of two live hares or rabbits poking their heads out through the bars of a wooden crate in which they are housed, ready for sale.

The relief depicting the vegetable seller, known today as the Episcopo relief, is sadly without specific provenance, though it can probably be assumed to have come from a funerary monument of

some kind (see image 55). The depicted scene is less busy than the scene of poultry selling. Nonetheless, it has a vibrancy that would have appealed greatly to the Roman viewer. There is only one figure on the relief, the vegetable seller herself, depicted in the very centre of the scene, face-on to the viewer, as if the viewer were indeed a customer at the stall. She stands with her left hand resting on the stall in a proprietary gesture and her right hand held up in a gesture as if speaking directly to the viewer. Vegetables are laid out on a trestle-table, with a basket beneath it. More produce is stacked on shelves or racks behind, both to the left and right.

Finally, the partial relief depicting the cobbler or shoemaker is particularly exciting a find in that the fragment of the funerary relief that has come down to us includes part of a long inscription which names the woman portrayed as Septimia Stratonice, a *sutrix* or shoemaker (see image 56). Septimia appears to one side of the central inscribed panel, depicted sideways-on to the viewer. She sits in a low-backed chair and in her right hand holds up what appears to be a cobbler's last or a wooden shoe form. Her name indicates that she was a freed slave, perhaps the slave of Marcus Acilius who refers to her as his *carissima amica* – dearest friend – on her epitaph inscription and who, it also tells us, had given her a share in his son's burial tomb.

Although there are only six known working-women relief images from Ostia, Natalie Kampen was able to divide these images up into two specific categories, with additional reference to the data also provided by the representations of working men from the same town. She identified these two groups as being 'literal scenes' and 'subordinate scenes'.[2] Literal scenes were just that: scenes in which workers were portrayed doing a specific job in a correct and natural context. In such scenes there was usually a plethora of incidental detail and acute observation; 'These localize each image enough to make it recognizable to the indigenous population'.[3] The workers indeed would have been able to see themselves in these images and to see their town and their workplaces. However, they were presented as real but not as specific individuals in portrait form in

any sense. It may have been though that the viewer, whether the subject herself or not, identified with the role portrayed much more than they would have done with a portrait of an individual. As for the so-called subordinate scenes, they stressed 'something other than work, although [they] may represent work'.[4] In other words, they were more complex and sometimes almost metaphorical in intent and reading.

They Also Serve

Other women workers can be found represented on artworks in Rome itself and more widely in Italy, as well as in some of the provinces, particularly Gaul and Germany. The relatively limited number of recorded images probably seriously fails to reflect and underestimates the true figure of numbers of working women in the Roman world, even excluding slaves. Working women were also, of course, represented and commemorated by inscriptions which help to some extent to flesh out our knowledge of the multiplicity of professional roles that women played. For example, there are epigraphic references to wet nurses (*netrices*), a silk worker (*sericaria*), a spinner (*quasillaria*), a dyer of purple (*purpuraria*), a seamstress (*sarcinatrix*), a jeweller (*gemmaria*), a pearl setter (*margaritaria*), a lead worker (*plumbaria*), a gilder (*brattiaria*) and so on.

From Rome come three shop scenes depicted on reliefs, which, like those from Ostia, could either have been shop signs or might have been derived from funerary monuments. The first of these shop reliefs is now in the Museo Torlonia in Rome and depicts two female game butchers, though the classical appearance of the women almost makes them appear like deities rather than mortal working women. The relief is divided into two zones by a pillar: on the left-hand side of the relief hang six carcasses of dead birds and animals, including two suckling pigs, a hare and two geese; on the right-hand side are the two young women, one standing and pointing to an inscription on the back wall of the shop and the other seated on a low-backed chair and plucking a bird hanging

from the ceiling over a small table. The inscription is a four-line quotation from the *Aeneid*, whose reference to remembrance of an individual and the everlasting memory of him or her suggests a funerary purpose for the relief, if indeed it is a genuine Roman piece and not an eighteenth-century pastiche piece in the Roman style as some authorities have suggested.[5] Again, if genuine, the disparity between the appearance of the women and their dirty task might be explained if they were figures preparing a funerary feast rather than employees in a butcher's shop.

The second shop relief from Trastevere in Rome probably dates to the first half of the second century AD and is now in the Staatlichen Skulpturensammlung in Dresden, Germany, and again is a relief depicting the inside of a butcher's shop. In this case we see the bearded male butcher at work chopping a joint of meat on his block with a large cleaver. A set of scales hangs from a frame, along with a second cleaver. A range of cut joints of meat and a pig's head hang on hooks from the frame. A basket for offcuts sits on the shop floor to one side of the chopping block. On the far right-hand side of the scene sits a woman with an elaborately braided hairstyle in a high-backed chair. She is writing on tablets resting in her lap and may therefore be identified as a bookkeeper, though some authorities have suggested that she may simply be a customer with a shopping list, which seems less likely an interpretation.

The third shop scene is probably the best known of the three being discussed here. Dating to the mid-first century AD, this relief, originally from Rome but now in the Uffizi Gallery in Florence, shows the interior of a shop selling cushions and other textiles and materials. A woman and man sit together on a bench, while a male figure, perhaps the shop owner, stands by as two of his assistants hold up a bolt of cloth for the delectation and approval of the shopping couple. Another male assistant stands to one side of the seated couple and a young woman can just be seen standing behind them. She could either be the couple's own servant or she could be a member of the shop's staff.

A fourth marble relief from Rome, and now in the Virginia Museum of Fine Arts, Richmond, Virginia, is a first- or second-century AD funerary piece and appears to show a potter seated on a stool in his workshop applying slip with a brush to the outside of a pot in his hand. A table with other pots on it stands in front of him. Seated in a high-backed chair on the other side of the table from him is a woman holding up a fan in her left hand and an object in her right, which might be a small loaf of bread. It may be that the woman is the wife of the potter and not an active participant in the business.

In Chapter 3 we saw how the influential fullers' guild at Pompeii had honoured their supporter Eumachia after she had sponsored the building of a new headquarters for them near the town forum. Perhaps it is not then too surprising to learn that from Pompeii come two sets of painted images showing women working alongside men in a fuller's workshop – a *fullonica*. The first set of depictions comes from the *fullonica* building in Insula VI and includes a depiction of a female worker possibly cleaning a wool-working tool, perhaps a wool comb, in her lap, while another shows a female overseer sitting on a stool and inspecting a piece of cloth being held up for her by another woman worker, possibly a slave.

The second set of painted images adorned the entrance into the shop of the cloth manufacturer and seller Marcus Vecilius Verecundus on Via dell'Abbondanza in Insula IX in Pompeii and consisted of scenes of gods and goddesses, including a residing Venus of Pompeii and Mercury, and scenes of manufacturing and commercial activity, including a depiction of Verecundus himself with workers in his dye shop. The lower scene on the left of the shop door is of a seated, well-dressed woman inside a shop, who is probably the wife of Verecundus, selling bolts of cloth and perhaps felt slippers to a male customer sitting waiting on a bench while his purchases are dealt with on a large high table in front of the woman.

Of course, from Pompeii there are a also number of infamous representations of women working in buildings and houses that

are thought to have been brothels, which would in that case make such women prostitutes. However, as John Clarke has pointed out, it simply cannot be the case that all of the buildings identified by various commentators as brothels in Pompeii were actual bordellos.[6] Some of these erotic images do come from the few buildings that Clarke suggests can confidently be identified as brothels, but even then the women depicted in wall paintings in those buildings do not necessarily have to have been images of real women or of prostitutes. In other words, they could simply be idealised women or fantasy figures and for that reason are not being further discussed here.

From Gaul and Germany there comes a small but growing number of images of women engaged in some form of work, including both agricultural labouring and other, more specialised jobs.[7] Agricultural work is represented on a well-known mosaic from Saint-Romaine-en-Gal that includes a depiction of a woman milling grain along with other rural activities; on a relief from Mainz, which depicts a man winnowing wheat while a woman carries a basket on her shoulders; on a relief from Chauviré, on which can be seen a woman holding a bunch of grapes and a purse; and on a relief from near Trier in Gallia Belgica, which includes an image of a woman carrying a basket filled with grapes, the latter three reliefs all being from funerary contexts. From Narbonne comes a tombstone carrying an image of a blacksmith hammering metal while a woman operates the bellows at the forge.

A female doctor is commemorated on a second- or third-century AD funerary relief from Metz, now in the Musée de la Cour d'Or there (see image 57). Named as a *medicus* in the otherwise badly damaged inscription on the tombstone, she appears as a standing, heavily cloaked figure holding a small box in her right hand which presumably contains her surgical instruments. Were it not for the surviving part of the inscription we would have been unable to identify her profession from the image alone.

Depictions of more specialised jobs undertaken by women include

that on the so-called stele of a *meditrina* or pharmacist from near the amphitheatre at Grand and now in the Musée Départemental des Vosges in Épinal, which carries the depiction of a scene inside what could be a pharmacy, or which could equally be a glassworks or a workshop of some other kind, filled with equipment and various vessels and containers. Two women are depicted: the main female subject sits on a stool holding writing tablets in one hand and a *patera* in the other containing some liquid that she may be heating up; the second woman is more incidental to the scene and can be seen stirring a large pot or cauldron. The stele probably dates to the mid-second century AD.

Two funerary reliefs from Soulosse, Vosges, France, and in the Musée Soulosse-sous-Saint-Élophe, are also of particular interest here, in that one depicts a female itinerant merchant with a hand-rule indicating merchandise in a cart and the other a woman and man together on either side of a shop counter. The woman holds a purse and coffer while the man holds a balance. Other depictions of women holding balances, probably used for the weighing out of goods for sale, appear on funerary reliefs from Saintes, Poitou Charentes and Bordeaux, the woman on the latter, Severan tombstone also holding a mirror with her other hand. A man and woman selling fruit and vegetables off a trestle table appear among a number of scenes of rural production and trading on a second-century AD funerary monument from Arlon and now in the Musée Luxembourgeois.

Not included in this discussion are the many depictions of women with weaving or wool-working equipment from the Roman world, as many or most of these are likely to have been individual crafters rather than textile-making professionals. The significance of weaving as a female-related craft and as a metaphor for stability and order has already been mentioned in Chapter 2 in relation both to the association of craft with feminine virtue and, in the Augustan period, to moral probity, and is also discussed in Chapter 6. We have again seen that the woman and weaving link also had a similar, though slightly different, cultural resonance in certain provinces

of the empire, such as Pannonia. Some depictions of larger-scale wool-working or textile production, as on a sarcophagus from Salona in Croatia or on the frieze in the Forum Transitorium in Rome, were both again probably intended to be metaphorical rather than literal.

All the World's a Stage

Stretching the definition of a working woman to include an actress and a female gladiator will allow us to explore here two incredibly interesting images of named individual women, one from Aquiliea in Northern Italy and the other from Halicarnassus in Asia Minor/ Turkey, both of which illustrate how sometimes unusual occupations and lifestyles, unrestricted by general social conventions and mores, could be chosen by some women in the Roman world.

From the amphitheatre at Aquileia, in north-eastern Italy, comes a tombstone of a woman whose remarkable story is laid bare both by her smiling image and by the lengthy accompanying Greek inscription (see image 59). The tombstone dates from the third century AD and is dedicated by Herakleides, a fellow 'good speaker and character mime', to his great friend, the actress, dancer and mime, Bassilla. The inscription lauds her for her 'resounding fame on the stage' gained 'among many peoples and many cities' and suggests that she was in fact 'the tenth Muse', 'thus not dead'. Though now a corpse 'she has won life as her fair reward' and a resting place 'in a place sacred to the Muses'. The already touching greetings in her epitaph are further added to at the very end of the inscription, 'Your fellow performers say to you "Take heart Bassilla, nobody is immortal".'

Another example of what might be termed a working woman in the entertainment field is provided by a marble relief from Halicarnassus, Bodrum, Turkey, and now in the British Museum, London, one of the few items of material culture that has come down to us to confirm the existence of the female gladiator – the *gladiatrix* – though there are numerous historical references to the existence of these female fighters (see image 58).[8] The relief depicts

two fighting female gladiators, each armed with a sword and shield and clad in standard gladiatorial costume, the female sex of the two protagonists being made clear both by the depiction of their bared breasts and by the accompanying inscribed labels that tell us that one of these fighters bore the arena name of Amazon and the other was known popularly as Achillia. The phrase *missae sunt* on the stone suggests that the two women, once slaves, were now being honourably released from their gladiatorial duties.

All kinds of layers of meaning can be read into both the Halicarnassus image on its own and the image interpreted anew in the light of the fighters' given stage names. Female gladiatorial combat might have been expected to appeal to both those Romans for whom the games were culturally embedded in their psyches and of course to the male gaze in particular. While the fact that one of the Halicarnassus female gladiators fought under the name Amazon does not seem in the least bit surprising, the name of her opponent most certainly is. That they must presumably have been acting out the mythological combat between Penthesilea, the Amazon queen, and the Greek hero Achilles is again inspired but perhaps relatively unsurprising. The feminising of the name of Achilles to produce her *nom de guerre* Achillia introduces an element of gender confusion, even gender role reversal, into the drama. Perhaps some frisson of sexual excitement was provided for the benefit of male viewers of their combat by the very fact that both combatants were women.

Valid Lives

Even though the creation of images of working women as discussed above constitutes a genuine phenomenon in Roman art, or rather two phenomena in the form of Roman and Roman Italian images and Romanised provincial images, nevertheless the number of such images that has come down to us is still relatively small. As a group, they are perhaps an exception to the rule that women remained relatively invisible in Roman or Romanised society even if cumulatively the roles they played made a significant contribution to the overall

contemporary economy. Some of these women, of course, might have been slaves or freed slaves, and therefore their representation in active rather than passive or submissive roles had a further nuance.

If we are going to compare these images of working women to any other group of Roman images, it would not only be to the significant corpus of images of working men but also to images of soldiers and veterans who, in many respects, were also working men of some kind. While soldiers and veteran soldiers appeared in a great deal of imperial art and on most of the major monuments of Rome and the provinces, it is their own private funerary memorials and tombstones which are of interest here. The erection of such monuments, often paid for during service through a military burial club, allowed individual men or their colleagues, family or heirs to celebrate both that service in the cause of Rome and in many cases their ethnic origins. It was a way of stating, staging and promoting their identity and individuality, as well as their pride in their job. A similar process might be thought to be behind the creation of many of the images of Roman working women discussed above, which would suggest some active role for these women in the creation and presentation of their own images.

It is indeed true to say that with the exception of the images of working women discussed in this chapter, the majority of images of Roman or Romanised women that form the core subject of this book are of passive individuals. This female passivity may have reflected roles thrust upon such women by the men in Roman society, or at least those men who acted as patrons of the artists who produced these images for them. Elite women as subordinate or inactive image types, as women of leisure, were simply representative of a social group whose very status was expressed through female passivity subsidised usually by male wealth, though of course there were exceptions to this gendered rule. The exercise of social, political or cultural power did not require such women to be seen to break a sweat.

Thus, in conclusion, it can be suggested that the relative paucity

of images of working women in the Roman world can be accounted for by the fact that such images would have been expensive for such women or their families to commission and that the subject of women at work, while a daily reality, was not thought to be a suitable one for general illustration. Natalie Boymel Kampen believed that the elite Romans were somehow well aware of the reality of these women's existence and labour but otherwise were in denial about this, in the same way that they were probably in denial about the reality of slavery. Slaves were also evidently not thought to be particularly appropriate people to appear as images in artworks. Yet those few non-elite women who commissioned representations of themselves or of their trade in an idealised form were quite the opposite of being in denial; rather, their social reality was accepted by them, deemed acceptable by many of their non-elite contemporaries and was something in which they felt pride rather than shame. The art was an expression of their pleasure in their labour. They recognised their own story in these images. If, in Roman society, status were the achievement or privilege of those who manipulated wealth rather than generated it, then identity was an altogether more fluid concept.

If we are to assume that the working women portrayed in most of the works discussed above had some hand in their commissioning and in final approval of their depiction, it does not necessarily follow that every viewer would take away from their viewing experience the intended message of the work. A particular identified strain of erotic voyeurism, a genuine fetishism known as mysophilia, may have been implicit in some male viewings of images of working women. We only have to look at the extraordinary life of the Victorian barrister and poet Arthur Munby, who pursued a lifelong interest in observing, photographing and befriending working women in hard, physical jobs, a pursuit which was both overt, and therefore deemed to be harmless by his contemporaries, and covert, in that few were aware at the time of the obsessive nature and personal sexual connotations of his mysophiliac hobby.[9] Indeed, Munby's hard-working maid Hannah Cullwick was in actual fact later

revealed to have been his wife, though they lived to all intents and purposes the life of master and servant, in a slightly grotesque form of public and private role playing. To return to the Roman images of working women, while this might appear to be an argument for a particularly curious instance of the male gaze being turned upon a specialised genre of imagery, it is one that has not been considered previously in studies such as Boymel Kampen's.

We might be seeing a difference of emphasis being placed on professional work and craft as leisure, on working women from the non-elite classes and elite women, either Roman, Italian or provincial. The question needs to be asked if the viewing of any of this art could have changed perceptions or have been opinion forming. Roman art was, of course, a social phenomenon whose regulators were not necessarily always in control of it. If art was some kind of auditor of Roman institutions, then efficient and responsive systems might have encouraged a culture of innovations where content overwhelmed form.

The sheer visual complexity of these artworks is impressive: they were framing and presenting not just an image but a life. They are documentary evidence of myths about the complexity and variety of female roles in the process of formation. Each is so specific and yet so generic that they take the viewer up short. They bring to mind Roland Barthes' idea or concept of the *punctum* – the accidental or telling detail that draws in the viewer's eye and almost evokes a physical response from him or her, as elucidated in his short but exquisite 1980 study of photography, *Camera Lucida: Reflections on Photography*. And surely this is what they were intended to do.

In the last four chapters, discussion has been concentrated on images of mortal women from all levels of Roman and provincial society. However, there is another, larger group of images of women that differs significantly from those already discussed in that these are images not of mortals, but of goddesses of one kind or another, personifications and mythological women. These will form the main topic of discussion in the next chapter.

6

PERFORMANCE

Up to now, discussion in this book has focused on images of mortal women, of empresses and other female members of the imperial family, on elite women in Rome and the provinces and on working women. In this chapter, though, attention will be turned to the portrayal of immortal women, in the form of goddesses, mythological women and female personifications, and to how images of such 'unreal' women nevertheless could have impacted on the lives of 'real' women and on perceptions of their lives. The artistic and philosophical concept of women being closer to nature and somehow more primal than men will also be explored.

A World of Goddesses

Pagan Roman culture and society functioned to some extent on its need for the constant referencing of its deep past of myth and ritual, and of a shared Greco-Roman cultural heritage. Interactions between the world of mortals in Rome and the lives of the gods mediated through religious rites helped maintain social cohesion and, later, underpin Roman imperial power. Living with myths must have been a reality to some extent. In the case of the city of Rome, this deep past also included its own complex foundation myths and was peopled with figures such as Aeneas, Rhea Silvia, Romulus

and Remus, the shepherd Faustulus and his wife Acca Larentia, the Sabine women and Tarpeia. Myths therefore could sometimes mirror, strengthen and, on some occasions, even subvert societal norms, including gender ideologies, and therefore their reading is often reliant on context. Unfortunately, in the case of many Roman works of art, information about their original context of discovery and acquisition is simply not available.

The various female deities most commonly depicted in Roman art were those with whom Roman or Romanised women could most closely associate and identify, and the use of their images might therefore sometimes have carried no more significance and meaning than that. Sometimes mortal women chose or were chosen to take on the identity of particular goddesses in certain images, in which cases the significance of this hyper-identification and merging of identities requires explanation of some kind. Sometimes images of certain goddesses were used in contexts where their appearance was part of a metaphorical narrative, often created by men. All of these types of portrayals of goddesses will be considered here, particularly with regard to Juno, Minerva, Venus and Ceres.

The contexts in which images of mortal women in the Roman world appeared were restricted in various ways and the form and carrying media for these images were likewise often limited. However, this was certainly not true in the case of images of pagan gods and goddesses which appeared in temples, shrines and at other types of religious sites, in public buildings and spaces, in gardens, in shrines inside private homes and commercial premises, in military installations, in everyday contexts and, of course, in funerary contexts. They appeared in the form of cult statues and other forms of statuary in gold, silver, bronze, marble and stone, statuettes, images on major civic and imperial monuments, on reliefs, on altars and all kinds of religious equipment and paraphernalia, on the reverses of some coin issues, on intaglios in finger rings, on cameos and cut gemstones, on other items of jewellery including hairpins, on plaques, in wall paintings, on mosaics, on tile antefixes,

on boxes, caskets and other items of furniture, on gold and silver vessels, on copper or bronze vessels, on miscellaneous metal items, on glassware, on household pots and many other kinds of everyday items. In other words, there must be hundreds of thousands of items surviving from the Roman world which bear images of their gods and goddesses.

As with many aspects of Roman society, religious affiliation could often be a signifier of status and class identity. The Capitoline cult of the triad of Jupiter, Juno and Minerva was very much a patrician cult, and later also linked to imperial ideology and concerns, as was the cult of the Magna Mater or Cybele, though that had a much lesser link with the imperial system. At some periods, this very much operated in opposition to the plebeian cult of the triad of Ceres, Liber and Libera.

Juno, equivalent to the Greek Hera, was the wife of Jupiter and thus was the most senior of the Roman goddesses. She was the mother of Mars and goddess of marriage and childbirth. As one of her most common epithets Pronuba suggests – literally, 'she who prepares the bride' – she was thought to be present at this most significant rite of passage for Roman women and was often portrayed as such in Roman art. Minerva, equivalent to the Greek Athena, was both a goddess of war and of crafts. Numerous temples to these two goddesses are known to have existed across the Roman world.

Outside of the two female members of the Capitoline Triad, perhaps the most potent female goddess in terms of the way in which mortal Roman or Romanised women could identify with her was Venus, the Roman goddess of love and female beauty, the Roman equivalent of the Greek Aphrodite, and consort of Mars, the god of war (see image 60). As well as worshipping the goddess in temples and homes, some women at Rome demonstrated a particular and highly personalised identification with Venus, as has already been discussed in relation to examples such as the matron in the guise of Venus on the Tomb of the Haterii and those more mature matrons who had themselves recreated as the goddess in full-length statuary

or on funerary monuments with their own portraits heads placed on lithe, youthful, desirable bodies. In all such cases these would appear to have been as much statements about female sexuality as they were about gender identification.

It is of great interest here to also note that a popular Antonine statuary theme was to depict mortal married couples as Mars and Venus, with the figure of Venus/wife sometimes modelled on the Aphrodite of Capua statue type in order 'to praise the wife's beauty, desirability, and love for her husband'. One of the best examples of this type comes from the Isola Sacra cemetery at Ostia and is now in the Musei Capitolini in Rome.

Individual free-standing statues of the naked Venus, which were probably very commonly used for decorative purposes in many Roman homes and gardens, were subject on occasions to both female approval and empathy and to the sexualised male gaze. On my many visits to museums in Rome and Italy over the years, I have lost count of the number of Roman copies on display of the coy, crouching Venus/Aphrodite of Knidos statue, originally carved by Praxiteles in the fourth century BC and endlessly copied and adapted in the Hellenistic period and subsequently in Roman times. All of these must have been derived from just such settings.

Venus was, of course, most commonly portrayed in Roman art with a mirror, and it was therefore fitting that many Roman and Romanised woman chose to identify with her both overtly and sometimes more allusively by having themselves depicted in this way, as indeed we have seen in Chapter 3 when discussing the significance of the imagery on the silver Projecta Casket. Such images were both somehow sacred and profane.

Highly significant personal identification with a goddess can also be seen in the case of Ceres, in most respects equivalent to the Greek Demeter (see image 61).[1] Ceres was the Roman goddess of corn and thus of agricultural prosperity and, by obvious extension, of fertility and plenty. She may also have been called upon to act as a facilitator in social rituals of transition, particularly involving

marriage and death rituals. Studies of the goddess have quite rightly stressed her origins in pre-Roman Italic societies and her links to the Italic earth goddess Tellus. She became very much associated with the other deities Liber and Libera in a triad that had a particular appeal to the Roman plebs, while the Greek mythological stories concerning her and her daughter Persephone or Proserpina appealed to the literate classes at Rome, especially women. Thus Ceres had an unusually broad appeal in terms of both class and gender, as well as being strategically employed in imperial artworks on a number of occasions in contexts that overtly politicised her image and used it to support male imperial power.

The origins of the Cerealia, the festival of the goddess celebrated on 19 April each year, lay firmly in Rome's foundation centuries and the early city's symbiotic relationship with its agricultural hinterland. After the foundation of the Roman Republic in around 509 BC, the Temple of Ceres, Liber and Libera was to become a focus for the political agitation of Rome's plebeian class against the patrician class. But no images of the goddess from this period have come down to us and indeed the earliest images of her from Rome date to the middle Republic. During the reign of Augustus, the emperor would occasionally be depicted wearing the *corona spicea*, a garland of corn, suggesting his role of guarantor of the overseeing of the grain supply to Rome, while his wife Livia made a more overt statement about her identification with the goddess in more common images on coins and carved gemstones, as we have seen in Chapter 2, something that was to be continued by subsequent imperial women whose roles as mothers were being stressed in their associated imagery. Emulation of the imperial identification with Ceres occurred among the Roman and Romanised elite women of the empire and indeed it has been suggested that the common and much-replicated statue type called The Large Herculaneum Woman, discussed in Chapter 3, was in fact a way for contemporary women to appear in her guise.

Another goddess linked with Rome's deep past was Vesta, the

Roman goddess of the hearth, and thus of the *domus* or home – that hugely important symbolic centre of Roman social structures. Her small, round temple in the Roman Forum housed a sacred flame that represented the hearth of the city itself. Each year this fire would be rekindled and otherwise would be tended throughout the year by the Vestal Virgins, the six priestesses of the cult. This linking of the cult of Vesta with the very origins of Rome, and thus with its highly potent foundation myths, was further emphasised by the Vestal Virgins' curation of a statue of Athena said to have been rescued from Troy by Aeneas and small statues of the guardian deities, the *penates*. These were kept in secure storage in the cult's *penus* or storehouse. Access to the storehouse was restricted to the Vestal Virgins and the *pontifex maximus*, although once a year at the festival of the Vestalia it was opened to married women who walked in barefooted procession through the building and left food offerings that they brought with them. Later in the same week, the storehouse was ritually cleansed and the offerings taken to the River Tiber for formal disposal. The College of the Vestals was disbanded in AD 394 and the sacred flame extinguished.

The priestesses were chosen at a young age by lot and groomed for the role before induction. Over the years a number of female members of the imperial house became Vestals, indicating the importance of the cult. That women had to renounce their natural sexuality and forego marriage at the traditional age to fulfil the role is curious, in that chastity in a woman and favouring the single state would appear to have been diametrically opposed to the idea that the greatest virtues that a Roman woman possessed were related to marriage and motherhood. Stranger still, perhaps, was the fact that the Vestal Virgins each served thirty years in the role before stepping down to allow a younger Virgin to take their place and then were permitted to marry. A man who married an ex-Vestal gained a great deal of social cachet by doing so.

In terms of representations of Vesta and the Vestal Virgins, it might be the case that such images even if made by male artists

or craftsmen were intended to be viewed more or less exclusively by women, and mainly in contexts in the city of Rome itself (see image 62). This is not to say that the cult of the Vestal Virgins did not receive interest from Roman emperors and other Roman males. Indeed, in Chapter 2 it was noted how Augustus took an especial interest in Vesta and her priestesses and that one of the most famous images of the Vestal Virgins to have come down to us is their appearance on the monumental frieze of the Ara Pacis or Augustan Altar of Peace. They also appeared on a relief now in the Museo Nazionale, Palermo, attendant upon the seated goddess Vesta, and on the so-called Sorrento Base. The Virgins wear heavy, hooded cloaks fastened on the chest with a large brooch. They are identifiable by their signature hairstyle, comprising a six-banded hair fillet terminating in cloth loops. A relatively small number of individual statues of Vestal Virgins are also known.

In the case of the Vestals, we may be looking at images which, when viewed, involved women looking at women, something that perhaps evoked a different kind of response when not filtered through the Roman male gaze and which therefore might require a different kind of analysis here. The very fact that when the Vestal Virgins were portrayed in Roman art they would be seen by female viewers as being almost symbolic of a kind of hyperfemininity, physically in a virginal state through a choice that allowed them to at once celebrate this natural female state while at the same time emphasising to women viewers how unnatural a choice this really was. They were not here defining themselves in relation to a man but simply by their own sexuality and by the control of their own bodies. There was a contradiction of some kind here between images of women as sources of meaning and the denial of their meaning. In Roman society women's ritual and religious lives often provided the only forum for them to access power and utilise public spaces, making membership of the cult of the Vestal Virgins a route to such power and status through the accepted denial of one's female sexuality.

While discussion so far in this chapter has concentrated on goddesses in the Greco-Roman pantheon, it must be remembered that as the Roman Empire was forged and then expanded, so the Roman pantheon of deities grew to accept, embrace and include gods from other cultures, from conquered territories. The logic behind such apparent acceptance of foreign deities was based upon religious syncretism, the recognition of similar traits and powers among individual gods and goddesses in Roman culture and in the wider Roman world. Such a process was part and parcel of the acculturation of conquered territories on which the ideology and programme of Roman imperialism depended. To some extent, it is therefore true to say that the Roman Empire was as much an integrated world of gods as it was a political entity.

It is not possible here to present an extended discussion of all the female deities from non-Roman societies that were accepted into the Roman pantheon. That would quite happily form the basis of a whole series of books. Rather, I will first discuss one or two individual foreign deities, including Cybele, Isis and Artemis Ephesia, and then survey the evidence from Roman Britain, the province with which I am most familiar.

The mythology surrounding the Phrygian mother-goddess Cybele, the Magna Mater or Great Mother, is particularly startling in terms of the gendered nature of the main narrative (see image 63).[2] That her cult broke out from its local appeal to encompass recognition across the whole of the Greek world seems surprising enough. That the Romans too became interested in the goddess appears even more curious, with a temple being built to Cybele on the Palatine Hill in the third century BC, following the war with Hannibal and the Romans' decision to import this goddess to the city. There are many versions of the story of Cybele, though in both main versions she is credited as being born from Zeus's spilled seed and in both she has a destructive love for Attis, who is usually referred to as being her consort. In one version of the story, Attis falls in love with a wood nymph who is killed by Cybele acting in a jealous rage. Attis

then castrates himself, mad with grief, and bleeds to death beneath a pine tree. In another version, Cybele is born a hermaphrodite – with both male and female genitalia – and is castrated by the gods. From the blood and semen of her severed male genitals an almond tree springs up whose fruit impregnates a nymph who subsequently gives birth to Attis. Cybele falls hopelessly and obsessively in love with Attis when he has grown into a handsome youth, so much so that she is consumed with such overwhelming, paranoid jealousy that she drives Attis mad and to suicide through self-castration. Again, death beneath a pine tree marks his end.

Almost inevitably, these stories can be and have been subject to psychoanalytical examination. In both these versions of the story, Cybele certainly comes across as not a beginner's girlfriend, while Attis appears to be a predestined loser of the very worst kind. The gender imbalance in their relationship was further emphasised in religious terms by the fact that the cult of Cybele once established was organised by a male priesthood whose members were eunuchs who had either castrated themselves or been castrated in an ecstatic ritual that based itself on the self-destruction and demise of the fated consort Attis. As has been noted by one authority, the cult of Cybele 'used sexuality for purposes of ideological communication ... A set of claims about the power of [the] goddess and her relationship with humans was expressed by and on the bodies of human representatives'.[3] Images of Cybele were relatively common, and it is likely that when they were viewed the specifics of her mythological backstory were in the mind of their viewers.

Another foreign deity who was to be taken into the Roman pantheon was the Egyptian goddess Isis, the sister/wife of Osiris and the mother of Horus (see image 64). In another highly symbolically gendered myth, Osiris was slain by the god Seth and his remains were scattered widely throughout Egypt. Against all the odds, Isis managed to locate and retrieve each and every one of these many dismembered body parts and reassembled his once-fragmented body. The popularity of the cult of Isis probably had a great deal

to do with the general Egyptomania that so captured the Roman imagination at the time of Cleopatra and which continued to resonate throughout Roman culture even into the fourth century AD, though it has been argued that the taste for Egyptian or Egyptianising art and motifs was simply part and parcel of Rome's voracious appetite for cultural appropriation that fitted its role as a cosmopolis.[4] Isis appealed to both the men and women of Rome and Italy, as reflected in the many images of her found there, most notably in the Iseum or temple of Isis at Pompeii and in the large room known as the *ekklesiasterion* there.

Images of the goddess Artemis Ephesia are found all over the Greco-Roman world, far from her original temple at Ephesus in present-day Turkey, and an example from Rome is illustrated here (see image 65). Her principal original role as protector of her home city came to be usurped by her special identification with issues of fertility and with the transition of girls to womanhood and thus with bodily change, therefore making her yet another of the goddesses with whom women could particularly empathise and identify. Her image was particularly striking in that the goddess's chest was usually depicted completely covered in breast-like protuberances, emphasising her gender and her hyperfemininty, and indeed her hypersexuality.

In Roman Britain there was an interest in both the two goddesses of the Capitoline Triad, Juno and Minerva, and other classical deities such as Venus and Diana, though mainly in the towns and military bases and the villa residences of the Romano-British elite where their images have been found. Syncretism led to the creation of paired deities in some cases, such as that of Sulis Minerva at Bath. Although the temple inscription from Bath quite clearly records the dedication to the local female water deity Sulis, the bronze head of the cult statue from the complex is most certainly a classical head of Roman Minerva. Other female regional or local deities, such as Coventina in Northern England, for instance, appeared on artworks and inscriptions from the province and represented links to pre-Roman deities and practices outside the classical sphere.

The vast majority of representations of female deities from Roman Britain occurred on decorated altars, in the form of uninscribed free-standing statues or small statuettes and figurines, on engraved gemstones or intaglios from rings, on metalwork, pottery and glassware and occasionally on mosaics. Sometimes the goddess can only be identified by her acknowledged attributes or companions, and often the identifications of the females represented cannot be verified in any way.

Though Roman Britain would appear not to have been a particularly visual culture, largely similar situations with regard to the balance of classical and indigenous deities through religious syncretism, and the importance of certain deities specifically to women, probably existed in most of the other western provinces of the empire. Sulis Minerva was invoked by many visitors to her temple and healing shrine at Bath to intercede on their behalf in matters sometimes relating to health, as might have been expected here, and sometimes relating to moral issues and crime. Image and text were powerful tools for conveying moral messages in the Roman world, particularly with regard to the role of women, and attention will now be turned to that very topic.

Moral Messages

The two most significant Roman artworks in terms of their being specifically designed to convey moral messages to the people of Rome are the frieze that adorned the late first-century AD Forum Transitorium or Forum of Nerva in Rome and the frieze from the Augustan reconstruction of the Basilica Aemilia, again in Rome.

The artworks adorning the Forum Transitorium have been the subject of a detailed and highly influential study by Eve D'Ambra.[5] In her book, D'Ambra not only examined the decorative frieze on the monument in detail but also set it within its broader social, political and cultural context. While in the Roman mind female virtues and respectability could usually be adequately represented by girlhood and virginity or by marriage and motherhood, there

were other modes of contrary female behaviour that could be used didactically to set a moral lesson for the women of Rome. The mythological tale of Arachne allowed her to be represented as one such negative role model and her story formed the subject of the frieze on the monument (see image 66).

Born in Lydia, Arachne became famed far and wide for her skill at weaving, despite her otherwise humble origins, but this fame went to her head and she sought to challenge Athena/Minerva to a weaving contest. As ever was the case with those who tried to challenge and better the gods, Arachne would be forced to learn a hard lesson from her folly. Despite an attempt by the goddess to warn her off pursuing such a foolhardy path, Arachne chose to proceed and the contest began. Athena/Minerva wove a tapestry depicting the gods competing to control Athenian affairs and scenes of the fates of mortals who had presumed to challenge the gods. Arachne, however, outdid her by weaving an exquisite tapestry depicting the duplicity of the gods in their love lives. The goddess destroyed Arachne's tapestry in fury and set about the girl with a weaving shuttle, driving her to despair and almost to suicide. The goddess then relented from her frenzied assault and turned Arachne into a spider, destined through her progeny the world over to be forever weaving. In many ways, Minerva was weaving a fabric that metaphorically represented the divine order and it was this that Arachne was challenging, rather than simply demonstrating excessive hubris by taking on the goddess herself.

The frieze is poorly preserved today, and, because of the small scale of the figures, virtually impossible to view in detail from the present-day ground level, so interpretation of it must rely largely on photographs. A central part of the frieze depicts Minerva's punishment of Arachne, and this is flanked by more generic scenes of young women spinning and weaving under the watchful eye of the goddess. Just above the central frieze is a panel containing a large image of Minerva to emphasise the extent of her power over an individual such as Arachne and over other women.

D'Ambra has pointed out that weaving not only helped to initiate girls into the Roman household, but also provided metaphors for political power, for statesmanship and civilization.[6] Images of weaving here were being used as a political metaphor for the cohesion of Roman society under imperial rule, rather than weaving simply being shown as representative of a typical, not to say archetypal, female, matronly pursuit.

The politicisation of women's craft activities as seen on the Forum Transitorium frieze was not a new thing. Indeed, mention was made in an earlier chapter to the connection between the empress Livia and weaving being used as a kind of moral exemplar for Roman women, and knowledge of this surely must have had some influence on the choice and design of the Forum Transitorium frieze. The significance of weaving as a generally female craft activity with considerable status capital in most societies and cultures, both historic and contemporary, is powerfully underlined by historical, archaeological and anthropological research. Certainly, such links can be found in a number of pre-Roman Italic cultural groups including the Etruscans. In Northern Italy, the connections between looms, weaving and women's rituals are brought out in several of the rock-art pictographs in prehistoric Valcamonica.[7]

The Basilica Aemilia in the Roman Forum was substantially rebuilt and dedicated during the reign of Augustus, and again it has been quite rightly assumed that the decorative programme of the building complex related to the now highly politically charged mythology of Rome's origins and included a didactic message intended for the contemporary women of Rome at whom much moral legislation was also aimed during his reign.[8] Found in a damaged and highly fragmentary state, the two most complete reconstructed relief scenes from the frieze on the interior of the basilica depict the Rape of the Sabine Women (see image 67) and the Punishment of Tarpeia (see image 68). Casts of these scenes are on show in the remains of the basilica today. Though fragmentary, the reliefs are astonishingly fluid and powerful in their composition,

as perhaps befitted such violent and harrowing scenes. The Rape of the Sabine Women – their abduction and rape by the men of Rome at a time of population shortage in the city and probably also as a tactic of war – occurred at the festival of Consualia, an agricultural festival celebrating the role of Consus, god of the agricultural storehouse. By this coincidence, the Sabine women could have been viewed as being simply analogous to produce. Tarpeia was a Roman woman who, in sympathy for her Sabine sisters, allowed the Sabine men to enter Rome and seek revenge; for her trouble she was then battered to death by the Sabines using their shields. A statue of Tarpeia is also known to have stood in the Temple of Jupiter in the Porticus Metelli in Rome and was evidently intended there to serve a similar didactic function, to encourage proper respect for family and civic duty.[9]

Images of mythological or mythico-historical moral exemplars were also chosen on occasions as being appropriate in non-imperial contexts, as demonstrated by the popularity in Roman art of depictions of the death of Niobe's children, the rape of Persephone, the rape of Cassandra, the death of Actaeon, the death of Alcestis and the story of Hercules and Omphale.

The myth of Niobe and the fate of her children at the vengeful hands of the gods was a popular subject for literary authors and for representation in art in both the Greek and Roman worlds in the form of free-standing statues of the Niobids (see image 69) and on Roman sarcophagi in particular. Niobe was the daughter of King Tantalus of Lydia who was himself a son of Zeus and who too was to eternally experience the wrath of the gods when he crossed them in an unrelated incident. Niobe became the wife of King Amphion of Thebes and was said to have borne him numerous children. The number of children she had varied anywhere between twelve and twenty, depending on which author retold the tale, the only constant factor being equal numbers of boys and girls. Amphion and his twin brother Zethus, like Tantalus, were also sons of Zeus. In a boast that in retrospect was to prove fateful, Niobe claimed that her

fecundity gave her superiority over the goddess Leto who had two rather than numerous children. The wrath of Leto was immediate and fierce: sending her two children, Apollo and Artemis, to earth, they respectively killed all of Niobe's sons and daughters, though some versions of the story allow for one or two of the children to survive. Niobe, utterly consumed by grief and wracked by guilt at her hubristic behaviour that had so angered the gods, left Thebes and returned to Lydia, perhaps to bury her children there. Obviously this story can be viewed on a number of levels, but ultimately it must be seen as a lesson or rebuke to women who somehow transgress against powerful individuals or powerful institutions.

Perhaps the most complex of a number of moralising abduction/rape stories used as illustration in Roman art in certain contexts was that of Persephone, or Proserpina as she was known to the Romans. This was a popular theme on Roman sarcophagi (see images 70 and 71), one of the best examples of which can be seen in the Musei Capitolini in Rome and which also appeared in a wall painting in the Tomb of the Nasonii on the Via Flaminia, Rome (see image 72). Persephone was the daughter of Zeus and Demeter. With her father's connivance, she was kidnapped one day while out picking flowers and carried off to the underworld by Hades, her uncle, and ravaged there.

Unaware of the fate of her daughter and the part in her abduction played by Zeus, Demeter wreaked revenge and havoc on humankind through famine and hunger. Eventually Zeus saw the error of his ways and dispatched Hermes to the underworld to bring back Persephone to be joyously reunited with her mother on Mount Olympus. However, as Persephone had eaten in Hades, she was fated forever to return there for part of each year, returning to the upper world each spring. Thus she was both a dark goddess of the underworld and a light, benevolent deity here on earth, associated with crops and regeneration.

On the Musei Capitolini sarcophagus front, as in most such scenes on other sarcophagi, Hades is caught in the act of carrying

away a naked Persephone in his chariot bound for the underworld as her companions look on aghast. The girl tries to cover her naked torso with a cloak that billows out behind her as the chariot picks up speed. This scene is placed firmly in the middle of the design, with Persephone's face being represented by a portrait carving of a woman, probably the deceased buried in the sarcophagus. A profusion of figures on the panel make it almost appear at first glance like one of the busy Antonine battle sarcophagi. Starting on the far left of the front, Demeter can be seen riding in a chariot pulled by a snake. She holds a torch and a sceptre and is evidently searching for her daughter, already concerned at her tardiness. This segues into a scene of Hades coming upon Persephone as she picks flowers, startling the girl. Aphrodite and Artemis, accompanying Persephone, look on; Artemis, perhaps sensing danger, has picked up her bow. The goddess Athena attempts to intervene to stop the abduction, while ahead of the racing chariot stands Hermes ready to direct the chariot on its way. Victory waits with a wreath and palm frond to congratulate Hades on his conquest and Hercules stands to attention behind her, his club in his hand. There are many other minor figures, including cupids around Hades's chariot, suggesting a romantic aspect to the encounter that the myth does not warrant, and various personifications appear along the bottom of the panel.

There is a sense of both tension and of controlled hysteria in this highly unsettling image. It might seem to us unfortunate that a motif of rape was used here as a pictorial device to lure in viewers and promote discussion on issues relating to birth, death and regeneration. The viewer was being invited to make a clear distinction between 'real' rape and rape as a metaphor, as part of an intellectual exercise in relation to its analysis through the male gaze. Today we might find it difficult to comprehend how in antiquity such images would have given some viewers an immediate satisfaction without apparently leaving a disquieting aftertaste from dealing with such difficult and ambiguous concepts.

Another rape story which came to be used for didactic purposes

was the Rape of Cassandra, and it is perhaps surprising to find a particularly graphic depiction of this event, and of the return of Helen of Troy to Menelaus, in a wall painting in the House of Menander in Insula I in Pompeii. If some of the images of other mythological rape stories being discussed in this chapter and elsewhere in this book have tended to gloss over the actual rape aspect of the story by picturing an abduction only, then this painting seems particularly shocking in a domestic context.[10] In the centre of the painting stands King Priam, Cassandra's father, watching the attack on his daughter taking place in front of him, on his left, with a downcast and shocked look on his face. He holds out one hand in a futile gesture to call a halt to the events rapidly unfolding before him. A Greek warrior, presumably Ajax or Odysseus, holding a shield and spear in one hand to further emphasise the power differential in the scene between the male and female protagonists, grabs Cassandra by the wrist and tries to drag her away. Cassandra is semi-naked, her robe having fallen off her shoulders and down to her waist, exposing her breasts, torso and back. She has fallen to the ground before a statue of Athena, presumably in supplication to the goddess to save her, and clings on to the statue with her left hand as the warrior attempts to prise her away. On the right hand side of the painting, a group of Greek warriors surround a semi-naked woman, caught sideways on with her bare buttocks towards the viewer, who must be Helen. One of the warriors, in all likelihood Menelaus, grabs her by the hair and she attempts unsuccessfully to fend him off by pushing against his chest with one hand while grabbing hold of his wrist with the other.

It has been suggested that this is simply a depiction of a well-known scene from the Iliad and that a craze for Homeric literature and allusions in Rome, Pompeii and elsewhere in Italy was part of an elite phenomenon at this time which took its lead from the personal tastes of the emperor Nero. That the owner of this house might have been related in some way to Nero's second wife, Poppaea Sabina, is thought to be possible.[11] The overall decoration

of the House of Menander was overtly theatrical and doubtless intended to impress visitors with the personality and taste of the owner. In the same house can also be found a panel depicting Diana and Actaeon, a story with fatal consequences for Actaeon, as will shortly be discussed below, but little can probably be read into this in relation to the Cassandra and Helen painting. That rape, male violence against women and the use of male power to exert control over women were deemed suitable themes to demonstrate the status and literary interests of the owner of the House of Menander might defy belief today, but they would appear to have been part of a programme of voyeurism that ran throughout the house and which must have been the result of a commission from a powerful elite man whose intended audience of viewers for the paintings in his house was almost exclusively male.

Images of the goddess Diana were extremely common in the Roman world, many of them in the form of the youthful, beautiful goddess while hunting, her bow strung across her shoulders. However, the less common depictions of the myth that involved Diana being spied on while bathing naked by Actaeon while he was out hunting have an altogether different purpose, it would appear, and a cautionary one at that. Outraged at the voyeuristic behaviour of Actaeon, Diana turned him into a stag and he was then torn to pieces by his own hounds who mistook him for their day's prey. Here, against the grain of much Roman moralistic art, much of it of the Augustan period, was a man being punished for outraging public decency and codes of behaviour, rather than a woman. One of the most striking and graphic depictions of the death of Actaeon appears on the third-century Romano-British Seasons mosaic from a townhouse in Roman Corinium, Cirencester, Gloucestershire. The artist/designer of this mosaic captured the moment at which Actaeon is caught in stasis turning into a stag: his body largely as yet unchanged and unaffected, he is starting to sprout antlers from his head. Sensing the change taking place, his two dogs turn on him. Diana herself is not shown.

Another mythological figure popular in particular on Roman women's sarcophagi was Alcestis, with the portrait face of the deceased placed on her body in scenes relating to aspects of her life and death. Alcestis was the daughter of King Pelias of Iolcus and Anaxibia. She was famed for her beauty, but it was not this aspect of her story that appealed so much to Roman women or to those who chose their sarcophagi for them. She married King Admetus of Pherae who had been aided by Apollo to win the heart of this much sought-after bride and who had helped Admetus to escape his allotted fate of dying soon, on a particular day and at a particular time. But, as so often in classical mythology, the help of the god came with a price tag attached. In return Apollo required Admetus to nominate someone else to die in his place at his allotted time and it was Alcestis who out of love for her husband volunteered to take his place. In different versions of the myth she was rescued by Hercules and brought back to the world of the living, while in another she was sent back from Hades by the gods in admiration of her courage and self-sacrifice.

Rather than dwelling on the futility of Alcestis's pointless sacrifice, in elite Roman society she was viewed as a model wife, her sacrifice being thought of as a desirable womanly virtue. Indeed, it is likely that when a Roman woman appeared on her sarcophagus in the guise of Alcestis, she had in fact died prematurely and had probably unexpectedly predeceased her husband, as in the myth.

Another quite fringe female figure from mythology, whose occasional appearance in Roman art perhaps requires careful examination and explanation, is Omphale, the queen of Lydia who ruled alone after the death of her husband Tmolus. She entered the mythological canon through her purchase of the god-hero Hercules as a slave, after the disgraced and repentant hero had submitted himself to life as a slave in punishment and mitigation for his treacherous slaying of Iphitus, king of Oechalia.

As might have been expected in the circumstances, Hercules served Omphale well during his period of servitude and in this

time performed many heroic deeds on her behalf and to the benefit of her kingdom. However, it is the interpersonal nature of their relationship that is of most interest here. It would appear that the queen wished to both dominate Hercules and humiliate him, almost emasculate him, while at the same time making use of his manly superhuman strength, courage and indomitable nature. As part of his ritual humiliation, the queen is said to have dressed up in the hero's trademark lionskin and brandished his wooden club, while Hercules was required on occasions to wear women's clothing and in this guise to help the women of the household with their tasks, including spinning.

It surely does not require the help of a psychologist to get to the bottom of these acts of gender inversion and role reversal, and to expose the link here between power and sexual submission. That Hercules had sired a child with Omphale before being set free comes altogether as no great surprise. If the figure of Omphale was seen by male Roman patrons as an appropriate subject for depiction in the artwork they were commissioning until possibly as late as the end of the second century AD, then it was as an image of Eastern decadence, of a dangerously powerful woman, a warning to other men to beware. And yet after this time she became a figure whose image would occasionally adorn a funerary sarcophagus or in whose guise Roman elite women would appear in portraits, the best-known example of the latter phenomenon being a statue of around AD 200 now in the collections of the Musei Vaticani in Rome (see image 73).[12] The full-length statue is of an almost naked Omphale, her modesty only just retained by being partially covered by the end of the lion pelt she holds over her nether regions and which covers her head and is draped over her shoulders and down her back. In her other hand she holds Hercules' club.

Images of Victory

A third category of non-mortal woman to be considered in this chapter is the female personification, of which the figure of Victory

was without doubt the most common in the Roman world.[13] She commonly appeared on imperial monuments, on other imperial artworks including carved gems and cameos, on civic monuments, on numerous coin issues and in statuary form (see image 74). Her image was found right across the empire from the Antonine frontier in Scotland to the cities of the North African littoral. Victory was the Roman equivalent of the Greek goddess Nike, but her image was perceived and used in a way that presented her more as a personification than as a goddess as such. In Roman imperial art, Victory could represent victory in a specific battle or in a specific campaign or war. She could represent the general martial nature of a particular emperor or dynasty, and indeed in time she came to represent a much more generalised allusion to the might of Roman imperial power. She was sometimes portrayed holding or crowning a Roman emperor with a victor's laurel wreath, or was pictured inscribing the victor's name and military achievements on a burnished shield. Perhaps the best two examples of images of Victory to discuss here are the life-size, bronze-winged Victory statue from Brescia in Northern Italy and the appearance of Victories on the frieze around the Column of Marcus Aurelius in Rome.

The full-size bronze statue known today as the Winged Victory of Brescia was discovered in 1826 near the Roman city's Capitolium, or temple to the Capitoline Triad of gods, and is now housed in the magnificent Santa Giulia della Città museum in the city (see image 75). Thought to date to the second century AD, the Brescia Victory may be a copy of the now-lost but historically attested golden Victory that Augustus set up in the Roman curia a few years after his naval victory over Antony and Cleopatra at Actium in 31 BC. She stands with her wings folded behind her and one leg bent at the knee, probably originally to support a large bronze shield. Both her arms are outstretched, the left to hold the now-missing shield and the right to hold an implement with which she would have been pictured inscribing details of a military victory on the shield. There are also certainly similarities in composition and pose between the

Brescia Victory and the bronze statue known as the Aphrodite/Venus of Capua now in the Museo Nazionale in Naples, which is actually a Roman copy of a Greek original from the fourth century BC. The partially naked Aphrodite/Venus here originally gazed at her own reflection in the shield of her lover Ares, the Greek god of war and equivalent to Roman Mars, and stood with her foot resting on his helmet.

The figure of Victory on the Column of Marcus Aurelius appears almost precisely half way up the column shaft, her appearance marking the end of the first phase of the Germanic wars in or around AD 176. She is depicted as a giant figure, flanked by two battlefield trophies, trees hung with captured barbarian arms and armour and with stacks of shields at their bases. She is depicted in the act of writing upon a huge oval shield the details of the victory being celebrated and commemorated, but any inscription the shield's surface may originally have borne has now worn off through weathering. Again, she was undoubtedly modelled on the Aphrodite of Capua like the Winged Victory of Brescia, her forward-leaning pose and her semi-naked state – she is partially draped over her upper body by a robe which falls away to also reveal part of her upper thigh – adding a frisson of sexual tension to the testosterone-powered images that otherwise completely dominated the column frieze. Her closest Roman parallel is the image of Victory on Trajan's Column, again portrayed inscribing some words on a noticeably much-smaller shield. The Trajanic Victory is almost fully clothed, in contrast to the Aurelian Victory, and it must be asked whether there was some particular significance in this marked difference.

It is possible that the erotic, almost Venus-like Victory on the Aurelian Column could have been equated with the empress Faustina, just as statuary groups of couples in the guise of Venus and Mars were popular at this time, while the soldier-emperor guise for Marcus attributed to him on the column frieze could have equated him in the viewer's eyes with Mars. Along with other attested links between Faustina and other imperial women with Victory, then

such an interpretation may not be too far-fetched. This would, though, raise some issues about the relationship between Faustina and her son Commodus who commissioned the building of the column. Why would a son sanction the depiction of his mother in such a guise, eroticising his own mother through the promulgation of such a seductive public image?

Acting a Part

To fully understand the creation and use of personifications, we must go back to pre-Hellenistic Greece where personifications of emotions and certain aspects of the human condition, of human qualities and moral behaviour and even of the condition of the state were represented in both language and by images. However, the widespread use of personifications really started in earnest in the Hellenistic period.[14] It was then that national, city and general geographical or topographical personifications became common alongside the more abstract ones.

The use of personifications of abstract qualities and ideals, almost always represented by a female image, took root in early Roman society and indeed in the Republican period it is known that there were state cults dedicated to Fortuna (Fortune), Concordia (Concord), Salus (Health), Victoria (Victory), Virtus (Virtue) and Bonus Eventus (Good Outcome), though interest in engaging with such concepts tailed off towards the end of the Republican period, to be revived in imperial times to largely political ends. Certainly, an ideological and symbolic armoury that included such concepts was to be invaluable in the construction of imperial rhetoric. Indeed, new abstractions such as Clementia (Clemency), Indulgentia (Leniency) and Providentia (Providence) came to the fore in imperial contexts. Pudicitia (Modesty) was well known in the Augustan period (see image 76). Abundantia (Abundance), Spes (Hope), Fecunditas (Fertility), Pollentia (Power) and Disciplina (Discipline) were all commonly invoked in word and image, and the list goes on.[15]

But it was the personification of peoples and places that found

its most potent use in Roman imperial ideology, on some coin issues and most tellingly in the artworks for two monuments in particular, the Sebasteion dedicated to the Julio-Claudian imperial cult in Aphrodisias, Turkey, which will be discussed in Chapter 7 in relation to the viewing of these artworks through the male gaze, and the so-called Hadrianeum in Rome.

On a *sestertius* coin issue of AD 105 a female personification of the province of Dacia is shown being subdued by a male personification of the River Danube, an unusual juxtaposition of female and male personifications and a reflection of imperial gender politics to some extent.[16] Generally coins provided a regular forum for the depiction of simplified images of personifications of defeated provinces: Germania capta; Britannia capta; Judaea on some Flavian coin issues, seated bound beneath a tree; and on the Arras medallion of AD 296 a female personification of Londinium kneels before Constantius Chlorus. Contrastingly, Britannia is depicted proudly greeting Carausius on a coin of AD 286.

A large number of female personifications of Roman provinces are represented in the artworks from the Hadrianeum or Temple of the Divine Hadrian built by his successor Antoninus Pius in or around AD 145, which stood in the Campus Martius in Rome.[17] A number of these reliefs are on display today in the courtyard of the Museo del Palazzo dei Conservatori and in other museum collections in Rome. Some are in the Museo Archeologico Nazionale, Naples.

These personifications are in keeping with the original Greek ethos of benign personification rather than the degraded and degrading images to be discussed from Aphrodisias in Chapter 7. Their individual attributes, dress and posture were intended to evoke in the viewer recognition of the material ethos of their home country. The Hadrianeum personifications represented an empire united under a benevolent, anti-expansionist emperor with refined intellectual tastes, and represented a geography of both difference and unity. Even though, as was traditional, the personifications here

were all female, there is no sense that the images were in any way being presented in some way for the edification of the male gaze. They could be said to represent the strain of Roman provincial personifications that were '*provinciae fideles*', or friendly provinces, as opposed to the more negative connotation of the image of the '*provinciae captae*', or conquered provinces. Nevertheless, it is possible that the Roman artists before Hadrian's time, and indeed afterwards, rather than simply producing an ideal classical image as a personification, chose to base some of their personifications on real models of captive individuals from those provinces displayed in Rome or living there as sold-on slaves. Before Hadrian's time it is true to say that there had not been a particular interest in the use of province personifications in the visual and ideological armoury of Roman imperial art and rhetoric; indeed, it has been estimated that only nine of the empire's provinces had appeared as personifications in imperial artworks.[18]

Twenty-one or twenty-two reliefs from the Hadrianeum carry depictions of Roman provinces, while another nine or ten depict trophies, the discrepancy in the actual numbers being accountable by academic differences over assigning some particular fragmentary images to the monument. While the latter images are standard tropes in the visual ideology of Roman imperial power and military might, quite tellingly the trophies are not accompanied by images of defeated or abject barbarian enemies of Rome as was most usually the case. The trophies here might more properly be thought of as representing Rome's military power acting as some kind of guarantor of peace for the provinces. While certainly the style and composition and artistic techniques employed in the creation of these works were both novel and original, these are not issues that can be discussed further here without diverting from the main topic.

As the individual province personification reliefs were not accompanied by inscriptions, it is not always possible to identify which personification is which province, though some candidates' identifications can be more confidently suggested than others. It has

been noted that in Hadrian's time the empire consisted of thirty-six provinces, of which twenty-five named ones were depicted on coin issues of the time, some of these coin images bearing a great deal of similarity to some of the Hadrianeum relief personification images. These include the personification of Gaul, an upright female figure standing with feet slightly apart and her arms crossed over in front of her, her right hand holding the elbow of her left arm (see image 77). Like all the personifications, she is depicted with her body facing the viewer and with her head turned slightly to one side, catching her face in three-quarters view. Her long hair is parted down the centre and pushed behind her ears, to flow down her back. She wears a two-piece tunic and skirt and a heavy woollen cloak draped around her neck and shoulders. While the gesture of standing with folded arm might be viewed by us today as being somehow defensive, there is otherwise an air of confidence and assertiveness about this woman. Indeed, the image in its composition and bearing is not dissimilar to many much later images of French ideas on nationhood personified in the figure of Marianne.

Also noteworthy are the reliefs possibly representing the provinces of Egypt, Mauretania and Thrace. Egypt once more faces out towards the viewer, her head only slightly turned. Her hair is elaborately curled and held in place by a hairband across her forehead. She wears a fine robe and a thin shawl-like garment and her feet are shod in sandals. In her right hand she holds a pomegranate, an attribute which is not original to the work and which drawings of the relief as first discovered shows was certainly added during a later restoration. In her left hand she holds a bunch of flowers and corn ears, signifying both peace and abundance. In the case of Mauretania, the female personification again faces us, her tightly curled hair cascading down almost to her shoulders. She wears a long tunic and cloak ensemble and high boots. She may well have held something in her left hand, but the arm of the figure is broken off at the elbow. In her right hand she holds a fringed *vexillum* or standard. A strap crosses her chest, attached to a tube-like container

of some kind, the top of which is just visible over her right shoulder. Finally, Thrace appears in a diaphanous tunic and light cloak, her right shoulder and breast bared. Her hair is shoulder length and arranged in straight locks. In her right hand she holds a bouquet of flowers and in her left she holds what is either a short sword with a curved blade or a reaping tool of some kind (see image 78).

One of the most significant aspects of the reign of Hadrian was his policy of consolidation of the empire and the physical halt brought about to its expansion at the time. The inevitability of expansion, indeed the result of a mixture of economic inertia and the need for the constant reinvention of the rhetoric of Roman imperial political ideology, was now questioned, and stock was taken of the empire, its lands and assets and peoples. Hadrian's famous journeys around the empire were both real and yet at the same time also highly symbolic, like a beating of the bounds. Their routes were connectors, linking Rome to individual provinces and the person of the emperor to those provinces visited in a way that had not been attempted before or indeed would not be attempted again. The creation of a symbolic geography of empire and of Hadrian's visitations through the issuing of an extended series of twenty-five coins bearing depictions of the personified provinces of the empire was part of the same process. That process was completed after Hadrian's death by the decorative scheme of the Hadrianeum, even if belief in his project and enthusiasm for its ideological programme had by now more or less evaporated.

Nature and Culture

There was most certainly a correlation between grammatical gender and representation in Greco-Roman culture and to some degree a correlation between woman and nature, as best represented by the goddess Flora (see image 79).[19] Again, one only has to think of the figure of Tellus – the earth – as a woman to see how powerful this idea was in cultural terms in the Roman world (see image 80). Images of women could also be used to represent the seasons,

though images of men were commonly deployed to do this as well, and women were sometimes metaphorically linked in images with wild animals. Women themselves could also be portrayed as wild animals or as feral mythological forces of nature. The employment of images of these wild animals and more monstrous creatures could have been intended as allusions to the chaos and disorder so often associated with the natural world. A nature versus culture opposition could sometimes be created by the appearance of male and female images together, and yet culture itself was best exemplified in Roman art by the depiction of one or all of the nine female Muses, born to the titaness Mnemosyne and fathered by Zeus. There was a continuation in Roman culture of the idea derived from Greek mythology that erotic drive and madness were often linked to death and destruction, or at least were the signs of some inner turmoil or a psychological or societal malaise. In order to pursue these themes it is intended here to consider images of Amazons and female mythological monsters in Roman art and to discuss how such images may have been intended to be reflections of contemporary mortal women as a gender group.

Certain types of images of mythological women could be seen to be images of apprehension by men in particular. Fear of untamed women such as Amazons, Maenads and Medusa and the gorgons, for instance, placed the use and deployment of such images often in a didactic context aimed at female viewers. It was as if the appeal of such rogue and feral women could have negatively influenced ordinary Roman women and subverted individual male power and society's institutions in the process.

In common with earlier Greek art, Roman artists were especially fond of the image of the Amazon. These fearsome warrior women from Greek mythology came from the then farthest reaches of the known world and from a society whose domination by women was seen by ancient writers as being unnatural and abhorrent, akin to barbarism. In Amazonian society only female children were reared, any male children born to Amazon women presumably being killed

at birth or soon thereafter. Outright rejection of men in this way would have been barely comprehensible to most Roman men. The image of the Amazons battling with Greeks – an Amazonomachy – became a generic image for the battle between civilization and barbarity.[20]

Through their depiction as images in Roman art, it was perhaps thought that the ferocity of the Amazons was being harnessed and the warrior women tamed, often through their eroticisation. Had Alexander the Great not slept with the Amazon queen Thalestris and thus 'conquered' her? Indeed, this was to some extent a metaphor for his conquest of Asia, a metaphorical image of a kind that was to sit well with the Romans' own concepts of imperialism.

Perhaps the most significant artistic motif involving Amazons was the pairing of Penthesileia and Achilles together in an image. Penthesileia was the daughter of the Amazon queen Otere and Ares. She accidentally slew one of her fellow Amazons and was then forced to seek absolution of some kind from King Priam of Troy. Along with her band of fellow Amazon warriors, she joined battle on the Trojan side against the Greeks, but though she slew many Greeks she met her match in Achilles who killed her in battle. However, the story goes that as their eyes locked together during combat, Achilles instantly fell in love with Penthesileia or at least with her soul at her moment of death.

Representations of the death of Penthesileia at the hands of Achilles are quite common in Greco-Roman art and indeed the image was seen to be particularly fitting in a funerary context, on sarcophagi, sometimes with portraits of one or both of the deceased superimposed on the faces of the two main mythological protagonists. The example illustrated here is in the Musei Vaticani in Rome (see image 81). The underlying sentiment behind this scene of lovers united in death is well beyond simply being trite or mawkish. Its linking of ideas of love, violence and (female) death might appear perverse to us today, but its reflection through the male gaze at the time of its first viewings in Roman times might

indeed have been as much about male status and power as it was about love between equals. It must have been more than simply a sophisticated intellectual identification with Greek myths and culture.

If the Amazons represented the inherent dangerous wildness of women personified, then a more monstrous regiment of mythological female figures could equally be utilised in Roman art to depict the potential of women to emasculate men and disrupt or destroy the natural order of things – male power and control. The half-woman, half-lion sphinx commonly appeared on funerary monuments in an apotropaic or protective role. The three Sirens, the three Furies and the three Harpies were rather rarer as images. Most common, though, of these ravening monsters were the three Gorgons. Medusa and her two Gorgon sisters with their destructive gaze represented an inversion of the power of the male gaze. Their fangs, snake hair and ability to turn mortals to stone with their glare made them anathema to many men, an untamed, demonic female sexual energy. Medusa in Roman art was generally shown just as a severed head – a *gorgoneion* – particularly in military contexts throughout the empire where her ferocity might have often been admired and in funerary contexts as well where, like the sphinx, she served a protective purpose.[21] Perhaps surprisingly, images of Medusa were also popular on mosaic pavements, serving as talismanic, apotropaic protectors of the household, their ubiquity in this context being well illustrated by the fact that they occur quite widely in the western provinces on mosaics, with at least five examples being known from Roman Britain alone.[22]

The linking of women with nature in Roman art was not necessarily always to the bad, and indeed statues of more benign female figures were incredibly common in the semi-natural but controlled environments such as house courtyards and gardens, and in Rome in the great, vast *horti* or pleasure gardens established by the city's patrician elite, at country houses and on rural estates and in association with fountains and other water features. Thus

these settings would have hosted together thousands of statues of figures such as Aphrodite/Venus, Maenads, Danaids, nymphs, dancing women, Muses such as Polymnia, Demeter/Ceres, the goddess most linked to agricultural and horticultural fertility and Hygeia, goddess of health. But these women would not be alone and these courtyards, gardens and rural settings would also have been decorated with statues of male figures equally associated with the natural world, especially Bacchus, satryrs, Pan, Faunus and male athletes (see images 82 and 83).[23]

Yet while both the maenads and danaids were appropriate female figures to find in such settings, they also had darker sides to their stories that might have unsettled some male viewers in their otherwise idyllic reveries. In myth, the Maenads, the female companions of Bacchus, were civilised, mortal women who had left their homes to join the Bacchic *thiassos* or throng and who had offered themselves up to the ecstatic celebration of their god in a temporary state of madness that had led some of them to have frenziedly killed men and even their own children in other cases. The mythological Danaids were the fifty daughters of Danaus, who, in one version of their story, were forced to marry the fifty sons of Aegyptus. Forty-nine of the Danaids slew their husbands on their wedding night and in punishment in the underworld were for all eternity destined to fill and refill leaking water containers from a spring.

Deep History

The great foundation myth of the city of Rome was very much a male-dominated affair, in that the maternal nurturer of Romulus and Remus was a she-wolf and not a real human woman. However, Rhea Silvia, the birth-mother of Romulus and Remus, was celebrated in Rome and can be seen represented on a number of artworks. Her link to the cultic sect the Vestal Virgins was also highly significant. Rhea Silvia, in legend the daughter of Numitor, a descendant of Aeneas, was forced to become a Vestal Virgin by her uncle Amulius after he had deposed her father from the throne of Alba Longa

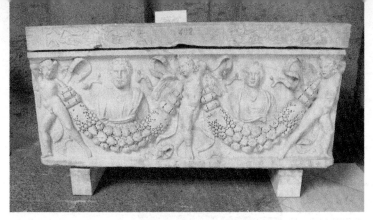

1. Sarcophagus of husband and wife. Third century AD. Pozzuoli. Museo Archeologico Nazionale di Napoli. (Photo courtesy of the author)

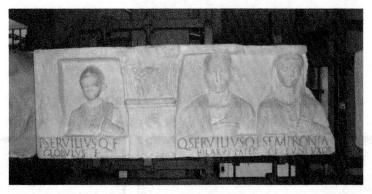

2. Funerary relief of the Servilii family: Hilarus, wife Eune, and son Globulus. Rome. Augustan period. Musei Vaticani, Rome. (Photo courtesy of the author)

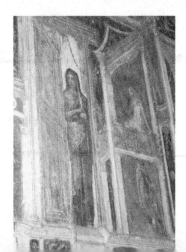

3. Detail of a wall painting from the House of Meleager, Pompeii. First century BC to first century AD. Museo Archeologico Nazionale di Napoli. (Photo courtesy of the author)

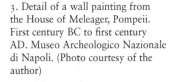

4. Funerary statue of mother and daughter. Rome. 50–40 BC. Musei Capitolini, Centrale Montemartini, Rome. (Photo courtesy of the author)

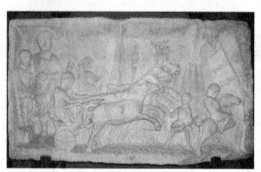

Left: 5. Funerary relief depicting the deceased and a circus scene. Ostia. Early second century AD. Musei Vaticani, Rome. (Photo courtesy of the author)

Right: 6. Close-up of couple on funerary relief depicting the deceased and a circus scene. Ostia. Early second century AD. Musei Vaticani, Rome. (Photo courtesy of the author)

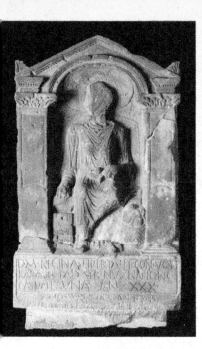

Left: 7. Tombstone of Regina. South Shields/Arbeia. Mid- to late second century AD. Arbeia Roman Fort and Museum. (Photo copyright of Arbeia Roman Fort, Tyne and Wear Archives and Museums)
Above: 8. Portrait head of Livia. From the Tiber, Rome. Last two decades of the first century BC. Museo Nazionale Romano, Palazzo Massimo alle Terme, Rome. (Photo courtesy of the author)

Left: 9. Portrait head of Livia. San Giovanni Incarico, Rome. Early first century AD. Museo Nazionale Romano, Palazzo Massimo alle Terme, Rome. (Photo courtesy of the author)
Right: 10. Bronze statue of Livia. The theatre at Herculaneum. AD 67–70. Museo Archeologico Nazionale di Napoli. (Photo courtesy of the author)

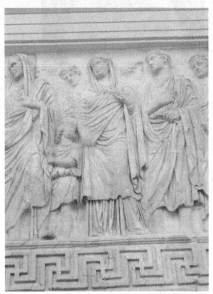

Left: 11. Livia. South frieze on the Ara Pacis Augustae, Rome. 13–9 BC. (Photo courtesy of the author)

Right: 12. Statue of the empress Sabina in the guise of Ceres. Baths of Neptune, Ostia. Late AD 130s. Museo Ostiense. (Photo courtesy of the author)

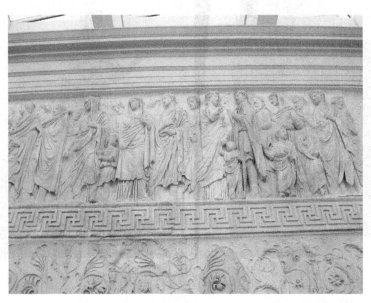

13. Procession of imperial family and entourage. South frieze on the Ara Pacis Augustae, Rome. 13–9 BC. (Photo courtesy of the author)

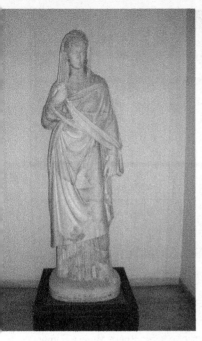 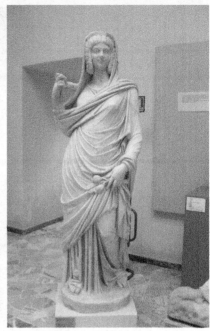

Left: 14. Statue of Faustina the Elder. Horti Maecenatiani, Rome. AD 138–150. Musei Capitolini, Rome. (Photo courtesy of the author)

Right: 15. Statue of Julia Domna as Ceres. Ostia, *c.* AD 203. Museo Ostiense. (Photo courtesy of the author)

16. Sacrificial scene involving Severus and family, including Julia Domna (now headless), on the Arch of Septimius Severus at Leptis Magna, Libya. AD 203. Original panel in site museum. (Photo copyright of Roberto Piperno)

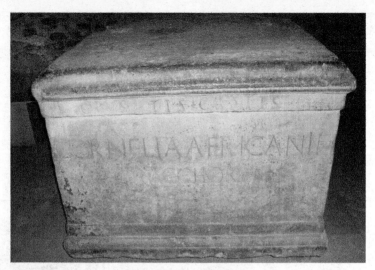

Above: 17. Inscribed base of statue dedicated to Cornelia, the mother of the Gracchi, *c.* 100 BC. Forum Romanum, Rome. Musei Capitolini, Rome. (Photo courtesy of the author)

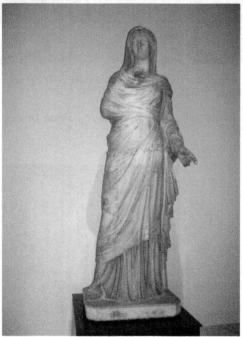

Left: 18. Statue of Eumachia in the form of the Large Herculaneum Woman type. Pompeii. Augustan. Museo Archeologico Nazionale di Napoli. (Photo courtesy of the author)

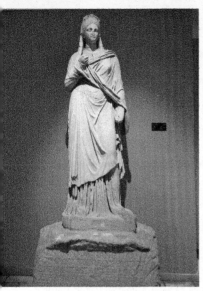
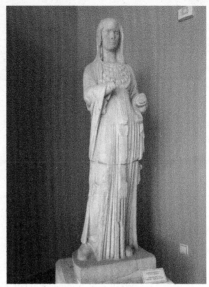

Left: 19. Statue of Plancia Magna of Perge. Antalya Müzesi, Antalya, Turkey, *c.* AD 120. (Photo copyright of Carl Rasmussen of www.HolyLandPhotos.org)

Right: 20. Statue of Aurelia Paulina of Perge. Severan. Antalya Müzesi, Antalya, Turkey. (Photo copyright of Linda Davis)

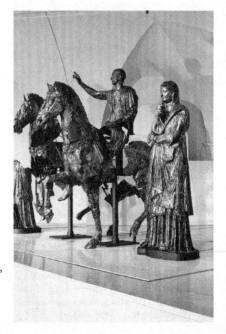

21. The conserved Cartoceto bronzes on display in the Museo Archeologico Nazionale delle Marche, Ancona. End of first century BC to early first century AD. (Photo courtesy of Soprintendenza per i Beni Archeologici delle Marche)

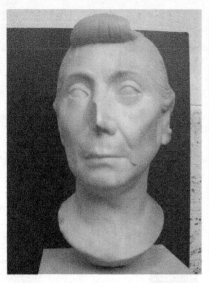 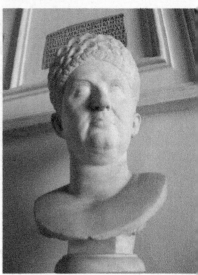

Left: 22. Portrait bust of older woman. Colle Fagiano, Palombara Sabina, Rome. 30s BC. Museo Nazionale Romano, Palazzo Massimo alle Terme, Rome. (Photo courtesy of the author) *Right:* 23. Portrait bust of older woman. Rome. Late Trajanic. Musei Capitolini, Rome. (Photo courtesy of the author)

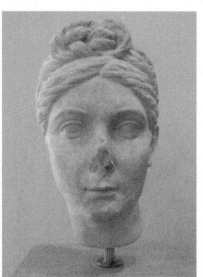 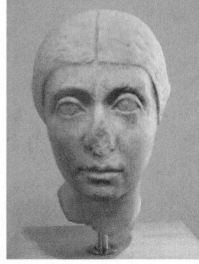

Left: 24. Portrait head of young woman. Tivoli, near Rome. AD 117–138. Museo Nazionale Romano, Palazzo Massimo alle Terme, Rome. (Photo courtesy of the author) *Right:* 25. Portrait head of young woman. Cinecitta, Rome. Mid-second century AD. Museo Nazionale Romano, Palazzo Massimo alle Terme, Rome. (Photo courtesy of the author)

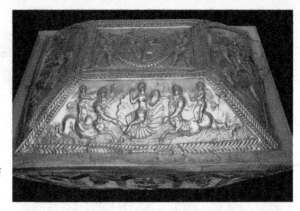

26. Detail of the lid of the Projecta Casket. Esquiline Treasure, Rome, *c*. AD 380. British Museum, London. (Photo copyright of the Trustees of the British Museum)

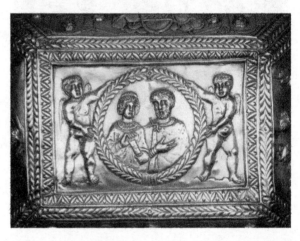

27. Detail of the top of the lid of the Projecta Casket. Esquiline Treasure, Rome, *c*. AD 380. British Museum, London. (Photo copyright of the Trustees of the British Museum)

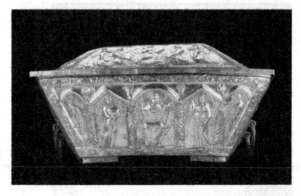

28. Detail of the scene of a lady at her toilet on the side of the Projecta Casket. Esquiline Treasure, Rome, *c*. AD 380. British Museum, London. (Photo copyright of the Trustees of the British Museum)

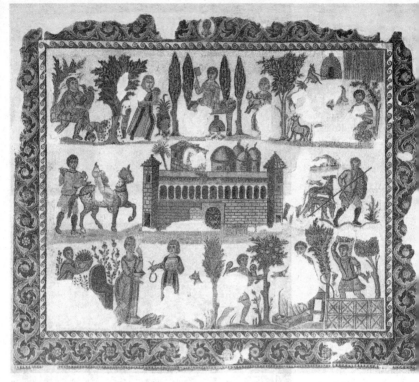

29. The Dominus Julius mosaic from Carthage, including scenes involving the mistress of the estate. Late fourth century AD. Musée National du Bardo, Tunis. (Photo courtesy of the Agence de Patrimonie Tunisie and the Musée National du Bardo, Tunis)

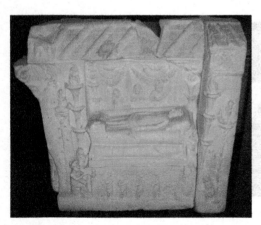

30. Lying in state scene. Tomb of the Haterii, Via Casilina, Rome. Late first century AD. Musei Vaticani, Rome. (Photo courtesy of the author)

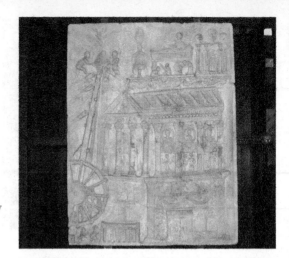

31. The tomb-crane scene. Tomb of the Haterii, Via Casilina, Rome. Late first century AD. Musei Vaticani, Rome. (Photo courtesy of the author)

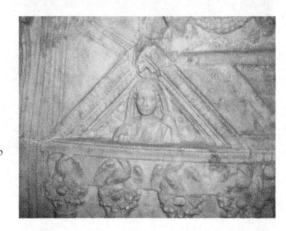

32. Detail of the veiled woman in the tomb-crane scene. Tomb of the Haterii, Via Casilina, Rome. Late first century AD. Musei Vaticani, Rome. (Photo courtesy of the author)

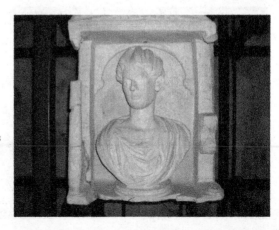

33. Portrait bust of the deceased wife of Quintus Haterius. Tomb of the Haterii, Via Casilina, Rome. Late first century AD. Musei Vaticani, Rome. (Photo courtesy of the author)

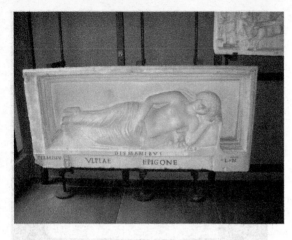

34. Funerary relief of Ulpia Epigone, Rome. Late first or early second century AD. Musei Vaticani, Rome. (Photo courtesy of the author)

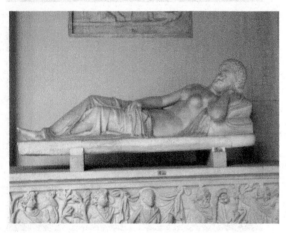

35. Sarcophagus lid bearing a reclining or sleeping woman in the guise of the naked Venus. Flavian. Musei Vaticani. (Photo courtesy of the author)

36. Sarcophagus lid bearing a reclining or sleeping woman in the guise of Venus holding a pomegranate, *c.* AD 140. Musei Vaticani. (Photo courtesy of the author)

37. Tomb of Caecilia Metella, Via Appia, Rome. First century BC. (Photo courtesy of the author)

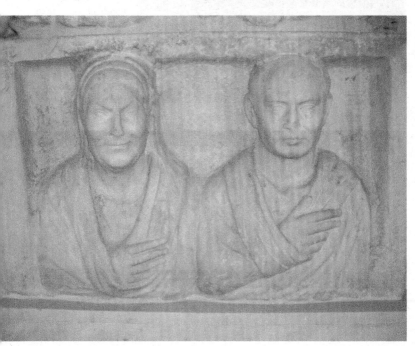

38. Funerary window relief with Roman couple at front. Rupilii family. Early Augustan. Musei Capitolini, Rome. (Photo courtesy of the author)

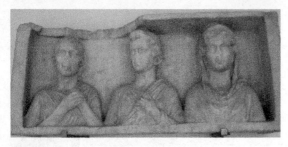

39. Funerary window relief of Roman family of three. Early Augustan. Palazzo Altemps, Rome. (Photo courtesy of the author)

40. Funerary window relief of Roman family of three. Mid-Augustan. Musei Vaticani, Rome. (Photo courtesy of the author)

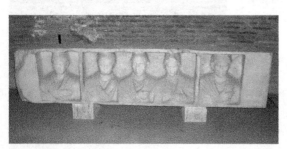

41. Funerary window relief of Roman family of five – three men and two women. Via Appia, Rome. Museo Nazionale Romano, Terme di Diocleziano, Rome. (Photo courtesy of the author)

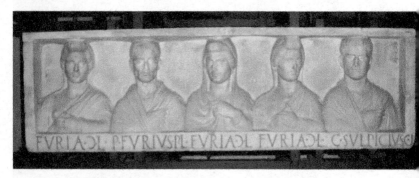

42. Funerary relief of Roman family of five. Mid-Augustan. Musei Vaticani, Rome. (Photo courtesy of the author)

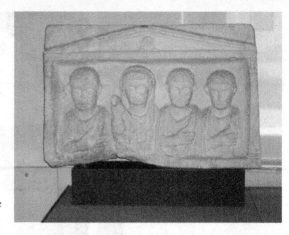

43. Funerary relief of provincial Roman family. Mid-first century AD. Brescia. Santa Giulia Museo della Città, Brescia. (Photo courtesy of the author)

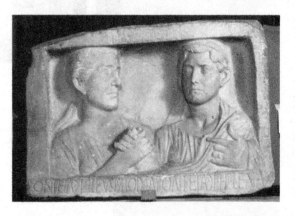

44. Tombstone of freedwomen Fonteia Eleusis and Fonteia Helena from Rome. Augustan period. British Museum, London. (Photo copyright of the Trustees of the British Museum)

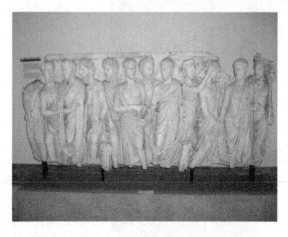

45. Sarcophagus of the Brothers. Detail of marriage scene with *dextrarum iunctio*. Mid-third century AD. Museo Archeologico Nazionale di Napoli. (Photo courtesy of the author)

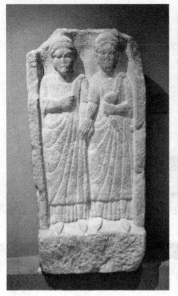

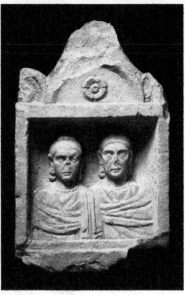

Left: 46. Stele of two women from Horbourg-Wihr, Alsace. Second to third century AD. Musée Unterlinden, Colmar. (Photo courtesy of Musée Unterlinden, Colmar, France)

Right: 47. Tombstone of two women from Lyon. Second to third century AD. Musée Gallo-Romain de Lyon. (Photo courtesy of the Musée Gallo-Romain de Lyon, C. Thioc)

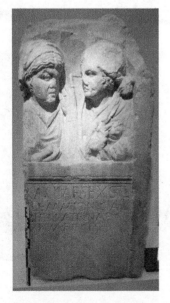

48. Tombstone of Tyrrania Philematio from Arles, also depicting Chia. First half of first century AD. Musée Départemental Arles Antique. (Photo courtesy of Musée Départemental Arles Antique. Copyright M. Lacanaud.)

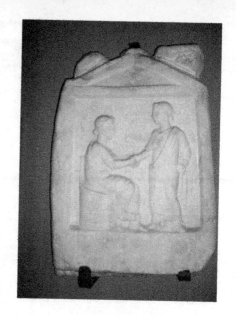

49. Funerary relief depicting two women. First century BC. Herculaneum. Museo Archeologico Nazionale di Napoli. (Photo courtesy of the author)

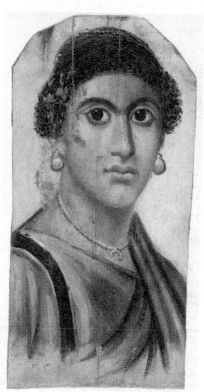

50. Mummy-portrait of a Romanised woman from Hawara, Fayum, Egypt. AD 55–70. British Museum, London. (Photo copyright of the Trustees of the British Museum)

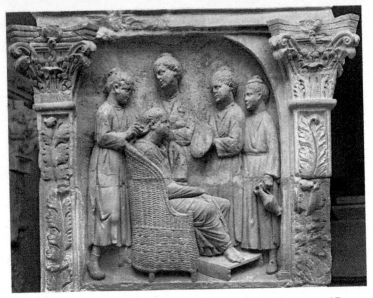

51. Funerary relief of a woman's toilet. Elternpaarpfeiler, Neumagen. AD 235. Rheinisches Landesmuseum Trier. (Photo copyright of Rheinisches Landesmuseum Trier)

Left: 52. Grave stele or tombstone of eighty-year-old Flavia Usaiu from Gorsium, Hungary, *c.* AD 130. Tác-Gorsium Archaeological Park. (Photo courtesy of the slide archive of the former School of Continuing Studies, Birmingham University)
Right: 53. Tombstone of Valeria Severa from Aquincum, Pannonia. First half of the second century AD. Aquincum Múzeum, Budapest, Hungary. (Photo courtesy of BHM Aquincum Museum, Collection of Photographs, Inv. No.: 2000.14.4)

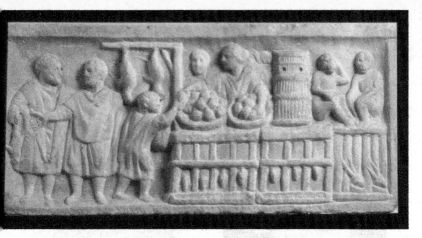

54. Relief of a female poultry seller from Ostia. Late second century AD. Museo Ostiense. (Photo copyright of Scala Firenze)

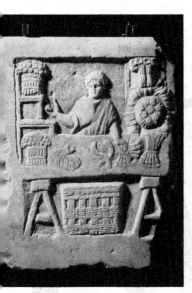

Left: 55. Female vegetable seller from Ostia. Late second century AD. Museo Ostiense. (Photo copyright of Bridgeman Images)

Right: 56. Female shoemender or cobbler from Ostia. Second century AD. Museo Ostiense. (Photo courtesy of the slide archive of the former School of Continuing Studies, Birmingham University)

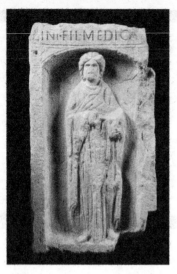

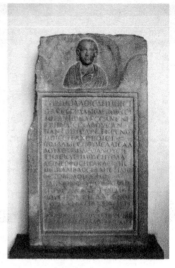

Left: 57. Funerary stele of a female doctor or *medica*. Second or third century AD Musée de la Cour d'Or, Metz. (Photo copyright of Lauriane Kieffer- Musée de la Cour d'Or-Metz Métropole) *Right:* 58. Tombstone of the mime Bassilla from Aquileia, northern Italy. First half of the third century AD. Museo Archeologico Nazionale di Aquileia. (Photo courtesy of Museo Archeologico Nazionale di Aquileia and the Soprintendenza per I Beni Archeologici del Friuli Venezia Giulia)

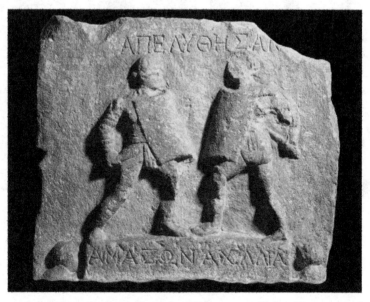

59. Relief of two female gladiators from Halicarnassus, Turkey. First to second century AD. British Museum, London. (Photo copyright of the Trustees of the British Museum)

60. Crouching Venus with a cupid. Mid-second century AD Roman copy of a fourth-century BC Greek original. Museo Archeologico Nazionale di Napoli. (Photo courtesy of the author)

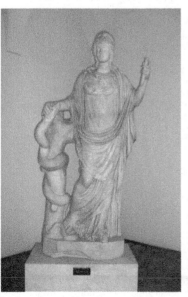 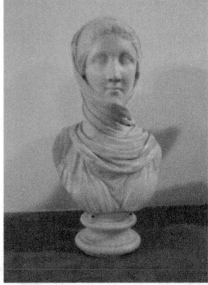

Left: 61. Statue of Ceres/Demeter. Roman copy of Greek original of fourth century BC. Palazzo Altemps, Rome. (Photo courtesy of the author) *Right:* 62. Head of Vestal Virgin. First century BC to third century AD. Museo Archeologico Nazionale di Napoli. (Photo courtesy of the author)

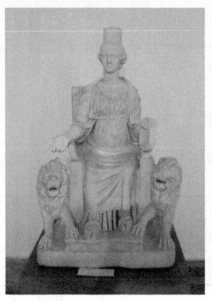 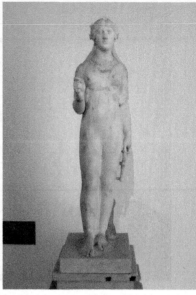

Left: 63. Statue of Cybele dedicated by Virius Marcarianus. Third century AD. Museo Archeologico Nazionale di Napoli. (Photo courtesy of the author)

Right: 64. Statue of Isis. Temple of Isis, Pompeii. First century BC to first century AD. Museo Archeologico Nazionale di Napoli. (Photo courtesy of the author)

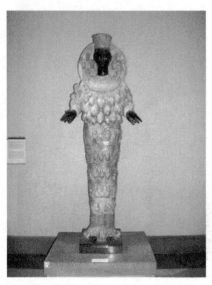

65. Statue of Artemis Ephesia. Second century AD Museo Archeologico Nazionale di Napoli. (Photo courtesy of the author)

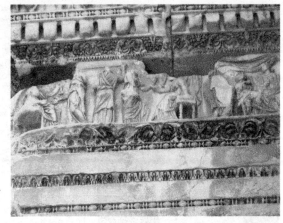

66. Detail of the frieze on the Forum Transitorium, Rome, showing women engaged in textile working. AD 80s–90s. (Photo courtesy of the author)

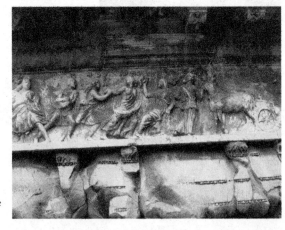

67. The Rape of the Sabine Women on the frieze from the Basilica Aemilia, the Forum, Rome. Modern cast of original of 14 BC. (Photo courtesy of the author)

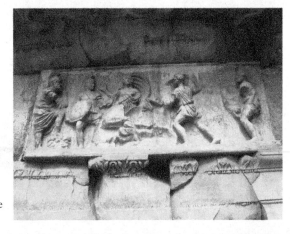

68. The Punishment of Tarpeia on the frieze from the Basilica Aemilia, the Forum, Rome. Modern cast of original of 14 BC. (Photo courtesy of the author)

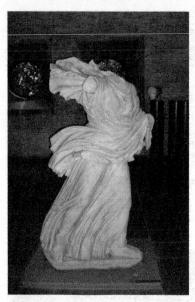

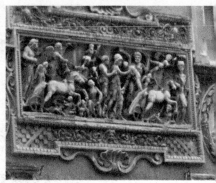

Left: 69. The Chiaramonti Niobid statue. Second century AD Roman copy of a Hellenistic original. Musei Vaticani, Rome. (Photo courtesy of the author)
Above: 70. Sarcophagus depicting the Rape of Persephone. Third century AD. Palazzo Mattei di Giove, Rome. (Photo courtesy of the author)

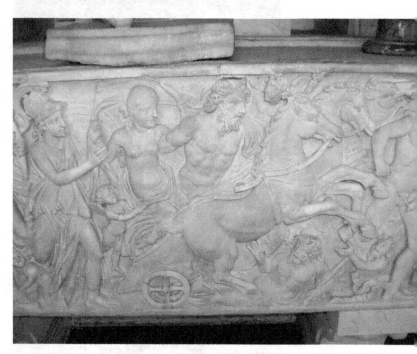

71. Detail from sarcophagus depicting the Rape of Persephone. Third century AD. Musei Capitolini, Rome. (Photo courtesy of the author)

72. Wall painting from the Tomb of the Nasonii, Via Flaminia, Rome depicting the Rape of Persephone, *c*. AD 150. British Museum, London. (Photo copyright of the Trustees of the British Museum)

Left: 73. Funerary statue of Omphale dressed in Hercules's lionskin. AD 210–220. Musei Vaticani, Rome. (Photo courtesy of the author) *Right:* 74. Statue of Victory in Piazzale della Victoria at Ostia. Replica. Late first century AD. (Photo courtesy of the author)

75. Lifesize bronze statue of Victory from the Capitolium, Brescia, Northern Italy. First or second century AD. Santa Giulia Museo della Città, Brescia. (Photo courtesy of the author)

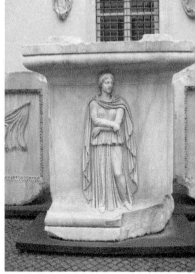

Left: 76. Statue of Pudicitia. Musei Vaticani, Rome. (Photo courtesy of the author)
Right: 77. Personification of Gaul from the Hadrianeum in Rome, *c.* AD 145. Museo del Palazzo dei Conservatori, Rome. (Photo courtesy of the author)

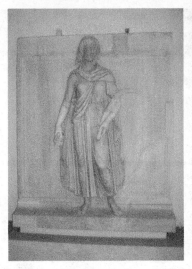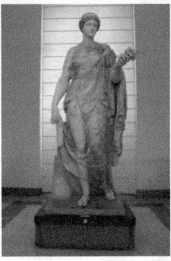

Left: 78. Personification of Thrace from the Hadrianeum in Rome, *c.* AD 145. Museo Nazionale Romano, Palazzo Massimo alle Terme, Rome. (Photo courtesy of the author)

Right: 79. Massive statue of Flora from the Baths of Caracalla, Rome. Second century AD. Museo Archeologico Nazionale di Napoli. (Photo courtesy of the author)

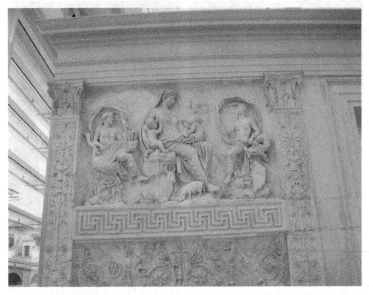

80. Figure of Tellus or Roma on the Ara Pacis Augustae, Rome. 13–9 BC. (Photo courtesy of the author)

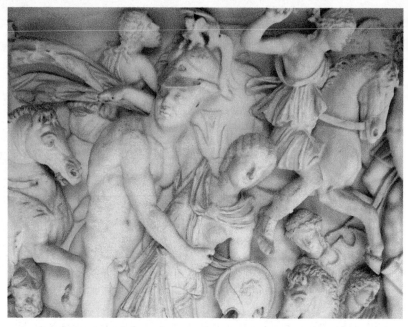

81. Detail showing Achilles and Penthesilea on a sarcophagus from Villa Giulia, Rome. Third century AD. Musei Vaticani, Rome. (Photo courtesy of the author)

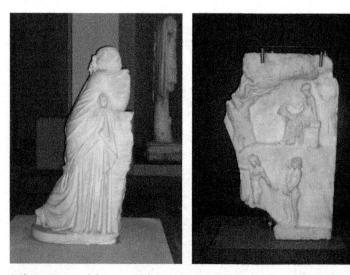

Left: 82. Statue of the Muse Polymnia. Copy of Greek original of second century BC. Via Terni, Horti Variani, Rome. Musei Capitolini, Centrale Montemartini, Rome. (Photo courtesy of the author) *Right:* 83. Relief of a Muse and a scene of Bacchic initiation. Copy of Hellenistic original. Horti di Mecenate, Rome. Musei Capitolini, Rome. (Photo courtesy of the author)

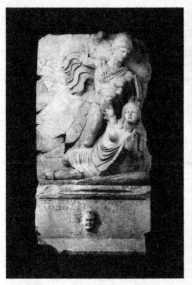

Left: 84. Relief of Claudius and Britannia from the Sebasteion at Aphrodisias. Julio-Claudian. (Photo courtesy of New York University Excavations at Aphrodisias (G. Petruccioli)) *Right:* 85. Relief of Nero and Armenia from the Sebasteion at Aphrodisias. Julio-Claudian. (Photo courtesy New York University Excavations at Aphrodisias (G. Petruccioli))

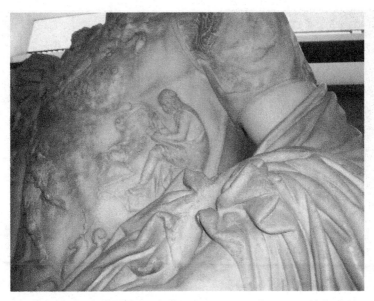

86. Close-up detail of mourning barbarian woman on the cuirass of the Prima Porta Augustus statue. Copy of original of 20 BC. Musei Vaticani, Rome. (Photo courtesy of the author)

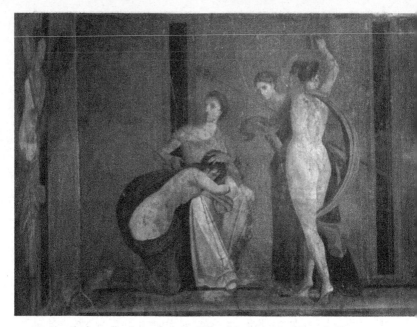

87. Detail of a wall painting from the Villa of the Mysteries, Pompeii. First century BC. (Photo copyright of Scala Firenze)

88. Female athletes on a mosaic pavement from the Villa Romana del Casale on Sicily, better known as Piazza Armerina. Fourth century AD. (Photo courtesy of the slide archive of the former School of Continuing Studies, Birmingham University)

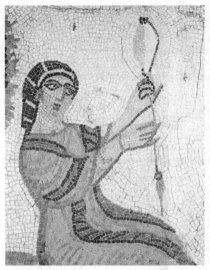

Left: 89. Detail of a woman spinning wool on a mosaic from Tabarka, Tunisia. Late fourth century AD. Musée National du Bardo, Tunis. (Photo courtesy of the Agence de Patrimonie Tunisie and the Musée National du Bardo, Tunis)

Right: 90. Young woman, Primilla, with jewellery box from Lyon. Second to third century AD. Musée Gallo-Romain de Lyon. (Photo courtesy of the Musée Gallo-Romain de Lyon, J.-M. Degueule)

91. Part of a Roman jointed bone doll from Ephesus, Turkey. British Museum, London. (Photo copyright of the Trustees of the British Museum)

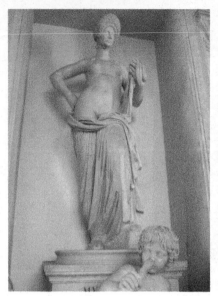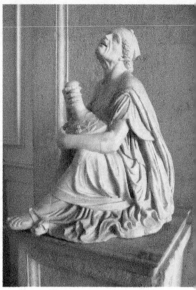

Left: 92. Statue of woman in the guise of naked Venus. First century AD Porta San Sebastiano, Rome. Musei Capitolini, Rome. (Photo courtesy of the author) *Right:* 93. Statue of elderly woman known as the Vecchia Ebbra. Roman copy of *c.* AD 280–300 of a Hellenistic original. Via Nomentana, Rome. Musei Capitolini, Rome. (Photo courtesy of the author)

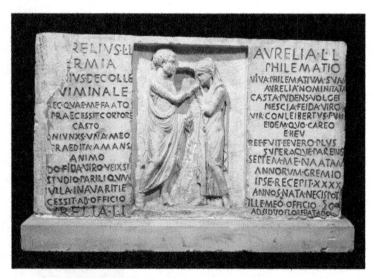

94. Inscribed funerary relief of Lucius Aurelius Hermia, butcher of the Viminal Hill, Rome, and his wife Aurelia Philematium. From Via Nomentana, Rome. First century BC. British Museum, London. (Photo copyright of the Trustees of the British Museum)

and slain her brothers. It was intended through this that she would remain barren. But this attempt to wipe out Numitor's line was inevitably thwarted by the actions of the gods, and Mars sought out Rhea Silvia and sired two sons with her, the twins Romulus and Remus. As a result, Amulius imprisoned Rhea Silvia and the twin babies were placed in a basket which was then thrown into the River Tiber. The basket floated to safety and the twins were found by a she-wolf, who suckled and nurtured them, and a woodpecker, who brought them food. Eventually the infants were discovered by the shepherd Faustulus who took them home and with his wife raised them to maturity. Subsequently the twins went on to found the city of Rome.

The story of Rhea Silvia can be seen represented in whole or in part on a number of Roman artworks, including, most significantly here, a sarcophagus in Palazzo Mattei di Giove in Rome; a relief on the Casali Altar in the Musei Vaticani, Rome, dedicated to Tiberius Claudius Faventinus, dating to around AD 200, on which are relief scenes focusing on the Trojan Wars and on Roman foundation myths; and on the famous Augustan Portland Vase, a cameo glass vessel in the British Museum in London, on which are depicted scenes of love and marriage, which may possibly include images of Mars and Rhea Silvia.

The Palazzo Mattei Rhea Silvia/Mars sarcophagus bears on its front a busy and dense depiction of the myth. Central to the scene is the figure of Mars striding towards Rhea Silvia as she is lulled into unconsciousness by Somnus who pours a sleeping draught over her from a horn cup. As Mars in his approach negotiates the figure of Oceanus and some mythical sea creature it must be assumed that he is crossing water to be with her. On the far left of the scene are three figures of deities, among whom are probably Vulcan and Venus and personifications of some of the seasons. A classical building on a hill, perhaps a temple, can be seen in the upper background, perhaps suggesting the city of Rome itself, which would arise in the not too distant future as a result of the chain of events being set in

train here. On one of the short sides of the sarcophagus is depicted the shepherd Faustulus. A fragment of another Rhea Silvia/Mars sarcophagus is in the collections of the Metropolitan Museum of Art, New York.

Myths were part of a formal system in Roman culture, as they have been and are in other societies, and would have been responded to or viewed interactively with one another and with other aspects of the overall culture, including its religions. While there was a shared base of Greco-Roman myth in Roman mythology, there was also an original Roman mythology of an altogether different nature in which many myths were historicised and presented visually, sometimes in startlingly original ways. These myths lived on their substance and derived their truth from the complicity of their viewers, who recognised their own story in them until new myths came along and the old images became so much dead wood and dry straw. Rather than simply being an illusionist creation, this mythology represented an armature of words and gestures out of which images were created and on which they fed. This was fundamentally about the metamorphosis of memory and feeling achieved through art.

Many of the images of women discussed in this chapter have in some way appeared in scenes of discovery or revelation, rather than simply having been passive representations. Conversely, the motif of sleeping men and women was quite common in both Greek and Roman art and had a significance of its own, particularly in the case of the depiction of sleeping figures on Roman sarcophagi. The most commonly depicted sleeping woman was Ariadne, daughter of King Minos of Crete, who famously dozed while Theseus abandoned her on Naxos; the most commonly depicted sleeping man was Endymion, who after crossing Zeus chose his fate as being condemned to sleep forever and to remain ever young. The common choice of images of sleep on sarcophagi seems particularly apposite as it represented the soul of the departed awakening to a new life with the gods. It represented a salvation of some kind or

even sacred marriage mediated by death. As has been noted, 'Sleep alters ... consciousness, repressing or totally nullifying rationality or changing the ordinary boundaries of thought. It may isolate [the sleeper] from society and often strengthens links to nature or to divinity.'[24] Sleepers, of course, can also be passive and at their most vulnerable in this altered state of consciousness. They sometimes became nothing more than objects, dangerously at the mercy or whims of others.

As has been demonstrated in this chapter, mythological tales could often be deployed in Roman art in a didactic manner, particularly with regard to the moral behaviour of Roman women. Whether the presentation of such obvious and blatant images had any effect in this regard cannot be known. While the messages might well have been understood, it does not necessarily follow that they were heeded. They would certainly have elicited different responses in male and female viewers, as would many of the images of goddesses and other mythological figures discussed above. In the next chapter I will therefore turn specifically to the issue of sexual morals and power in ancient Rome, of eroticism, voyeurism and the Roman male gaze, and how these too can be explored through the analysis of the use of images of women in Roman art.

7

THE MALE GAZE

The Politics of Sexual Desire

Anyone with only a passing interest in the Roman world will probably be aware of the fact that erotic and sexual images abounded in Roman art and that much of this art was at one time deemed too shocking and explicit to be openly displayed to the public. In this chapter I will consider the nature and context of eroticised and sexualised images of women in Roman art in terms of their viewing through both the male and female gaze and the meaning and reception of such images in different contexts. The theory of the 'male gaze' is of some interest here, as it may well have been that some images of women in Roman art were intended to be filtered or processed through the Roman male gaze or indeed will have been created purely and simply for male viewing, delectation or gratification.[1] Sometimes erotic or sexual images may also have been politicised and the relationship between male imperial power and female (sexualised) subjugation will need to be considered first.

Though erotic or sexualised images abounded in the Roman world, Roman sexuality was very different in character from twenty-first-century sexuality. That vision was an instrument and symbol of Roman male sexual power is without doubt, but viewers of many

Roman artworks could be both male and female. To some extent, the demonstration of restricted or limited access to certain erotic or sexualised images at this time might suggest the operation of power on behalf of the work's owner, especially if access was allowed or denied on gender grounds alone. The penetrability of space was a crucial factor in the display of sometimes explicit images.

The politics of sexual desire and of male dominance in the Roman world are two separate issues altogether. Erotic images that were politicised and public were very different indeed from those that were public but linked to the commercialisation of sex and again from those that were private rather than public erotic images. Much has been made of the theory that the Augustan city of Rome was to some extent an architectural model of phallocentricity, even down to the ground plan of its forum. Whether this was indeed the case is open to debate. How would a woman feel living in a phallocentrically designed city and moving through its public spaces? How might the form of such a city have affected the display and reception of works of art there that bore images of women?

There is an undoubted link between eroticism and power in certain works of Roman imperial art, most significantly on a number of the marble reliefs found in the Sebasteion at Aphrodisias in modern-day Turkey, a temple to the imperial cult at the time of the Julio-Claudian emperors. Panels depicting Claudius conquering Britannia and Nero conquering Armenia could be read as object-lessons in the visualisation of male imperial potency, though other, more benign interpretations of these scenes are also equally possible.

The religious context may have been significant here. Roman state power was further codified and strengthened through religious rites and control of 'foreign' goddesses such as Cybele. The highly overt female sexuality of the goddess as originally conceived was turned around on itself by Roman usurpation and control over her story and the religious rituals of her cult. This sexuality almost became a metaphor for Roman imperial power and its expansionist nature and became more explicit in terms of ritual symbolism as the

religious vision was further distorted over time in new territories and in new contexts.

As far as I am aware I was the first person to suggest that the Claudius and Britannia panel depicted a virtual rape caught in stasis and that this said a great deal about Roman male imperial power. When I made this observation during the delivery of a paper on Roman–barbarian relationships at a conference in 1994 I was vigorously challenged by a leading Roman-art historian whose work I generally admired but whose writings often veered towards antiquarian connoisseurship. I was apparently casting unnecessary aspersions on the civilized Romans, according to his argument, almost as if the Romans at war were nothing more than the equivalent of a japing amateur cricket team on tour.

The first of these two reliefs, Claudius and Britannia, as named in the inscription on a plinth below, is the most complete (see image 84). The figure of Claudius dominates the scene and is portrayed in what is known as 'heroic nudity'. He towers over the female figure, a personification of the province of Britannia, and with his left hand grasps or pulls her hair at the back of her head, thus pulling up her head ready to receive a blow from a weapon held in his right hand, though both the weapon and the emperor's right forearm are now unfortunately missing, so that his original stance and attitude cannot be fully reconstructed. One of the emperor's legs is hidden behind Britannia's body, but his stance suggests that he could be bracing her body against this leg, which he is driving into the small of her back. With his other leg he is kneeling on her thigh in an attempt to pinion her body down. The expression on the emperor's face is perhaps both determined and cruel. Britannia lies partially sprawled on the ground, apparently stunned and overwhelmed by the ferocity of the onslaught, but still appears to be trying to fend off Claudius with her raised right arm. Her right breast is exposed. On her face is an expression of evident pain and an almost stunned resignation to her fate.

It seems inconceivable that the role playing depicted here was

not obvious to the contemporary viewer: that the Roman emperor in the guise of a Greek hero or god was a man for all that and that the personification of a conquered province in the guise of a mythological Amazon was a woman underneath all this pictorial, metaphorical subterfuge. I have suggested that no matter how many layers of allegorical and symbolic meaning are heaped upon this work in order to understand and interpret its message, once they are stripped away there remains what is a profoundly disturbing event caught in stasis.

If simply territorial conquest is shown here by the action of a male figure battering a female figure, then this must surely be a statement of some kind, at once both startlingly direct and yet deliberately allusive and oblique, about attitudes to Roman imperial actions and policies and to conquered lands and peoples and, finally, of course, about contemporary male attitudes to women. The scene might also be considered to be the prelude to a sexual assault, in addition to a physical assault, and to the rape of the woman. Certainly, the hair pulling, the pinioning with the knee and the striking of a blow to the head could suggest such a culmination to this act of 'conquest'.

The Nero and Armenia relief is more damaged and therefore less complete (see image 85). Again, the emperor appears in heroic nudity, looming over the female personification of the conquered province. She is virtually naked and only the fold of a thin cloak is draped around her neck. Both of her breasts are bared. She is slumped either in a faint or at the point of death, her head lolling to one side and her body partially supported by the hands of the emperor.

Arguing to some extent against my interpretation is the broader geographical and specific architectural contexts of the Aphrodisias reliefs, produced and commissioned in a locale far from the centre of Roman power, in the Greek east of the empire where a marrying of Roman themes and concerns with a Greek sensibility might have dictated their form.[2] Sponsored by two local elite families, the Sebasteion was profusely furnished with artworks. The two individual

reliefs discussed here were but two out of over 200 reliefs from the building complex, comprising three main series of representations: *ethnos* reliefs, or peoples of the empire; gods and emperors; and myths and heroes. There were also honorific statues inside the building as well. Thus it might be possible to see the overall artistic scheme as representing the deployment of innovative strategies of imperial portrayal almost in a grand Hellenistic style that located the Roman emperors in a continuum of Greek mythological heroes. For instance, it has been suggested that the scene of the emperor Claudius overcoming and conquering Britannia represented a variation on the common image trope of Achilles slaying Penthesilea or indeed mirrored another depiction elsewhere in the Sebasteion of a Greek warrior grasping the hair of a falling Amazon.

But, of course, these two reliefs are not altogether unique and can indeed also be seen in the broader context of depictions in Roman imperial art of violence against women and of the commonly employed trope of female abduction and rape in Greek and Roman art.

The most common mortal woman portrayed in Roman imperial art in all media was the generic barbarian woman (see image 86).[3] In the earlier Roman Empire, before what could be called the Aurelian watershed, that time around which attitudes to barbarian peoples seem to have hardened, there may have been more of an emphasis, in terms of numbers of appearances on public monuments, on the use of more mixed-gender images of barbarian groups and peoples. It can be suggested that in some depictions of barbarian couples, the fact that the man was bound or in chains and the woman remained untied, in a mournful or dejected pose, indicated a definite strategy of suggesting barbarian male aggression and female passivity, for the woman evidently posed no threat and was therefore not constrained. All the more extraordinary, then, was the depiction of the Dacian women torturing Roman prisoners on Trajan's Column.

When barbarian couples were depicted, this would seem to have been a way of staking out some element of common ground, of a

common humanity between the Romans and the barbarian peoples portrayed. An absence of such pairings could be construed as the opposite – a declaration of a state of complete otherness. As well as sharing common humanity with the Roman couple, the barbarian couple, though defeated and often shown dejected and distraught, could then be transformed by the incorporation of their land into the empire and subject territory of Rome. While they themselves may not have become citizens, their children and their children's children may have achieved such a status, perhaps through the service of a son in the auxiliary units of the Roman army. A people defeated by Rome was not necessarily a despised people. However, the wars fought by Marcus Aurelius were not wars of incorporation as such, though he may have hoped to eventually create new provinces in captured lands, and therefore it is this spirit of civilising Romanitas that is missing from the depictions of warfare and of violence against barbarian women on Marcus's column. There may have been a sense to the male gaze that these women were somehow colluding in their own subjugation and objectification.

Of the individual images of barbarian women suffering violence found in Roman art, the most noteworthy individual violent motifs pre-dating the Column of Marcus Aurelius occur on the Gemma Augustea, an Augustan court cameo, where the so-called hair-pulling motif is employed in the depiction of a barbarian woman being pulled along by the hair by a Roman soldier and on the two reliefs from the Aphrodisias Sebasteion already discussed. The harrowing scenes of desperate warfare and depictions of violence against women on the Column of Marcus Aurelius, including another hair-pulling scene, represented an altogether different conception of the boundaries of taste in visual representation of imperial policies. That there is always sexual tension and sexual violence between the men of an invading or victorious force and the women of a conquered area is unfortunately and sadly true for all conflicts, both ancient and modern. While the hair-pulling scenes on the Gemma Augustea, the Claudius and Britannia relief and the Column of Marcus Aurelius

were isolated examples in Roman art, they may have derived from the hair-pulling motif in a mythological battle on the Altar of Zeus at Pergamon and could thus be construed as being stock Greco-Roman images. Nevertheless, they were used in contexts which, in the case of the Augustan example, denoted a generalised state of mistreatment of a captive and, in that of the Antonine image, a more-focused use in the context of the fate of female victims in the German campaigns of the time. The Aphrodisias depiction of Claudius physically overcoming and conquering Britannia was an image that denoted one version of the nature of the relationship of the male conquerors with the female conquered, between whom sexual and social boundaries were perhaps deemed not to exist.

The most intensive use of images of barbarian women suffering from Roman military violence occurs on the Column of Marcus Aurelius where it perhaps provides an insight into the Roman male imperial psyche.[4] Many of these barbarian women portrayed were mothers, and the interaction between these mothers and their children and between some of these mothers and Roman soldiers was often portrayed in quite fraught images of violence and of the threat of impending violence. These scenes can be divided up into four categories, the first being scenes of actual physical violence against barbarian women, including the killing of some women, the second being a scene of the aftermath of a possible rape or sexual assault, the third being scenes involving the physical manhandling of women and children, or their mistreatment as they are taken prisoner, and the fourth and final category being scenes of women in captivity and their transportation away from the area, presumably into slavery in Rome and elsewhere.

There are two definite instances of the depiction of barbarian women being killed in Scene XCVII on the column, following a battle. A third possible killing appears in Scene XLIII, although in this instance the actual killer blow is not depicted as it happens; rather, it would appear to be about to be struck by a Roman horseman during the sacking of a German village. The depiction

of the terrified woman in an almost diaphanous robe, which clings to her legs and hips as she runs for her life, the material billowing out with her movements, is like an image of an eroticised dancer, perhaps a Maenad, rather than a victim of war. The killing of these barbarian women is shocking in its ferocity and understatement and perhaps also surprising, given that captured women would have been valuable to the Romans as slaves.

The scene that perhaps shows the aftermath of a possible rape occurs on the column in Scene CII, a composition that is again centred on the portrayal of the destruction and burning of a German village. As huts are set ablaze by a Roman soldier holding a flaming torch, other soldiers proceed to capture, bind and lead away the men of the village. On the right hand side of the scene stands the solitary figure of a woman holding the shoulder of a small girl standing at her feet. The woman's dress is pulled completely off her shoulders and her upper body is exposed and naked. With her other hand she is holding up her ripped dress and has managed to bring it up sufficiently to cover her breasts and secure some modesty. It is difficult not to view this woman as the victim of a sexual assault by one of the Roman soldiers sacking the village. Here, the rape of the woman was being equated with the rape of her people by the Romans and the rape of their village and homeland.

Scenes involving the physical manhandling of women and children or their mistreatment are more numerous than killing scenes and include further hair-pulling scenes, as well as more general depictions of mistreatment and herding of captives. Taken together, these scenes seem to be suggesting that war is inevitably something that affects all society, and that women and men are equally affected, even if victims rather than active protagonists. Portrayal of such events without the masking and filtering gauze of allegory or allusion was something quite new and revealing in Roman art. A comparison with the scenes involving women on Trajan's Column is instructive. There, barbarian women were captured or taken as hostages. They were present at scenes of siege and to the rear of

battle, but nowhere were they shown being mistreated or killed as part of the general routine of war, as seems to have been the message on the Aurelian Column. The only jarring scene involving women on Trajan's Column was one showing Dacian women torturing captured Roman soldiers, a scene so extraordinary in that context that it can be interpreted as probably relating to a recorded, notorious incident from the Dacian wars or as an allusion to the inherent cruelty of Dacian and barbarian women in general.

The scenes of violence against women on the Column of Marcus Aurelius do not represent the portrayal of soldiers somehow out of control, of the breakdown of military discipline, but they do represent perhaps the first portrayal on a Roman imperial monument of what some have called the collateral damage of war, a more honest portrayal of the carnage and randomness of war. Was this a return to some earlier modes of the portrayal of Roman conquest by the use of the metaphor of sexual conquest as in the Sebasteion reliefs? The masculine sexual conquest of feminised space in both cases had a very real, non-metaphorical dimension. We are seeing here a political landscape that was also the setting for the human body, observed almost with a clinician's eye as it underwent trauma, as it was anatomised, penetrated, cut, crushed and humiliated. This body landscape was also an image of itself, a mass-media projection made up of female erotica and news footage of the wars of Roman conquest. Exploring the psychic fallout of all this horror and violence, a new logic was needed which would explain all these events, with bloody apocalypse being not some kind of abolition but more a transfiguration. There is an underlying sense that a more primitive world was biding its time, that there was no past, no future and a diminishing present in a transforming but still deeply conservative society that did not know, but was perhaps coming to realise, that its past was all it had.

Despite having written an extended study of Roman–barbarian interrelationships a few years ago, it had escaped my attention until relatively recently that it became fashionable for first Roman imperial

women and then presumably elite women to wear hair extensions or false hairpieces made from German barbarian women's hair, at least in the early empire.[5] Whether the hair was cut off women forcibly or willingly sold to Roman merchants is uncertain. This extraordinary phenomenon quite literally represented conquest and imperialism on a very personal micro-scale. Whether, when worn by imperial women, the visual and physical response of their menfolk was one of voyeuristic, vicarious excitement can only be guessed, though of course the imperial women could themselves have experienced similar feelings of power through adding such pieces to their costume repertoire.

It was noted above and in Chapter 6 that depictions of abductions leading to rape were quite common in Roman art, as in the popularity of depictions of the abduction/rape of Persephone in funerary contexts for instance. While it might be true to say that rape was perhaps being used here as a metaphor for the violence with which death can carry us off, with a promise of some type of return from Hades as achieved by Persephone herself, the underlying violence of the action and its suggestion of a state of social and sexual disorder still remained at the heart of both the image and the metaphor.[6]

When viewed in isolation, individual images representing abduction or rape stories from Greco-Roman mythology or from Roman historico-mythology might be viewed as metaphorical. However, when viewed in the broader context of Roman art, so often dominated as it was by depictions of warfare, battle, hunting and the celebration and commemoration of male achievement and power, abduction or rape scenes might be thought of as having been part of an overall narrative of male dominance, of a cultural male hypersexuality.

By implying that rape was about to take place in such images rather than depicting rape itself, a boundary was usually established in matters of taste. Indeed, it might have been possible for Roman women viewers to place some positive spin on these at first sight wholly negative images, particularly as these were generally individual women portrayed and not anonymous signifiers of

female powerlessness. The abduction and rape of Persephone did not define her; indeed, her place in mythology relied as much on her escape and afterlife as it did on her suffering. She was never allowed to forget what had happened and was forced to remember by being fated to return to the underworld for part of each year for ever afterwards. Again, in the case of the Sabine women they eventually came to accept their fate.

Erotic and Sexualised Images of Women

Many erotic images from the Roman world have already had a pejorative value placed on them by the way that they have been treated with kid gloves by antiquarians and archaeologists in the past, being placed in restricted museum collections such as the so-called Secretum, or Secret Museum, at the British Museum or the Gabinetto Segreto, or the Secret Cabinet, in the Museo Archeologico Nazionale di Napoli.[7] Such acts immediately placed such objects beyond the bounds of open scholarship and into the realms of below-the-counter items of pornography. Many of these items still retain some negative value today as a result.

Perhaps the largest coherent group of erotic and sexual images in the Roman world in the form of wall paintings come from the site of Pompeii in Italy, buried under the debris resulting from the eruption of Mount Vesuvius in 79 AD. But the graphic images of sexual activity in the brothels and some private houses of Pompeii, in public as well as in private locations, represent a body of evidence that is difficult to interpret as a whole. The key to decoding the meaning of these images often depends on their being treated as individual images whose significance is almost entirely dependent on context rather than as a coherent structured group 'from Pompeii'. Again, as a group they do not necessarily tell us about an all-encompassing 'Roman sexuality' but rather about the sexuality of individuals in one Italian town at one particular period, and possibly about the buying and selling of sex in some cases. Images from buildings which are interpreted as brothels cannot be discussed

alongside erotic images from private houses and I will attempt to keep discussion of them separate here. Such images might in some cases have been intended to be erotic or stimulating, others might have had a didactic purpose, while others still could have been intended to simply be amusing. It must be made clear that erotic images can include representations of male-to-male lovemaking as well as male to female lovemaking, but it will be the latter category of image that is concentrated on here.

Erotic or sexual images from Pompeii have been found in a number of public buildings, as opposed to private houses, though the actual functions of each of these public buildings have been a matter of considerable debate among archaeologists. John Clarke, in his magisterial study of 1998, *Looking at Lovemaking: Constructions of Sexuality in Roman Art 100 BC–AD 250*, noted that thirty-five individual buildings at Pompeii had at one time or another been suggested to have been brothels – *lupenaria* – a figure that he maintained was ridiculously high.[8] Clarke felt more comfortable with only one of these buildings being a large formal brothel, with nine more smaller establishments being in operation as well; the other twenty-five public buildings boasting erotic or sexual murals he suggested to have been drinking or eating establishments. I will follow Clarke's reasoning here.

The large brothel occupied the property in Insula VII at Pompeii known to archaeologists as VII.12.18–20 and consisted of five ground-floor rooms and five on the upper floor above. The clientele and the prostitutes themselves would appear from the evidence of graffiti to have respectively been freedmen and both male and female slaves. The erotic or sexual paintings in the property were restricted to just six painted panels above the lintels of doorways giving access into private cubicles. John Clarke sees some of these scenes as representing the clients' potential range of fantasies set in luxuriously appointed bedrooms and taking place on soft, well-upholstered beds rather than on the stone beds in the brothel's cramped, claustrophobic and sordid cubicles.[9] Along with a seventh

panel depicting a figure of Priapus with two phalluses, they consist of a male and female couple, the man in bed, the woman standing beside the bed, both caught admiring and contemplating a picture of lovemaking themselves; a male and female couple on a bed engaged in lovemaking, with the woman on top; a male and female couple on a bed engaged in lovemaking with the man on top; and three scenes presenting variations on a male entering a woman from behind, perhaps up the anus.

While these scenes may well have had some degree of promotional value, letting waiting clients see the exciting range of services on offer at the brothel, rather more banally they might have been simple distractions to entertain clients while they sat waiting for their turn in the stark cubicles. John Clarke's view that these were fantasies of class envy and sexual aspiration is intriguing; that the brothel's poorer clients aspired to undertake their lovemaking in the kind of plush surroundings in which elite men sported and romped at leisure, and perhaps to make love to the refined and classically beautiful women pictured here who would remain forever out of their league, as we might say today. John Clarke believes that these brothel murals 'have as much to do with evoking elite values as they do with depicting sexual acts ... [and] elevate to high ideals what was surely rough-and-ready sexual commerce'.[10]

Another Pompeian building where erotic or sexually themed wall paintings have been found is the Caupona of the Street of Mercury in Insula VI. Here, four such paintings were represented out of the thirteen pictures adorning the tavern walls. Images of sexual acrobatics involving well-endowed men vied for the viewer's attention here alongside images of drinking, eating and gambling. In one of the erotic scenes, a surprisingly nonchalant woman pours herself a glass of wine while being penetrated from behind by a well-endowed man who too holds a wine glass with his admirably steady free hand. Perhaps rather than once more being adverts for sex for sale, sex here was simply being presented as one of a number of enjoyable leisure activities that might have some call on

the time of the Pompeian man in the street. The emphasis in these pictures appears not to have been on the domination of the women by the rampant men but rather the physical ridiculousness of the men's members. John Clarke has suggested that these scenes are either of comic sexual mimes or are simply intended to be somehow humorous.[11] In all probability, there will have been women involved in the running of this bar and there will also undoubtedly have been female customers; therefore, the joke, if that is indeed what it was, will have been intended to be shared by both men and women together.

The same cross-gender appeal might therefore also have been intended for the erotic or sexual murals in the dressing room of the suburban public bath house outside Pompeii's walls off Via Marina. There is certainly nothing to suggest that the bath complex was a men-only establishment or that this particular room was reserved for male bathers, so the murals here again need to be interpreted in the light of their having been viewed by both men and women, though not necessarily at the same time. That this room had been recently redecorated and the erotic scenes painted over shortly before the destruction of the city is interesting, but it is impossible to interpret this as a possible change in the owner's sexual attitudes. Rather, it simply may have been the result of a decorative makeover.

The paintings consisted of sixteen pictorial vignettes, eight on the south wall of the changing room and eight on the east wall, unlinked scenes rather than snapshots together forming a consistent narrative, which together with painted numbers on the walls possibly acted as aide memoires to the bathers to help them locate the lockers in which they had left their clothes. The vignettes on the east wall are no longer extant and were never recordable. Those on the south wall depict a woman and man caught in coitus, with the woman sitting on top of the man; a man entering the woman in a more conventional manner; a scene of fellatio; a scene of cunnilingus; a possible scene of lesbian lovemaking; a threesome, involving a man penetrating another man who in turn penetrates a

woman on a bed; a foursome, involving a man penetrating another man who in turn is being fellated by a woman who in turn is having cunnilingus performed on her by a second woman; and in the eighth and last vignette a naked man with enormous testicles stands by a table reading a scroll.

John Clarke has read this programme of paintings as a sequence of increasingly absurd sexual encounters which would have both outraged and amused its viewers at the same time, rather than an exercise in the semiotics of sexual deviancy.[12] His contention that men and women would in all likelihood have taken away different things from their experience of viewing, whether as individuals or by viewing and discussing the pictures with a group of friends or relatives, seems beyond doubt. Whether the now-lost paintings in sequence on the east wall would have repeated this formula in some way, or even upped the ante in terms of challenging public perceptions of sexual acceptability and attempted to similarly provoke amused outrage, cannot ever be known. What is certain is that there appeared to be no attempt here to depict or glory in female discomfort and degradation or to present an ideological programme that promoted the primacy of male power over women by sexual exploitation. Clarke indeed has suggested that some of the female images were larger in scale than the images of some men and that some of the males appeared awkward or ridiculous in their postures or bearing. There is no hint of violence or oppression in the images from the suburban baths at Pompeii. Men and women were depicted both taking pleasure or giving pleasure, with no evidence to suggest that sex was being bought or sold in any of the paintings or that the baths were the venue for sexual congress in all the various forms depicted here.

If the clientele of the baths were not from the town's elite class, perhaps they were being invited to laugh at the absurdity of the elite's prescriptive views on the tastefulness and acceptability of certain sexual practices, as suggested by the works of various contemporary writers, or at least a public avowal of practices that

might after all have been pursued avidly behind closed doors in the town's elite houses, as will now be considered.

Erotic or sexual images come from a number of private elite houses in Pompeii and objects bearing sexual symbolism come from even more. It would certainly not be viable, feasible or useful to try to list all of these here, so I have chosen instead to concentrate discussion on a small number of instances where the depiction of women engaged in sexual practices of some sort, or depicted in a sexualised way, allows some new interpretations to be made about the position of women in elite Pompeian society and the construction of sexual identities either by them or for them. Discussion will therefore be centred on wall paintings in the House of the Beautiful Impluvium, the House of Caecilius Iucundus, the House of the Centenary and the House of the Vettii. Once more I will be relying on the sophisticated contextual discussion of these images presented by John Clarke in his groundbreaking book.

In the compact House of the Beautiful Impluvium, named after its striking ornamental water tank in its atrium, in Pompeii's Insula 1, erotic wall paintings featured in the house's *cubiculum* or bedroom, though only one of the painted panels survives. The content of the picture is remarkably tame, indeed rather coy, when compared to the more explicit pictures we have been discussing from some of the town's public buildings, and depicts the prelude to male and female lovemaking. A man lies back on a bed, one arm bent behind his head. His naked body is more or less hidden by the body of the woman who is caught in the process of climbing up onto the bed beside him. Her garment has slipped off her shoulders, indeed has fallen to a position around her thighs, exposing her buttocks and the long sensual curve of her bare back. She moves to caress the man, her head caught in profile as she returns his amorous gaze. If any kind of power differential can be read between the man and the woman depicted, it is suggested that the work is very much catering to the male gaze and male sexual desire, with any inspection of the man's body being denied the viewer.

In the House of Caecilius Iucundus, a freedman, a number of extremely well-executed wall paintings based on sophisticated themes have been recorded, including a judgement of Paris and one depicting the mythological tale of Theseus abandoning Ariadne on the island of Naxos. That a painting with an erotic or sexual scene should also come from here is of great interest in terms of what the complete decorative scheme of the house might tell us about its male owner. John Clarke sees the erotic picture here not as an aberration to be explained away against the evidence of the other paintings but rather as an integral part of the overall artistic programme whose aim was to present the house's owner to his visitors as someone with good taste and elite pretensions, a Pompeian social climber.[13]

The erotic panel was located on the peristyle wall of the house between the *triclinium*, or dining room, and a *cubiculum*, or bedroom. The action of the painting takes place on a bed in a comfortable, indeed opulent *cubiculum*, and depicts a scene of heterosexual lovemaking. A male figure lies back on the bed and reaches out either to grasp the hands of a naked woman or has just released his grasp on her hands. She has her back to him and is posed as if she has been sat on his lap or is about to sit on his lap, with the man therefore having entered her from behind or being about to do so. Plush fabrics drape the bed and the woman wears gold bracelets and earrings, indicating beyond any doubt that we are witnessing a scene of lovemaking involving a well-off couple. So far all very titillating for the viewer, whether male or female. I must depart from John Clarke's interpretation of the male-female dynamic here in that I do not feel that his suggestion that the woman is somehow openly resisting the man's sexual advances holds up at all. However, setting the possible motives of the couple aside for the moment, the viewer may well have been surprised and taken up short by the fact that there is a third person in the room with the amorous couple. She stands towards the foot of the bed on its far side. John Clarke sees her as a bedroom servant, a *cubicularius*, but other interpretations of her role may well be possible.[14] Unusually, Clarke has little more

to say about this shadowy background figure, though he maintains elsewhere in his book that bedroom servants would most likely have been present in the *cubiculum* even during lovemaking, suggesting that the presence of the girl is simply a signifier of elite aspirations on Caecilius Iucundus's behalf. I find this difficult to agree with.

But what then what might she be doing here if Clarke is not correct in his assumption? Has she just walked into the *cubiculum* unaware of what is going on inside and is taken aback by surprise? Has she been summoned into the *cubiculum* for some reason by her mistress? Does she represent us, the viewer coolly observing the lovemaking on the bed? Or is she perhaps a third party in some sex game? Does her gender in any way alter the balance in the interpretation of the scene?

Let us deal with these questions in order. Firstly, her appearance in the *cubiculum* unannounced and unaware of what was happening in there might account for the man and woman rapidly decoupling, as they appear possibly to be doing. Their mortification at this intrusion, this discovery, this revelation, might be the theme of the picture rather than it being an erotic or sexual scene per se, and that theme might have been intended to be in some way amusing. With regard to the second question, if the female servant has been summoned into the room, then the mistress arising to talk to her would make sense; hence the uncoupling in progress. However, had the mistress needed something it would surely be more likely that she would have got out of bed first, put on some clothes, and covered up her bed-prone lover before summoning her *cubicularius*. Thirdly, if the serving girl was simply a cipher acting as the eyes of the viewer, then one wonders why that cipher should take the form of a woman rather than a man; who, in that case, was the intended viewer of this picture? To address the fourth and fifth questions together, if the girl was being invited in or ordered in to make up a sexual threesome or to watch her master and mistress make love, then not only was she potentially being exploited because of her young age and her gender but of course she was being subjected to the exploitation of

the unequal relationship between master or mistress and servant or slave. To acquiesce to such a request would have been to recognise the hopeless nature of such a power differential and to submit to male dominance. Again, had the servant girl been a non-Roman slave then yet another layer of complexity would have been added to the mix.

In terms of parallels for a scene of a servant being in some way involved in their owner's lovemaking we need look no further than the scenes on the famous silver vessel known as the Warren Cup, now in the British Museum in London. The great difference in the case of the Warren Cup is that the servant is viewing a scene of homosexual lovemaking.

Another private Pompeian house with erotic wall paintings is the extremely large House of the Centenary in Insula IX. Here the paintings were on the walls of a secluded room where the need for privacy was underlined by the difficulty of gaining access into the part of the house where the room was located, except by one of the house's occupants or their servants. In this room, the principal painting was of a sleeping Hercules. The accompanying erotic panels were of heterosexual lovemaking, both depicting women squatting over recumbent men positioning themselves to be entered, one woman facing her lover and the other with her back sideways on to him.

Finally, in the House of the Vettii in Insula XV wall paintings depicting commercial activity attest to the professional business of the brothers who owned the property, such scenes being mixed with the more usual and acceptable depictions of scenes from classical myths. Yet in this lavish house it almost comes as a surprise to find one of the ground-floor rooms, next to the kitchen, decorated with erotic or sexual paintings. Three heterosexual couplings were depicted: a by now familiar scene of lovemaking with the woman on top, straddling her partner; a scene of a woman partially reclining while a man lifts one of her legs over his shoulder and enters her; and a scene which is so badly deteriorated as to be virtually

indistinct. It would be altogether surprising if this room, with its quite poorly executed paintings, was intended for use by the house's owners. If it had been decorated this way for the benefit of the house's servants, this might reflect the potentially indulgent nature of the Vettii brothers who, although now wealthy and aspiring to elite aesthetic standards, nevertheless had a number of well-painted amusing erotic pictures and a sexualised statue elsewhere in the house, perhaps having not shed a coarse sense of humour, even if their money could now potentially buy them the best. Perhaps the most famous of these ribald paintings is that of the god Priapus using a set of balance scales to weigh his huge member against a bag of coins. Here a highly satirical comment was being made on both the nature of commerce and on an associated hypermasculinity that equated the size of one's penis with the size of one's moneybag. Priapus also stood in statue form in the fountain in the peristyle pissing water into the pool as if pissing money. Hermaphroditus appeared on two walls.

Thus, of the private houses discussed here we can perhaps ascertain that different attitudes to sex and sexual mores existed in each house, not necessarily reflecting the situation in the broader population of the town. In the House of the Beautiful Impluvium, the wall painting was titillating rather than overtly erotic but still suggested a male gaze turned on a passive female body. In the House of Caecilius Iucundus, I feel that again some male-centred power fantasy was being played out here, rather than John Clarke's more benign view of the image involving a servant girl. In the House of the Centenary, the surviving erotic pictures once more seem to have been aimed at male viewers who might have been particularly interested in female partners taking the lead in sexual activity while the man could take a passive role. Finally, it can be suggested that the indulgent and still perhaps uncouth Vettii brothers encouraged, indeed rewarded, a leading servant in their house with the decoration of a room in their quarters with erotic wall paintings. If that servant was male then the male power and dominance of the master was

here being transferred down the line in some way, while if female there might not necessarily have been a concordance between the hypersexual fascination and interest of the brothers and their female servant. We will all in our lives have met tedious men in positions of power who want others to share in inappropriate and smutty jokes.

Male Gazing

Throughout this book, and in this chapter in particular, I have drawn attention to a considerable number of instances in which the meaning of certain images could be wholly dependant on the gender of the viewer of the images, and that often images were created to be specifically consumed by the male gaze, creating both a complicity between men and an immediate power differential in terms of control between men and women. The manipulation of images of women in this way was especially prevalent and usually deliberate. It occurred in both the private sphere, as has just been discussed using case studies from Pompeii, as well as in the public arena.

For instance, we have seen that there may well have been some significance in the number of instances in which barbarian women appeared in Roman art, reflecting not only a distinct historical role for the female barbarian in the visual narrative of Roman history but also a very distinct perception of her in the minds of the viewers of these artworks.[15] The image of the female captive, either represented explicitly by the image of a barbarian woman and her fate, or implicitly by the use of female personifications in a way that was at odds with the original Greek conception of such figures, was a tellingly common motif. Its use related to the gendered nature of Roman imperial power as mirrored by the male gaze of many of the viewers of such images, and almost certainly also testified to a fear of female transgression and unsuitable behaviour, both by barbarian women and by the women of Rome and the empire.

Part of a strategy of defining acceptable female roles and behaviour in Roman society included the employment of mythological

exemplars in Roman art for didactic purposes. Under Augustus, for example, the appearance of depictions of the Rape of the Sabine Women and the Punishment of Tarpeia in the Basilica Aemilia would have sent a very clear message to its viewers about Roman and non-Roman relationships and about male–female relationships in Augustan Rome. Again, the sculptural frieze of Domitian's Forum, the so-called Forum Transitorium in Rome, concerned itself with mythological imagery used in an imperial context, images that were almost exclusively of women, something that was itself unusual. Here, encapsulated within images of the act of weaving, were ideas relating to the value and dignity of female creative pursuits – in this context a dignity and moral value defined and assigned by male imperial ideology – while Arachne was present as a warning of the potential fate of those women who transgressed. These were messages to the women of Rome, but a different interpretation of these images would have been possible depending on the sex of the viewer.

If the famous scene of Dacian women torturing Roman soldiers on the decorated frieze on Trajan's Column represented a rare example of explicit violence involving women being turned against Roman male power and thus affronting the male gaze, then it is difficult to know what would have been made by male and female viewers of a scene on part of a sarcophagus lid from the Catacomb of Praetextatus in Rome. Here is depicted what may well be the ritual flagellation of a woman, possibly at the pastoral festival of the Lupercalia or quite possibly flagellation being meted out to her as a punishment. If a punishment, she might have been expected to have been a slave or of the freedmen class. Though the lid bears the name [A]elia Afanacia this inscription may not be original to the sarcophagus. The scene is deeply disturbing and consists of a crowd of men who may be the *apparitores* or magistrate's assistants, gathered around a central group of two men who have caught hold of the naked or near-naked woman, one holding her by the ankles and the other under the arms. She is being laid out horizontally

with her back to the flagellant who with whip arm raised is about to bring the whip's tails down onto her bare flesh.

Some years ago, Barbara Kellum published an interesting paper called, 'The Phallus as Signifier: The Forum of Augustus and Rituals of Masculinity', which is of relevance here to the discussion of gendered messages encoded in the art and architecture of Rome. Kellum described Augustus's Forum as 'a sexually charged, gendered masculine environment' and discussed whether the ground plan of the forum was in fact deliberately intended to be phallic in shape as part of the overall scheme to celebrate Roman masculinity here.[16] Such an analysis could indeed have usefully been extended to the phallic-like obelisk that formed the pointer of the Horologium Augusti, the Augustan sundial in the Campus Martius that is now re-erected in Piazza del Parlamento. With the erection of the Column of Marcus Aurelius in around AD 192, the Campus Martius would then have been graced with four such thrusting phallic monuments – the Augustan obelisk, Trajan's Column, the Column of Antoninus Pius and Marcus's column – that perhaps together served to emphasise the potency of Roman imperial masculinity. Perhaps in such an environment the use of images of an eroticised Victory and eroticised but suffering barbarian women on Marcus's column was more understandable. Public space was here being dominated by a cityscape aimed at the male gaze, if you accept this theory.

We have seen that the Roman use of ethnic personifications, an artistic strategy adopted from Greek art, could be both positive and negative in intent and usage. However, it did not require a great deal of imagination to understand the implications inherent in the regular equation of a woman's body with conquered or subject territory, and it did not necessarily require that this equation be made as overly explicit as in the case of the Claudius/Britannia and Nero/Armenia sculptures from the Sebasteion at Aphrodisias. The same effect was achieved in the Hadrianeum in Rome without the images of these female personifications being sexualised or eroticised. In these two cases the first set of images would most certainly seem to

have been targeted at the male gaze while the second set were quite obviously gender neutral in intent and purpose.

In this chapter attention has been focused on sexualised and erotic images of women in Roman art, on themes of power and control and on the male gaze and its place in Roman visual culture when relating to images of women. While many of the images discussed have been somewhat negative in terms of presenting an unbiased image of women's sexuality to the Roman viewer, particularly in the case of images forming part of the rhetoric of imperial ideology, some of them have proved more neutral or accepting in the context of then contemporary mores.

8

REALITY AND IMAGE

Strength in Numbers

In a number of the previous chapters discussion has tended to focus on images of individual women or of women in relation to men – as their mothers, wives, daughters or sisters. Here, the opportunity will be taken to discuss images where groups of women were involved in some gendered communal activity portrayed in almost hermetically closed environments where the female group and perhaps its inherent solidarity is suggested by both the composition of the images and by their contexts. If women were largely denied a public role in the Roman world and derived their status from marriage, wealth and the management of the family and home, then religion and ritual allowed them a degree of active participation denied them in other fields of their lives and might have allowed or facilitated the gaining of power and social prestige that otherwise eluded them.

An Etruscan tomb painting from The Tomb of the Dancers at Ruvo di Puglia, Bari in Southern Italy, and now in the Museo Archeologico Nazionale in Naples, presents us with an image of female ritual and solidarity of a kind seldom found in the later Roman period. The painting of these dancing women with linked arms dates to the end of the fifth century BC. It raises the question

as to whether the position and status of women in other Italic societies were altogether different from within Roman society or whether in this instance we are seeing a specifically female ritual being depicted or indeed one in which the women of this particular society controlled ritual practice or part of ritual practice.

The scene brings to mind the much better-known fresco of a dancing woman from the Villa of the Mysteries at Pompeii. I am particularly fond of these paintings as I once won a bottle of champagne in a national newspaper competition by correctly identifying a fragment of the dancer's arm from this fresco. There is certainly not an academic consensus as to the meaning of the famous wall paintings in Room 5 of this Pompeian house, and it is unlikely that there ever will be (see image 87).[1] However, certain conclusions can be reached in terms of identifications of individual figures in the paintings and the broad meaning of the scenes. It would certainly appear that depicted here was a Bacchic ritual, the induction and initiation of a number of young women into the mysteries of the cult of Bacchus or Dionysus ahead of their marriage. Bacchus/Dionysus was the Greco-Roman god of wine, of viticulture, the celebration of his rites by his followers involving ecstatic celebration achieved through alcoholic consumption, music, dancing and general carousing.

The order in which the scenes of the ritual were intended to be viewed is now not necessarily obvious, though it is likely that the viewer would have been expected to start by examining the depiction of the women listening to the reading out of some document, perhaps sacred texts of the cult. They would then have moved on to view the scene involving the preparation and partaking of a ritual meal, followed by that of a woman startled by the appearance of Bacchus himself and an increasing strange turn of events as a ritual phallus was revealed and an initiate was whipped as a Maenad danced nearby. Finally, presumably after the Bacchic revels had been concluded, the viewer would have looked at the image of a woman dressing her hair, perhaps in readiness for her

wedding. That certain rites of passage, including cultic initiation and a wedding, were referred to in the paintings is indisputable.

An attempt has been made by one academic to analyse the ground plan of the villa to discover whether the room with the cultic fresco was potentially a public or a private room, and to further investigate whether the room could be considered to have been a gendered space, that is more-or-less restricted to female occupants of the house and women visitors.[2] She concluded that Room 5 was indeed one of the least accessible in the whole house and was therefore a private space and, following on from that, concluded less convincingly that access even by household members was probably infrequent.

Another scene of a group of women engaged in some communal activity can be found on the female athletes mosaic pavement from the Villa Romana del Casale on Sicily, better known as Piazza Armerina (see image 88). Often dismissively referred to as the 'bikini girls' mosaic, it is dated to the fourth century AD. The ten women depicted on the mosaic are involved in athletic activity of some kind: one lifts weights, two are engaged in sprint or relay running, another prepares to throw a discus and two play a ball game. Whether this scene needs interpretation beyond its obvious depiction of female athletes in training is debatable. It has been suggested that these women were in fact dancers at the games represented on other mosaics at the villa but this is uncertain.

One can run through a list of the most highly decorated civic monuments in Rome and throughout its empire and count numerous representations of emperors, male senators, soldiers and citizens in the artworks. However, few mortal women appeared on these monuments, as was discussed in Chapter 2, and the question therefore needs to be asked why this was the case and whether the absence of women or under-representation of women was a specific strategy for marginalising their true role in society. A fear of the general unpredictability, individuality and irregularity of the crowd affects many state authorities at some time or another,

though often they may seek recourse to the unity and single-minded determination of the chorus or the bought solidarity of the claque. It is just the latter situation which might be thought to apply to the motives for the two principal depictions on imperial monuments of numbers of mortal, non-imperial women, both monuments being linked to the emperor Trajan.

On the helical frieze adorning Trajan's Column in Rome is a particularly telling scene (Scene XXXVI) in which Trajan and his entourage are shown entering a provincial town, probably in Moesia, on his way to war in Dacia. The emperor is greeted by a large and enthusiastic crowd of men, women and children. To paraphrase Natalie Boymel Kampen, who first made this observation, the presence of women and children in the crowd here stresses the importance of a civilised and protective environment for the town's community, for these families especially, under the rule of Rome.[3] It suggests a guarantee of future prosperity in both the public and private spheres. Here the childless (infertile?) Trajan, as in contemporary panegyrics, was also being portrayed as the father of the country by his visual association with children and women. The same applies to the decorated Trajanic arch at Benevento in Southern Italy where another image of imperial potency relied on the depiction of the presence of the (fertile) women and children in the crowd receiving *alimenta* or free grain to underpin it.

Recurring Images

Another theme highlighted in this book has been the significance of the recurring image, both in terms of the replication of a particular statue type and replication of a stock pose or attribute. In the case of the recurring statue type, discussion has focused on the Large Herculaneum Woman and on the curious trend of Roman matrons' heads being attached to nude bodies of the goddess Venus. As to recurring poses or motifs, the three most significant would appear to be the presentation of images of women either with mirrors or jewel caskets, or with weaving equipment of some kind (see image

89). Indeed, both containers and weaving equipment sometimes acted as metaphors for women themselves.

In Chapter 3 discussion of jewellery boxes or caskets was focused on the Projecta Casket and the Trier ceiling panel as case studies. Another interesting example is provided by the funerary monument of Primilla, daughter of Terentius Pritto, from the Trion area of Lyon in Gaul (see image 90). This particular sculpture, now in the Musée Gallo-Romain de Lyon, is interesting in that Primilla was a younger woman rather than a matron. She was depicted wearing a necklace and earrings, caught in the act of taking out another necklace from the small jewellery box she holds in her left hand. The scene could be symbolic of the womanhood that Primilla unfortunately and tragically did not attain due to her early death, thus introducing another potential meaning for this already significant motif.

There is no doubt that boxes and containers were important items of material culture in a Roman woman's world and this accounts for why they were often shown in use in Roman images. Not only were these everyday utilitarian objects but they could also hold a symbolic value connected to the defining of female domestic space and sometimes quite specifically to weddings. Women used such containers to tidy up and help create order among their possessions, they guarded more valuable possessions when locked away inside, whether these were of monetary or sentimental value, and they held the jewellery or cosmetic products with which women helped to create their public selves through private preparation and adornment. However, if a container represented women's space then it can also perhaps have represented confinement or containment within that space. Through Greek mythology various stories had come down to the Romans in which containers of some kind had played a part, such as the story of Pandora, while baskets or chests also had links with female religious or cultic activity such as in the Eleusinian Mysteries.

Elsewhere in this book examples of the depiction of caskets on caskets have been discussed, most significantly on the magnificent

silver Projecta Casket. This self referencing and intertextuality would appear to have been a way of stressing female isolation, seclusion and inner strength. If a casket or box was depicted as being open, it is possible that some contrast between openness and confinement was being made, between revealing and concealing. The moment of opening a box – the reveal – is a moment when outside and inside are one, where interior space and exterior space are merged. If scenes on caskets or boxes of women preparing and adorning themselves might then sometimes be interpreted as having been preparations for a forthcoming or impending wedding, then the image of a box on the box in this context might be thought to have referred to both the owner's personal possessions over which she had control in the female space of the Roman home, and their portability in terms of being a part of that house that she was bringing with her to the new marriage abode. Similarly, with the importance of family in Roman society it might be seen that the woman was not only about to take the step towards marriage but possibly also towards motherhood. The woman here was herself analogous to a container, waiting to be filled with a growing baby. 'Through the metaphor of containment, women and their fertility are ascribed three important connotations: concealment with overtones of withholding, treasure, and mystery, all tinged with sexuality and undercurrents of anxiety.'[4] Thus a simple container could have acted as a reference to the start of the life cycle and also perhaps in some cases to its end, with the cremated remains of a deceased person being deposited in a cremation casket.

Repeated images of women also, of course, appeared on many items of portable material culture, most notably as miniature heads or busts forming the heads of hairpins of various material, including metal, bone or ivory and jet. These miniature women's heads often sported fashionable contemporary hairstyles. Again, there was a layer of intended intertextuality here in the form of images of women's hairstyles on hairpins which may themselves then be used to create similar hairstyles for real women. Such hairpins could have

become heirloom pieces, handed down from mother to daughter and so on, part of the process of the defining of social status or of female rites of passage.

The deliberate use of such repeated images not only invited discussion but facilitated it. Familiar artistic motifs or common tropes, once established, tended towards inertia. They attracted exegesis which swirled about them, making the viewers an audience which needed to engage thoroughly with them in order to be informed. Nevertheless, copying and repetition had a numbing comfort and yet a strange newness which could be intellectually satisfying without recourse to originality or constant reinvention. In summary, it can be seen as a code of representation of the world which retained its validity whatever may have been the form or medium employed. Illusions such as this were necessary and essential for the maintenance of society.

Bodies in Pieces
Attention will now be turned to an altogether different kind of female image, that of the sick woman, evidence presented below taking the form of anatomical or medical *ex votos*, models or representations of female body parts made in various materials, dedicated at healing shrines or sanctuaries throughout the Greco-Roman world, and statuary and dedicatory inscriptions set up by or for women at healing sites.[5] Creation and use of such *ex votos* possibly had independent origins in Greece and the Italian regions of Etruria and Latium in the fifth and fourth centuries BC, but in Italy the dedication of anatomical *ex votos* had become a less-common custom by the first century BC, though it did occur as a manifestation of Greco-Roman practice at numerous sites elsewhere within the empire well beyond this date, of which the Gallo-Roman healing shrines of Fontes Sequanae at the Source of the Seine, near Dijon, and the Source des Roches at Chamalières, Auvergne, represent the best-known examples. Some sites seem to have dealt specifically with female medical problems and dilemmas

and curing specialisation for both sexes is attested at other sites. For example, in Roman Britain the site of a specialist healing shrine for women might have existed at Lydney Park in Gloucestershire.

Simone Deyts, in one of her studies of the remarkable collection of dedicated *ex votos* and statuary from the Sources de la Seine site, has tabulated and quantified the occurrence here of different kinds of representation in different types of material – stone, bronze, pipeclay and wood – and compared this assemblage with those from other Gallic healing sanctuaries.[6] At the Sources de la Seine there was a large number of representations of 'whole people', a total of 97 to 102 men, women, unsexed representations and swaddled infants. There were 212 busts and heads, 172 torsos and pelvises, a figure that included 25 female breasts or pairs of breasts, as well as a number of both male and female lower torsos with sexual organs, 57 internal organs, 149 legs and feet, 54 hands and arms, 119 eyes, a ratio of body parts to whole people of around 7:1. At the other three Gallic sites quantified by Deyts, that is Alesia, Essarois and Halatte, ratios of body parts to whole people were respectively 200:1, 11:1 and 2:1. Comparison of the Sources de la Seine assemblage with the assemblage of anatomical *ex votos* from the Italian Republican healing sanctuary of Ponte di Nona near Rome is also interesting, in that more internal organs and more individual representations of sexual organs, both male and female, appeared at the Italian site.[7]

At Ponte di Nona, the huge collection of mainly terracotta *ex votos* of body parts – over 8,000 were recovered by excavation in the mid-1970s – represented all the most common body parts found at such sites – over 1,300 heads, over 2,300 feet, just under 1,000 limbs, just over 600 hands, just under 400 eyes, 44 ears, 160 male genitals and 8 breasts – but also included 27 uteri, 7 models of intestines, a tongue, a mouth, hearts, kidneys and vaginas, which suggests a much deeper knowledge of human anatomy than seen at many other healing shrines.

Anatomical *ex votos*, along with other categories of *ex votos*

dedicated at religious sites, signified the making of a contract between a man or woman and their gods, in this case related to petitions for the restoring of health to a sick individual through divine intervention or in thanks for health having been restored in answer to a prayer or previous visit to the site. Every type of *ex voto*, anatomical or otherwise, related to an individual person. Anatomical *ex votos* obviously and very specifically related to that individual's body and in many cases to highly specific parts of that body. The emotion encapsulated in these medical or anatomical *ex votos* was fear: fear of sickness, fear of infertility, fear of social exclusion or ostracism and, of course, fear of death. These items were tools in strategies of fear management, containment and alleviation. The role played by anatomical *ex votos* in the process of seeking a cure at such sites and the significance of the representative body parts themselves must be viewed in the context of the special position of the sick in the classical world.

These anatomical *ex votos* were a kind of folk art which perhaps allows us to gain some insight into how the representation of the female body in pieces may have differed from that of the male. Individual items were metaphors for bodies and minds in crisis.

Bodies in Miniature
Again, folk-art images of women also appeared in the form of dolls in the Roman world (see image 91). Around 500 such dolls were recorded by 1987 when these were analysed in print as a group by Michel Manson.[8] Some of these dolls were made of terracotta or wax, but most were of wood, bone or ivory and were jointed. These were quite obviously not representations of babies for female children to play with; most had adult sexual characteristics and thus, if playthings, were intended as representations or images of adult women. Others had elaborate hairstyles or incised jewellery in the form of earrings, bangles or necklaces. Examples come from the whole period spanning the first century BC to the fourth century AD, but most of these date to the first to third centuries AD. One of

the most famous of these dolls was found in the nineteenth century during the building of the Palazzo di Giustizia, Prati in Rome, and was inside a sarcophagus containing the body of Crepereia Tryphaena, according to the accompanying inscription, a seventeen-year-old girl who probably died some time in the mid-second century AD. Not only was there the exquisite jointed ivory doll with its fashionable contemporary hairstyle but also a tiny key in the doll's hand to open a small casket of ivory inside the sarcophagus which contained the doll's own silver mirrors and ivory combs. The complexity of the intertextuality here, a model casket within a funerary casket and a model woman accompanying a real flesh-and-blood, but now-dead, girl to the grave, is fascinating yet impossible to fully understand or appreciate.

A bone doll from a burial at the infant cemetery at Poggio Gramignano, Lugnano-in-Teverina, Umbria in Italy, may have been a marker of the rite of passage into adulthood missed by the prematurely deceased girl buried with it.[9] A *kline* – daybed – funerary monument in the J. Paul Getty Museum in Malibu, California, is in the form of a reclining girl, the deceased, petting her small dog. Two toy dolls lie against the backrest of the couch on which she lies. The hairstyle of the girl suggests that the monument dates to the Hadrianic period, around AD 120–40. The question then arises as to whether these dolls were toys or whether like the Poggio Gramignano doll they were somehow more complex in their meaning. Play and ritual need not be mutually exclusive in any particular society and it is now widely recognised that dolls in some contexts 'can be active in establishing value systems and [in] constructing identities'.[10]

Defying Categorisation

The material presented as evidence for the various arguments in this book has, of course, been skewed towards representations of four main groups of women: Roman imperial women, elite women of Rome and the provinces, barbarian women and mythological

women. Working women from Rome, Italy and the provinces formed a lesser group in terms of numbers of images apparently produced. Nevertheless, analysis of these five groups of images has suggested that female gender was not a fixed cultural construction in all contexts, either geographically or chronologically. The meaning of such images was also dependant on whether they were produced and displayed by women for other women to view and interpret, or by men for women to view. On top of all of this, the patriarchal structure of Roman society and of many Romanised societies in the provinces meant that many of the images viewed would have been filtered through the male gaze.

Many classic Roman tropes pepper the images so far discussed, but because the meaning of such images most probably shifted or altered over time and in different contexts they can sometimes elude the forensic approach of the archaeologist or art historian. Like emissaries from another world, they retain an odd mixture of focus and nonchalance but by a strange dialectic of exegesis and opacity they remain oblique. Warm feelings of pity and of passion course richly beneath the surface of their skin.

Mothers, wives, goddesses, battling Amazons, Victories, female gladiators, victims, redeemers, elite woman, empresses, Roman and provincial, town-bred and country-bred, embodiments of the nation or of society, embodiments of vice, the female image in Roman and Romanised society was a thing of almost endless variety. More darkly there were also images of women as victims sacrificed in the cause of male pleasure, objects of compassion or pity, of desire, of tender concern or of vicarious indignation. It would not appear that the rapid and profound transformation of Roman society and the Roman world led to changes in the number and variety of images of womanhood. Indeed, this great variety was there almost from the start of empire in the age of Augustus. Instead, some subjects and themes were diverted from their original or traditional meanings, others were emptied of their primary content, sometimes underpinned by new ideals, revitalised by a new

state of mind or carried to a quintessential extreme. If anything it was the proliferation of forms of representation in terms of the various media used to carry images and messages, from imperial monuments to knife handles and hairpins. Thus continuity, change and transformation ran side by side. Sometimes, though, where once there had been an idea, there was later just a pictorial tradition.

There was no one universal archetype of a Roman woman, if images in Roman art are to be believed. She was not after all just the Roman matron but rather a much more complicated series of figures than this. If it has done nothing else, this study has suggested that the category of 'women' has a multiplicity of meanings and definitions, dependant on context, as I have stressed throughout this book. This need not cause alarm or despondency for differences also can on occasion unite people in the way that sameness is always perhaps assumed to. The fact that the field of inquiry for this study is 500 or 600 years long suggests that we never should have expected to find an easy answer to the question of how the representation of women in Roman art might have reflected the workings of contemporary Roman society. While I have tried to group different types of images of Roman women thematically in this book, principally into imperial women, elite women, working women, non-mortal and mythological women and eroticised women, I could equally have adopted an alternative structure, in which the images were grouped according to themes of presence, absence, identity, inclusion, opposition, exclusion and marginality. All of these thematic abstractions have indeed been considered at different stages of the study and their examination has been seen to be a highly relevant theoretical platform for exploring the meaning of many images and the paradoxes behind many of them.

Rome itself was represented by a personification in the form of a woman – Roma – even if the city was founded by men. Conversely, either willingly or not, its women were Rome or of her family, imbued with the sheer grandeur of this idea, this ideal, the discovery of the world in the map of a woman's body. By allowing the creation

of a space in which images of other kinds of women could also be presented to the viewer and flourish in their imagination the central idea of Roma as woman and woman as Rome was actually strengthened. The Roman working women of Ostia and other towns were a function of the same society, were indeed human resources of and shaped by that society. They were not debauched or degraded by being turned into passive images of active lives.

To some extent, Roman imperial culture looked for powerful signs to represent its ideologies, and in a beloved woman, the demure, reticent and exemplary Roman matron found its perfect expression. In contrast, it also saw fit to celebrate a darker counterpart in figures of less moral certainty and more personal ambiguity. The image of the idealised woman excused or legitimised male mutability. Woman as transcendental and desirable, as a local spirit of place, was celebrated. The idealised woman, born of a river and of history, suggested Rome's association with nature, to form an explanatory figure. She was both society and nature, without there being any contradiction expressed about the possible incompatibility of the two. She belonged to sidereal time while most people had to deal in the quotidian. She helped allow a space in which politics, transgressive or not, might be practised. In an age of increasing political disorder, the female image was often unmistakably an imperative, beautiful and at one with nature. So very often the style, composition and subject matter of certain artworks were melded together in order to allow the viewer to look to the future, this being largely achieved by looking to the past.

Throughout this study examples have been given of numerous situations in which images of certain kinds of women were commonly placed in certain linked kinds of places, stressing the woman/nature duality that the figure of Roma herself encapsulated. Images of nymphs at springs or wells and by extension on fountains and in bath houses, images of maenads in gardens and country idylls, and so on. Small and medium private Roman gardens and courtyards became the repositories of such images, as did the great *horti* or

semi-estate gardens of the city of Rome itself, some in private hands, some imperial creations. A great deal of recent research on *horti* has been concentrated not only on the elucidation of the physical layout of these gardens and their plantings but also on their decoration, that is on the culture of collecting and commissioning of artworks specifically for display there.[11] Indeed, certain rooms in the Musei Capitolini in Rome have been revamped to reflect the results and significance of this research in terms of stressing the associations between artworks from certain *horti*.

Unlike art historians studying European art of the nineteenth and twentieth centuries, for instance, I have not had the luxury of being able to compare and contrast the representation of women and women's lives by male artists against that of female artists. Certainly, though, it has been possible to suggest instances where women have undoubtedly been artistic patrons and therefore probably directly involved in the commissioning of artworks and approval of their design.

The number of instances of metamorphosis, transformation and disguise encapsulated in so many of the images of women discussed in this book suggests that a sense of theatre or spectacle within the host culture relished the creation of such images, such masks. To reveal the true face would have been to reveal the skull beneath the skin. In interpreting this phenomenon perhaps reference should be made to the concept of 'the society of the spectacle', as espoused by Guy Debord and other members of the Situationist International.

Examples of this spectacle have included elderly empresses retaining the looks of their youth, dead empresses achieving immortality by becoming goddesses through apotheosis, the bodies of elderly Roman matrons being transformed into Venus (see image 92), the portrait faces of such women being used to turn them into figures such as Omphale, elite women in Rome, Italy and the provinces valuing sameness in statuary bodies and poses, two Roman women perhaps subversively undermining the definition of marriage in Roman society, a female gladiator channelling the character of

the hero Achilles, women's bodies becoming emblematic of cities and representations of sick parts of their bodies being dedicated to the gods.

This veritable theatre of transformations, role playing and archetypes relied entirely on the complicity of the viewer and on their knowledge of mythology in many cases. Even if it did remain uninterpreted by some viewers, the image still remained intact, if elusive in meaning. But it must be remembered that this role playing was not necessarily a strictly female preserve. One has only to think of the famous portrait bust of the emperor Commodus dressed as Hercules in the Museo del Palazzo dei Conservatori in Rome.

Roman society was a society which allowed for sometimes very significant transformations to take place, but in a strictly controlled manner, as for instance the transformation of a barbarian country into a Roman province and thus its inhabitants from barbarians to citizens, or slaves into freedmen and freedwomen. Some of these transformations were mediated through rites of passage and art provided an arena for role playing, role reversal or role projection, and often allowed women to transcend their more traditional roles. In the case of the medical or anatomical *ex votos* mentioned earlier in this chapter, they too marked the material manifestation of a desire to achieve transition from a state of sickness to a state of health.

Discussion in this book has primarily focused on images as reflections of identity and status in relation to female gender in the Roman world and it has been shown that there was a considerable degree of fluidity in how such images were created and consumed. Context and the knowledge of the viewer would have been of crucial importance. The examination of the presentation and manipulation of the images of the imperial women discussed towards the start of the book, with particular reference to the powerful and influential empresses Livia, Julia Domna and Helena, flagged up many of the themes pursued throughout the study. The importance of marriage in Roman society, of dynastic alliances, motherhood and family and of

political stability through continuity of purpose was often conveyed to the Roman people and the peoples of Italy and the provinces through the creation and deployment of carefully constructed images of the men and women of the various ruling houses. And yet on occasions all was not as it seemed to the viewer. Imperial images were, of course, highly influential, as has been shown by an analysis of representations of elite women on civic monuments and funerary monuments in Rome and the provinces sometimes echoing imperial strategies. Such images tell us a great deal about power, wealth, status and about the continuing significance of ethnic identities in the case of provincial women. The phenomenon of the portrayal of working women in the Roman world provides an intriguing contrast.

The widespread use and display of images of goddesses such as Venus and Ceres, female personifications such as Victory or of conquered provinces and mythological women such as Amazons or of a woman such as Niobe in various contexts, including major civic monuments in Rome, provides a remarkable series of insights into the Roman male psyche. In a number of instances, the metaphorical use of mythological representations of women to present moral and political lessons to the women of Rome was transparent enough to allow us to analyse these thinly disguised missives from the centre of power at Rome. Inevitably, such a strategy has led here to an examination of the concept of the Roman male gaze and the link between power and eroticism in imperial Rome. How this may have impacted on the reception of many of the images discussed in this book has been discussed at length. It is hoped that this study has successfully placed images of women in the Roman world in an understandable, broader cultural and historical context, including that of ancient sexual politics.

The Others

Although the Romans undoubtedly viewed barbarians as being 'other' in relation to themselves, and thus barbarian women as even further removed from their realm of understanding, I hope it

has not come through in any part of this book that I am suggesting that the Romans thought of their own women as being other in quite the same pejorative, negative and clear-cut way. Elite Roman women would seem to have been judged by elite Roman men first in terms of their status and familial relationships and thus would have been seen to be the same rather than other. When judged on their gender they were certainly seen as other in some way, but these two seemingly opposed judgements somehow needed to be balanced to create a more nuanced viewpoint. The exalted position in society of the Roman matron, of the bride, of the mother and of the virtuous woman argues for the manipulation of an ideological system for codifying female sexuality according to the creation of acceptable social roles for women. And yet in so many instances we have seen ways in which various images shattered this cosy consensus.

When I wrote a book on images of barbarians in Roman art many years ago I subtitled it 'Barbarians Through Roman Eyes' because the corpus of images assembled in the book for discussion told us more about the Romans in most cases than they did about barbarians.[12] These images were part of a strategy of self-definition through the depiction of the other. In other words the images were revelatory rather than documentary. Having now discussed female images in Roman art the same sort of question needs to be asked here. Did these images tell us nothing about Roman women as such and more about the Roman men who in many cases commissioned the images? Certainly many of the female representations discussed have been integral to the idea of self-definition or self-identification of others. It is certainly true that in many cases images of Roman women reflected Roman male attitudes. However, I do not feel that it would be altogether correct to say that in these cases Roman women were being treated or portrayed as being other, as some authorities have suggested. Rather, it would seem that there was a duality of mentality that allowed for both a narrative of difference to coexist with a narrative of similarity. Certainly, it would appear that this duality was reflected in literary sources around the turn of

the first century AD and it may be that the Augustan moral crusade centred on women's behaviour disrupted, interrupted and in some instances curtailed the more subtle dual narrative in Roman society. If men and women were seen to be at one in terms of intellect, morals and parenthood, as some writers at this time suggested, then this might account for the visual evidence which suggests that the rhetoric of otherness ascribed to some images of Roman women was not as widespread, insistent or unopposed as many have assumed. The two strains of rhetoric formed around a traditional, ideal stance and a more individualistic but realistic position. It has not caused me undue anxiety to renounce the theory of Roman woman as the other here because it refuses to obey facts.

If one thinks of the extraordinary funerary relief of the freedwomen Fonteia Eleusis and Fonteia Helena, presented for all the world to see in the guise of a married couple, and the two Gaulish women on the relief from Horbourg-Wihr in Alsace then it would seem that there was on occasions the opportunity for women to have themselves portrayed in a way that suggests that adherence to a narrative of otherness or permanent seclusion in the home is not necessarily proven to be universal. In this process, discovering was what mattered, not the discovery itself. If these were manifestations of a culturally determined expression of a new way of seeing or interpreting the world, then their attempt to explore the heady mix of fear, desire and yearning that evidently fuelled this imaginative artistic traffic was successful.

Such transformations were best seen at those times when public and private lives interpenetrated, as with the world of action and the world of the imagination. The lack of context for potentially transgressive images such as these means that to some extent we are lost in a strange region and have no map. But creative building upon cultural memory in this way perhaps marked a step towards new map making. The images were paraded before their viewers' eyes to be endowed with the appropriate topical or contemporary significance. The juxtaposition of banal reality and metaphor and

sometimes of hyperrealism and fractal distortion were deceptively conceptual, extrapolating truth and meaning from the position of subversive display.

Many of the artworks discussed in this book would have been commissioned either by members of the various imperial families of Rome or by members of the Roman and provincial elites, and similarly many of the viewers would also have belonged to that social class. This accounts for the fact that the women of this social milieu seldom appeared as anything other than ciphers for the culture, beliefs and attitudes of that class and indeed literally conformed to the ideological image of the moral Roman matron. When departures from this ideal image were found in such contexts they were often filtered through a gauze of mythological role playing or even of humour. It is evident that in certain contexts such attitudes held little sway, though freedmen and freedwomen would often ape and aspire to hold them or at least be thought to hold them. Non-elite working women and some provincial women lived an altogether different reality and expressed this difference through sometimes more nuanced imagery.

As this study has progressed I have found myself returning again and again to the writings of the feminist art historian Linda Nochlin on aspects of the relationship between women, art and power as represented by images of women in European art of the eighteenth to twentieth centuries. When Nochlin writes, 'Woman, in my examination of the various cases, cannot be seen as a fixed, pre-existing entity or "image", transformed by this or that historical circumstance, but as a complex, mercurial and problematic signifier, mixed in its messages, resisting fixed interpretation or positioning despite the numerous attempts made in visual representation literally to put "woman" in her place,' this could equally be applied to the corpus of images of Roman women discussed in this book.[13] Again, Nochlin's claim that 'the term "woman" fights back, and resists attempts to subdue its meaning or reduce it to some simple essence, universal, natural, and above all unproblematic', rings strangely

true and seems particularly apposite to our case studies from the much more distant past.[14]

The final question to be asked in this book is not simply about whether women in Roman art were allowed to be anything other than a symbol but rather whether these images reflected agency and interiority, that the idea of the image allowed for the women to act rather than just be acted upon. Of course, some images were created as a means of male aggrandisement, signifying the existence of things as a manifestation of an attitude. There was almost a kind of cognitive dissonance at play here, with conflicting world views on the status and identities of Roman and Romanised women seemingly being presented in contemporary visual culture and in literature and legal tracts.

Perhaps many of these images are more understandable if we measure them against two distinct scales of identity which might have been pre-eminent in Roman society, that is vertical identity and horizontal identity. Vertical identity might be thought of as being the identity you share with your parents in terms of race, class and religion. Horizontal identity on the other hand is more fluid and unpredictable and it separates you from your parents and makes you instead part of an outside community.

These images seem to me to succeed each other in time like waves, like a Roman woman's life-course through betrothal, marriage, ageing and death (see images 93 and 94). Their effect was cumulative, with one type of representation or image mixing with another to produce a state which was quite other than simply aesthetic appreciation or comprehension. We can scarcely know how brittle and inflexible the ties that bound these massed images became. Art is never about inventing the new, it is sometimes simply about the past re-emerging in the present.

If nothing else, this analysis of images of women in the Roman world has shown that while many of these images were simply anodyne statements on the Roman elite status quo and its attitudes and values, others were less ideologically rigorous in their

presentation of certain realities. These others were not necessarily subversive or in direct opposition to mainstream Roman elite values. Rather, they demonstrated in a blatantly overt manner that other realities also needed to find expression in the overall visual culture of the time. Identities were being constantly shaped and reshaped at micro-levels within society. As with any study there were inevitably outliers, and while some of these have been considered here, the main narrative of the book has been concerned with patterns and trends and not necessarily with exceptions. It was good to find that instead of being destroyed by society's conventions, some women were liberated by feeling outside of these in an experience of inner transformation and renewal. Their world could be remade by the human mind.

However, as we bring this study to a close it is well to remember Henri Matisse's reported response to a philistine member of the public, who, looking at one of his pictures, told him that 'I never saw a woman like that.' Matisse replied, 'It is not a woman, it is a painting.'

NOTES

I have tried to keep these notes to a minimum and, wherever possible, I have pointed the reader in the direction of the principal source or sources on a particular subject which can themselves then be interrogated for further references.

1 Image and Reality

1. Culham 1997.
2. Pomeroy 1975.
3. On various aspects of Roman women's lives see, for example, Achard 1995; Assa 1960; Augenti 2007; Bader 1877; Balsdon 1962; Borragán 2000; Burck 1969; Cantarella 1987 and 1996; Cenerini 2002; Chrystal 2013; Clark 1981 and 1994; D'Ambra 2006; D'Ambrosio 2002; D'Avino; Dixon 1988, 1992, and 2000; Dominguez Arranz 2010; Dixon 1983; Dubois 1998; Fantham *et al.* 1994; Foley 1981; Fraschetti 2001; Gardner 1986; George 2005; Gourevitch and Raepsaet-Charlier 2001; Hallett 2012; Hawley and Levick 1995; Hemelrijk 1999; Herzig 1983; James and Dillon 2012; Joshel and Murnaghan 2001; Kalavrezou 2012; Kampen 1982, 1988, 1991a, 1991b, 1994, 1995, 1996, 1996, 2007, and 2009; Kleiner 1987b and 2000; Kleiner and Matheson 1996 and 2000; Koloski-Ostrow and Lyons 1997; Larsson Lovén and Strömberg 1998 and 2007; Levy 1983; MacDonald 2000; MacLachlan 2013; MacMullen 1980 and 1986; Macurdy 1937; Mantle 2013; Marshall 1975; McHardy and Marshall 2004; Meyers 2012; Milnor 2005 and 2011; Mirón Pérez 1996; Montserrat 2000; Morello 2009; Neils 2011; Papin 2010; Parca and Tzanetov 2007; Peradotto and Sullivan 1984; Pleket 1969; Pomeroy 1975, 1976, and 1991; Rawson 1986; Rawson and Weaver 1997; Richlin 1992a, 1992b, 1995, 1997a and 1997b; Riggs 2012; Rodgers 1995, 1998, and 2003; Roisman 2014; Rottloff 2006; Salisbury 1997; Sándor 2002; Sawyer 1996; Scheid 1992; Schroer 2006; Scott 1995; Seltman 1956; Setälä 2002; Silberberg-Pierce 1993; Späth and Wagner-Hasel 2000; Staples 1998; Treggiari 1979 and 1993; Trimble 2011; Valentini 2012; Vandiver 1999; Viden 1993; Vivante 2007; Ward 1992; Will 1979; Winter 2003; Witherington 1988; Wyke 1994, 1998 and 2002; and Zinserling 1973. For Gaul see Pelletier 1984 and Rémy and Mathieu 2009. For Britain see Allason-Jones 1989. Sources on the Roman imperial women are listed in Chapter 2, Note 1 below. Sources on women as civic benefactors are listed in Chapter 3, Note 11 below.

4. On the Italian epigraphic evidence see Forbis 1990 and Keegan 2014.

5. On Roman working women see Kampen 1981 and 1982. On women on imperial and public monuments see Kampen 1991a, 1991b and 1995. On ancient sexuality see Kampen 1996a, 1996b and 1997. On women and families see Kampen 2007, 2009 and 2011.

6. Kleiner and Matheson 1996. See also the follow-up volume Kleiner and Matheson 2000.

7. On a Roman girl's transition to womanhood see Harlow and Laurence 2002, 54–64.

8. On this mother and daughter group see George 2001.

9. On the Ostia circus relief see, for example, Kleiner 1992a, 236–7 and Stewart 2003, 104–08.

10. On the Regina tombstone see Carroll 2012 and the bibliography there.

11. Parker 1983.

12. Collingwood, R. G. and R. P. Wright 1965 The Roman Inscriptions of Britain I. Inscriptions on Stone. RIB 1965.

13. As per Note 12. RIB 1171.

14. On the issue of dress versus nudity and the symbolism of costume see, for example, D'Ambra 1996 and 2000; Cleland *et al.* 2005; Harlow 2013; Nead 1992; Olson 2008; Rothe 2009 and 2013; Sebesta 1997 and 2001; and Sebesta and Bonfante 1994.

15. On male hypersexuality see, for example, Foxhall 1998; Foxhall and Salmon 1998; and Kampen *et al.* 2002.

2 *Power and the Imperial Women*

1. The literature on the imagery of the imperial women is vast, but see, for example, Alexandridis 2004; Babcock 1965; Baharal 1992; Barratt 1996; Bartman 1999 and 2012; Boatwright 1991b, 2000, and 2003; Brubaker 1997; Carandini 1969; Corbier 1995; Delia 1991; Dierichs 2000; Erhard 1978; Fejfer 1985 and 1988; Fischler 1994; Fittschen 1982; Flory 1993 and 1996; Fuchs 1990; Garcia and Gustavo 2013; Giacosa 1977; Ginsburg 2006; Grether 1946; Gross 1962; Harlow 2004; Hidalgo de la Vega 2010; Holum 1982; Kleiner 1996; Kleiner and Kleiner 1980; Kleiner and Matheson 1996 and 2000; Kokkinos 1992; Lambrechts 1952; Langford 2013; Levick 2007 and 2014; McClanan 2002; Meischner 1964; Mikocki 1995; Oost 1968; Pohlsander 1995; Polaschek 1973; Portale 2013; Poulsen 1964; Purcell 1986; Richlin 1992c; Rottloff 2006; Saavedra 1994; Scheid 2001; Sivan 2011; Smith 1985; Sowers-Lusnia 1990 and 1995; Späth 2000; Trillmich 1978; Varner 1995; Winkes 1995; and Wood 1988, 1992, 1995 and 1998.

2. Bartman 1999.

3. Bartman 1999, 24.

4. Bartman 1999, 11.

5. Bartman 1999, 144–5, 144 Figures 112–13.

6. Bartman 1999, 36–8.

7. Bartman 1999, 144–5, 144 Figures 114–15.

8. Bartman 1999, 75 suggests 27–17 BC.

9. Bartman 1999, 74.

10. Bartman 1999, 62, 70 Note 73; Flory 1993, 295; and Kleiner 1996, 37.

11. Bartman 1999, 144–5, 144 Figures 116–17.

12. Bartman 1999, 145, 145 Figures 118–19.

13. On the *Ara Pacis* identifications see, for example, Kleiner 1992a, 92–3 and Rossini 2006, 48–79.
14. On the figure of Roma/Tellus see, for example, Booth 1966 and Galinsky 1966 and 1992.
15. Bartman 1999, 85–6, 86 Figure 72.
16. Zanker, as noted by Bartman 1999, 14.
17. Bartman 1999, 5.
18. Bartman 1999, 79.
19. On the Sebasteion see principally Smith 1988 and 2013.
20. Boatwright 1991b, 535.
21. Boatwright 1991b, 536.
22. On Faustina the Elder statue types see, for example, Kleiner 1992a, 277–8 and Levick 2014.
23. On Faustina the Younger statue types see, for example, Boatwright 2003; Kleiner 1992a, 278–80; and Levick 2014.
24. On the title of *Mater Castrorum* see, for example, Boatwright 2003 and Calabria 1989.
25. Ferris 2009, 112 and 175 Note 5.
26. On Venus and Mars see Kleiner 1981.
27. On Julia Domna and the Leptis arch see Kampen 1991a.
28. On imperial women and *damnatio memoriae* see Varner 2001.
29. Kleiner 1992a, 376.
30. Ferris 2013, 101–04.
31. Ferris 2013, 50–66 and 109–10.
32. On the Ada Cameo see Nolden 2007.
33. Smith 1985, 214.
34. Harlow 2004. On Galla Placidia also see Deliyannis 2001; Oost 1968; Richlin 1992c; and Sivan 2011.
35. On the Stilicho diptych see, for example, Ferris 2000, 140–2 and Kampen 2009, 123–6 and 135–8.
36. Kampen 2009.
37. Kampen 2009, 134.

3 Public and Private Identities

1. Bartman 1999, XXIII Note 1 and Pliny *Naturalis Historia* 34. 30–1.
2. Pliny *Naturalis Historia* 34. 31.
3. Flory 1993, 291.
4. Flory 1993, 292.
5. Bartman 1999, 63; Flory 1993, 292; and Lewis 1988.
6. Bartman 1999, 79.
7. On Cornelia see Beness and Hillard 2013 and Petrocelli 2001.
8. On the Large Herculaneum Woman type see principally Daehner 2007 and Trimble 2011.
9. Trimble 2011, 1.
10. Ibid.
11. On women benefactors and women in public life see Boatwright 1991a and 1993; Dixon 1983; Fantham 1995; Forbis 1990; Hemelrijk 2012 and 2013; Hoffsten 1939; Larsson Lovén and Strömberg 2007; Lefkowitz 1983; Nichols 1989; Setälä 2002; Van Bremen 1983 and 1996; and Woodhull 2004.
12. On Plancia Magna see Boatwright 1991a and 1993.

13. Lefkowitz 1983, 57.
14. On the murder of Regilla see Pomeroy 2007.
15. On the Cartoceto bronzes principally see Pollini 1993 and Ferris 2013, 124–8.
16. Pollini 1993, 440–4.
17. Pollini 1993, 425.
18. Boatwright 1991a, 260–1.
19. Harlow and Laurence 2002, 118–19.
20. On the Projecta Casket see principally Elsner 2003 and 2007, 200–24.
21. On mirrors and reflections see Taylor 2008 and Wyke 1994.
22. On the Trier ceiling painting see Rose 2006.

4 A Fine and Private Place

1. On the Tomb of the Haterii see principally Kleiner 1992a, 196–9 and Leach 2006.
2. D'Ambra 1996, 219–21.
3. D'Ambra 1996, 229.
4. Martial *Epigrams* 3.93, 11.21, 11.99.
5. On the Tomb of the Varii see principally Petersen 2006, 203–10.
6. Kleiner 1977.
7. On the relief of Fonteia Eleusis and Fonteia Helena see Walker and Burnett 1981. On same-sex and lesbian relationships in antiquity see principally Abrahamsen 1997; Auanger 2002; Boehringer 2007 and 2014; Brooten 1998; D'Angelo 1990; Dubois 1995; Rabinowitz and Auanger 2002; Walker and Burnett 1981; and Yatromanolakis 2007. On the *dextrarum iunctio* gesture see Baillargeon 2013 and Mander 2012.
8. Baillargeon 2013, 51.
9. Baillargeon 2013, 53.
10. On the Fayum portraits see, for example, Doxiadis 1995; Riggs 2012; and Walker and Bierbrier 1997.
11. Doxiadis 1995, 51 Plate 33.
12. Wyke 1994, 141–2; Rodgers 1998, 171–2.
13. On the symbolism of women and weaving equipment in different contexts see, for example, D'Ambra 1993; Pasztókai-Szeöke 2011; Rodgers 1998, 169; and Waelkens 1977, 150.
14. Pasztókai-Szeöke 2011, 129.
15. Pasztókai-Szeöke 2011, 127.
16. On female imagery on Pannonian gravestones see, for example Boatwright 2005; Carroll 2012 and 2013; Pasztókai-Szeöke 2011; and Sándor 2002.

5 The Dignity of Labour

1. Kampen 1981. Also, on freedmen reliefs depicting work see George 2006 and on women and retail see Holleran 2013.
2. Kampen 1981, 82–6.
3. Kampen 1981, 83.
4. Kampen 1981, 82.
5. Kampen 1981, 154.
6. Clarke 1998, 195–6.
7. Rodgers 1998, 184–94.
8. On the Halicarnassus *missio* see Coleman 2000. On female gladiators see Brunet 2004.

9. On Munby see Hudson 1972.

6 *Performance*

1. On Ceres see principally De Angeli 1988; Le Bonniec 1958; Spaeth 1994 and 1996; and Zeitlin 1982. On the Vestal Virgins see Beard 1980; Parker 2004; Scheid 2001; Staples 1998; Takacs 2008; and Wildfang 2006.
2. On Cybele see, for example, Beard 1994; Borgeaud 2004; Gruen 1990; Lambrechts 1952; Roller 1997; Spickerman 2013; Stehle 1989; Thomas 1984; and Wiseman 1984. On Isis see, for example, Heyob 1975; North 2013; and Witt 1971. On Artemis Ephesia see LiDonnici 1992. On women and the Bacchic cult see Kraemer 1979 and Zeitlin 1982.
3. Stehle 1989, 143.
4. On this Egyptomania see, for example, Vout 2003.
5. D'Ambra 1993.
6. D'Ambra 1993, 102–04.
7. On the cultural significance of spinning and weaving in the Roman world see, for instance Carroll 2012; Cottica 2007; D'Ambra 1993; Hultin 2010; Larsson Lovén 1998 and 2007; Parker 1983; and Pasztókai-Szeöke 2011. For an ethnographic perspective on the cultural significance of textiles and textile working see Kreamer and Fee 2002.
8. Kampen 1991b. See also on the Sabine women Stehle 1989 and Vandiver 1999. On Augustan moralising see Corbier 1991; Frank 1975; Galinsky 1981; Hallett 2012; Kampen 1991b; Kleiner 1994; Milnor 2005; Norr 1981; Raditsa 1980; Sebesta 1997; Severy 2003; Walker 2000; and Wyke 1992.
9. Bartman 1999, 63, 70 notes 80 and 81.
10. On the House of Menander in general see, for example, Varriale 2012. On male control in fresco images here see Koloski-Ostrow 1997.
11. Koloski-Ostrow 1997, 252–4.
12. On Omphale see Kampen 1996b. On bisexual figures see Brisson 2002 and Delcourt 1961.
13. On Victory see principally Hassall 1977 and Hölscher 1967 and 2006.
14. On personifications of one kind or another see Axtell 1907; Broucke 1994; James 2003; Matheson 1994; Panella 1966–7; Poulsen 2014; Ryan 1989; Sapelli 1999; Smith 1988; Stafford 1998; and Toynbee 1934.
15. Axtell 1907, 35.
16. Rodgers 1998, 84; Toynbee 1934, 75.
17. On the *Hadrianeum* personifications see principally Kleiner 1992a, 283–5; Sapelli 1999; and Toynbee 1934.
18. Toynbee 1934, 22.
19. Rodgers 1998, 144–7.
20. On Amazons see, for example, Cuchet 2013; Dubois 1982; Geary 2006; Mayor 2014; Ridgway 1974; and Tyrrell 1984.
21. On Medusa and the Gorgons see, for example, Topper 2007.
22. Rodgers 1998, 117.
23. On Roman gardens and *horti* see Cima and LaRocca 1998 and Cima and Talamo 2008.
24. McNally 1985, 153.

7 *The Male Gaze*

1. On the male gaze in relation to Roman culture see the papers in Fredrick 2002.

On imperial power and eroticism see Vout 2007 and Winter 1996. On Roman sexuality and visual culture in general see Clarke 1998, 2002, and 2014; Clarke and Larvey 2003; Johns 1982; and Vout 2013. On slaves and master-servant relationships see Cohen 2014.

2. The definitive works on the *Sebasteion* reliefs and sculpture are Smith 1988 and 2013.
3. On images of barbarians see Ferris 2000 and bibliography. On women and children on the Column of Marcus Aurelius see Zanker 2000.
4. On the artworks on the Column of Marcus Aurelius see Ferris 2009 and bibliography. On women on both columns see Dillon 2006.
5. Bartman 1999, 39.
6. On scenes of abduction and rape in classical art see, for example, Cohen 1996; Donaldson 1982; and Topper 2007.
7. On the *Gabinetto Segreto* in Naples museum see De Caro 2000.
8. Clarke 1998, 195–6.
9. Clarke 1998, 196–206.
10. Clarke 1998, 205–06.
11. Clarke 1998, 209.
12. Clarke 1998, 212–40.
13. Clarke 1998, 160–1.
14. Clarke 1998, 156.
15. See Note 3 above.
16. Kellum 1996, 170. See also Kellum 1997.

8 Reality and Image

1. On women's rites in prehistoric Valcamonica see Bevan 2006. On women and gender in pre-Roman Italy see, for instance the papers in Cornell and Lomas 1997; Gleba 2011; and Stoddart 2009. On the paintings from the Villa of the Mysteries see principally Gazda 2000 and Sauron 1998. On the Piazza Armerina athletes see Lee 1984.
2. Longfellow 2000a.
3. Kampen 1991a, 219–20. Other women taking part in sacrifices at Roman military camps have now apparently been identified on Trajan's Column by Elizabeth Greene of the University of Western Ontario, Canada (Archaeological Institute of America annual meeting January 2015, New Orleans).
4. Reeder 1995, 195.
5. See Ferris 2007 and the bibliography there.
6. Deyts 1994.
7. On Ponte di Nona see Potter 1985.
8. Manson 1987. On Roman dolls see Dolansky 2012; Elderkin 1930; Manson 1987 and 1991; and Soren and Soren 1999, 615–18. On the sarcophagus with images of dolls see Wrede 1990. For ethnographic perspectives on dolls see, for example, Cameron 1996.
9. Soren and Soren 1999, 615–18.
10. Cameron 1996, 11.
11. Cima and La Rocca 1998 and Cima and Talamo 2008.
12. Ferris 2000.
13. Nochlin 1999, 7.
14. Ibid.

BIBLIOGRAPHY

Abrahamsen, V. (1997) 'Burials in Greek Macedonia: Possible Evidence for Same-Sex Committed Relationships in Early Christianity', *Journal of Higher Criticism* 4/2, pp. 33–56.

Achard, G. (1995) *La Femme à Rome*, Paris: Presses Universitaires de France.

Ahearne-Kroll, S. P., P. A. Holloway and J. A. Kelhoffer (eds) (2010) *Women and Gender in Ancient Religions. Interdisciplinary Approaches*, Tubingen: Mohr Siebeck.

Alexandridis, A. (2004) *Die Frauen des Römischen Kaiserhauses: Eine Untersuchung Ihrer Bildlichen Darstellung von Livia bis Iulia Domna*, Mainz: Philipp von Zabern.

Alison, J. (2014) *Change Me: Stories of Sexual Transformation from Ovid*, Oxford: Oxford University Press.

Allason-Jones, L. (1989) *Women in Roman Britain*, London: British Museum Press.

Alston, R. (1998) 'Arms and the Man: Soldiers, Masculinity and Power in Republican and Imperial Rome' in L. Foxhall and J. B. Salmon (eds) (1998), pp. 205–23.

Anderson, M. L. and L. Nista (1988) *Roman Portraits in Context. Imperial and Private Likenesses from the Museo Nazionale Romano*, Rome: De Luca Edizioni.

Archer, L. J. (1990) *Her Price is Beyond Rubies: the Jewish Women in Graeco-Roman Palestine*, Sheffield: JSOT Press.

Archer, L., S. Fischler and M. Wyke (1994) *Women in Ancient Societies. An Illusion of the Night*, London: MacMillan.

Assa, J. (1960) *La Donna Nell'Antica Roma*, Rome: Mondadori Editore.

Auanger, L. (2002) 'Glimpses Through a Window: an Approach to Roman Female Homoeroticism Through Art Historical and Literary Evidence' in N. S. Rabinowitz and L. Auanger (eds) (2002) *Among Women. From the Homosocial to the Homoerotic in the Ancient World*, Austin: University of Texas Press, pp. 211–55.

Augenti, D. (2007) *Momenti e Immagini della Donna Romana*, Rome: Edizioni Quasar.

Axtell, H. L. (1907) *The Deification of Abstract Ideas in Roman Literature and Inscriptions*, Chicago: University of Chicago Press.

Aymard, J. (1934) 'Vénus et les Impératrices sous les Derniers Antonins', *Mélanges de l'Ecole Francaise de Rome* 51, pp. 178–96.

Babcock, C. L. (1965) 'The Early Career of Fulvia', *American Journal of Philology* 86, pp. 1–32.

Bader, C. (1877) *La Femme Romaine. Étude de la Vie Antique*, Paris: Didier.

Baharal, D. (1992) ' Portraits of Julia Domna from the Years 193–211 AD and the Dynastic Propaganda of L. Septimius Severus', *Latomus* 51.1, pp. 110–18.

Baharal, D. (1996) *Victory of Propaganda: The Dynastic Aspect of the Imperial Propaganda of the Severi: the Literary and Archaeological Evidence AD 193–225*, Oxford: BAR International Series 657, Archaeopress.

Baillargeon, D. (2013) *Marriage or a Multiplicity of Meanings? The Dextrarum Iunctio on Roman and Early Christian Funerary Monuments*, M.A. Thesis, University of Calgary.

Balsdon, J. P. V. D. (1962) *Roman Women. Their History and Habits*, Revised Edition (1977), London: Bodley Head.

Barratt, A. A. (1996) *Agrippina: Sex, Power and Politics in the Early Empire*, New Haven: Yale University Press.

Bartman, E. (1999) *Portraits of Livia: Imaging the Imperial Women in Augustan Rome*, Cambridge: Cambridge University Press.

Bartman, E. (2001) 'Hair and the Artifice of Roman Female Adornment', *American Journal of Archaeology* 105 (1), pp. 1–25.

Bartman, E. (2012) 'Early Imperial Female Portraiture' in S. L. James and S. Dillon (eds) (2012), pp. 414–22.

Barton, C. (2002) 'Being in the Eyes: Shame and Sight in Ancient Rome' in D. Fredrick (ed.) (2002), pp. 216–35.

Bauman, R. A. (1992) *Women and Politics in Ancient Rome*, London: Routledge.

Beard, M. (1980) 'The Sexual Status of Vestal Virgins', *Journal of Roman Studies* 70, pp. 12–27.

Beard, M. (1994) 'The Roman and the Foreign: the Cult of the "Great Mother" in Imperial Rome' in N. Thomas and C. Humphrey (eds) (1994) *Shamanism, History and the State*, Ann Arbor: University of Michigan Press, pp. 164–90.

Benario, H. (1958) 'Julia Domna *mater castrorum et senatus et patriae*', *Phoenix* 12.2, pp. 67–70.

Beness, L. and T. Hillard (2013) 'Insulting Cornelia, Mother of the Gracchi' in P. J. Burton (ed.) (2013) *Culture, Identity and Politics in the Ancient Mediterranean World. Papers from a Conference in Honour of Erich Gruen. Antichthon* 47, pp. 61–79.

Bergmann, B. (1996) 'The Pregnant Moment: Tragic Wives in the Roman Interior' in N. B. Kampen (ed.) (1996), pp. 199–218.

Bevan, L. (2006) *Worshippers and Warriors. Reconstructing Gender Relations in the Prehistoric Rock Art of Naquane National Park, Valcamonica, Brescia, Northern Italy*, Oxford: British Archaeological Reports International Series 1485, Archaeopress.

Birk, S. (2013) *Depicting the Dead: Self-Representation and Commemoration on Roman Sarcophagi With Portraits*, Aarhus: Aarhus University Press.

Birk, S. (2014) 'Using Images for Self-Representation on Roman Sarcophagi' in S. Birk, T. M. Kristensen and B. Poulsen (eds) (2014), pp. 33–47.

Birk, S., T. M. Kristensen and B. Poulsen (eds) (2014) *Using Images in Late Antiquity*, Oxford: Oxbow Books.

Blaze de Bury, H. (1875) *Les Femmes et la Société au Temps d'Auguste*, Paris.

Boatwright, M. T. (1991a) 'Plancia Magna of Perge: Women's Roles and Status in Roman Asia Minor' in S. B. Pomeroy (ed.) (1991), pp. 249–72.

Boatwright, M. T. (1991b) 'The Imperial Women of the Early Second Century AC', *American Journal of Philology* 112, pp. 513–40.

Boatwright, M. T. (1993) 'The City Gate of Plancia Magna in Perge' in E. D'Ambra (ed.) (1993) *Roman Art in Context: An Anthology*, New Jersey: Prentice Hall, pp. 189–207.

Boatwright, M. T. (2000) 'Just Window Dressing? Imperial Women as Architectural Sculpture' in D. E. E. Kleiner and S. B. Matheson (eds) (2000) *I Claudia II*, Austin: University of Texas Press, pp. 61–75.

Boatwright, M. T. (2003) 'Faustina the Younger, "Mater Castrorum"' in R. Frei-Stolba, A. Bielman and O. Bianchi (eds) (2003) *Les Femmes Antiques Entre Sphère Privée et Sphère Publique*, Bern: Actes du Diplôme d'Etudes Avancées, Universites de Lausanne et Neuchâtel, Lang, pp. 249–68.

Boatwright, M. T. (2005) 'Children and Parents on the Tombstones of Pannonia' in M. George (ed.) (2005) *The Roman Family in the Empire: Rome, Italy and Beyond*, Oxford: Oxford University Press, pp. 287–318.

Boehringer, S. (2007) *L'Homosexualité Féminine dans L'Antiquité Grecque et Romaine*, Paris: Les Belles Lettres.

Boehringer, S. (2014) 'Female Homoeroticism' in T. K. Hubbard (ed.) (2014), pp. 150–63.

Bonfante, L. (1997) 'Nursing Mothers in Classical Art' in and A. O. Koloski-Ostrow and C. L. Lyons (eds) (1997), pp. 174–96.

Booth, A. (1966) 'Venus on the Ara Pacis', *Latomus* 25, pp. 873–9.

Borragán, N. (2000) *La Mujer en la Sociedad Romana del Alto Imperio (Siglio II d.C.)*, Uriéu: Trabe.

Borgeaud, P. (2004) *Mother of the Gods: from Cybele to the Virgin Mary*, Baltimore: Johns Hopkins University Press.

Borgeaud, P. and D. Fabiano (eds) (2013) *Perception et Construction du Divin dans l'Antiquité*, Geneva: Recherches et Rencontres 31. Librairie Droz.

Bradley, K. (1991) *Discovering the Roman Family. Studies in Roman Social History*, Oxford: Oxford University Press.

Brandl, U. (ed.) (2008) *Frauen und Römisches Militär. Beiträge eines Runden Tisches in Xanten vom 7. bis 9. Juli 2005*, Oxford: British Archaeological Reports International Series S1759, Archaeopress.

Brennan, T. C. (2012) 'Perceptions of Women's Power in the Late Republic: Terentia, Fulvia, and the Generation of 63 BCE' in S. L. James and S. Dillon (eds) (2012), pp. 354–66.

Brisson, L. (2002) *Sexual Ambivalence. Androgyny and Hermaphroditism in Graeco-Roman Antiquity,* Berkeley: University of California Press.

Brooten, B. J. (1998) *Love Between Women: Early Christian Responses to Female Homoeroticism*, Chicago: University of Chicago Press.

Broucke, P. B. F. J. (1994) 'Tyche and the Fortune of Cities in the Greek and Roman World' in S. B. Matheson (ed.) (1994), pp. 35–49.

Brown, S. (1993) 'Feminist Research in Archaeology: What Does It Mean? Why Is It Taking So Long?' in N. S. Rabinowitz and A. Richlin (eds) (1993) *Feminist Theory and the Classics*, London: Routledge, pp. 238–71.

Brown, S. (1997) 'Ways of Seeing Women in Antiquity: an Introduction to Feminism in Classical Archaeology and Ancient Art History' in A. O. Koloski-Ostrow and C. L. Lyons (eds) (1997) *Naked Truths*, London: Routledge, pp. 12–42.

Brubaker, L. (1997) 'Memories of Helena: Patterns in Imperial Female Matronage

in the Fourth and Fifth Centuries' in L. James (ed.) (1997) *Men, Women, and Eunuchs. Gender in Byzantium*, London: Routledge, pp. 52–75.

Brubaker, L. (2013) 'Looking at the Byzantine Family' in L. Brubaker and S. Tougher (eds) (2013) *Approaches to the Byzantine Family*, Farnham: Ashgate, pp. 177–206.

Brunet, S. (2004) 'Female and Dwarf Gladiators', *Mouseion* 3.4, pp. 145–71.

Burck, E. (1969) *Die Frau in der Griechisch-Römischen Antike*, Munich: Heimeran Verlag.

Calabria, P. (1989) 'La Leggenda 'Mater Castrorum' sulla Monetazione Imperiale', *Miscellanea Greca e Romana* XIV, pp. 225–33.

Cameron, A. (1994) 'Early Christianity and the Discourse of Female Desire' in L. Archer *et al.* (eds) (1994), pp. 152–68.

Cameron, A. and Kuhrt, A. (eds) (1993) *Images of Women in Antiquity*, Revised edition. London: Routledge.

Cameron, E. L. (1996) *Isn't S/he A Doll? Play and Ritual in African Sculpture*, Los Angeles: UCLA Fowler Museum of Cultural History.

Cantarella, E. (1987) *Pandora's Daughters: Women in Greek and Roman Antiquity*, Baltimore: Johns Hopkins University Press.

Cantarella, E. (1996) *Passato Prossimo: Donne Romane da Tacita a Sulpicia*, Milan: Feltrinelli.

Carandini, A. (1969) *Vibia Sabina: Funzione Politica, Iconografia e il Problema del Classicismo Adriano*, Florence: Olschki.

Carp, T. (1981) 'Two Matrons of the Late Republic' in H. Foley (ed.) (1981) *Reflections of Women in Antiquity*, London: Routledge, pp. 343–54.

Carroll, M. (2006) *Spirits of the Dead. Roman Funerary Commemoration in Western Europe,* Oxford: Oxford University Press.

Carroll, M. (2012) '"The Insignia of Women": Dress, Gender and Identity on the Roman Funerary Monument of Regina from Arbeia', *Archaeological Journal* 169, pp. 281–311.

Carroll, M. (2013) 'Ethnicity and Gender in Roman Funerary Commemoration: Case Studies from the Empire's Frontiers' in S. Tarlow and L. Nilsson Stutz (eds) (2013) *The Oxford Handbook of the Archaeology of Death and Burial*, Oxford: Oxford University Press, pp. 559–80.

Carroll, M. (2014) 'Mother and Infant in Roman Funerary Commemoration' in M. Carroll and E-J. Graham (eds) (2014) *Infant Health and Death in Roman Italy and Beyond*, Portsmouth, Rhode Island: Journal of Roman Archaeology Supplementary Series 96, pp. 159–78.

Carroll, M. (Forthcoming) 'Commemorating Military and Civilian Families on the Danube Limes', Proceedings of the 22nd International Congress of Roman Frontier Studies, Ruse, Bulgaria, September 2012.

Castello, C. (1940) *Il Tema di Matrimonio e Concubinato nel Mondo Romano*, Milan: A. Giuffrè.

Cenerini, F. (2002) *La Donna Romana*, Bologna: Il Mulino.

Cenerini, F. (2013) 'The Role of Women as Municipal Matres' in E. A. Hemelrijk and G. Woolf (eds) (2013), pp. 9–22.

Centlivres Challet, C-E. (2013) *Like Man, Like Woman: Roman Women, Gender Qualities and Conjugal Relationships at the Turn of the First Century*, Oxford: Peter Lang.

Chrystal, P. (2013) *Women in Ancient Rome*, Stroud: Amberley.

Cima, M. and E. La Rocca (1998) *Horti Romani: Atti del Convegno, Roma 1995,*

Bullettino della Commissione Archeologica Communale di Roma, Rome: L'Erma di Bretschneider.

Cima, M. and E. Talamo (2008) *Gli Horti di Roma Antica*, Rome: Quaderni Capitolini. Electa.

Claridge, A. (1998) *Rome. An Oxford Archaeological Guide*, Oxford: Oxford University Press.

Clark, G. (1981) 'Roman Women', *Greece and Rome* Series 2. 28, pp. 193–212.

Clark, G. (1994) *Women in Late Antiquity*, Oxford: Clarendon.

Clarke, J. R. (1998) *Looking at Lovemaking: Constructions of Sexuality in Roman Art 100 BC–AD 250*, Berkeley: University of California Press.

Clarke, J. R. (2002) 'Look Who's Laughing at Sex: Men and Women Viewers in the Apodyterium of the Suburban Baths at Pompeii' in D. Fredrick (ed.) (2002), pp. 111–49.

Clarke, J. R. (2003) *Art in the Lives of Ordinary Romans: Visual Representation and Non-Elite Viewers in Italy, 100 BC-AD 315*, Berkeley: University of California Press.

Clarke, J. R. (2014) 'Sexuality and Visual Representation' in T. K. Hubbard (ed.) 2014, pp. 509–33.

Clarke, J. R. and M. Larvey (2003) *Roman Sex: 100BC to 250 AD*, New York: Harry J. Abrams.

Cleland, L., M. Harlow and L. Llewellyn-Jones (eds) (2005) *The Clothed Body in the Ancient World*, Oxford: Oxbow.

Cohen, A. (1996) 'Portrayals of Abduction in Greek Art: Rape or Metaphor?' in N. B. Kampen (ed.) (1996), pp. 117–35.

Cohen, B. (1997) 'Divesting the Female Breast of Clothes in Classical Sculpture' in A. O. Koloski-Ostrow and C. L. Lyons (eds) (1997), pp. 66–92.

Cohen, B. (2000) 'Man-Killers and Their Victims: Inversions of the Heroic Ideal in Classical Art' in B. Cohen (ed.) (2000) *Not the Classical Ideal: Athens and the Construction of the Other in Greek Art*, London: Routledge.

Cohen, E. E. (2014) 'Sexual Abuse and Sexual Rights: Slaves' Erotic Experience at Athens and Rome', in T. K. Hubbard (ed.) (2014), pp. 184–98.

Coleman, K. (2000) 'Missio at Halicarnassus', *Harvard Studies in Classical Philology*, pp. 100, 487–500.

Corbier, M. (1991) *Family Behaviour of the Roman Aristocracy, Second Century BC-Third Century AD* in S. B. Pomeroy (ed.) (1991), pp. 173–96.

Corbier, M. (1995) 'Male Power and Legitimacy Through Women: the Domus Augusta Under the Julio-Claudians' in R. Hawley and B. Levick (eds) (1995), pp. 178–93.

Cornell, T. and K. Lomas (eds) (1997) *Gender and Ethnicity in Ancient Italy*, Accordia Specialist Studies on Italy Volume 6, London: University of London.

Cottica, D. (2007) 'Spinning in the Roman World: from Everyday Craft to Metaphor of Destiny', in C. Gilles and M-L. B. Nosch (eds) (2007), pp. 221–8.

Crook, J. A. (1986) 'Women in Roman Succession' in B. Rawson (ed.) (1986), pp. 58–82.

Cuchet, V. S. (2013) 'Femmes et Guerrières: les Amazones de Scythie (Hérodote IV, 110–17)' in S. Boehringer and V. S. Cuchet (eds) (2013) *Des Femmes en Action: l'Individu et la Fonction en Grèce Antique*, Mètis, hors-série, Paris: Éditions de l'Ehess, Daedalus, pp. 169–84.

Culham, P. (1997) 'Did Roman Women Have an Empire?' in M. Golden and P. Toohey (eds) (1997), pp. 192–204.

Currie, S. (1996) 'The Empire of Adults: the Representation of Children on Trajan's Arch at Beneventum' in J. Elsner (ed.) (1996) *Art and Text in Roman Culture*, Cambridge: Cambridge University Press, pp. 153–81.

Daehner, J. (ed.) (2007) *The Herculaneum Women: History, Context, Identities*, Los Angeles: J. Paul Getty Museum.

D'Ambra, E. (1989) 'The Cult of Virtues and the Funerary Relief of Ulpia Epigone', *Latomus* 48, pp. 392–400.

D'Ambra, E. (1993) *Private Lives, Imperial Virtues: The Frieze of the Forum Transitorium in Rome*, Princeton: Princeton University Press.

D'Ambra, E. (1996) 'The Calculus of Venus: Nude Portraits of Roman Matrons' in N. B. Kampen (ed.) (1996), pp. 219–32.

D'Ambra, E. (1998) 'Representing Roman Women', *Journal of Roman Archaeology* 11, pp. 546–53.

D'Ambra, E. (2000) 'Nudity and Adornment in Female Portrait Sculpture of the Second Century AD' in D. E. E. Kleiner and S. B. Matheson (eds) (2000), pp. 101–14

D'Ambra, E. (2006) *Roman Women*, Cambridge: Cambridge University Press.

D'Ambra, E. (2012) 'Women on the Bay of Naples' in S. L. James and S. Dillon (eds) (2012), pp. 400–13.

D'Ambra, E. (2014) 'Beauty and the Roman Female Portrait' in J. Elsner and M. Meyer (eds) (2014) *Art and Rhetoric in Roman Culture*, Cambridge: Cambridge University Press, pp. 155–80.

D'Ambra, E. and G. P. R. Métraux (eds) (2006) *The Art of Citizens, Soldiers and Freedmen in the Roman World*, Oxford: British Archaeological Reports International Series 1526, Archaeopress.

D'Ambrosio, A. (2002) *Women and Beauty in Pompeii*, Oxford: Oxford University Press.

D'Angelo, M. R. (1990) 'Women Partners in the New Testament', *Journal of Feminist Studies in Religion* 6.1, pp. 65–86.

Dasen, V. and T. Späth (eds) (2010) *Children, Memory, and Family Identity in Roman Culture*, Oxford: Oxford University Press.

Davies, G. (2013) 'Honorific Vs. Funerary Statues of Women: Essentially the Same or Fundamentally Different?' in E. A. Hemelrijk and G. Woolf (eds) (2013), pp. 171–200.

D'Avino, M. (1964) *La Donna a Pompei*, Naples: Loffredo.

De Angeli, S. (1988) 'Demeter/Ceres', *Lexicon Iconographicum Mythologiae Classicae* 4.1, pp. 893–908.

De Caro, S. (2000) *Il Gabinetto Segreto del Museo Archeologico Nazionale di Napoli. Guida Rapida*, Naples: Electa.

Deichmann, F. W. and A. Tschira (1957) 'Das Mausoleum der Kaiserin Helena und die Basilika der Heiligen Marcellinus und Petrus an der Via Labicana vor Rom', *Jahrbuch des Deutschen Archäologischen Institus* 72, pp. 44–110.

Delcourt, M. (1961) *Hermaphrodite: Myths and Rites of the Bisexual Figure in Classical Antiquity*, London: Studio Books.

Delia, D. (1991) 'Fulvia Reconsidered' in S. B. Pomeroy (ed.) (1991), pp. 197–217.

Deliyannis, D. M. (2001) '"Bury Me in Ravenna?": Appropriating Galla Placidia's Body in the Middle Ages', *Studi Medievali* 42, pp. 289–99.

Demandt, A. and J. Engemann (eds) (2007) *Konstantin der Grosse: Geschichte, Archäologie, Rezeption. Internationales Kolloquium vom 10–15 Oktober 2005 an der Universität Trier*, Trier: Rheinisches Landesmuseum Trier.

Denzey, N. (2007) *The Bone Gatherers: The Lost Worlds of Early Christian Women*, Boston: Beacon Press.

Deyts, S. (1994) *Un Peuple de Pelerins: Offrandes de Pierre et de Bronze des Sources de la Seine*, Dijon: Revue Archeologique de l'Est et du Centre-Est, Trezieme Supplement.

Dierichs, A. (2000) 'Das Idealbild der Romischen Kaiserin: Livia Augusta', in T. Späth and B. Wagner-Hasel (eds) (2000), pp. 241–61.

Dignas, B. and R. R. R. Smith (eds) (2012) *Historical and Religious Memory in the Ancient World*, Oxford: Oxford University Press.

Dillon, S. (2006) 'Women on the Columns of Trajan and Marcus Aurelius and the Visual Language of Victory', in S. Dillon and K. Welch (eds) (2006), pp. 244–71.

Dillon, S. (2010) *The Female Portrait Statue in the Greek World*, Cambridge: Cambridge University Press.

Dillon, S. and K. E. Welch (eds) (2006) *Representations of War in Ancient Rome*, Cambridge: Cambridge University Press

Dixon, S. (1983) 'A Family Business: Women's Role in Patronage and Politics at Rome 80–44 BC', *Classica et Medievalia* 34, pp. 91–112.

Dixon, S. (1988) *The Roman Mother*, London: Routledge.

Dixon, S. (1992) *The Roman Family*, Baltimore: Johns Hopkins University Press.

Dixon, S. (2000) *Reading Roman Women: Sources, Genres and Real Life*, London: Duckworth.

Doherty, L. E. (2001) *Gender and the Interpretation of Classical Myth*, London: Duckworth.

Dolansky, F. (2012) 'Playing with Gender: Girls, Dolls and Adult Ideals in the Roman World', *Classical Antiquity* 31 (2), pp. 256–92.

Dominguez Arranz, A. (ed.) (2010) *Mujeres en la Antigüedad Clásica. Género, Poder y Conflicto*, Madrid: Silex.

Donaldson, I. (1982) *The Rapes of Lucretia: a Myth and its Transformations*, Oxford: Clarendon Press.

Donaldson, J. (1907) *Woman: Her Position and Influence in Ancient Greece and Rome*, London: Longmans, Green and Co..

Dowden, K. and N. Livingstone (eds) (2011) *A Companion to Greek Mythology*, Chichester: Wiley-Blackwell.

Doxiadis, E. (1995) *The Mysterious Fayum Portraits: Faces from Ancient Egypt*, London: Thames and Hudson.

D'Souza, A. (ed.) (2001) *Self and History: A Tribute to Linda Nochlin*, London: Thames and Hudson.

Dubois, P. (1982) *Centaurs and Amazons: Women and the Pre-History of the Great Chain of Being*, Ann Arbor: University of Michigan Press.

Dubois, P. (1995) *Sappho Is Burning*, Chicago: University of Chicago Press.

Dubois, P.(1998) *Sowing the Body: Psychoanalysis and Ancient Representations of Women*, Chicago: University of Chicago Press.

Edwards, C. (1997) 'Unspeakable Professions: Public Performance and Prostitution in Ancient Rome' in J. P. Hallett and M. B. Skinner (eds) (1997), pp. 66–95.

Elderkin, K. M. (1930) 'Jointed Dolls in Antiquity', *Amerian Journal of Archaeology* 34/2, pp. 455–79.

Elsner, J. (1995) *Art and the Roman Viewer: The Transformation of Art from the Pagan World to Christianity*, Cambridge: Cambridge University Press.

Elsner, J. (2003) 'Visualizing Women in Late Antique Rome: the Projecta Casket' in C. Entwistle (ed.) 2003, pp. 23–36.

Elsner, J. (2007) *Roman Eyes: Visuality and Subjectivity in Art and Text*, Princeton: Princeton University Press.

Entwistle, C. (ed.) (2003) *Through a Glass Brightly: Studies in Byzantine and Medieval Art and Archaeology Presented to David Buckton*, Oxford: Oxbow Books.

Entwistle, C. and Adams, N. (eds) (2011) *'Gems of Heaven': Recent Research on Engraved Gemstones in Late Antiquity c. AD 200–66*, London: British Museum.

Erhard, P. (1978) 'A Portrait of Antonia Minor in the Fogg Art Museum and its Iconographical Tradition', *American Journal of Archaeology* 82, pp. 193–212.

Espérandieu, E. (1907–66) *Recueil Général des Bas-Reliefs, Statues et Bustes de la Gaule Romaine*. Volumes I–XV. Paris.

Evans, J. K. (1991) *War, Women and Children in Ancient Rome*, London: Routledge.

Fabiano, D. (2013) 'La Nympholepsie Entre Possession et Paysage' in P. Borgeaud and D. Fabiano (eds) (2013), pp. 165–96.

Fantham, E. (1991) '*Stuprum*: Public Attitudes and Penalties for Sexual Offences in Republican Rome', *Échos du Monde Classique* 35, pp. 267–91.

Fantham, E. (1995) 'Aemilia Pudentilla: or the Wealthy Widow's Choice' in R. Hawley and B. Levick (eds) (1995) *Women in Antiquity: New Assessments*, London: Routlegde, pp. 220–32.

Fantham, E., H. P. Foley, N. B. Kampen, S. B. Pomeroy and H. A. Shapiro (1994) *Women in the Classical World: Image and Text*, Oxford: Oxford University Press.

Feitosa, L. C. (2013) *The Archaeology of Gender, Love and Sexuality in Pompeii*, Oxford: British Archaeological Reports International Series S2533, Archaeopress.

Fejfer, J. (1985) 'The Portraits of the Severan Empress Julia Domna: a New Approach', *Analecta Romana Instituti Danici*, 14, pp. 129–37.

Fejfer, J. (1988) 'Official Portraits of Julia Domna' in N. Bonacasa and G. Rizza (eds) (1988) *Ritratto Ufficiale e Ritratto Privato: Atti della II Conferenza Internazionale sul Ritratto Romano 1984*, Rome: Consiglio Nazionale delle Ricerche, pp. 295–301.

Ferris, I. M. (2000) *Enemies of Rome: Barbarians Through Roman Eyes*, Stroud: Sutton Publishing.

Ferris, I. M. (2007) 'A Severed Head: Prolegomena to a Study of the Fragmented Body in Roman Archaeology and Art' in R. Hingley and S. Willis (eds) (2007) *Roman Finds: Context and Theory*, Oxford: Oxbow Books, pp. 116–27.

Ferris, I. M. (2009) *Hate and War: The Column of Marcus Aurelius*, Stroud: The History Press.

Ferris, I. M. (2012) *Roman Britain Through Its Objects*, Stroud: Amberley Publishing.

Ferris, I. M. (2013) *The Arch of Constantine: Inspired By the Divine*, Stroud: Amberley Publishing.

Finley, M. I. (1965) 'The Silent Women of Rome', *Horizon* 7, pp. 57–64.

Fischler, S. (1994) 'Social Stereotypes and Historical Analysis: the Case of the Imperial Women at Rome', in L. J. Archer *et al.* (eds) (1994), pp. 115–34.

Fittschen, K. (1982) *Die Bildnistypen der Faustina Minor und die Fecunditas Augustae*, Göttingen: Vandenhoeck und Ruprecht.

Flemming, R. (2000) *Medicine and the Making of Roman Women: Gender, Nature and Authority from Celsus to Galen*, Oxford: Oxford University Press.

Flory, M. B. (1984) 'Sic Exempla Parantur: Livia's Shrine to Concordia and the Porticus Liviae', *Historia* 33.3, pp. 309–30.

Flory, M. B. (1993) 'Livia and the History of Public Honorific Statues for Women in Rome', *Transactions of the American Philological Association* 123, pp. 287–308.

Flory, M. B. (1996) 'Dynastic Ideology, the Domus Augustus and Imperial Women: a Lost Statuary Group in the Circus Flaminius', *Transactions of the American Philological Association* 126, pp. 281–306.

Flower, H. I. (1996) *Ancestor Masks and Aristocratic Power in Roman Culture*, Oxford: Clarendon Press.

Flower, H. I. (2002) 'Were Women Ever "Ancestors" in Republican Rome?' in J. M. Højte (ed.) (2002) *Images of Ancestors*, Aarhus: Aarhus University Press, pp. 159–84.

Forbis, E. P. (1990) 'Women's Public Image in Italian Honorary Inscriptions', *American Journal of Philology* 111, pp. 493–512.

Fox, M. (2011) 'The Myth of Rome' in K. Dowden and N. Livingstone (eds) (2011), pp. 243–64.

Foxhall, L. (2013) *Studying Gender in Classical Antiquity*, Cambridge: Cambridge University Press.

Foxhall, L., H-J. Gehrke and N. Luraghi (eds) (2010) *Intentional History: Spinning Time in Ancient Greece*, Stuttgart: Franz Steiner Verlag.

Foxhall, L. and J. B. Salmon (eds) (1998) *When Men Were Men: Masculinity, Power and Identity in Classical Archaeology*, London: Routledge.

Frank, R. I. (1975) 'Augustus' Legislation on Marriage and Children', *University of California Studies in Classical Archaeology* 8, pp. 41–52.

Fraschetti, A. (ed.) (2001) *Roman Women*, Chicago: University of Chicago Press.

Fredrick, D. (1995) 'Beyond the Atrium to Ariadne: Erotic Painting and Visual Pleasure in the Roman House', *Classical Antiquity* 14, pp. 266–87.

Fredrick, D. (ed.) (2002) *The Roman Gaze: Vision, Power, and the Body*, Baltimore: The Johns Hopkins University Press.

Frymer-Kensky, T. (1992) *In the Wake of the Goddess: Women, Culture, and the Biblical Transformation of Pagan Myth*, New York: Fawcett Columbine-Ballantine.

Fuchs, M. (1990) 'Frauen um Caligula und Claudius: Milonia Caesonia, Drusilla, und Messalina', *Archäologischer Anzeiger* 1990, pp. 107–22.

Furnee-van-Zwet, L. (1956) 'Fashion in Women's Hairdress in the First Century of the Roman Empire', *Bulletin Antieke Beschaving* 31, pp. 1–22.

Futre Pinheiro, M. P., M. B. Skinner and F. I. Zeitlin (eds) (2012) *Narrating Desire: Eros, Sex, and Gender in the Ancient Novel*, Trends in Classics-Supplementary Volumes, 14, Berlin: De Gruyter.

Gagetti, E. (2011) 'Three Degrees of Separation: Detail Reworking, Type Updating and Identity. Transformation in Roman Imperial Glyptic Portraits in the Round' in C. Entwistle and N. Adams (eds) (2011), pp. 135–48.

Galinsky, G. K. (1966) 'Venus on a Relief of the Ara Pacis Augustae', *American Journal of Archaeology* 70, pp. 223–43.

Galinsky, G. K. (1981) 'Augustus' Legislation on Morals and Marriage', *Philologus* 125, pp. 126–44.

Galinsky, G. K. (1992) 'Venus, Polysemy, and the Ara Pacis Augustae', *American Journal of Archaeology* 96, pp. 457–75.

Garcia, V. and A. Gustavo (2013) *Octavia contra Cleopatra: el papel de la mujer en la propaganda politica del Triumvirato (44–30 a.C.)*, Collección Estudios, Madrid: Liceus.

Gardner, J. F. (1986) *Women in Roman Law and Society*, London: Routledge.

Gazda, E. K. (1973) 'Etruscan Influence in the Funerary Reliefs of Late Republican Rome: a Study of Vernacular Portraiture', *Aufstieg und Niedergang der Römischen Welt* 1,4, pp. 855–870.

Gazda, E. K. (ed.) (2000) *The Villa of the Mysteries in Pompeii: Ancient Ritual, Modern Muse*, Ann Arbor: Kelsey Museum of Archaeology and University of Michigan.

Geary, P. (2006) *Women at the Beginning: Origin Myths from the Amazons to the Virgin Mary*, Princeton: Princeton University Press.

George, M. (2001) 'A Roman Funerary Monument with a Mother and Daughter' in S. Dixon (2001) *Childhood, Class and Kin in the Roman World*, London: Routledge, pp. 178–89.

George, M. (2005) 'Family Imagery and Family Values in Roman Italy' in M. George (ed.) (2005), pp. 37–66.

George, M. (ed.) (2005) *The Roman Family in the Empire: Rome, Italy and Beyond*, Oxford: Oxford University Press.

George, M. (2006) 'Social Identity and the Dignity of Work in Freedmen's Reliefs' in E. D'Ambra and G. P. R. Métraux (eds) (2006), pp. 19–29.

Giacosa, G. (1977) *Women of the Caesars: Their Lives and Portraits on Coins*, Milan: Arte e Moneta.

Gilles, C. and M-L. B. Nosch (eds) (2007) *Ancient Textiles: Production, Craft and Society*, Oxford: Oxbow.

Ginsburg, J. (2006) *Representing Agrippina: Constructions of Female Power in the Early Roman Empire*, Oxford: Oxford University Press.

Glazebrook, A. and K. Olson (2014) 'Greek and Roman Marriage' in T. K. Hubbard (ed.) (2014), pp. 69–82.

Gleba, M. (2011) 'The "Distaff Side" of Early Iron Age Aristocratic Identity in Italy' in M. Gleba and H. W. Hornaes (eds) (2011) *Communicating Identity in Italic Iron Age Communities*, Oxford: Oxbow, pp. 27–32.

Golden, M. and P. Toohey (eds) (1997) *Inventing Ancient Culture: Historicism, Periodization, and the Ancient World*, London: Routledge

Gourevitch, D. and M-T. Raepsaet-Charlier (2001) *La Femme dans la Rome Antique*, Paris: Hachette.

Gratwick, A. S. (1984) 'Free or Not Free? Wives and Daughters in the Late Roman Republic' in E. M. Craik (ed.) (1984) *Marriage and Property*, Aberdeen: Aberdeen University Press, pp. 30–53.

Green, C. M. C. (2010) 'Holding the Line: Women, Ritual, and the Protection of Rome', in S. P. Ahearne-Kroll *et al.* (eds) (2010), pp. 279–98.

Green, M. J. (1995) *Celtic Goddesses*, London: British Museum Press.

Green, M. J. A. (2003) 'Poles Apart? Perceptions of Gender in Gallo-British Cult-Iconography', in S. Scott and J. Webster (eds) (2003), pp. 95–118.

Grether, G. (1946) 'Livia and the Roman Imperial Cult', *American Journal of Philology* 67, pp. 222–52.

Groen-Vallinga, M. J. (2013) 'Desperate Housewives? The Adaptive Family Economy and Female Participation in the Roman Urban Labour Market', in E. A. Hemelrijk and G. Woolf (eds) (2013), pp. 295–312.

Gross, W. H. (1962) *Iulia Augusta: Untersuchungen zur Grundlegung Einer Livia-Ikonographie*, Göttingen: Vandenhoeck und Ruprecht.

Gruen, E. S. (1990) *The Advent of the Magna Mater: Studies in Greek Culture and Roman Society*, Leiden: Brill, pp. 5–33.

Hall, J. and A. Wardle (2005) 'Dedicated Followers of Fashion? Decorative Bone Hairpins from Roman London' in N. Crummy (ed.) (2005) *Image, Craft and the Classical World: Essays in Honour of Donald Bailey and Catherine Johns*, Instrumentum M1–29, pp. 173–9.

Hallett, J. P. (1984) *Fathers and Daughters in Roman Society: Women and the Elite Family*, Princeton: Princeton University Press.

Hallett, J. P. (2012) 'Women in Augustan Rome' in S. L. James and S. Dillon (eds) (2012), pp. 372–84.

Hallett, J. P. and M. B. Skinner (eds) (1997) *Roman Sexualities*, Princeton: Princeton University Press.

Halperin, D., J. Winkler, and F. Zeitlin (1990) *Before Sexuality: the Construction of the Erotic Experience in the Ancient Greek World*, Princeton: Princeton University Press.

Hamer, M. (1992) *Signs of Cleopatra: History, Politics, Representation*, London: Routledge.

Hammer, C. (2000) 'Women, Ritual, and Social Standing in Roman Italy' in E. K. Gazda (ed.) (2000), pp. 38–49.

Harlow, M. (2004) 'Galla Placidia: Conduit of Culture?' in F. McHardy and E. Marshall (eds) (2004), pp. 138–50.

Harlow, M. (2013) 'Dressed Women on the Streets of the Ancient City: What To Wear?' in E. A. Hemelrijk and G. Woolf (eds) (2013), pp. 225–42.

Harlow, M. and L. Larsson Lovén (eds) (2012) *Families in the Imperial and Late Antique Roman World,* London: Continuum.

Harlow, M. and R. Laurence (2002) *Growing Up and Growing Old in Ancient Rome: A Life Course Approach*, London: Routledge.

Harlow, M. and R. Laurence (2010) *The Cultural History of Childhood and the Family Volume One: Antiquity*, Oxford: Berg.

Hassall, M. W. C. (1977) 'Wingless Victories', in J. Munby and M. Henig (eds) (1977) *Roman Life and Art in Britain*, Oxford: British Archaeological Reports British Series 41, pp. 327–40.

Hawley, R. and B. Levick (eds) (1995) *Women in Antiquity: New Assessments*, London: Routledge.

Hemelrijk, E. A. (1999) *Matrona Docta: Educated Women in the Roman Elite from Cornelia to Julia Domna*, London: Routledge.

Hemelrijk, E. A. (2005) 'Priestesses of the Imperial Cult in the Latin West: Titles and Function', *Antiquité Classique* 74, pp. 137–70.

Hemelrijk, E. A. (2006) 'Priestesses of the Imperial Cult in the Latin West: Benefactions and Public Honour', *Antiquité Classique* 75, pp. 85–117.

Hemelrijk, E. A. (2007) 'Local Empresses: Priestesses of the Imperial Cult in the Cities of the Latin West', *Phoenix* 61.3.4, pp. 318–49.

Hemelrijk, E. A. (2012) 'Public Roles for Women in the Cities of the Latin West' in S. L. James and S. Dillon (eds) (2012), pp. 478–90.

Hemelrijk, E. A. (2013) 'Female Munificence in the Cities of the Latin West' in E. A. Hemelrijk and G. Woolf (eds) (2013), pp. 65–84.

Hemelrijk, E. A. and G. Woolf (eds) (2013) *Women and the Roman City in the Latin West*, Leiden: Brill.

Hersch, K. (2010) *The Roman Wedding: Ritual and Meaning in Antiquity*, Cambridge: Cambridge University Press.

Herzig, H. E. (1983) 'Frauen in Ostia', *Historia* 32, pp. 77–92.

Hesberg, von H. (2008) 'The Image of the Family on Sepulchral Monuments in the New Provinces' in S. Bell and I. G. Hansen (eds) (2008) *Role Models in the Roman World: Identity and Assimilation*, Ann Arbor: University of Michigan Press, pp. 256–69.

Heyn, M. K. (2012) 'Female Portraiture in Palmyra' in S. L. James and S. Dillon (eds) (2012), pp. 439–41.

Heyob, S. K. (1975) *The Cult of Isis Among Women in the Greco-Roman World*, Leiden: Brill.

Hidalgo de la Vega, M. J. (2010) 'Emperatrices Paganas y Cristianas: Poder Oculto e Imagen Pública' in A. Dominguez Arranz (ed.) (2010), pp. 185–210.

Hinks, R. (1939) *Myth and Allegory in Ancient Art*, London: Warburg Institute.

Hoffsten, R. B. (1939) *Roman Women of Rank of the Early Empire in Public Life as Portrayed by Dio, Paterculus, Suetonius and Tacitus*. PhD Thesis, University of Philadelphia, Philadelphia.

Holland, L. L. (2012) 'Women and Roman Religion' in S. L. James and S. Dillon (eds) (2012), pp. 204–14.

Holleran, C. (2013) 'Women and Retail in Roman Italy' in E. A. Hemelrijk and G. Woolf (eds) (2013), pp. 313–30.

Hölscher, T. (1967) *Victoria Romana: Archäologische Untersuchungen zur Geschichte und Wesenart der Römischen Siegesgöttin von den Anfängen bis zum Ende der 3. Jhrs n. Chr*, Mainz: Philipp von Zabern.

Hölscher, T. (2006) 'The Transformation of Victory into Power: from Event to Structure' in S. Dillon and K. E. Welch (eds) (2006), pp. 27–48.

Holum, K. (1982) *Theodosian Empresses*, Berkeley: University of California Press.

Hope, V. (1997a) 'Constructing Roman Identity: Funerary Monuments and Social Structure in the Roman World', *Mortality* 2, pp. 103–21.

Hopkins, M. K. (1965) 'Age of Roman Girls at Marriage', *Population Studies* XVIII No. 3, pp. 309–27.

Hopman, M. G. (2012) *Scylla: Myth, Metaphor, Paradox*, Cambridge: Cambridge University Press.

Hubbard, T. K. (ed.) (2014) *A Companion to Greek and Roman Sexualities*, Oxford: Blackwell Companions to the Ancient World. Blackwell.

Hudson, D. (1972) *Munby, Man of Two Worlds: The Life and Diaries of Arthur J. Munby, 1828–1910*, London: John Murray.

Hughes-Hallett, L. (1990) *Cleopatra: Histories, Dreams, and Distortions*, London: Bloomsbury.

Hultin, J. F. (2010) 'A New Web for Arachne and a New Veil for the Temple: Women and Weaving from Athena to the Virgin Mary' in S. P. Ahearne-Kroll *et al.* (eds) (2010), pp. 209–26.

Jaccottet, A-F. (2013) 'Du Corps Humain au Corps Divin: l'Apothéose dans l'Imaginaire et les Représentations Figurées' in P. Borgeaud and D. Fabiano (eds) (2013), pp. 293–322.

Jacobelli, L. (1995) *Le Pitture Erotiche delle Terme Suburbane di Pompei*, Rome: L'Erma di Bretschneider.

James, L. (2003) 'Who's That Girl? Personifications of the Byzantine Empress' in C. Entwistle (ed.) (2003), pp. 51–6.

James, S. L. and S. Dillon (eds) (2012) *A Companion to Women in the Ancient World*, Oxford: Blackwell.

Johns, C. (1982) *Sex or Symbol: Erotic Images of Greece and Rome*, London: British Museum Publications.

Joshel, S. R. (1997) 'Female Desire and the Discourse of Empire: Tacitus's Messalina' in J. P. Hallett and M. B. Skinner (eds) (1997), pp. 221–55.

Joshel, S. R. and S. Murnaghan (eds) (2001) *Women and Slaves in Greco-Roman Culture: Differential Equations*, London: Routledge.

Kalavrezou, I. (2012) 'Representations of Women in Late Antiquity and Early Byzantium', in S. L. James and S. Dillon (eds) (2012), pp. 513–23.

Kampen, N. B. (1981) *Image and Status: Roman Working Women in Ostia*, Berlin: Gebr. Mann Verlag.

Kampen, N. B. (1982) 'Social Status and Gender in Roman Art: the Case of the Saleswoman' in N. Broude and M. D. Garrard (eds) (1982) *Feminism and Art History*, New York: Harper and Row, pp. 63–77.

Kampen, N. B. (1988) 'The Muted Other', *Art Journal* 47, pp. 15–19.

Kampen, N. B. (1991a) 'Between Public and Private: Women as Historical Subjects in Roman Art' in S. B. Pomeroy (ed.) (1991), pp. 218–48.

Kampen, N. B. (1991b) 'Reliefs of the Basilica Aemilia', *Klio* (Beitrage zur Alten Geschichte) 73, pp. 448–58.

Kampen, N. B. (1994) 'Material Girl: Feminist Confrontations with Roman Art', *Arethusa* 27/1, pp. 111–49.

Kampen, N. B. (1995) 'Looking at Gender: the Column of Trajan and Roman Historical Relief', in D. Stanton and A. J. Stewart (eds) (1995) *Feminisms in the Academy*, Ann Arbor: University of Michigan Press, pp. 46–73.

Kampen, N. B. (1996a) 'Gender Theory in Roman Art' in D. E. E. Kleiner and S. Matheson (eds) (1996), pp. 14–25.

Kampen, N. B. (1996b) 'Omphale and the Instability of Gender' in N. B. Kampen (ed.) (1996), pp. 233–46.

Kampen, N. B. (ed.) (1996) *Sexuality in Ancient Art*, Cambridge: Cambridge University Press.

Kampen, N. B. (1997) 'Epilogue: Gender and Desire' in A. O. Koloski-Ostrow and C. L. Lyons (eds) (1997), pp. 267–77.

Kampen, N. B. (2007) 'The Family in Late Antique Art' in L. Larsson Lovén and A. Strömberg (eds) (2007), pp. 123–44.

Kampen, N. B. (2009) *Family Fictions in Roman Art*, Cambridge: Cambridge University Press.

Kampen, N. B. (2011) 'Houses, Painting, Family Emotion' in R. Laurence and A. Strömberg (eds) (2011), pp. 159–78.

Kampen, N. B., E. Marlowe and R. M. Molholt (2002) *What is a Man? Changing Images of Masculinity in Late Antique Art*, Portland: Douglas F. Cooley Memorial Art Gallery, Reed College.

Keegan, P. (2014) *Roles For Men and Women in Roman Epigraphic Culture and Beyond: Gender, Social Identity and Cultural Practice in Private Latin Inscriptions and the Literary Record*, Oxford: British Archaeological Reports International Series S2626, Archaeopress.

Kellum, B. (1996) 'The Phallus as Signifier: the Forum of Augustus and Rituals of Masculinity' in N. B. Kampen (ed.) (1996), pp. 170–83.

Kellum, B. (1997) 'Concealing/Revealing: Gender and the Play of Meaning in the Monuments of Augustan Rome' in T. Habinek and A. Schiesaro (eds) (1997) *The Roman Cultural Revolution*, Cambridge: Cambridge University Press, pp.158–81.

Kellum, B. (1999) 'The Spectacle of the Street' in B. Bergmann and C. Kondoleon (eds) (1999) *The Art of Ancient Spectacle*, New Haven: National Gallery of Art, Washington and Yale University Press, pp. 283–300.

Kertzer, D. I. and R. P. Saller (eds) (1991) *The Family in Italy from Antiquity to the Present*, New Haven: Yale University Press.

Kirk, S. S. (2000) 'Nuptial Imagery in the Villa of the Mysteries Frieze: South Italian and Sicilian Precedents' in E. K. Gazda (ed.) (2000), pp. 98–115.

Kleiner, D. E. E. (1977) *Roman Group Portraiture: The Funerary Reliefs of the Late Republic and Early Empire*, New York: Garland Publishing.

Kleiner, D. E. E. (1981) 'Second Century Mythological Portraiture: Mars and Venus', *Latomus* 40.3, pp. 512–44.

Kleiner, D. E. E. (1987a) *Roman Imperial Funerary Altars With Portraits*, Rome: G. Breitschneider.

Kleiner, D. E. E. (1987b) 'Women and Family Life on Roman Imperial Funerary Altars', *Latomus* 46, pp. 545–54.

Kleiner, D. E. E. (1992a) *Roman Sculpture*, New Haven: Yale University Press.

Kleiner, D. E. E. (1992b) 'Politics and Gender in the Pictorial Propaganda of Antony and Octavian', *Echos du Monde Classique/Classical Views* 36 (11), pp. 357–67.

Kleiner, D. E. E. (1994) '"Democracy" for Women in the Age of Augustus', *American Journal of Archaeology* 98, p. 303.

Kleiner, D. E. E. (1996) 'Imperial Women as Patrons of the Arts in the Early Empire' in D. E. E. Kleiner and S. B. Matheson (eds) (1996), pp. 28–41.

Kleiner, D. E. E. (2000a) 'Now You See Them, Now You Don't: The Presence and Absence of Women in Roman Art' in E. R. Varner (ed.) (2000), pp. 45–57.

Kleiner, D. E. E. (2000b) 'Family Ties: Mothers and Sons in Elite and Non-Elite Roman Art' in D. E. E. Kleiner and S. B. Matheson (eds) (2000), pp. 43–60.

Kleiner, D. E. E. (2005) *Cleopatra and Rome*, Cambridge: Harvard University Press.

Kleiner, D. E. E. and F. S. Kleiner (1980) 'The Apotheosis of Antoninus and Faustina', *Rendiconti. Atti della Pontificia Accademia Romana di Archeologia* 51–2, pp. 389–400.

Kleiner, D. E. E. and S. B. Matheson (eds) (1996) *I Claudia: Women in Ancient Rome*, Austin: University of Texas Press.

Kleiner, D. E. E. and S. B. Matheson (eds) (2000) *I Claudia II: Women in Roman Art and Society*, Austin: University of Texas Press.

Kokkinos, N. (1992) *Antonia Augusta: Portrait of a Great Roman Lady*, London: Routledge.

Koloski-Ostrow, A. O. (1997) 'Violent Stages in Two Pompeian Houses: Imperial Taste, Aristocratic Response, and Messages of Male Control' in A. O. Koloski-Ostrow and C. L. Lyons (eds) (1997), pp. 243–66.

Koloski-Ostrow, A. O. and C. L. Lyons (eds) (1997) *Naked Truths: Women, Sexuality, and Gender in Classical Art and Archaeology*, London: Routledge.

Koortbojian, M. (1995) *Myth, Meaning, and Memory on Roman Sarcophagi*, Berkeley: University of California Press

Kraemer, R. S. (1979) 'Ecstacy and Possession: the Attraction of Women to the Cult of Dionysos', *Harvard Theological Review* 72, pp. 55–80.

Kraemer, R. S. (1983) 'Women in the Religions of the Greco-Roman World', *Religious Studies Review* 9, pp. 127–39.

Kraemer, R. S. (2004) *Women's Religions in the Greco-Roman World: A Sourcebook*, Oxford: Oxford University Press.

Kraemer, R. S. (2011) *Unreliable Witnesses: Religion, Gender and History in the Greco-Roman Mediterranean*, Oxford: Oxford University Press.

Kreamer, C. M. and S. Fee 2002 *Objects as Envoys: Cloth, Imagery, and Diplomacy in Madagascar*, Washington: Smithsonian Institution, National Museum of African Art and Seattle: University of Washington Press.

Krug, A. (2007) 'Gemmen und Kameen' in A. Demandt and J. Engemann (eds) 2007b, pp. 132–9.

Lambrechts, P. (1952) 'Livie-Cybèle', *La Nouvelle Clio* 4, pp. 251–60.

Langford, J. (2013) *Maternal Megalomania: Julia Domna and the Imperial Politics of Motherhood*, Baltimore: Johns Hopkins University Press.

Bibliography

Larson, J. (2014) 'Sexuality in Greek and Roman Religion' in T. K. Hubbard (ed.) (2014), pp. 214–29.

Larsson Lovén, L. (1998) '*Lanam Fecit*: Woolworking and Female Virtue' in L. Larsson Lovén and A. Strömberg (eds) (1998), pp. 85–95.

Larsson Lovén, L. (2003) 'Funerary Art, Gender and Social Status: Some Aspects from Roman Gaul' in L. Larsson Lovén and A. Strömberg (eds) (2003), pp. 54–71.

Larsson Lovén, L. (2007) 'Wool Work as a Gender Symbol in Ancient Rome: Roman Textiles and Ancient Sources' in C. Gilles and M-L. B. Nosch (eds) (2007), pp. 229–38.

Larsson Lovén, L. and A. Strömberg (eds) (1998) *Aspects of Women in Antiquity: Proceedings of the First Nordic Symposium on Women's Lives in Antiquity*, Jonsered: Paul Åströms Förlag.

Larsson Lovén, L. and A. Strömberg (eds) (2003) *Gender, Cult, and Culture in the Ancient World from Mycenae to Byzantium: Proceedings of the Second Nordic Symposium on Women's Lives in Antiquity*, Jonsered: Paul Åströms Förlag.

Larsson Lovén, L. and A. Strömberg (eds) (2007) *Public Roles and Personal Status: Men and Women in Antiquity. Proceedings of the Third Nordic Symposium on Women's Lives in Antiquity*, Jonsered: Paul Åströms Förlag.

Laurence, R. and A. Strömberg (eds) (2011) *The Family in the Greco-Roman World*, London: Continuum.

Leach, E. (2006) 'Freedmen and Immortality in the Tomb of the Haterii' in E. D'Ambra and G. P. R. Métraux (eds) (2006), pp. 1–18.

Le Bonniec, H. (1958) *Le Culte de Cérès à Rome, des Origines à la Fin de la République*, Paris: Klincksieck.

Lee, H. (1984) 'Athletics and the Bikini Girls from Piazza Armerina', *Stadion* 10, pp. 45–76.

Lefkowitz, M. R. (1983) 'Influential Women' in A. Cameron and A. Kuhrt (eds) (1983), pp. 49–64.

Lefkowitz, M. R. and M. B. Fant (eds) (1992) *Women's Life in Greece and Rome: a Sourcebook in Translation*. Second Edition, Baltimore: Johns Hopkins University Press.

Levick, B. M. (2007) *Julia Domna: Syrian Empress*, London: Routledge.

Levick, B. M. (2014) *Faustina I and II: Imperial Women of the Golden Age. Women in Antiquity*, Oxford: Oxford University Press.

Levin-Richardson, S. (2013) '*futura sum hic*: Female Subjectivity and Agency in Pompeian Sexual Graffiti', *Classical Journal* 108, pp. 319–45.

Levy, E. (ed.) (1983) *La Femme dans les Sociétés Antiques*, Strasbourg: AECR.

Lewis, R. G. (1988) 'Some Mothers', *Athenaeum* 66, pp. 198–200.

Lewis, S. (2002) *The Athenian Woman: An Iconographic Handbook*, London: Routledge.

LiDonnici, L. R. (1992) 'The Images of Artemis Ephesia and Greco-Roman Worship: a Reconsideration', *Harvard Theological Review* 85.4, pp. 389–415.

Lissarague, F. (1990) 'Figures of Women' in P. S. Pantel (ed.) 1992 *A History of Women in the West Vol. 1: From Ancient Goddesses to Christian Saints*, Cambridge: Belknap Press of Harvard University Press, pp. 139–229.

Longfellow, B. (2000a) 'A Gendered Space? Location and Function of Room 5 in the Villa of the Mysteries' in E. K. Gazda (ed.) (2000), pp. 24–37.

Longfellow, B. (2000b) 'Liber and Venus in the Villa of the Mysteries' in E. K. Gazda (ed.) (2000), pp. 116–28.

MacDonald, F. (2000) *Women in Ancient Rome*, New York: Peter Bedrick.

MacLachlan, B.(2013) *Women in Ancient Rome: A Sourcebook*, London: Bloomsbury.

MacMullen, R. (1980) 'Women in Public in the Roman Empire', *Historia* 29, pp. 208–18. Reprinted 1990 in R. MacMullen (1990) *Changes in the Roman Empire: Essays in the Ordinary*, Princeton: Princeton University Press.

MacMullen, R. (1986) 'Women's Power in the Principate', *Klio* 68, pp. 434–43.

Macurdy, G. H. (1937) *Vassal-Queens and Some Contemporary Women in the Roman Empire*, Baltimore: Johns Hopkins University Press.

Magnen, R. and E. Thévenot (1953) *Epona*, Bordeaux: Delmas.

Mander, J. (2012) 'The Representation of Physical Contact on Roman Tombstones' in M. Harlow and L. Larsson Lovén (eds) (2012), pp. 64–84.

Manson, M. (1987) 'Le Bambole Romane Antiche', *Ricerca Folklorica, Contributi allo Studio della Cultura delle Classi Popolari* 16, pp. 15–26.

Manson, M. (1991) 'Les Poupées Antiques' in R. May, J-P. Neraudau and M. Manson (eds) (1991) *Jouer dans L'Antiquité*, Marseille: Musée d'Archéologie Méditerranéenne. Musées de Marseille, pp. 54–8.

Mantle, I. (2013) 'Women of the Bardo', *Omnibus* 65, pp. 4–6.

Marshall, A. J. (1975) 'Roman Women and the Provinces', *Ancient Society* 6, pp. 124–5.

Matheson, S. B. (1994) 'The Goddess Tyche' in S. B. Matheson (ed.) (1994), pp. 19–33.

Matheson, S. B. (ed.) (1994) *An Obsession with Fortune: Tyche in Greek and Roman Art*, New Haven: Yale University Art Gallery, Yale.

Mayer, E. (2012) *The Ancient Middle Classes: Urban Life and Aesthetics in the Roman Empire, 100 BCE-250 CE*, Harvard: Harvard University Press.

Mayor, A. (2014) *The Amazons: Lives and Legends of Warrior Women Across the Ancient World*, Princeton: Princeton University Press.

McClanan, A. (2002) *Representations of Early Byzantine Empresses: Image and Empire*, New York: Palgrave.

McClure, L. (ed.) (2002) *Sexuality and Gender in the Classical World: Readings and Sources*, Oxford: Blackwell.

McGinn, T. A. J. (2004) *The Economy of Prostitution in the Roman World: a Study of Social History and the Brothel*, Ann Arbor: University of Michigan Press.

McHardy, F. and E. Marshall (eds) (2004) *Women's Influence on Classical Civilization*, London: Routledge.

McNally, S. (1985) 'Ariadne and Others: Images of Sleep in Greek and Early Roman Art', *Classical Antiquity* 4 No. 2, pp. 152–92.

Meischner, J. (1964) *Das Frauenporträt der Severerzeit*, Berlin: Diss.

Metrau, G. P. R. and E. D'Ambra (eds) (2006) *The Art of Citizens, Soldiers and Freedmen in the Roman World*, Oxford: British Archaeological Reports International Series 1526, Archaeopress.

Metzler, D. (1994) 'Mural Crowns in the Ancient Near East and Greece' in S. B. Matheson (ed.) (1994), pp. 77–85.

Meyers, R. (2012) 'Female Portraiture and Female Patronage in the High Imperial Period' in S. L. James and S. Dillon (eds) (2012), pp. 453–66.

Mikocki, T. (1995) *Sub Specie Deae: Les Impératrices et princesses Romaines Assimilées à des déesses: Étude Iconologique*, Rome: L'Erma di Bretschneider.

Milnor, K. (2005) *Gender, Domesticity, and the Age of Augustus: Inventing Private Life*, Oxford: Oxford University Press.

Milnor, K. (2011) 'Women in Roman Society' in M. Peachin (ed.) (2011) *The Oxford Handbook of Social Relations in the Roman World*, Oxford: Oxford University Press, pp. 609–22.

Mirón Pérez, M. D. (1996) *Mujeres, Religión y Poder: el Culto Imperial en el Occidente Mediterráneo*, Granada: Universidad de Granada.

Montserrat, D. (2000) 'Reading Gender in the Roman World' in J. Huskinson (ed.) (2000) *Experiencing Rome: Culture, Identity and Power in the Roman Empire*, London: Routledge, pp. 153–81.

Morello, A. (ed.) (2009) *La Donna Romana: Immagini e Vita Quotidiana. Atti del Convegno*, Cassino: Editrice Diana.

Nead, L. (1992) *The Female Nude: Art, Obscenity and Sexuality*, London: Routledge.

Neils, J. (2011) *Women in the Ancient World*, London: British Museum.

Newby, Z. (2011a) 'Displaying Myth for Roman Eyes' in K. Dowden and N. Livingstone (eds) (2011), pp. 265–82.

Newby, Z. (2011b) 'Myth and Death: Roman Mythological Sarcophagi' in K. Dowden and N. Livingstone (eds) (2011), pp. 301–18.

Nichols, J. (1989) 'Patrona Civitatis: Gender and Civic Patronage' in C. Deroux (ed.) (1989) *Studies in Latin Literature and Roman History*, Brussels: Latomus, pp. 117–42.

Nochlin, L. (1989) *Women, Art, and Power and Other Essays*, London: Thames and Hudson.

Nochlin, L. (1994) *The Body In Pieces: The Fragment as a Metaphor for Modernity*, London: Thames and Hudson.

Nochlin, L. (1999) *Representing Women*, London: Thames and Hudson.

Nolden, R. (2007) 'Das Ada-Evangeliar' in A. Demandt and J. Engemann (eds) (2007), pp. 498–500.

Norr, D. (1981) 'The Matrimonial Legislation of Augustus', *Irish Jurist* 16, pp. 350–64.

North, J. (2013) 'Gender and Cult in the Roman West: Mithras, Isis, Attis' in E. A. Hemelrijk and G. Woolf (eds) (2013), pp. 109–28.

Oaks, S. (1986) 'The Goddess Epona: Concepts of Sovereignity in a Changing Landscape' in M. Henig and A. King (eds) (1986) *Pagan Gods and Shrines of the Roman Empire*, Oxford: Oxford University Committee for Archaeology, pp. 77–83.

Oost, S. I. (1968) *Galla Placidia Augusta*, Chicago: University of Chicago Press.

Olson, K. (2008) *Dress and the Roman Woman: Self-Presentation and Society*, London: Routledge.

Osborne, R. (1994) 'Looking-On-Greek Style: Does the Sculpted Girl Speak to Women Too?' in I. Morris (ed.) (1994) *Classical Greece: Ancient Histories and Modern Archaeologies*, Cambridge: Cambridge University Press.

Panella, C. (1966–7) 'Iconografia delle Muse sui Sarcofagi Romani', *Studi Miscellanei: Seminario di Archeologia e Storia dell'Arte Greca e Romana dell'Università di Roma* XII, pp. 11–43.

Papin, N. (2010) *Femme dans la Rome Impériale*, Levallois-Perret: Éditions Altipresse.

Parca, M. and Tzanetov, A. (eds) (2007) *Finding Persephone: Women's Rituals in the Ancient Mediterranean*, Bloomington: Indiana University Press.

Parker, H. N. (1992) 'Love's Body Anatomized: the Ancient Erotic Handbooks and the Rhetoric of Sexuality' in A. Richlin (ed.) (1992), pp. 90–111.

Parker, H. N. (2004) 'Why Were the Vestals Virgins? Or the Chastity of Women and the Safety of the Roman State', *American Journal of Philology* 125 No. 4, pp. 563–601.

Parker, R. (1983) *The Subversive Stitch: Embroidery and the Making of the Feminine*, London: Women's Press.

Pasztókai-Szeöke, J. (2011) "The Mother Shrinks, the Child Grows? What Is It?' The Evidence of Spinning Implements in Funerary Context from the Roman Province of Pannonia', in C. A. Giner, M. J. M. Garcia and J. O. Garcia (eds) (2011) *Mujer y Vestimenta: Aspectos de la Identidad Femenina en la Antigüedad*, Valencia: Monografias del Sema de Valencia II, pp. 125–40.

Pelletier, A. (1984) *La Femme dans la Société Gallo-Romaine, Paris:* Picard.

Penner, T. and C. V. Stichele (eds) (2007) *Mapping Gender in Ancient Religious Discourses*, Leiden: Brill.

Peradotto, J. and J. P. Sullivan (eds) (1984) *Women in the Ancient World*, Albany: Arethusa Papers. State University of New York Press.

Petrocelli, C. (2001) 'Cornelia the Matron' in A. Fraschetti (ed.) (2001), pp. 34–65.

Pleket, H. W. (1969) *The Social Position of Women in the Greco-Roman World. Epigraphica II: Texts on the Social History of the Greek World*, Leiden: Brill.

Pohlsander, H. A. (1995) *Helena: Empress and Saint*, Chicago: Ares Publishers.

Polaschek, K. (1973) *Studien zur Ikonographie der Antonia Minor*, Rome: L'Erma di Bretschneider.

Pollini, J. (1993) 'The Cartoceto Bronzes: Portraits of a Roman Aristocratic Family of the Late First Century BC', *American Journal of Archaeology* 97, 423–46.

Pollini, J. (2012) *From Republic to Empire: Rhetoric, Religion, and Power in the Visual Culture of Ancient Rome*, Norman: Oklahoma Series in Classical Culture 48. University of Oklahoma Press.

Pollitt, J. J. (1994) 'An Obsession with Fortune' in S. B. Matheson (ed.) (1994), pp. 13–17.

Pomeroy, S. B. (1975) *Goddesses, Whores, Wives, and Slaves: Women in Classical Antiquity*, New York: Schocken Books Inc..

Pomeroy, S. B. (1976) 'The Relationship of Married Women to her Blood Relatives at Rome', *Ancient Society* 7, pp. 215–27.

Pomeroy, S. B. (ed.) (1991) *Women's History and Ancient History*, Chapel Hill: University of North Carolina Press.

Pomeroy, S. B. (2007) *The Murder of Regilla: a Case of Domestic Violence in Antiquity*, Harvard: Harvard University Press.

Portale, E. C. (2013) 'Augustae, Matrons, Goddesses: Imperial Women in the Sacred Space' in M. Galli (ed.) (2013) *Roman Power and Greek Sanctuaries: Forms of Interaction and Communication*, Tripodes 14, Athens: Scuola Archeologica Italiana di Atene, pp. 205–44.

Potter, T. (1985) 'A Republican Healing Sanctuary at Ponte di Nona Near Rome and the Classical Tradition of Votive Medicine', *Journal of the British Archaeological Association* 138, pp. 23–47.

Poulsen, B. (2014) 'City Personifications in Late Antiquity' in S. Birk, T. M. Kristensen, and B. Poulsen (eds) (2014), pp. 209–26.

Poulsen, V. (1964) 'Portraits of Claudia Octavia', *Opuscula Romana* 4, pp. 107–11.

Purcell, N. (1986) 'Livia and the Womanhood of Rome', *Proceedings of the Cambridge Philological Society* 32, pp. 78–105.

Raditsa, L. F. (1980) 'Augustus' Legislation Concerning Marriage, Procreation, Love Affairs and Adultery', *Aufstieg und Niedergang der Römischen Welt* II.13, pp. 278–339.

Rawson, B. (ed.) (1986) *The Family in Ancient Rome: New Perspectives*, Ithaca: Cornell University Press.

Rawson, B. and P. Weaver (eds) (1997) *The Roman Family in Italy: Status, Sentiment, Space*, Oxford: Clarendon Press.

Reeder, E. (1995) *Pandora: Women in Classical Greece*, Princeton: Princeton University Press.

Reggiani, A. M. (2004) *Adriano: Le Memorie al Femminile*, Milan: Electa.

Rémy, B. and Mathieu, N. (2009) *Les Femmes en Gaule Romaine 1er Siècle av. J.C.-Ve Siècle apr J.C.*, Paris: Éditions Errance.

Richlin, A. (1992a) *The Garden of Priapus: Sexuality and Aggression in Roman Humour*, Second edition. Oxford: Oxford University Press.

Richlin, A. (ed.) (1992b) *Pornography and Representation in Greece and Rome*, Oxford: Oxford University Press.

Richlin, A. (1992c) 'Julia's Jokes, Galla Placidia and the Roman Use of Women as Political Icons' in B. Garlick, S. Dixon and P. Allen (eds) (1992) *Stereotypes of Women in Power: Historical Perspectives and Revisionist Views*, New York: Greenwood Press, pp. 65–91.

Richlin, A. (1995) 'Making Up a Woman: the Face of Roman Gender' in H. Eilberg-Schwartz and W. Doniger (eds) (1995) *Off With Her Head! The Denial of Women's Identity in Myth, Religion, and Culture*, Berkeley: University of California Press, pp. 185–213.

Richlin, A. (1997a) 'Towards a History of Body History' in M. Golden and P. Toohey (eds) (1997), pp. 16–35.

Richlin, A. (1997b) 'Carrying Water in a Sieve: Class and the Body in Roman Women's Religion' in K. L. King (ed.) (1997) *Women and Goddess Traditions in Antiquity and Today*, Minneapolis: Fortress Press, pp. 330–74.

Ridgway, B. S. (1974) 'A Story of Five Amazons', *American Journal of Archaeology* 78, pp. 1–17.

Riggs, C. (2012) 'Portraits, Prestige, Piety: Images of Women in Roman Egypt' in S. L. James and S. Dillon (eds) (2012), pp. 423–36.

Rodgers, R. (1995) 'Women Underfoot in Life and Art: Female Representations in Fourth-Century Romano-British Mosaics', *Journal of European Archaeology* 3 (15), pp. 178–87.

Rodgers, R. H. (1998) *Imagery and Ideology: Aspects of Female Representation in Roman Art, with Special Reference to Britain and Gaul.* PhD Thesis, Durham University. http://etheses.dur.ac.uk/1135/

Rodgers, R. H. (2003) 'Female Representation in Roman Art: Feminising the Provincial "Other"' in S. Scott and J. Webster (eds) (2003), pp. 69–94.

Roisman, J. (2014) 'Greek and Roman Ethnosexuality' in T. K. Hubbard (ed.) (2014), pp. 398–416.

Roller, L. E. (1997) *In Search of God the Mother: the Cult of Anatolian Cybele*, Berkeley: University of California Press.

Rose, C. B. (1996) *Dynastic Commemmoration and Imperial Portraiture in the Julio-Claudian Period*, Cambridge: Cambridge University Press.

Rose, M. E. (2006) 'The Trier Ceiling: Power and Status on Display in Late Antiquity', *Greece and Rome* Second Series 53.1, pp. 92–109.

Rossini, O. (2006) *Ara Pacis*, Milan: Electa.

Rothe, U. (2009) *Dress and Cultural Identity in the Rhine-Moselle Region of the Roman Empire*, Oxford: British Archaeological Reports International Series S2038, Archaeopress.

Rothe, U. (2013) 'Whose Fashion? Men, Women and Roman Culture As Reflected In Dress in the Roman North-West' in E. A. Hemelrijk and G. Woolf (eds) (2013), pp. 243–70.

Rottloff, A. (2006) *Lebensbilder Römischer Frauen*, Mainz: Verlag Philipp von Zabern.

Rousselle, A. (1988) *Porneia: On Desire and the Body in Antiquity*, Oxford: Blackwell.

Ryan, M. (ed.) (1989) *La France: Images of Woman and Ideas of Nation 1789–1989*, London: South Bank Centre.

Saavedra, M. D. G. (1994) 'El Mecenazgo Femenino Imperial: el Caso de Julia Domna', *L'Antiquité Classique* LXIII, pp. 193–200.

Salisbury, J. E. (1997) *Perpetua's Passion: The Death and Memory of a Young Roman Woman*, London: Routledge.

Saller, R. P. and B. Shaw (1984) 'Tombstones and Family Relationships in the Principate: Civilians, Soldiers and Slaves', *Journal of Roman Studies* 74, pp. 124–256.

Sándor, B. (2002) *Kelta Asszonyok-Romai Hölgyek: Celtic Women-Roman Ladies*. Temporary Exhibition in the Aquincum Museum May 2000–October 2001, Budapest.

Sapelli, M. (1999) *Provinciae Fidelis: Il Fregio del Tempio di Adriano in Campo Marzio*, Milan: Electa.

Sauron, G. (1998) *La Grande Fresque de la Villa des Mystères à Pompéi*, Paris: Picard.

Sawyer, D. F. (1996) *Women and Religion in the First Christian Centuries*, London: Routledge.

Scheid, J. (1992) 'The Religious Roles of Roman Women' in P. Schmitt-Pantel (ed.) (1992) *A History of Women in the West I: From Ancient Goddesses to Christian Saints*, Cambridge: Harvard University Press, pp. 377–408.

Scheid, J. (2001) 'Claudia the Vestal Virgin' in A. Fraschetti (ed.) (2001), pp. 23–33.

Schroer, S. (ed.) (2006) *Images and Gender: Contributions to the Hermeneutics of Reading Ancient Art*, Fribourg: Academic Press.

Scott, E. (1995) 'Women and Gender Relations in the Roman Empire' in P. Rush (ed.) (1995) *Theoretical Roman Archaeology: Second Conference Proceedings*, Aldershot: Avebury, pp. 174–89.

Scott, S. and J. Webster (eds) (2003) *Roman Imperialism and Provincial Art*, Cambridge: Cambridge University Press.

Sebesta, J. L. (1997) 'Women's Costume and Feminine Civic Morality in Augustan Rome', *Gender and History* 9, pp. 529–54.

Sebesta, J. L. (2001) *Symbolism in the Costume of the Roman Woman*, Madison: University of Wisconsin Press.

Sebesta, J. L. and L. Bonfante (eds) (1994) *The World of Roman Costume*, Madison: of Wisconsin.

Seltman, C. (1956) *Women in Antiquity*, New Edition. London: Thames and Hudson.

Setälä, P. (2002) 'Women, Wealth and Power in the Roman Empire', *Acta Instituti Romani Finlandiae* 25.

Severy, B. (2003) *Augustus and the Family at the Birth of the Roman Empire*, London: Routledge.

Silberberg-Peirce, S. (1993) 'The Muse Restored: Images of Women in Roman Painting', *Woman's Art Journal* 14 No. 2, pp. 28–36.

Simon, M. (ed.) (2011) *Identités Romaines: Conscience de Soi, et Représentations de l'Autre dans la Rome Antique*, Paris: Éditions Rue d'Ulm. Presses de l'ENS.

Sivan, H. (2011) *Galla Placidia: The Last Roman Empress*, Oxford: Oxford University Press.

Skinner, M. B. (2014a) *Sexuality in Greek and Roman Culture*, Second Edition. Oxford: Blackwell.

Skinner, M. B. (2014b) 'Feminist Theory' in T. K. Hubbard (ed.) (2014), pp. 1–16.

Smith, R. R. R. (1985) 'Roman Portraits, Honours, Empresses and Late Emperors', *Journal of Roman Studies* 75, pp. 209–21.

Smith, R. R. R. (1988) 'Simulcra Gentium: the Ethne from the Sebasteion at Aphrodisias', *Journal of Roman Studies* 78, pp. 50–77.

Smith, R. R. R. (1997) 'The Public Image of Licinius I: Portrait Sculpture and Imperial Ideology in the Early Fourth Century', *Journal of Roman Studies* 87, pp. 170–202.

Smith, R. R. R. (1998) 'Cultural Choice and Political Identity in Honorific Portrait Statues in the Greek East in the Second Century AD', *Journal of Roman Studies* 88, pp. 56–93.

Smith, R. R. R. (2013) *The Marble Reliefs from the Julio-Claudian Sebasteion. Aphrodisias 6*, Munich: Verlag Phillip von Zabern.

Soren, D. and N. Soren (1999) *A Roman Villa and a Late Roman Infant Cemetery: Excavation at Poggio Gramignano, Lugnano in Teverina*, Rome: Bibliotheca Archaeologica 23. L'Erma di Bretschneider.

Sowers-Lusnia, S. E. (1990) *The Public Image of Julia Domna and Her Role In Severan Dynastic Propaganda*, Cincinnati: University of Cincinnati.

Sowers-Lusnia, S. E. (1995) 'Julia Domna's Coinage and Severan Dynastic Propaganda', *Latomus* 54, pp. 119–40.

Spaeth, B. S. (1994) 'Ceres in the Ara Pacis Augustae and the Carthage Relief', *American Journal of Archaeology* 98, pp. 65–100.

Spaeth, B. S. (1996) *The Roman Goddess Ceres*, Austin: University of Texas Press.

Späth, T. (2000) 'Skrupellose Herrsclerin? Das Bild der Agrippina Minor Bei Tacitus', in T. Späth and B. Wagner-Hasel (eds) (2000), pp. 262–80.

Späth, T. and B. Wagner-Hasel (eds) (2000) *Frauenwelten in der Antike*, Stuttgart: Verlag J. B. Metzler.

Spickermann, W. (2013) 'Women and the Cult of Magna Mater in the Western Provinces' in E. A. Hemelrijk and G. Woolf (eds) (2013), pp. 147–70.

Stafford, E. J. (1998) 'Masculine Values, Feminine Forms: on the Gender of Personified Abstractions' in L. Foxhall and J. Salmon (eds) (1998), pp. 43–55.

Staples, A. (1998) *From Good Goddess to Vestal Virgins: Sexual Category in Roman Religion*, London: Routledge.

Stehle, E. (1989) 'Venus, Cybele, and the Sabine Women: the Roman Construction of Female Sexuality', *Helios* 16, pp. 143–64.

Stehle, E. and A. Day (1996) 'Women Looking at Women: Women's Ritual and Temple Sculpture' in N. B. Kampen (ed.) (1996), pp. 101–16.

Stewart, P. (2003) *Statues in Roman Society: Representation and Response*, Oxford: Oxford University Press.

Stoddart, S. (2009) *The Etruscan Body*, London: Accordia Research Papers 11, pp. 137–52.

Takacs, S. A. (2008) *Vestal Virgins, Sibyls, and Matrons: Women in Roman Religion*, Austin: University of Texas Press.

Taylor, R. (2008) *The Moral Mirror of Roman Art*, Cambridge: Cambridge University Press.

Thomas, G. (1984) 'Magna Mater and Attis', *Aufstieg und Niedergang der Römischen Welt* 2.17.3, pp. 1500–35.

Topper, K. (2007) 'Perseus, the Maiden Medusa, and the Imagery of Abduction', *Hesperia* 76, pp. 73–105.

Toynbee, J. M. C. (1934) *The Hadrianic School: A Chapter in the History of Greek Art*, Cambridge: Cambridge University Press.

Treggiari, S. (1976) 'Jobs for Women', *American Journal of Ancient History* 1, pp. 76–104.

Treggiari, S. (1979) 'Lower Class Women in the Roman Economy', *Florilegium* 1, pp. 65–86.

Treggiari, S. (1993) *Roman Marriage*, New Edition. Oxford: Oxford University Press.

Trillmich, W. (1978) *Familienpropaganda der Kaiser Caligula und Claudius: Agrippina Major und Antonia Augusta auf Münzen*, Berlin: De Gruyter.

Trimble, J. (2011) *Women and Visual Replication in Roman Imperial Art and Culture*, Cambridge: Cambridge University Press.

Tyrrell, W. B. (1984) *Amazons: a Study in Athenian Mythmaking*, Baltimore: Johns Hopkins University Press.

Uzzi, J. D. (2005) *Children in the Visual Arts of Imperial Rome*, Cambridge: Cambridge University Press.

Valentini, A. (2012) *Matronae tra Novitas e Mos Maiorum: Spazie Modalità dell'Azione Pubblica Femminile nella Roma Medio Repubblicana*, Venice: Memorie Classe di Scienze Morali, Lettere ed Arte 138. Istituto Veneto di Scienze, Lettere ed Arti.

Van Bremen, R. (1983) 'Women and Wealth' in A. Cameron and A. Kuhrt (eds) (1983), pp. 223–42.

Van Bremen, R. (1996) *The Limits of Participation: Women and Civic Life in the Greek East in the Hellenistic and Roman Periods*, Amsterdam: J. C. Gieben.

Vandiver, E. (1999) 'The Founding Mothers of Livy's Rome: The Sabine Women and Lucretia' in F. B. Titchener and R. F. Moorton (eds) (1999) *The Eye Expanded: Life and the Arts in Greco-Roman Antiquity*, Berkeley: University of California Press, pp. 206–32.

Varner, E. R. (1995) 'Domitia Longina and the Politics of Portraiture', *American Journal of Archaeology* 99, pp. 187–206.

Varner, E. R. (ed.) (2000) *From Caligula to Constantine: Tyranny and Transformation in Roman Portraiture*, Atlanta: Michael C. Carlos Museum, Emory University.

Varner, E. (2001) 'Portraits, Plots and Politics: *Damnatio Memoriae* and the Images of Imperial Women', *Memoirs of the American Academy in Rome* XLVI, pp. 41–93.

Varner, E. R. (2004) *Mutilation and Transformation: Damnatio Memoriae and Roman Imperial Portraiture*, Leiden: Brill.

Varriale, I. (2012) 'Architecture and Decoration in the House of Menander in Pompeii' in D. L. Balch and A. Weissenneder (eds) (2012) *Contested Spaces: Houses and Temples in Roman Antiquity and the New Testament*, Tübingen: Mohr Siebeck, pp. 163–84.

Vernant, J-P. (1991) *Mortals and Immortals: Collected Essays*, Edited by F. I. Zeitlin. Princeton: Princeton University Press.

Vidén, G. (1993) *Women in Roman Literature*, Göteborg: Acta Universitatis Gothoburgensis.

Vikan, G. (1990) 'Art and Marriage in Early Byzantium', *Dumbarton Oaks Papers* XLIV, pp. 145–63.

Vivante, B. (2007) *Daughters of Gaia: Women in the Ancient Mediterranean World*, Westport, Connecticut: Praeger.

Vout, C. (2003) 'Embracing Egypt' in C. Edwards and G. Woolf (eds) (2003) *Rome the Cosmopolis*, Cambridge: Cambridge University Press, pp. 177–202.

Vout, C. (2007) *Power and Eroticism in Imperial Rome*, Cambridge: Cambridge University Press.

Vout, C. (2013) *Sex On Show: Seeing the Erotic in Greece and Rome*, London: British Museum.

Waelkens, M. (1977) 'Phrygian Votic and Tombstones as Sources of the Social and Economic Life in Roman Antiquity', *Ancient Society* 8, pp. 277–93.

Walker, A. (2002) 'Myth and Marriage in Early Byzantine Marriage Jewelry: the Persistence of Pre-Christian Traditions' in A. L. McClanan and K. R. Encarnacion (eds) (2002) *The Material Culture of Sex, Procreation and Marriage in Pre-Modern Europe*, New York: Palgrave.

Walker, S. (2000) 'The Moral Museum: Augustus and the City of Rome' in J. Coulston and H. Dodge (eds) (2000) *Ancient Rome: The Archaeology of the Eternal City*, Oxford: Oxford University School of Archaeology, pp. 61–75.

Walker, S. and M. Bierbrier (1997) *Ancient Faces: Mummy Portraits from Roman Egypt*, London: British Museum Press.

Walker, S. and A. Burnett (1981) 'A Relief With Portrait of Two Women' in *Augustus, Handlist of the Exhibition and Supplementary Studies*, London: British Museum Occasional Papers 16. British Museum, pp. 43–7.

Walker, S. and P. Higgs (ed.) (2001) *Cleopatra of Egypt: From History to Myth*, London: British Museum Press.

Wildfang, R. L. (2006) *Rome's Vestal Virgins*, London: Routledge.

Will, E. (1979) 'Women in Pompeii', *Archaeology* 32, pp. 37–41.

Williams, C. A. (2012) *Reading Roman Friendship*, Cambridge: Cambridge University Press.

Winkes, R. (1995) *Livia, Octavia, Julia: Porträts und Darstellungen*, Louvain-la-Neuve and Providence: Art and Archaeology Publications.

Winter, B. (2003) *Roman Wives, Roman Widows: The Appearance of New Women and the Pauline Communities*, Grand Rapids, Michigan: William B. Eerdmans Publishing.

Wiseman, T. P. (1974) 'Legendary Genealogies in Late-Republican Rome', *Greece and Rome* 21.2, pp. 153–64.

Wiseman, T. P. (1984) 'Cybele, Virgil and Augustus' in T. Woodman and D. West (eds) (1984) *Poetry and Politics in the Age of Augustus*, Cambridge: Cambridge University Press.

Witherington, B. (1988) *Women in the Earliest Churches*, Cambridge: Cambridge University Press.

Witt, R. E. (1971) *Isis in the Greco-Roman World*, London: Thames and Hudson.

Wood, S. E. (1988) 'Memoriae Agrippinae: Agrippina the Elder in Julio-Claudian Art and Propaganda', *American Journal of Archaeology* 92, pp. 409–26.

Wood, S. E. (1992) 'Messalina, Wife of Claudius: Propaganda Successes and Failures of His Reign', *Journal of Roman Archaeology* 5, pp. 219–34.

Wood, S. E. (1995) 'Diva Drusilla Panthea and the Sisters of Caligula', *American Journal of Archaeology* 99, pp. 457–82.

Wood, S. E. (1998) *Imperial Women: A Study in Public Images, 40 BC–AD 68*, Leiden: Brill.

Woodford, S. (2003) *Images of Myths in Classical Antiquity*, Cambridge: Cambridge University Press.

Woodhull, M. L. (2004) 'Matronly Patrons in the Early Roman Empire: the Case of Salvia Postuma' in F. McHardy and E. Marshall (eds) (2004), pp. 75–91.

Wrede, H(1990) 'Der Sarkophagdeckel eines Mädchens in Malibu und die Frühen Klinesarkophage Roms, Athens und Kleinasiens' in M. True and G. Koch (eds) (1990) *Roman Funenary Monuments in the J. Paul Getty Museum*.

Volume 1, Malibu: J. Paul Getty Museum Occasional Papers on Antiquities 6, pp. 15–46.

Wyke, M. (1992) 'Augustan Cleopatras: Female Power and Poetic Authority' in A. Powell (ed.) (1992) *Roman Poetry and Propaganda in the Age of Augustus*, Bristol: Bristol Classical Press, pp. 98–140.

Wyke, M. (1994) 'Women in the Mirror: the Rhetoric of Adornment in the Roman World' in L. Archer *et al.* (eds) (1994), pp. 134–51.

Wyke, M. (ed.) (1998) *Gender and the Body in the Ancient Mediterranean*, Oxford: Blackwell.

Wyke, M. (2002) *The Roman Mistress: Ancient and Modern Representations*, Oxford: Oxford University Press.

Yatromanolakis, D. (2007) *Sappho In the Making: the Early Reception*, Harvard: Harvard University Press.

Zanker, P. (1982) 'Herrscherbild und Zeitgesicht', *Wissenschaftliche Zeitschrift der Humboldt-Universität zu Berlin. Ges.-Sprach.* 31.2/3, pp. 207–12.

Zanker, P. (1988) *The Power of Images in the Age of Augustus*, Ann Arbor: University of Michigan Press.

Zanker, P. (2000) 'Die Frauen und Kinder der Barbaren auf der Markussäule' in J. Scheid and V. Huet (eds) (2000) *Autour de la Colonne Aurélienne: Geste et Image sur la Colonne de Marc Aurèle à Rome*, Turnhout: Brepols, pp. 163–74.

Zanker, P. and BC Ewald (2012) *Living With Myths: the Imagery of Roman Sarcophagi*, Oxford: Oxford University Press.

Zeitlin, F. (1982) 'Cultic Models of the Female: Rites of Dionysos and Demeter', *Arethusa* 15, pp. 129–57.

Zinserling, V. (1973) *Women in Greece and Rome*, New York: A. Schram.

LIST OF IMAGES

15. Apotheosis of Antoninus Pius and Faustina the Elder on the pedestal base of the Column of Antoninus Pius, Rome. AD 161. Musei Vaticani, Rome. (Photo courtesy of the author)

16. Sacrificial scene involving Severus and family, including Julia Domna (now headless), on the Arch of Septimius Severus at Leptis Magna, Libya. AD 203. Original panel in site museum. (Photo copyright of Roberto Piperno)

17. Inscribed base of statue dedicated to Cornelia, the mother of the Gracchi, *c.* 100 BC. Forum Romanum, Rome. Musei Capitolini, Rome. (Photo courtesy of the author)

18. Statue of Eumachia in the form of the Large Herculaneum Woman type. Pompeii. Augustan. Museo Archeologico Nazionale di Napoli. (Photo courtesy of the author)

19. Statue of Plancia Magna of Perge. Antalya Müzesi, Antalya, Turkey, *c.* AD 120. (Photo copyright of Carl Rasmussen of www.HolyLandPhotos.org)

20. Statue of Aurelia Paulina of Perge. Severan. Antalya Müzesi, Antalya, Turkey. (Photo copyright of Linda Davis)

21. The conserved Cartoceto bronzes on display in the Museo Archeologico Nazionale delle Marche, Ancona. End of first century BC to early first century AD. (Photo courtesy of Soprintendenza per i Beni Archeologici delle Marche)

22. Portrait bust of older woman. Colle Fagiano, Palombara Sabina, Rome. 30s BC. Museo Nazionale Romano, Palazzo Massimo alle Terme, Rome. (Photo courtesy of the author)

23. Portrait bust of older woman. Rome. Late Trajanic. Musei Capitolini, Rome. (Photo courtesy of the author)

24. Portrait head of young woman. Tivoli, near Rome. AD 117–138. Museo Nazionale Romano, Palazzo Massimo alle Terme, Rome. (Photo courtesy of the author)

25. Portrait head of young woman. Cinecitta, Rome. Mid-second century AD. Museo Nazionale Romano, Palazzo Massimo alle Terme, Rome. (Photo courtesy of the author)

26. Detail of the lid of the Projecta Casket. Esquiline Treasure, Rome, *c.* AD 380. British Museum, London. (Photo copyright of the Trustees of the British Museum)

27. Detail of the top of the lid of the Projecta Casket. Esquiline Treasure, Rome, c. AD 380. British Museum, London. (Photo copyright of the Trustees of the British Museum)

28. Detail of the scene of a lady at her toilet on the side of the Projecta Casket. Esquiline Treasure, Rome, *c.* AD 380. British Museum, London. (Photo copyright of the Trustees of the British Museum)

29. The Dominus Julius mosaic from Carthage, including scenes involving the mistress of the estate. Late fourth century AD. Musée National du Bardo, Tunis. (Photo courtesy of the Agence de Patrimonie Tunisie and the Musée National du Bardo, Tunis)

30. Lying in state scene. Tomb of the Haterii, Via Casilina, Rome. Late first century AD. Musei Vaticani, Rome. (Photo courtesy of the author)

31. The tomb-crane scene. Tomb of the Haterii, Via Casilina, Rome. Late first century AD. Musei Vaticani, Rome. (Photo courtesy of the author)

32. Detail of the veiled woman in the tomb-crane scene. Tomb of the Haterii, Via Casilina, Rome. Late first century AD. Musei Vaticani, Rome. (Photo courtesy of the author)

33. Portrait bust of the deceased wife of Quintus Haterius. Tomb of the Haterii, Via

53. Tombstone of Valeria Severa from Aquincum, Pannonia. First half of the second century AD. Aquincum Múzeum, Budapest, Hungary. (Photo courtesy of BHM Aquincum Museum, Collection of Photographs, Inv. No.: 2000.14.4)

54. Relief of a female poultry seller from Ostia. Late second century AD. Museo Ostiense. (Photo copyright of Scala Firenze)

55. Female vegetable seller from Ostia. Late second century AD. Museo Ostiense. (Photo copyright of Bridgeman Images)

56. Female shoemender or cobbler from Ostia. Second century AD. Museo Ostiense. (Photo courtesy of the slide archive of the former School of Continuing Studies, Birmingham University)

57. Funerary stele of a female doctor or *medica*. Second or third century AD Musée de la Cour d'Or, Metz. (Photo copyright of Lauriane Kieffer- Musée de la Cour d'Or-Metz Métropole)

58. Tombstone of the mime Bassilla from Aquileia, northern Italy. First half of the third century AD. Museo Archeologico Nazionale di Aquileia. (Photo courtesy of Museo Archeologico Nazionale di Aquileia and the Soprintendenza per I Beni Archeologici del Friuli Venezia Giulia)

59. Relief of two female gladiators from Halicarnassus, Turkey. First to second century AD. British Museum, London. (Photo copyright of the Trustees of the British Museum)

60. Crouching Venus with a cupid. Mid-second century AD Roman copy of a fourth-century BC Greek original. Museo Archeologico Nazionale di Napoli. (Photo courtesy of the author)

61. Statue of Ceres/Demeter. Roman copy of Greek original of fourth century BC. Palazzo Altemps, Rome. (Photo courtesy of the author)

62. Head of Vestal Virgin. First century BC to third century AD. Museo Archeologico Nazionale di Napoli. (Photo courtesy of the author)

63. Statue of Cybele dedicated by Virius Marcarianus. Third century AD. Museo Archeologico Nazionale di Napoli. (Photo courtesy of the author)

64. Statue of Isis. Temple of Isis, Pompeii. First century BC to first century AD. Museo Archeologico Nazionale di Napoli. (Photo courtesy of the author)

65. Statue of Artemis Ephesia. Second century AD Museo Archeologico Nazionale di Napoli. (Photo courtesy of the author)

66. Detail of the frieze on the Forum Transitorium, Rome, showing women engaged in textile working. AD 80s–90s. (Photo courtesy of the author)

67. The Rape of the Sabine Women on the frieze from the Basilica Aemilia, the Forum, Rome. Modern cast of original of 14 BC. (Photo courtesy of the author)

68. The Punishment of Tarpeia on the frieze from the Basilica Aemilia, the Forum, Rome. Modern cast of original of 14 BC. (Photo courtesy of the author)

69. The Chiaramonti Niobid statue. Second century AD Roman copy of a Hellenistic original. Musei Vaticani, Rome. (Photo courtesy of the author)

70. Sarcophagus depicting the Rape of Persephone. Third century AD. Palazzo Mattei di Giove, Rome. (Photo courtesy of the author)

71. Detail from sarcophagus depicting the Rape of Persephone. Third century AD. Musei Capitolini, Rome. (Photo courtesy of the author)

72. Wall painting from the Tomb of the Nasonii, Via Flaminia, Rome depicting the Rape of Persephone, *c.* AD 150. British Museum, London. (Photo copyright of the Trustees of the British Museum)

73. Funerary statue of Omphale dressed in Hercules's lionskin. AD 210–220. Musei Vaticani, Rome. (Photo courtesy of the author)

94. Inscribed funerary relief of Lucius Aurelius Hermia, butcher of the Viminal Hill, Rome, and his wife Aurelia Philematium. From Via Nomentana, Rome. First century BC. British Museum, London. (Photo copyright of the Trustees of the British Museum)

I have attempted in all cases to track down the copyright holders of images used in the book. However, in the case that any are incorrect, please get in touch with me via Amberley Publishing.

INDEX